CW00690113

JAMES HUNT

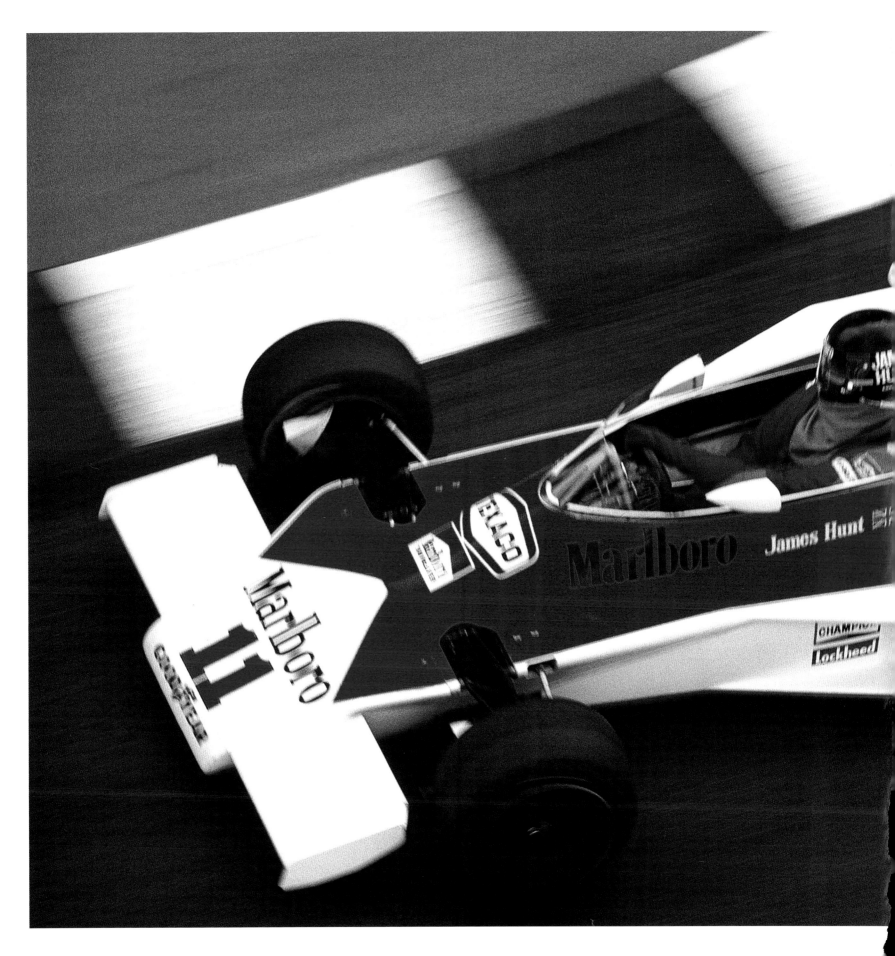

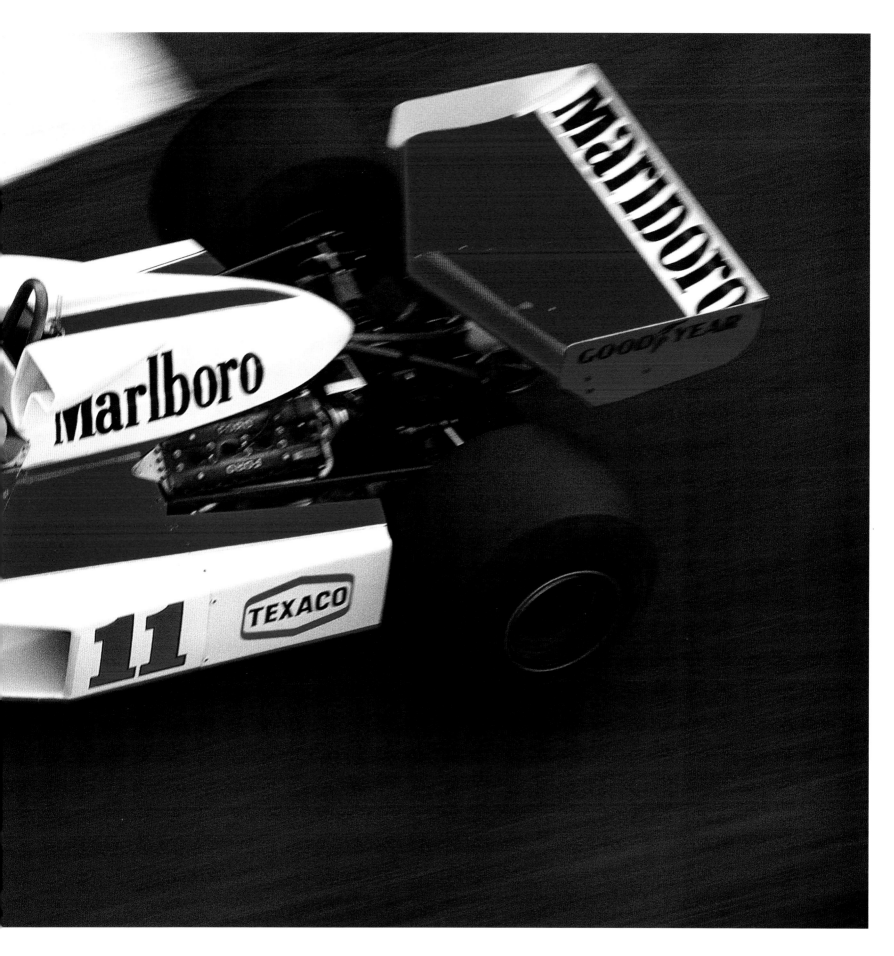

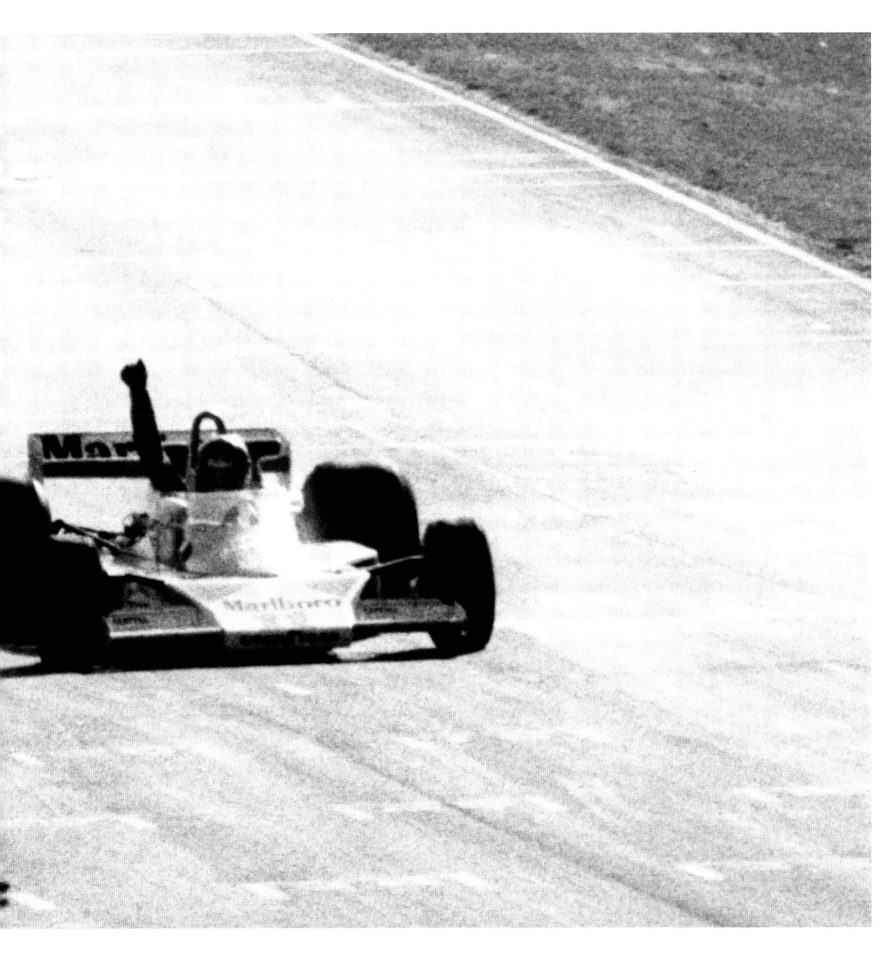

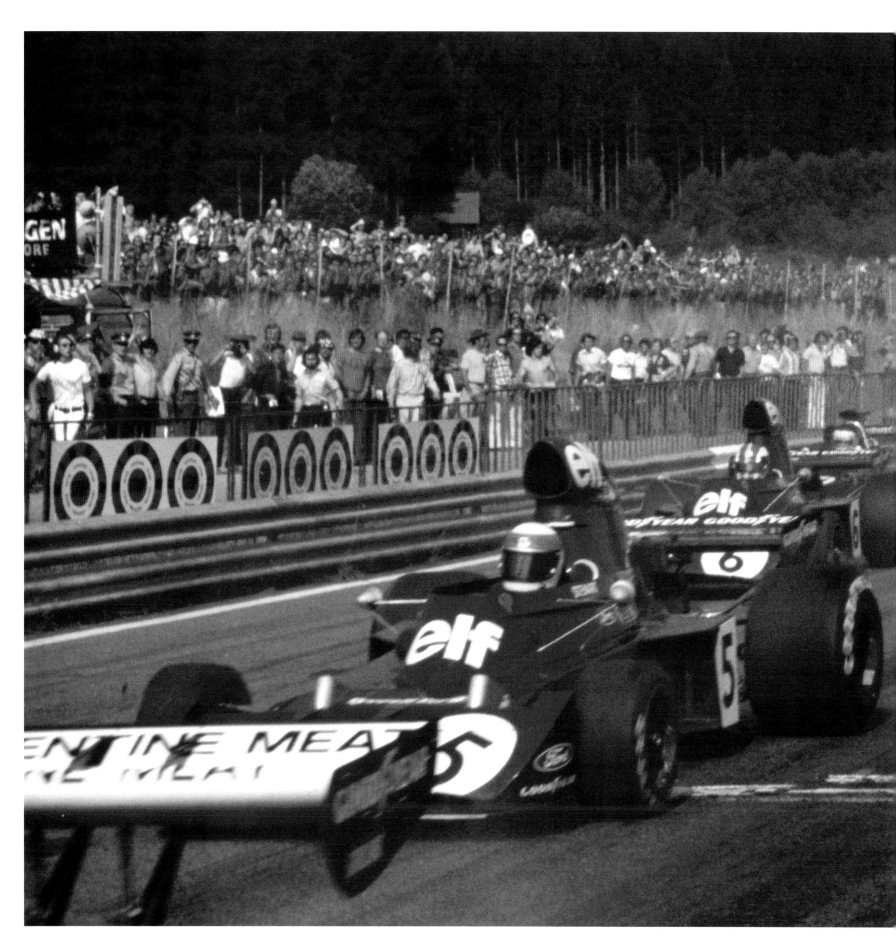

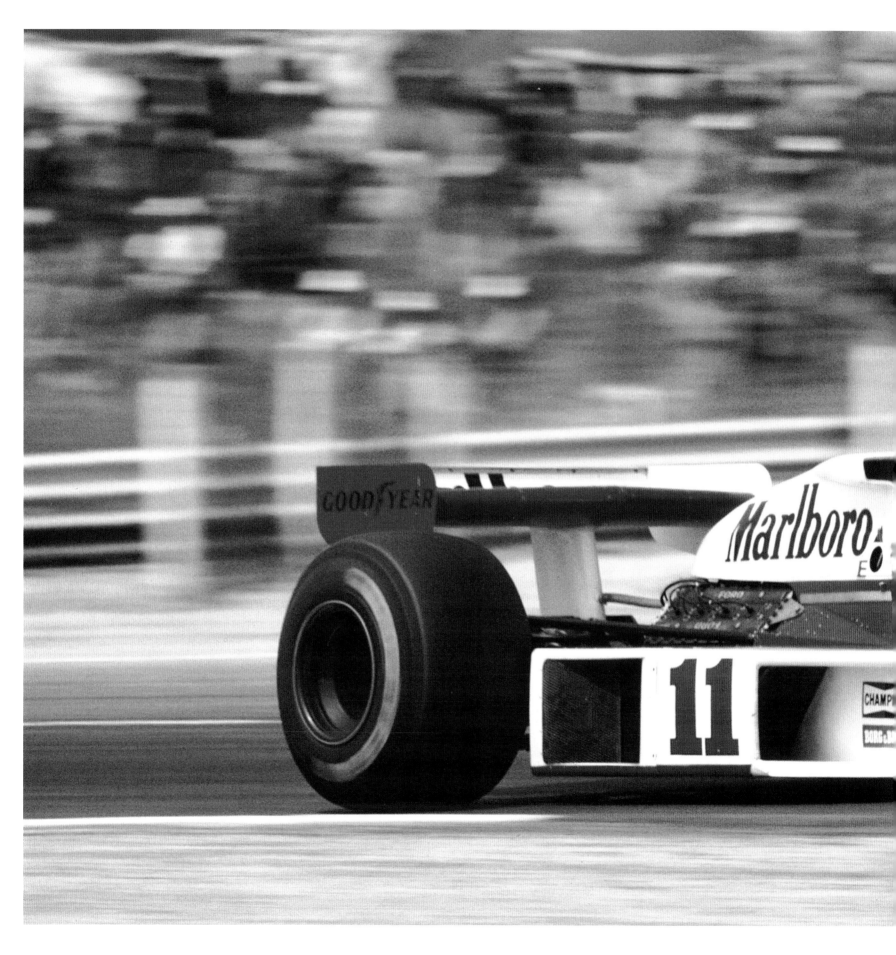

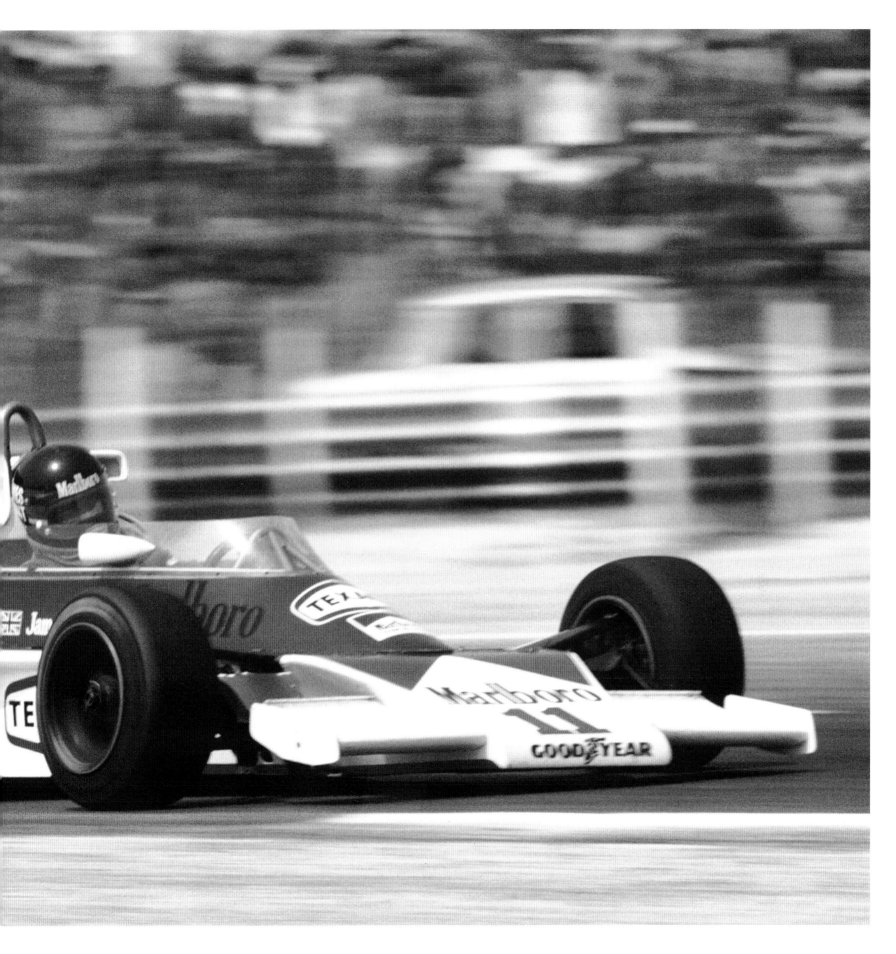

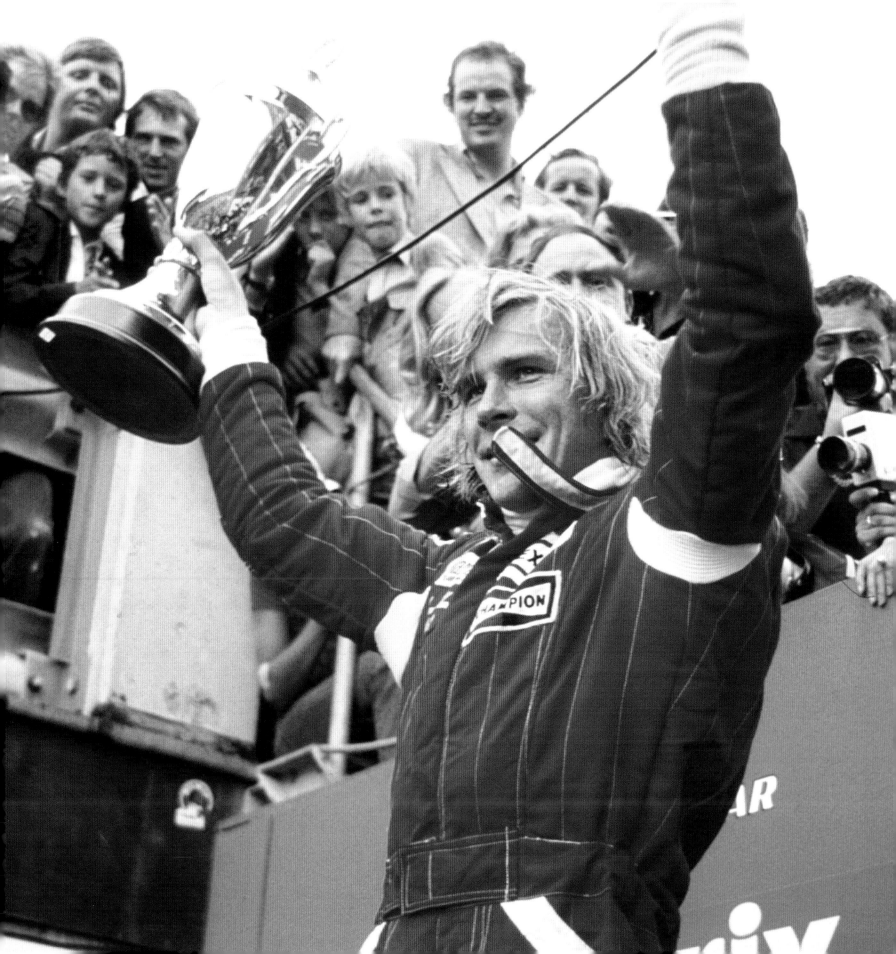

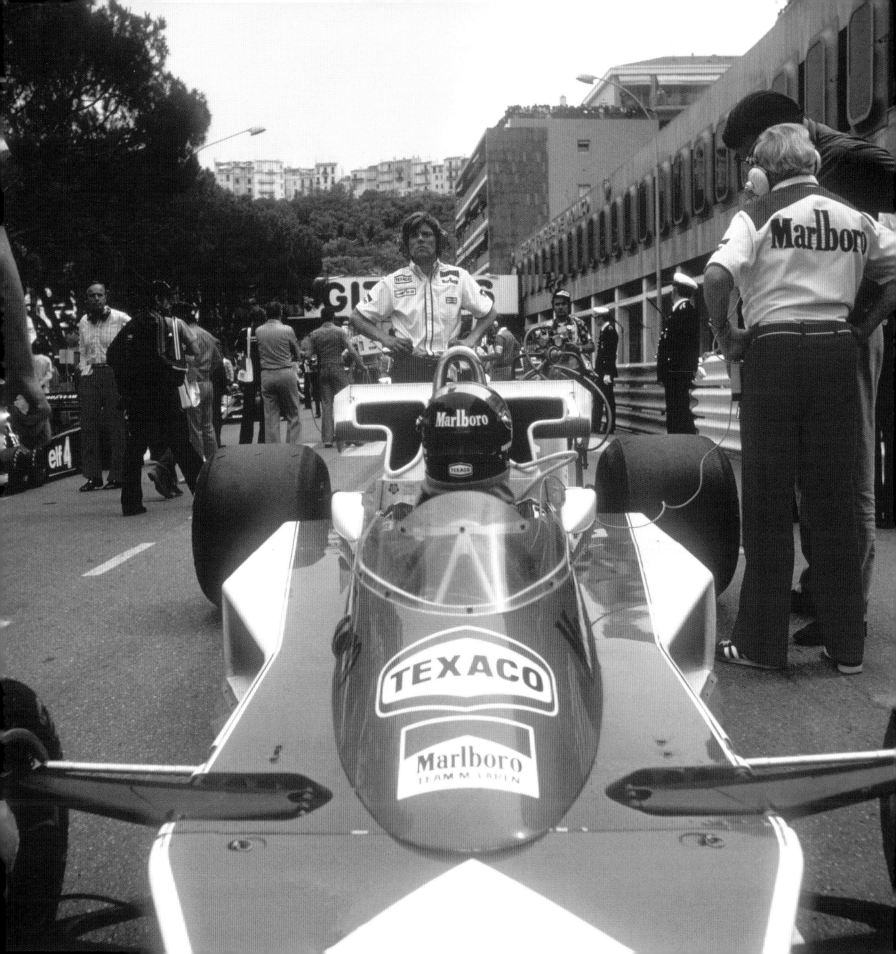

JAMES HUNT

MAURICE HAMILTON

BLINK
bringing you closer

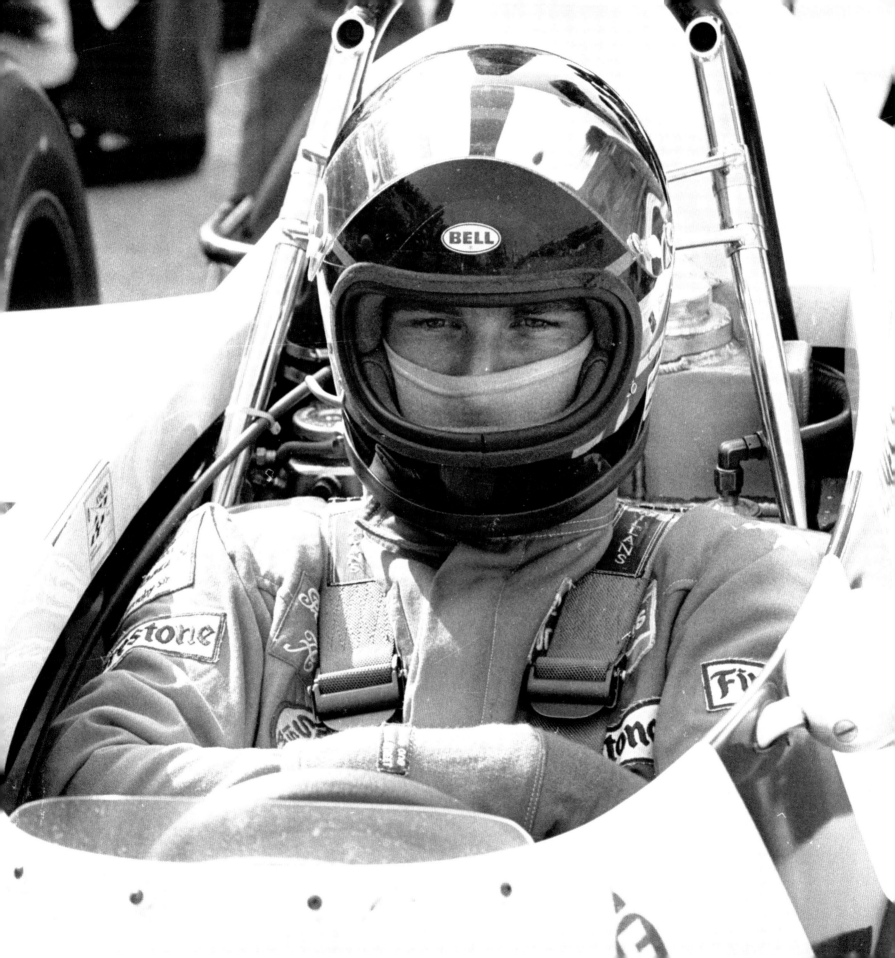

CONTENTS

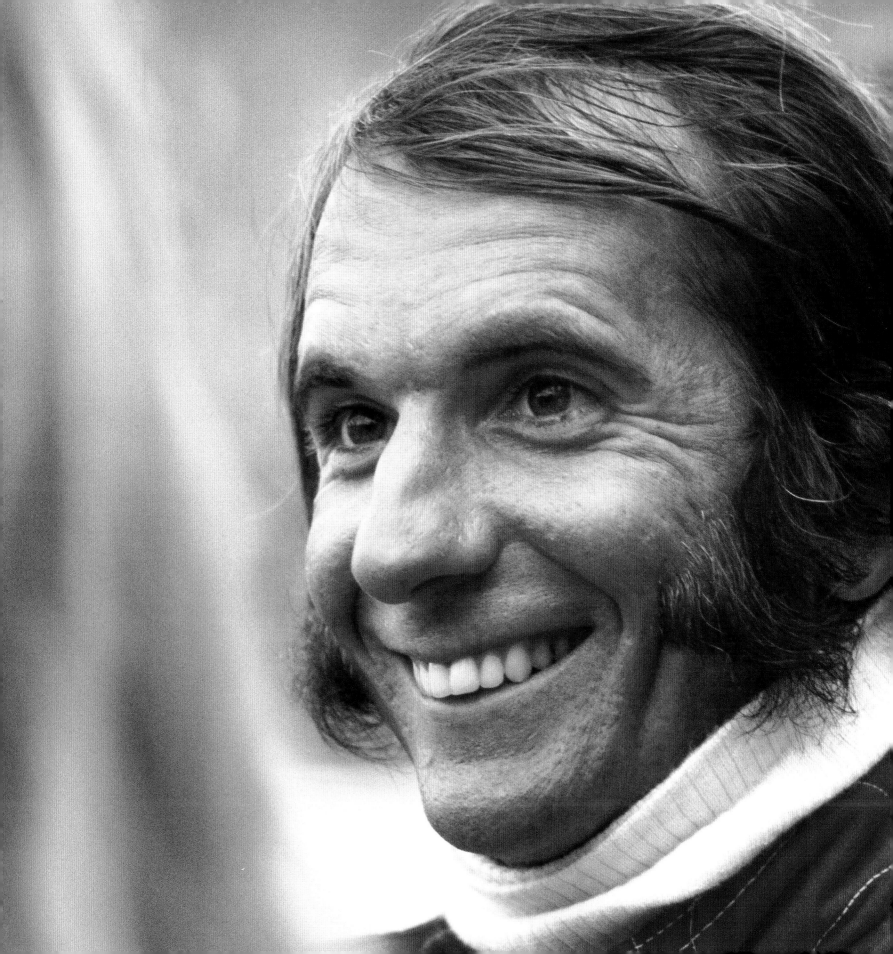

FOREWORD

Although our time together in Formula 1 was comparatively short, I have fantastic memories of James Hunt as both a tough competitor and a very good friend. It was difficult not to like such a tremendous character!

Our paths crossed very little in the lower categories of racing where, I have to say, James was never outstanding. But when he entered Formula 1 with Hesketh, he immediately began to emerge as a driver who could do something and, eventually, as this book shows, become a really great champion.

I got to know him during his years with Hesketh, not only through the results he achieved with such a small team but also because, before almost every race, he would come and ask to use the toilet in my motor home! James would become quite anxious before every Grand Prix. But he really had no reason to get worried because his races were always consistent and very quick. And the more powerful and competitive his car, the better he performed. It was obvious that if he ever got to drive with a top team, he would be a serious threat to the rest of us.

Saying that, I was really pleased when James was chosen by McLaren to take my place in 1976. By then, we had become really good friends. The Brazilian Grand Prix at Interlagos was always near the start of the season and, over the years, drivers such as Jackie

Stewart and François Cevert would spend a week before the race on the beach at Guaruja. My parents had a house there and the drivers would stay in a nearby hotel as we spent time together, relaxing and getting ready for the championship. James fitted in immediately at Guaruja and, when it came to 1976, the Brazilian Grand Prix happened to be the first race in what would turn out to be such an important year for him.

It was well known that James was a champion squash player, but I can tell you that he was really good at tennis as well. He was very fit and had a lot of stamina and tremendous concentration. He would need all of these things during that incredible season and the fight for the championship with Niki Lauda and Ferrari. James immediately proved the potential he had with Hesketh. Every time I saw him that year, he would say: 'Emerson – thank you for the car you've given me!'

It's true that the McLaren M23 was a beautiful car, very well balanced with everything working well. It's also true that this was a continuation of the great team effort I had enjoyed while winning the championship in 1974. McLaren worked continually to improve the car. Everything came together. But the point is, James made the most of it. He was extremely competitive and delivered everything that was needed when pushed to the limit: the sign of a true champion.

There is so much history at McLaren. James Hunt is a big part of that and I'm so happy to see such a fantastic story recorded in this book.

Emerson Fittipaldi
April 2016

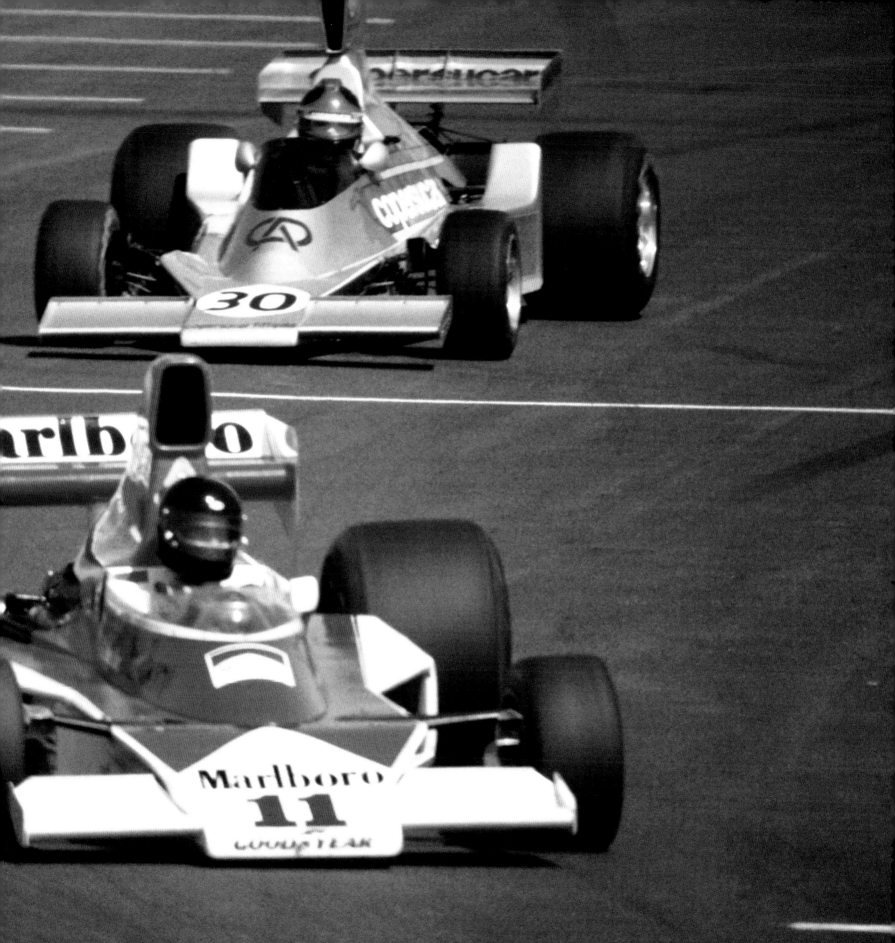

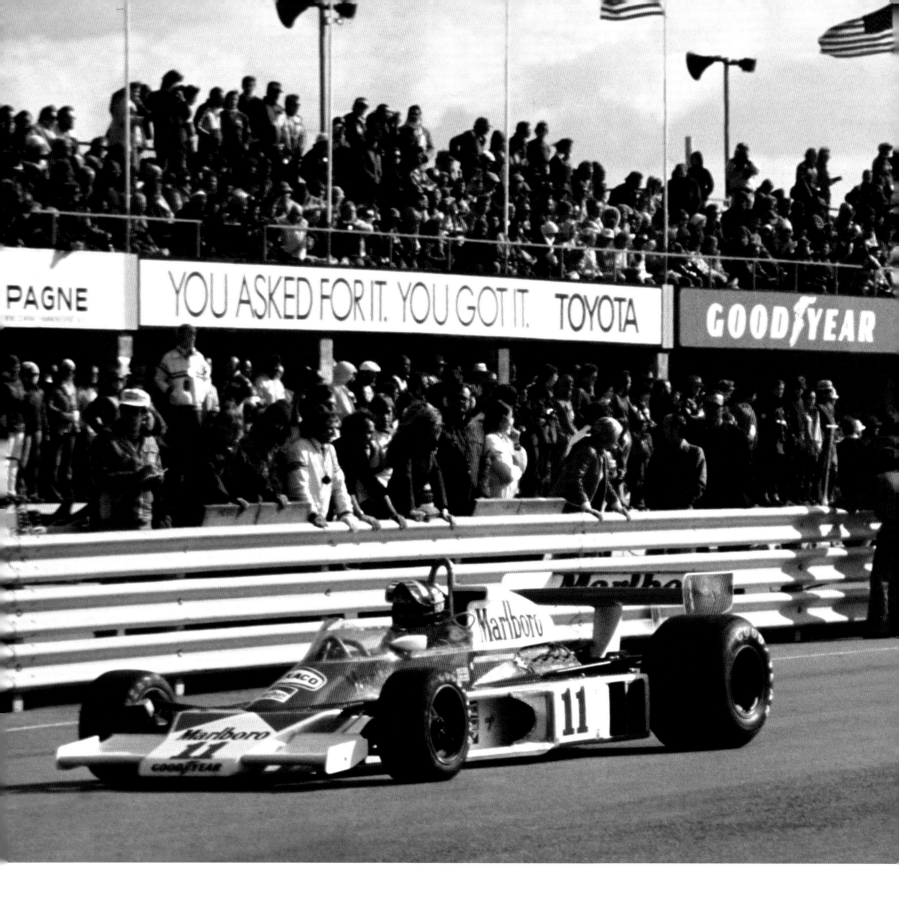

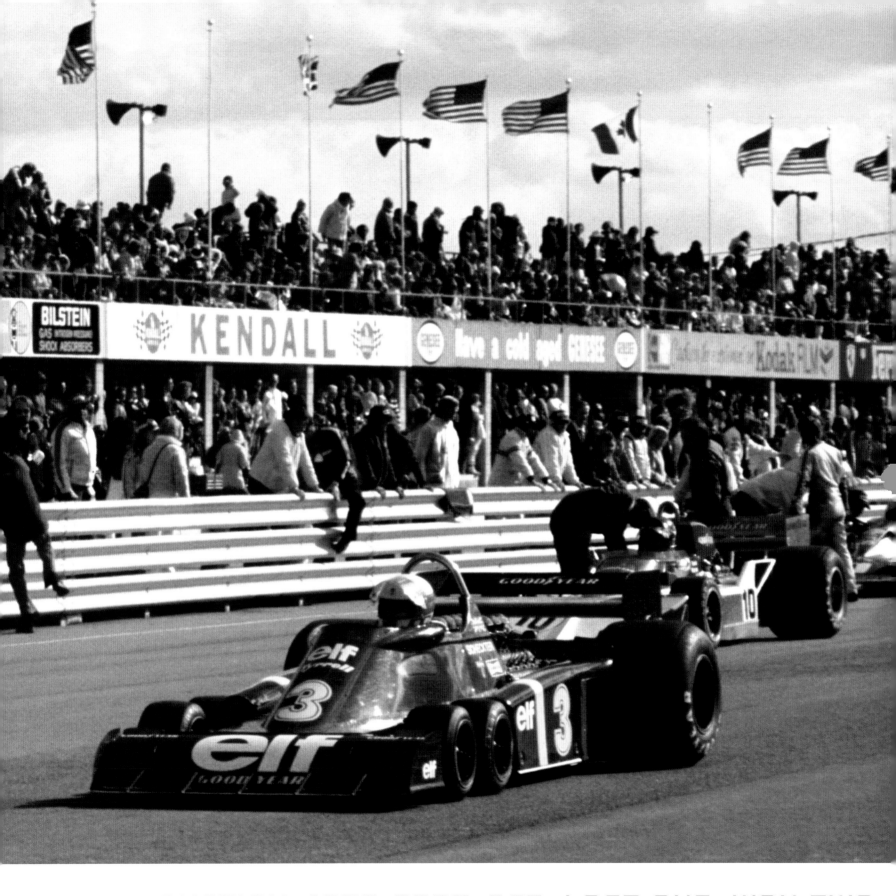

INTRODUCTION, 1976 SEPT-OCT: **LOST ONE, WON TWO**

James Hunt would forever associate the game of squash with one of the worst moments of his sporting career. On 24 September 1976, Hunt arrived at a sports club in Toronto, Canada, to be told that a Canadian journalist had been looking for him. The writer wanted James to call back in connection with a hearing in the FIA court of appeal in Paris. The news, apparently, was not good.

Hunt knew that could mean just one thing: his victory in the British Grand Prix two months earlier had been thrown out, his championship aspirations receiving a massive setback with just three races to run. Wanting time to think about this worst-case scenario, he did not return the call but went to the changing rooms and straight onto court. Hunt, as relentless a competitor as you could wish to find, would play one of the worst squash games of his life.

His mind was all over the place. How could this have happened? In Hunt's view, victory at Brands Hatch had been fair and square. Ferrari had appealed, citing an instance after the start when the race was stopped and, in the Italian team's opinion, James had not brought his damaged McLaren back to the pits in the prescribed manner.

As far as Hunt and McLaren were concerned, the race stewards had dealt with the matter on the day and he had been allowed to take the restart. End of story. The case was so clear-cut that James did not feel it necessary to trek to Paris during a time when he would rather be preparing for the Canadian Grand Prix and his battle for the championship with Ferrari's Niki Lauda. Far better, he reasoned, to leave this in the capable hands of Teddy Mayer, the head of McLaren Racing, who also happened to be a lawyer.

Previous page: The continuing come-back. James Hunt's McLaren M23 (left) lines up on pole position alongside the six-wheel Tyrrell of Jody Scheckter and ahead of Ronnie Peterson's March before the start of the 1976 United States Grand Prix at Watkins Glen. Niki Lauda's Ferrari is behind Peterson.

Opposite page: Hunt addresses his fellow drivers about safety concerns over Mosport during a coach ride around the Canadian circuit.

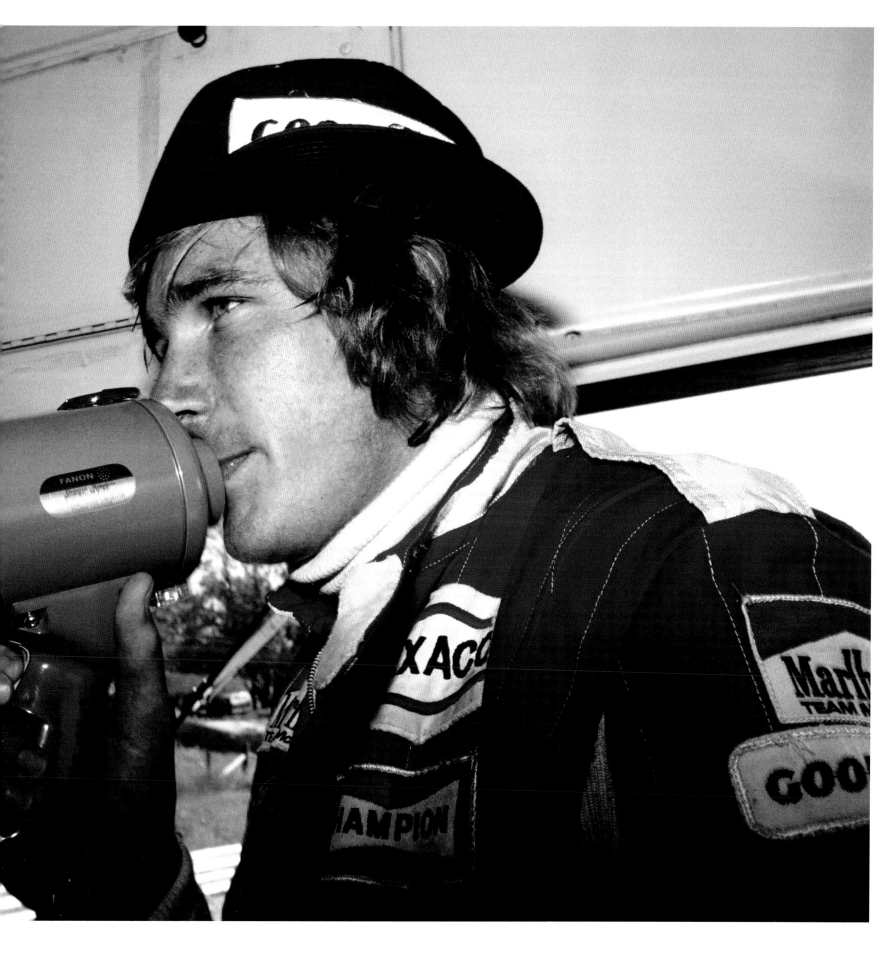

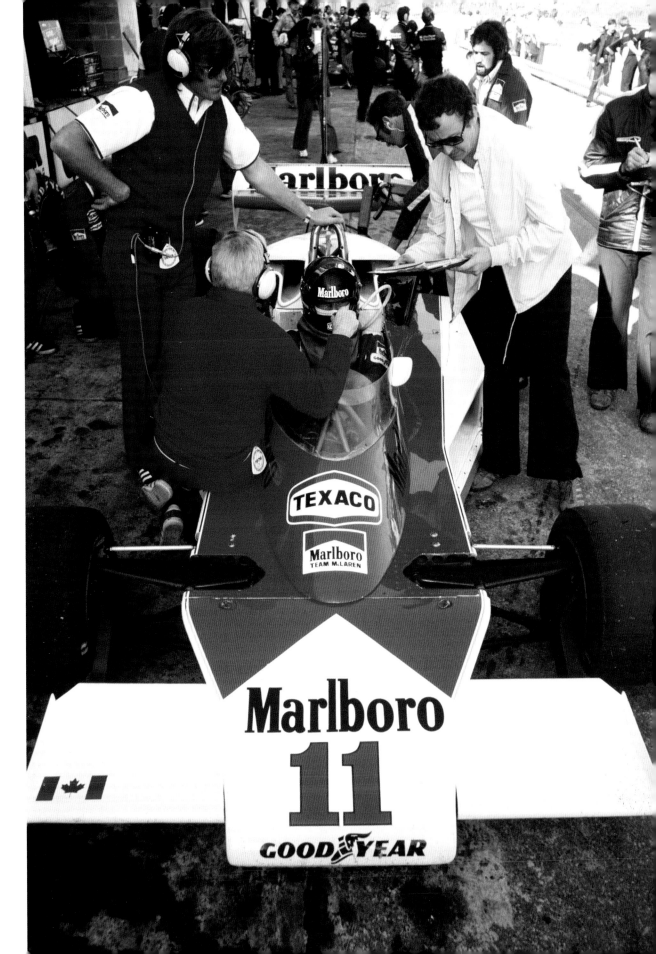

Alastair Caldwell (left) looks on as Teddy Mayer sits on a sidepod of the McLaren M23 and discusses the car's set-up during practice at Mosport. Bert Baldwin, a leading Goodyear technician (yellow jacket), adds tyre information.

As this story will reveal in later pages, it was to prove a major misjudgement. Ferrari were pulling every emotional trick in the book to sway the panel of judges in Paris. The disqualification not only robbed Hunt of nine points, but gave Lauda an extra three as he became the belated winner of the Brands Hatch race. In the space of an afternoon, the Austrian's championship lead had stretched from five points to 17. The only downside for Lauda was that he had just made James Hunt an extremely angry man.

By the time he had finished playing squash that day, there was no need to return the call. A number of journalists had arrived and were only too keen to confirm Hunt's worst fears. He left the club stony-faced. Gone – for the moment, at least – was the cheery, carefree manner that matched his flowing blond locks and perpetual state of casual dress.

In his view, the verdict had to be wrong on several counts and the resentment intensified when James discovered that the appeal court had given no reason for the judgement. In Hunt's mind, this was yet another anomaly in a season that had already seen victory denied (and later reinstated) in Spain because the McLaren was 1.8 cm too wide. And, two weeks before this latest harassment, the discovery of allegedly illegal fuel had sent him to the back of the grid for the Italian Grand Prix at Monza. Even by the standards of F1's political machinations, events in 1976 had become extreme – and aimed, it seemed, at McLaren.

A difficult week lay ahead. Judging by the impromptu press reception at the squash club, most of the aggravation would be generated off the track. Bracing himself for the coming media onslaught, Hunt headed east on Highway 401 for the 45-mile drive to a sleepy town that was about to become the epicentre of a motor sport storm.

On a quiet day, of which there were many, the rural community of Bowmanville could muster no more than 10,000 souls. During the first weekend of October 1976, however, visitors to the Mosport Park race track, 15 miles to the north, dramatically swelled the numbers. A comparative dearth of hotels in the area led many of the 14 F1 teams to stay in the Flying Dutchman, a modest establishment about to be submerged and elevated at one and the same time.

Hunt arrived to find the news agencies had been hard at work. A war of words had begun as one wire service tried to outdo the next. Lauda was reported to have said that this had been 'a correct decision' that was 'for the good of the sport'. Even worse, one report given to James by a British journalist (with, the writer claimed, the best of intentions) quoted Lauda as saying, 'I'm madly delighted'. Hunt's predictable outrage fulfilled the media man's real aim and the increasingly juicy story grew legs long enough to run all weekend.

The story continued to gather momentum as Lauda showed little sympathy for his rival's setback. 'James broke the rules in England,' he said. 'If you break the rules you are out. No argument. Now he shouts at me. This is not right. He should respect me as a driver. We have a job to do. Bad feeling only makes it more difficult.'

No sooner had every angle of the argument been examined than another disagreement was launched in the press. Lauda and Hunt, each as outspoken as the other, were at the forefront of a driver-inspired safety campaign. This previously overlooked cause had risen rapidly to the top of the agenda following Lauda's miraculous escape from a fiery accident. He had come close to death during the German Grand Prix eight weeks previously.

Before travelling to Canada, however, Hunt had told Lauda that, as the Mosport track was generally agreed to be in poor shape, he knew what needed to be done and would not require any help from Hunt. James had been granted permission to stand down from safety affairs until the rules and regulations were improved. He figured he had enough on his plate trying to win the championship. Later asked about his planned absence from the safety meeting, Hunt retorted, 'To hell with safety. All I want to do is race.'

Those were the basic facts, agreed without rancour or intrigue. At this stage, however, the rather dull truth was not about to stand in the way of a good story that erupted when James met Lauda in the foyer of the Holiday Inn at Oshawa, near Bowmanville. Lauda was fresh from passing his final exams for a private pilot's licence.

'How's your brain-fade, James?'

'Bad – and it's going to be worse when I get in the car.'

Hunt explained his tactics some months later to his biographer, Eoin Young.

James Hunt *I was deliberately trying to make Niki think I was freaked out. Because if he thought I was freaked out by what was happening he would steer clear of me on the track. It was purely a professional piece of gamesmanship. That's all part of the game. If you can psyche another driver out and make him frightened of you, then he's much easier to pass. I had cultivated the idea with Niki that I was worked up and, without ever saying it, made him think that I was going to push him off the track – which was the last thing I'd do; I didn't want to get tangled up with another car because it would probably have sent me off the road. But I wanted him to think that way, because after his accident and everything, if he saw me coming up in his mirrors he'd pull sharply over and let me through. As for talk that I didn't care about safety – I cared very much.*

There were suggestions that the race might not be held at all. Since the 2.6-mile circuit at Mosport opened in 1961, harsh Canadian winters had taken their toll on the surface. A disagreement over finance led to the cancellation of the Grand Prix in 1975 and the two-year absence from Mosport merely highlighted its shortcomings when the F1 teams returned.

That said, the drivers did at least agree that the circuit layout, rising and falling through 450 acres of rolling countryside to the north of Lake Ontario, was as testing as any on the championship trail, the downhill Turn 1 being particularly outstanding. Typical of the practices of the time, however, after much talk on the subject and one or two cosmetic changes, the track's deficiencies were immediately forgotten as helmet visors were flicked shut and practice got under way.

James Hunt *By this time, I was fired up and really wanted to drive. And the only place I could be on my own and get on with the job was in the car. So I enjoyed my driving more than ever because it was such a super relief. The rest of it, I hated.*

There would be another unwelcome distraction. During the three-week break since Monza, James found it difficult to turn down the chance to take part in the dollar-rich International Race of Champions, a series in which top drivers from different disciplines (but mainly North American racing) drove identical Chevrolets. Hunt's left arm and elbow had been strained by the heavy steering on his Camaro, not helped by a shunt in the same car during a race at the Michigan International Speedway. When he finished the first practice at Mosport, James had to be helped from the cockpit by one of his mechanics.

Despite that handicap, Hunt's enthusiasm was immediately apparent. Thanks to running at Mosport a few weeks before (testing between races being routine at the time), both the driver and his McLaren-Ford M23 were ready from the outset to deal with the bumps. Hunt was almost one second faster than anyone else during first practice on the Friday morning. His margin of superiority would be reduced as the weekend went on but, when it really mattered during qualifying, Hunt took pole by half a second from the March-Ford of Ronnie Peterson. Lauda was sixth.

Bowmanville became gridlocked from an early hour on race day as 85,000 spectators poured off Highway 401 on a fine autumnal morning. Acupuncture had not cured Hunt's painful left arm and he had not slept well that night. When he arrived at the track he was notably edgy, pacing around the garage, smoking and, as was his wont before a race, being sick into a bucket.

His adrenalin began pumping even harder as the day's schedule fell behind. Crash-barrier rebuilding had followed a hectic Formula Ford race for young heroes who wanted to impress the influential audience in the F1 paddock. Their desire to win – almost at any cost – was shared by the man in the red-and-white McLaren no. 11. In a race without pit stops, the strategy needed little discussion; James Hunt simply had to go for it.

That plan received an immediate setback as Peterson made the better start and swooped across the bows of the McLaren and led through the downhill first corner. Hunt hounded the Swede for eight laps before finding a way through. Immediately, he pulled out 1.5 seconds on the March. James desperately needed to score the maximum points, but any thought he might be left to get on with it ended four laps later when Patrick Depailler forced his Tyrrell-Ford into second place.

BEFORE THE CANADIAN GRAND PRIX, MY CHANCES OF WINNING THE CHAMPIONSHIP MUST HAVE BEEN 20 TO 1 AGAINST.
JAMES HUNT

Hunt and Depailler had history. Earlier in the season, they had collided at Long Beach, the Tyrrell continuing while James spent the next few laps standing on the track, shouting obscenities and gesticulating furiously each time Depailler came by. Not satisfied with that, Hunt later marched into the winner's press conference (Depailler had finished third) and continued the tirade in front of the startled Frenchman and a room full of reporters, some appalled but the majority delighted as they scribbled furiously. And now, six months later, the contest was rejoined as the two got ever closer with each lap.

Depailler, a cigarette-smoking, feisty little man who had come through the French F3 ranks, was driving a Tyrrell P34, a car with a highly unusual look thanks to four tiny wheels at the front. The introduction of the first six-wheel F1 car in Spain in May led to a period of acclimatisation but, by autumn, Depailler was flinging the ungainly car into corners with exhilarating abandon on a circuit he clearly loved. By quarter-distance, he was less than 2 seconds behind the McLaren and showing every sign of wanting to score his first Grand Prix win. Five laps later, he was 1.5 seconds behind. Then 1.3 seconds; then 0.8 seconds. Hunt was being made to work extremely hard. Lauda, meanwhile, was fifth and struggling with his Ferrari's handling.

As the leaders began to work through the backmarkers, Hunt employed all of his cunning to keep Depailler at arm's length.

By carefully timing his passing moves, James would minimise any hindering and, if he played it absolutely right, he could leave Patrick to struggle as he attempted to follow through on a difficult section of the track. It was notable, too, that the slower cars were more obliging to Hunt than usual. They might not interfere anyway with the progress of a contender, but perhaps the back markers had also noted the approach of a driver who had given the worrying impression of being 'freaked out'.

Occasionally, Depailler managed to haul the Tyrrell onto the tail of the McLaren. Indeed, on one lap, he was so close that a move to take the lead seemed inevitable. It was a superb contest of enterprise and daring: Hunt with everything to play for, Depailler chasing the scent of a long-awaited victory.

In fact, Patrick was beginning to sniff something else. A special petrol-filled safety diaphragm had been incorporated in the Tyrrell's system to sidestep the need for the dashboard gauge to be fed by petrol. This precaution had been taken to avoid the hazard of routing fuel into the cockpit. Ironically, the safeguard had gone wrong. A fine spray of petrol was feeding into the cockpit and beginning to work its way up and into the driver's helmet.

Hunt drove a powerful race in the beautiful autumnal setting of Mosport Park to win the Canadian Grand Prix.

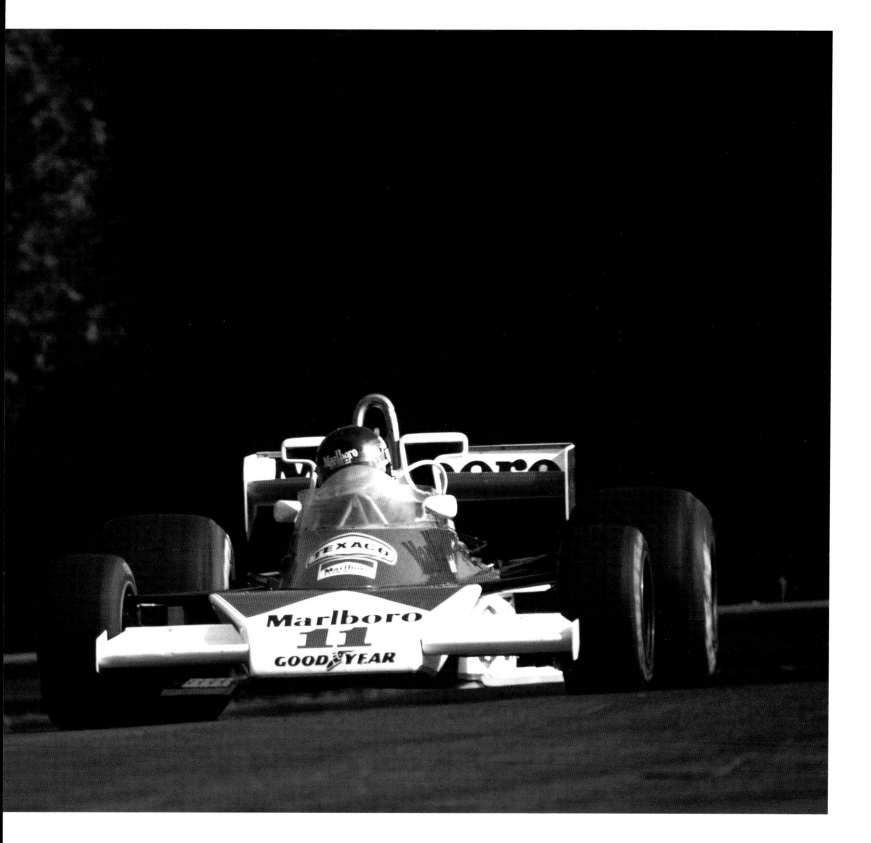

A quick cigarette before the race at Watkins Glen.

With five laps remaining, Hunt sliced past a battle for ninth place. When Depailler did likewise, everyone waited for a certain final attack. It never came. The Tyrrell began to drop back and, immediately on crossing the line for the 80th and final time, Depailler pulled up sharply, flung off his belts and stumbled from the car. Overcome by fumes, his swollen left eye virtually closed, the final laps had been driven as if on automatic pilot. Depailler at times had only a vague idea of his location. Lauda, meanwhile, finished out of the points in eighth place.

In part, Hunt had been lucky with his opponent's misfortune. But he had also driven arguably one of the most determined races of a Formula 1 career that had started in 1973 and included his maiden F1 victory two years later. James had enjoyed the *joie de vivre* endemic to the small team owned by Lord Hesketh but, in truth, this privately run operation, serious though they might often have been, could never give Hunt the chance he needed to mix it with the major players.

That opportunity arose when Emerson Fittipaldi left McLaren to start his own team for 1976 and Hunt filled the vacancy created by the departing world champion. Since his January debut Hunt had been first across the finishing line on seven occasions. The roller-coaster season and the fight with Lauda that followed could have made a movie – and did, 37 years later, with *Rush*. And here in the space of one week, another dramatic chapter had been written. With Lauda's lead reduced to eight points and the momentum in Hunt's favour, he headed across the US border. The next race was in seven day's time and Hunt could not wait to get started.

In fact, he hardly stopped. The sense of injustice continued to rage and fired the belief that he had nothing to lose. This seemed to apply to life both on and off the track. Embracing the tenet of working hard and playing hard, James enjoyed a drink – or several – and made full use of his appeal to women.

Fortunately for Hunt, this was when the term social media referred only to a good night in Fleet Street's Cheshire Cheese pub. The hacks present in Canada in 1976 were either too busy filing their 'Our boy James fights the arrogant Austrian' stories or felt it was intruding on the British hero's privacy to report his exploits with, to give just one example, the singer working with the hotel's band. Or, at the race track itself, his 'physical examination' in an ambulance with the wife of an official. The McLaren mechanics desperately kept the husband talking while the vehicle rocked in the background.

Watkins Glen, scene of the US Grand Prix, was bound to guarantee more of the same. Not that he needed encouraging, but Hunt felt there was all to play for.

James Hunt

Before the Canadian Grand Prix, my chances of winning the championship must have been 20 to 1 against. I was 17 points behind Lauda, which meant that I had to take 18 points from the final three Grands Prix without Niki winning. Even if he hadn't turned up at the race he was still clear favourite to take the title because 18 points is more than most drivers score in a season, let alone three races. If I had one retirement, it meant I had to win the other two races to win the championship by one point – even if Niki hadn't bothered to come.

It was really too much to do so, by Watkins Glen, I wasn't too bothered about the championship but I hadn't given up completely because while there's life there's hope. I could only knuckle under and go after each race as it came and try to win it. If I couldn't win, I had to finish as high as I could.

The scene shifted from the Flying Dutchman to the Glen Motor Inn, another small motel in the eminently more picturesque surroundings of the Finger Lake district of upper New York State. Hunt and Lauda were in adjoining rooms. But the set-up was not to provide the social drama yearned for by the media. Immediately after the race at Mosport, the two rivals had shaken hands and applied the brakes to a loathing that had in reality been largely generated elsewhere.

James Hunt *The press was winding us both up badly and we both got irritated. For a few hours we hated each other but after we got it sorted out, our good relationship continued. For example, we had these adjoining rooms in Watkins Glen and in the evenings we had our door open and we socialised together.*

I'll never forget Niki's attempt to psyche me out on race day. I always got up at eight o'clock on race days to be at the circuit at nine. Knowing full well what time I had my call booked, Niki barged into my room at seven o'clock. He was fully bedecked in his overalls and stood to attention over my bed as he said: 'Today I vin ze championship!' And then he marched out again. I thought that was hilarious.

Lauda (affectionately known as 'The Rat' because of his prominent front teeth) had not been amused the previous day with a Ferrari that handled badly as he qualified fifth, more than half a second behind Hunt, on pole for the second race in succession. This time, Ferrari could not point to a test session as the reason for McLaren's superiority. The M23 was working well; almost as good as a driver continuing to combine dogged determination with sheer speed and the maxim of having absolutely nothing to lose.

In fact, Hunt's relentless attitude was almost identical to that of the driver with whom he would share the front row. Jody Scheckter had a surly reputation that actually disguised a keen sense of humour Hunt had got to know and enjoy as their relationship had flourished. The pair had flown together from Toronto to Los Angeles.

In LA, James had dinner with Richard Burton and his new wife, Suzy, the former Mrs Hunt. It was a sign of the warm relationship that the 50-year-old actor should encourage James to call him father-in-law. All of this was a suitable distraction and momentary release from the pressure of racing that would return as soon as Hunt flew east to resume hostilities.

Scheckter had made his F1 debut with McLaren at Watkins Glen back in 1972 and the South African put his experience of the undulating track to good use as he was second fastest on the first day, the Tyrrell driver a few tenths shy of Hunt. Those lap times would establish the grid when the second day of practice was washed out by stormy weather. The threat of winter continued with a bitterly cold wind on race morning. Lauda's chances of winning 'ze championship' seemed to be a possibility when he was as quick as Hunt during a 30-minute warm-up. Even if he could not win, scoring two more points than Hunt would be sufficient. As for James, his philosophy was exactly as before: go for the win and see how the points stacked up at the finish.

Scheckter rightly showed no interest in assisting his friend as the Tyrrell snatched the lead into the first corner and began to pull away. By the time Lauda had worked his way into third place on lap five, he was 5.8 seconds behind Hunt, who was 2.5 seconds adrift of Scheckter. For the next 20 laps, the gaps see-sawed as the stopwatch told the tale of three drivers, each making small errors while keeping one another in sight.

At around half-distance, the story began to change as Lauda fell away with a repeat of the oversteer that had dogged him during practice. And Hunt was on the move after giving himself a good talking to.

Another strong drive from Hunt at Watkins Glen brought victory in the United States Grand Prix and kept his championship hopes alive.

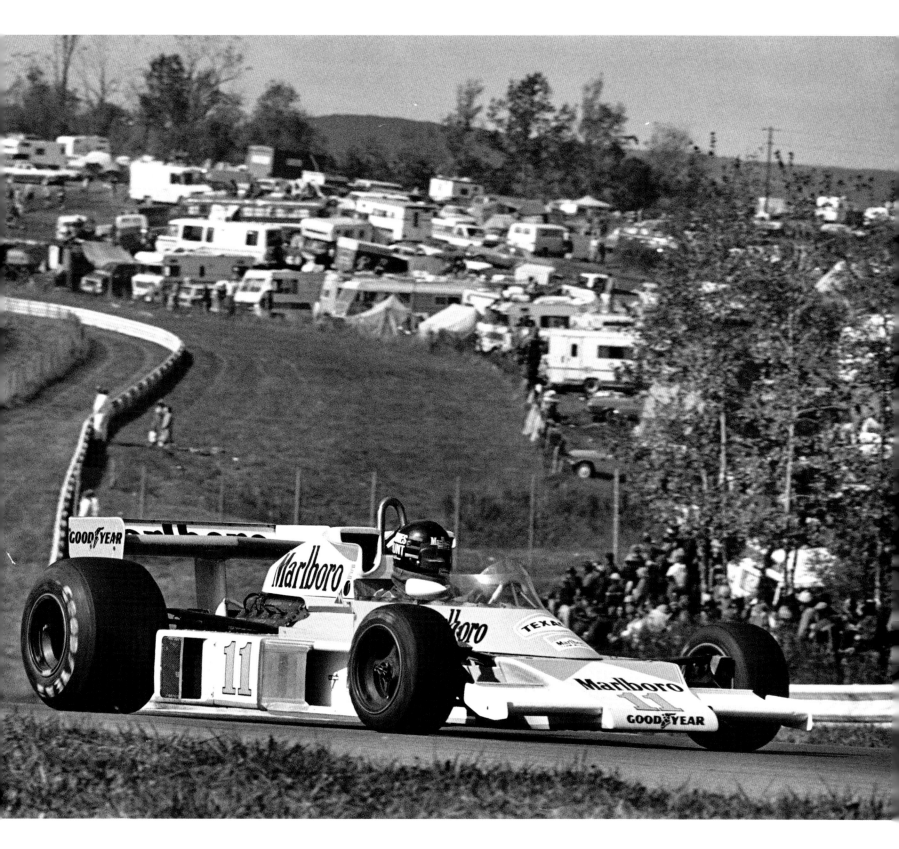

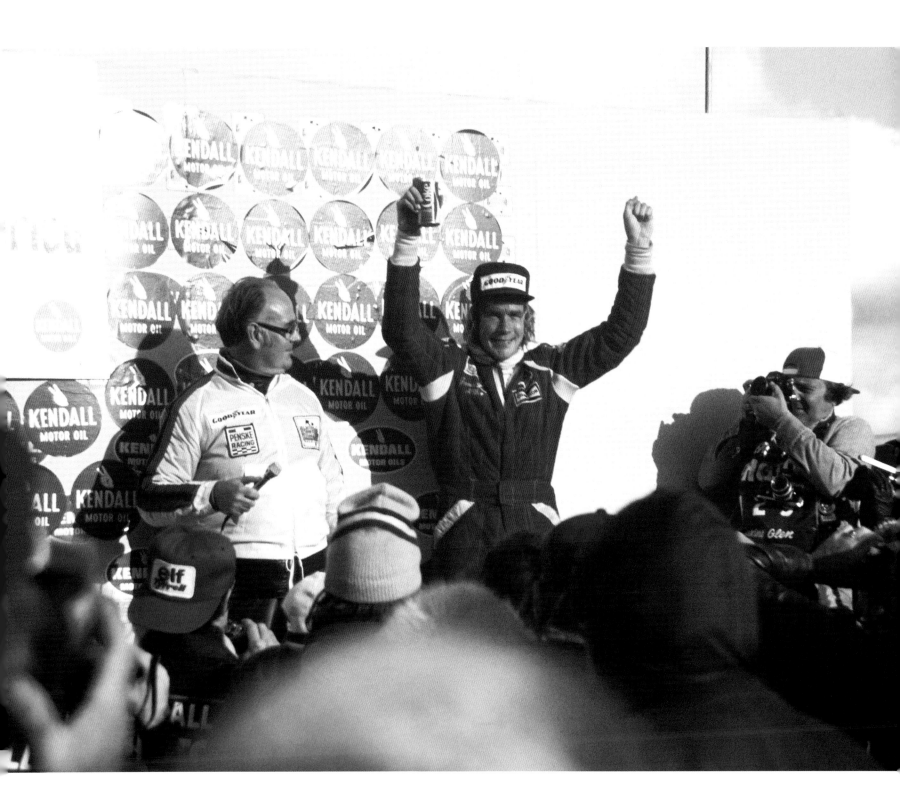

Job done and a can of Coca-Cola before something stronger. Hunt receives the plaudits at Watkins Glen before being interviewed by Anthony 'Bunter' Marsh, the international F1 commentator.

It was an interesting situation and taught me something about my driving. Normally, by race day, you know the car and the track so well that when the race starts and you're through the first lap, you switch onto auto-pilot and put your concentration onto the race, the more total and general picture because your driving – the physical art of getting the car around the lap quickly – is automatic.

After about ten laps at Watkins Glen, I realised I was driving like an old grandmother. Jody was about three seconds up on me and I was holding the gap, so there was no problem about that; no danger that he would disappear into the distance. But I wasn't closing on him either and I ought to have been. Niki was seven seconds behind me in third place and was holding that gap, so it could have gone either way – he might have gained or lost – and I couldn't afford to take the risk that he was going to get quicker.

It took me another few laps to realise what was happening with my driving and then get it together. The car was oversteering, which made it quick but difficult to drive, but I was driving like an old woman because I wasn't concentrating on the physical act of driving. I was making mistakes around the track and I had to spend time learning it all over again and then get going.

Hunt closed on Scheckter before spending several laps choosing his moment to slipstream, draw alongside and take the lead. Hunt immediately opened a 2-second gap but that would count for nothing when he came across a back marker at the chicane and had to yield. Hunt was literally powerless to prevent Scheckter from regaining the lead.

Furious, Hunt attacked immediately, pushing and probing for five laps before finally passing the Tyrrell at the end of the long back-straight. There were a dozen laps remaining – and Hunt made them all count. When James set a new lap record, Scheckter knew it was game over and focused on bringing the Tyrrell home, safe in the knowledge that he was almost a minute ahead of Lauda in the ill-handling Ferrari.

As it was, Lauda was busy fending off a late attack from Jochen Mass, Hunt's team mate being urged on by the McLaren pit wall to deprive Lauda of another point that could be absolutely vital. They crossed the line 0.13 seconds apart. Meanwhile, Hunt was well into his slowing-down lap and keen to get back to the pits and find where he stood in the championship. The points table showed he was now just three points behind Lauda. James could do no more apart from celebrate. And there was no question about where to go.

The Seneca Lodge, with its timber façade, was located in the woods on the downhill run from the track to the town of Watkins Glen. The dimly lit bar was a shrine to motor sport, the walls and ceiling smothered in memorabilia and the laurels of past winners at the race track five minutes up the road. Draught Genesee was the staple diet, the bar staff ringing a bell each time a customer bought them a drink.

It rang a great deal on the night of Sunday 10 October 1976. But not even the clang of that large bell could be heard above the roar when the winner of the Grand Prix staggered into the bar. James, having clearly begun celebrating some time before, was beaming from ear to ear – as well he might with a girl on each arm and a hard-earned win in his back pocket. At some point during the short journey, he had found or been presented with a builder's hardhat, complete with a flashing orange light, that now perched on his unkempt, blond mop.

He looked comical and happy – and with good reason. One race to go and three points difference. It was game on. This was the sort of back-against-the-wall battle James Simon Wallis Hunt had seemed to relish, almost from the moment he was born 29 years earlier, into infinitely more genteel surroundings than that boisterous cavern of celebration high above Watkins Glen.

Wallis and Sue Hunt had six children: four boys and two girls. The parents were determined to have their family appreciate discipline and the values of respect in the post WWII years, but found that their second-born was reluctant to conform – to anything.

Restless, rebellious and prone to tantrums, James required more attention than the rest put together. There was a sense of urgency about him that came with an inquiring mind and a refusal to take no for an answer. These attributes would stand him in good stead later but, in the austere years that followed his birth on 29 August 1947, contributed to relentless and stressful conduct that his hard-working parents could do without.

A captain with the armoured corps of the 11th Hussars regiment, Wallis Hunt had been the only survivor when his armoured car was hit by a German shell on manoeuvres in northern France in August 1944. When the war ended, Hunt continued to be away from home for extended periods. He worked in South America for an international trading company while Sue raised the family on her own for the best part of the following decade. This arrangement was combined with the stiff-upper-lip traditions of the day and contributed to the way James withdrew into himself in such a large, industrious family.

Income was minimal after Wallis first demobbed. The Hunts lived in a flat, then a four-bedroom house in Cheam, Sutton, before moving to nearby Surrey and then a large Victorian property back in Sutton. Wallis's work abroad eventually began to bring in more money after Sue had given birth to Sally, James and Peter. The Hunts moved to a comfortable detached house in Belmont following the later arrival of Tim, David and Georgina.

A family of six was an approved size as Britain needed more people to rebuild its social structure in the post-war years but it meant the Hunt children needed to be self-sufficient. Each adopted their own personality, that of James Simon Wallis being the most pronounced – and not always in the most favourable way.

According to Sue, he would cry continually at night and was prone to tantrums during the day. But alongside this grew an eager mind and keen intellect, driven by a remarkable and sometimes scary determination to have his way. This burning desire to win was assisted by a fast-developing ability to talk and, by extension, to use a growing vocabulary in a persuasive, persistent manner. Proof that debate rather than materialism was the motivation would be demonstrated – to his mother's frequent exasperation - by James immediately discarding the object of his apparent desperate longing once the battle had been won. Which was to say, most of the time.

While James was hugely impatient, he was completely without malice. Occasionally, though, getting his own way with his siblings involved impulsive physical force. Aged four, James hit Peter over the head with a shovel and his baby brother required stitches, for which James received a parental whacking.

The punishment for a similar offence years later was more subtle and indicative of the strict upbringing in the Hunt home. In the heat of an argument, James took a swing at Peter, who saw the blow coming and swiftly evaded it. The resulting impact with a stout wall broke James's knuckles. His mother sent him to hospital. On a bus. On his own.

As Sue would later point out, the sometimes harsh realities of life in a large family, coupled with James's cast-iron determination, helped foster the fighting spirit and bloody-minded independence that contributed to becoming a successful racing driver even though, as a child, James did not have the slightest notion about becoming a world champion. His early years were spent coping predominantly with schools he hated.

Whether it was the nursery section of Ambleside, a pre-prep school in Cheam, or a prep school in Sutton, Sue braced herself each day for a bout of fierce resistance from a child unhappy within himself and in the company of other pupils. He hated rules and the need to conform. It was also the beginning of preparation for life in a boarding school: a given in the Hunt family as far as the boys were concerned.

Sally Jones (née Hunt)

James was my little brother, just over two years younger than me. We got on very well and played a lot together. But I can also recall him being quite awkward at times and needing my parents' attention quite a bit. When I was at Ambleside and James started in the same school, I remember being summoned up to the nursery to try and calm him down. He would be screaming or saying he didn't want to be there and wanted to go home. I'm not sure how much help I was!

The one educational positive was a focus on sport. James began to develop a lithe body while showing promising skill in sport, particularly with a racquet. Wallis had attended Wellington College where he too demonstrated prowess at sport.

Before James could be enrolled at the same institution, however, he needed to spend five years at Westerleigh school in Hastings, the hope being that he would pass his common entrance exam prior to moving up to Wellington at the age of 12. Westerleigh had been chosen because the headmaster had served with Wallis in the 11th Hussars and much admired him.

To the dismay of Wallis and Sue, their plan seemed doomed from the outset. James was extremely reluctant to make the lengthy journey south to the Sussex coast to start the next phase of his education. Once he got there, an absence of notable academic achievement at Westerleigh was offset in part by competence and dexterity in just about every sport – running, tennis and cricket, to name but three – that James turned his hand to. He was particularly successful in games that required stamina and good hand-to-eye coordination and individual sports.

And then there was his passion for knitting. James was not particularly dextrous with the needles but it was remarkable that he wanted to do it at all in the macho environment of a boys' school. He just didn't care what people said – indeed, being controversial was an attraction in itself for a boy who was a renegade and continued to be uninterested in the company of his fellow pupils.

Sally Jones

The reason he had started knitting was when Tim was a baby, I was 12 and James was ten, I knitted some little shorts or something for my little baby brother. James, being very competitive, wanted to do it too. It was a competition with his sister Sally. Typical James!

Achievements in needlework might have not greatly impressed the headmaster at Wellington but Hunt's sporting record was good enough to ensure his place. Predictably, he had comfortably failed the entrance exam and had no wish to go to the college in Berkshire in the first place.

Wellington, with a reputation for preparing boys for a military career, adopted a strict disciplinarian code. James thoroughly disliked it at the time but would later admit it had probably been good for him at such an important stage of his development. When confronted by the careers master and asked to make a choice, James briefly contemplated following his father's example by going into the army. He eventually decided on medicine, not through any interest in either human physiology or drugs – although both would follow later in more stimulating forms – but because the medical profession seemed the most attractive on a list of distinctly unappealing occupations.

In any case, there were plenty of distractions, one of which was the school orchestra that had the considerable benefit of offering an alternative to evening study. His chosen instrument was the trumpet, which he mastered with such skill that he was singled out as a soloist. This was a role he would unexpectedly occupy in the Royal Albert Hall many years later.

Playing an instrument was a rare form of relaxation in a school life filled as much as possible with sport. James took part in individual pursuits such as tennis, squash, racquets and cross-country running, representing Wellington in all of them. Such was his aptitude for squash that he would go on to play at county level for Surrey. Experts in the sport said he had the potential to become an international player. Doubtless, given his massive determination, he could have done so had he been minded. But a significant distraction had appeared in the form of a driving licence.

James had his first experience of mechanical movement at the age of 11 when on a family holiday on a farm in west Wales. A farm worker had explained the basics of driving a tractor but James was not strong enough to operate the clutch on the heavy vehicle. He found it easier in the landlord's well-used Rover on the farm road and afterwards persuaded his parents to allow supervised runs in the family car on private property.

James Hunt

I liked the sensation of driving and sense of control straight away but I hadn't channelled the idea of becoming a racing driver at all. When I passed my driving test at 17, I remember driving immaculately for the examiner, giving the correct hand signals [then an important part of the test procedure] and staying within the speed limit at all times. But as soon as the examiner gave me my slip of paper to say I had passed and got out of the car, I let out the clutch and roared off. And didn't slow down from there!

I just used to race everybody on the road without realising it. And that was right from the start but I had no thoughts whatsoever about doing this, even as a hobby, on a race track. The car was viewed as a means of transport even though I happened to like getting from A to B rather quickly. I never went anywhere without being flat out and have to confess I left no margin for error. None at all. I was so lucky I didn't kill myself or someone else.

It didn't seem to be for the want of trying, with the family cars bearing the brunt of his excesses. When James rolled the Hunt's Mini Van into a field near Epsom, Wallis and Sue rightly thought the only sensible course was to ban their eldest son from driving their other car. James took to the road on a moped but continued to make his views known – as only he could – about his preference for four wheels rather than two.

Six months later, Wallis and Sue made the mistake of believing that James could come to no harm in a Fiat 500, recently acquired as a second car, albeit a slow, underperforming, second car. But that did not take into account their boy wringing the little Fiat's neck first time out during a race with friends.

In the early hours of the morning, on the return journey from a lively house party, James got himself into the lead, which may have satisfied his desire to win, but it meant he was first to come across another car stopped in the middle of the road. Its occupants were looking for the party the North Surrey Grand Prix had just left. James managed to miss the car – but not a lamp post inconveniently situated by the roadside.

The first Wallis and Sue knew of the race was when a knock on their bedroom door announced the arrival of their son and, downstairs, a collection of his mates who, even to the most charitable eye, had clearly been consuming more than their fair share of alcohol. Faced with this burping, bleary-eyed gathering, it was the work of a moment for Wallis to discount their rambling excuse for an alibi, that the party had been travelling gently along when they came across a stationary car in the middle of the road with its lights off.

The smashed-up Fiat remained in the family driveway for a considerable time as a reminder for James to act more sensibly on the roads. But even then the thought of burning off his competitive urges on a race track never occurred – mainly because he had never heard of motor racing. That was about to change on Saturday 28 August 1965, the day before his 18th birthday.

Opposite page: The Hunt family album. Clockwise from top left. Ten-year-old James proudly holds his new brother, Tim, as Sally and Peter look on. James (10 months) with Sally. James, aged 10, puts on a smile for an official portrait. James (background) and Sally play with friends from the neighbourhood in Cheam. Wallis and Sue (seated and holding David and Georgina) with 15-year-old James (back row, left), Sally, Peter and Tim (looking up at his father). Sue, on holiday in Lyme Regis with James, aged 3, and Sally.

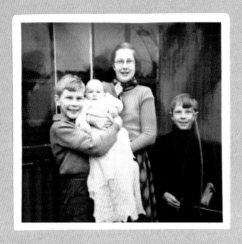

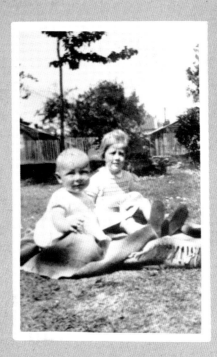

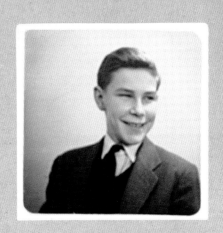

The final weekend in August 1965 was typical of bank holiday motor racing in the UK. There were 23 events covering the sport's spectrum from hill climbs and sprints to motor races of various sizes.

The most important by far was the Guards International Trophy at Brands Hatch. Full-blooded, sports racing cars were to be driven by the cream of F1 society on a spare weekend between Grands Prix. The entry included John Surtees (1964 world champion), Graham Hill (1962 world champion), Jim Clark (winner of the Indianapolis 500, world champion in 1963 and champion-elect for 1965), Bruce McLaren and Dan Gurney (three-time Grand Prix winners) and Jackie Stewart (due to win his first Grand Prix two weeks later).

James Hunt knew nothing about any of that and cared even less. When his tennis doubles partner, Chris Ridge, suggested that James accompany him to Silverstone to watch his brother, Simon, race a Mini, it seemed like fun. It was a jolly good idea for a bank holiday Saturday.

They were about to witness a minor club meeting typical of the genre and organised in this instance by the Jaguar Drivers' Club. Starting at 1.30 pm, this happy band of amateurs rattled through seven races, the longest being for sports and GT cars, over 25 laps of Silverstone's Club Circuit. Simon Ridge was taking part in a ten-lap event for saloon cars lasting all of 13 minutes. If he felt so inclined, Ridge could also enter a *Formule Libre* race in which all classes could have a final fling at the end of the day, each driver's starting time, or handicap, determined by past performances. It was a complicated and frequently a hit-or-miss affair that was part of the relaxed atmosphere.

On this occasion, rain increased the prospects for confusion and a mood that seemed to affect the correspondent reporting for the next issue of *Autosport*.

Patrick Benjafield (Autosport) *The final [Formule Libre] race was a handicap of great complexity. Both the commentators and ourselves [presumably a handful of reporters] worked out one result and the timekeepers something quite different. I believe some of the drivers were slightly at odds with the results, too. Suffice to say that a lot of Jaguars were sploshing around in the rain for ten laps, that there was some excellent driving and that as far as we were concerned, Roddy Harvey-Bailey won. We must have been wildly wrong as the winner turned out to be Peter Butt, also in an XK120 and jolly good luck to him.*

Simon Ridge was not himself mentioned in dispatches, perhaps having mechanical problems or simply enjoying himself among the also-rans. But the overall atmosphere of the day had a profound effect on one first-time visitor.

James Hunt *It was instant commitment. I'd never known there was such a thing as club racing. So far as I knew, motor racing was something impossibly remote; a thing carried out by Jim Clark and a lot of continentals with long names. I couldn't identify with them at all. But here was something within reach of a mere mortal. It was the immediate answer to a problem of having my needs satisfied, to compete.*

I thought, This is bloody good! I absolutely adored driving fast anyway and was always trying to organise races with my friends on the roads around home. Here was my mate's brother, who was about 20 with very little money but had worked as a garage mechanic and built himself a racing Mini. And all these guys from perfectly ordinary homes had saved up all their money and gone club racing, which was just about within range of one's pocket if one works at it and saves up very hard. I thought, Well, crikey, if they can do it so can I and I'm jolly well going to have a go.

Given Hunt's character so far in his life, the true meaning of that last sentence was not hard to discern. He *would* go racing, no matter what it took. The journey back to Belmont can be easily imagined, James loudly and enthusiastically talking about how he would (not might) raise the cash to float this new and jolly exciting venture.

It was a scenario that has been acted out thousands of times on a daily basis around the world. Only a tiny minority of these new converts ever make it to the fringes of professional motor racing. And of these persistent and talented grafters toiling away one or two grades below F1, only one – perhaps two – of the original cast of thousands ever reach the pinnacle of F1.

Such a thought about the realities of driving as sport was furthest from James's mind on the eve of his 18th birthday. There would be no point for him in taking up the pursuit if he couldn't win and prove he was the best. The law of averages and the application of tedious logic; none of this entered his mind as he marched into the house and told his parents that all their worries about his fecklessness and plans for the future could be put to bed. 'I'm going to be a racing driver,' he announced. 'And I shall be world champion.'

Wallis and Sue did not doubt his serious intent for one second but that did not detract from the belief that, this time, their rebellious child had lost all reason. It made perfect sense to James, who argued it would cost £5,000 to put him through medical school. As he was now to become a racing driver he would settle for £2,500 cash up front to allow the purchase of a racing car. And, besides, it was his birthday tomorrow – a win–win situation. Wallis Hunt, not surprisingly, failed to follow the logic. James's grandmother also rebuffed a request for a loan. She was of her daughter's opinion, that motor racing was 'totally useless and unproductive for society'.

The family were, nevertheless, fully aware that James was going to take this hazardous and expensive choice come what may. In which case, they reasoned, it might be wise to have their boy attend a racing drivers' school in the forlorn hope that this might purge the racing bug from his system.

A mutual friend knew Stirling Moss, who recommended the school at Brands Hatch. It was reasonably local and as good as any. James duly presented himself at Motor Racing Stables and failed to either impress or be impressed. It was, in his view, a complete waste of money that could have been put towards the purchase of a racing car – however far-fetched that might seem.

Much taken by the efforts of Simon Ridge and his Mini, James decided to follow that route. A glance through the classified adverts in *Autosport* turned up a one-year-old 1293 cc Morris Mini Cooper S, tuned by Downton (one of the country's top performance companies) and going for £650. At the bottom of the market, a second-hand, standard Mini was more affordable at £250, but that was still ten times what he had. He set about the lengthy task of acquiring further funds.

James took on a catholic mix of temporary occupations, ranging from delivery driver for a printing works to hospital porter and cleaner, ice-cream salesman, supermarket shelf stacker and van driver. An attempt to be a bus conductor failed because, at six feet and one inch, he was considered too tall. Or, at least, that was the flimsy excuse given by the London Green Line inspector as a means of getting rid of a would-be conductor who, in truth, had 'too much chat'. This was a reference to Hunt's habit of imitating the characters on one of his favourite television comedy shows, *On The Buses*, a chirpy repertoire that did not go down well with potential colleagues. James could not understand their peevish failure to see the funny side.

Undaunted, he pressed on, seeking any occupation that would raise cash. It was seen as a sign of Hunt's utter determination when he went as far as to have his hair cut reasonably short and wear a suit, collar and tie to be a salesman for a company renting telephone answering machines. These were a novel concept at the time and James used his cheery chat to sign up clients on lengthy contracts earning a healthy commission.

Eventually he had enough cash to buy a stripped shell from a crashed Mini. The purchase answered one question but posed an altogether different one. Starting with zero knowledge, could he build this metal box into a racing car? It would take two years of effort and, according to his mother, a lot of swearing.

James Hunt

It was a hell of an ordeal because I never actually liked things mechanical; I simply wasn't interested in them. But I had to become interested as a means to an end because I couldn't afford to pay anyone else to do it. I'd never examined a car or an engine in detail before and I built this car myself with bits from breakers' yards. I hated every minute of it. But it taught me a hell of a lot, not only in terms of engineering, which was important because now I at least had a basic background, but more than anything it taught me a great deal in terms of the sweat and tears that are necessary if you want to get anywhere.

James also worked as a hospital van driver and would go to scrapyards when his itinerary allowed. Prized parts were delivered to the family garage that had become a workshop – whether the family liked it or not.

Finishing the car became an obsession to the extent that it not so much ruled his social life as brought it to a complete halt. Every spare penny was spent on the racer. A weekly squash game provided the only diversion with an opportunity to have a few beers. James, an inveterate smoker from an early age, confined himself to just two cigarettes a day. Friends who understood nothing of the complexities or the attraction of motor sport realised how serious he was through this self-imposed curb on nicotine.

Bit by bit – literally – the car came together, albeit not necessarily in a conventional manner. A front passenger seat was necessary to conform with the racing definition of a saloon car. James overcame its absence by commandeering a canvas and steel-framed deck chair from the Hunt garden and securing it to the chassis with an ancient Meccano set. The tyres that came with the car were bald and James cut grooves in the worn tread with the aid of a knife. The alternative – purchasing a new set of racing tyres – was beyond his budget and considered an unnecessary luxury at this stage. The first priority was to get the car moving under its own steam.

To everyone's amazement – not least the driver – the engine (also acquired from a junk yard) burst into life once fitted, though the rattling and cranking did not bode well for its future as a high-revving racing unit. It made enough noise to get the neighbours' attention when James tested it in the driveway and, seeking to stretch its legs, took to the streets. Maire Marlow lived three doors along the road.

Maire Marlow

James used to play squash and tennis with my two daughters, so we knew James and the family very well. We knew that James had originally intended to be a doctor but that had changed and he was doing various things, including working on a Mini in the garage. One day, we suddenly heard this great roar. We ran out to the pavement, and there was James doing his first run on the road – a private road, with no speed bumps in those days. He roared up and down like a maniac! Every time he came out, we'd rush out and cheer him on. He was regarded by us all as a lovely young man.

It didn't seem inappropriate at all for James to be doing this. The Hunts were – how do I put it – an interesting family! I remember they had a very old parrot who lived in the kitchen. One day the gas stove went wrong and a man was called in to fix it.

Sue was standing by the kitchen door and the man was bending over the appliance doing something when he heard Sue's voice say, 'Tickle your arse with a feather!'

The man jumped up, his eyes on stalks and Sue said: 'I'm sorry, it's not me. It's the parrot.' Of course, the boys had taught the parrot to say this – and much worse. That's the sort of family they were. Lovely people. So, we didn't bat an eyelid at having this Mini roar up and down our road.

The fact that the vehicle was neither taxed nor insured was considered an irrelevance in this very proud moment for the young wannabe engineer/racing driver. Unfortunately, the scrutineers officiating at his first race would not view this disparate collection of parts in the same light as its enthusiastic owner.

Final preparations included finding necessities such as a crash helmet and a means of transporting his pride and joy to a race track. His startling blind faith stretched to acquiring a trailer and an equally well-used Rover to pull it; an optimistic call since the saloon, purchased for the princely sum of £15, was almost as old as its new owner. To the surprise of everyone but James, the combination managed to reach Snetterton in Norfolk, the race track that would see the debut of Britain's next world champion.

Or at least this was the young Hunt's view. The white-coated official in the scrutineering bay was about to put the brakes on the venture, partly because there were none on the car worth speaking of. The main objections to the vehicle were its excuse for a front passenger seat, the state of the tyres and – even more alarming, if that were possible – the complete absence of windows in the so-called saloon car. James had not troubled himself with the additional expense since the regulations made no mention of windows – which was a bit like saying the absence of the term 'steering wheel' meant there was no need for one.

Devastated by this news, delivered in minutes at the end of two years' hard labour, Hunt had no option but to push the subject of seemingly brutal disdain onto his trailer and begin the trek back home. The 130-mile journey must have seemed twice as long.

At the end of it – apart from proving to his worried mother that he was still alive – James put the disappointment behind him and began planning to make the racing car acceptable. Fortunately, success with the telephone sales job would contribute to the necessary £100 and get J. S. W. Hunt (Belmont, Surrey) from the entry list and through the scrutineering bay and onto the starting grid – albeit at the back.

Hunt actually took part in three races with the Mini in 1967. Getting there and back to circuits such as Brands Hatch and Snetterton would prove problematic when the Rover expired in an expensive cloud of smoke.

Sally Jones

I had obviously been aware of this car in various states of disarray in our garage and James and various friends spending a lot of time in there. I don't remember much else because, of course, I had my own interests and James's Mini was not one of them! But I do recall using my grandmother's Morris Minor to tow this Mini from Belmont to Brands Hatch. I don't recall there being a trailer; I simply towed the Mini all the way there and all the way back.

James lashed out £25 on an Austin. The elderly A90 did keep running, which was more than could be said for the trailer, which ran a bearing during a return journey from Silverstone. Refusing to abandon the Mini and trailer – as requested by a police traffic officer – James used his considerable power of persuasion to gain permission to tow the Mini home rather than risk having it stripped of parts if left overnight by the roadside. That little victory led to a nightmare journey for his girlfriend Taormina Rieck – affectionately known as 'Ping'. She became ever colder, steering the racer and attempting to follow Hunt's hand signals while simultaneously avoiding either hitting the back of the Austin or breaking the frayed tow rope.

Retirement was soon familiar territory for Hunt. He dropped out of each race, either for mechanical reasons or through choice, to avoid the former. It was nothing more than a learning process as he stood at the bottom of a long and near-vertical curve. James may have enjoyed the racing – such as it was – but quickly got to understand that he knew nothing about how to make competitive the collection of parts he referred to as a car. Examination of his competitors' more fleet machines showed many and varied preparation methods, few of which he understood.

Unexpectedly, his persuasive sales pitch then convinced another would-be racer that the Mini was worth £325. Done on the spur of the moment, the deal more or less covered his costs. Hunt's last outing in the car on which he had lavished so much effort was at Brands Hatch on 8 October, a seven-race event organised by the British Racing and Sports Car Club (BRSCC), similar to the one at Silverstone that had enticed Hunt into this expensive game two years before. Retirement that autumnal afternoon was forced upon him when he was black-flagged after five laps for dropping too much oil on the circuit.

The names of those taking part may have meant nothing to James at the time but one in particular would have a major say in not only the career of J. Hunt but also thousands of racing drivers the world over. Lying second in the first race of the day, Max Mosley was forced to retire when the prop-shaft broke on his U2 sports racing car. Mosley, a practising barrister, would go on to be a founding member of March Engineering and, in 1991, become president of the FIA, the governing body of motor sport. James would be linked with both organisations under separate but controversial circumstances: none more so than an incident at this very race track. If he headed home virtually unnoticed on 8 October 1967, the name James Hunt would be on everyone's lips nine years later.

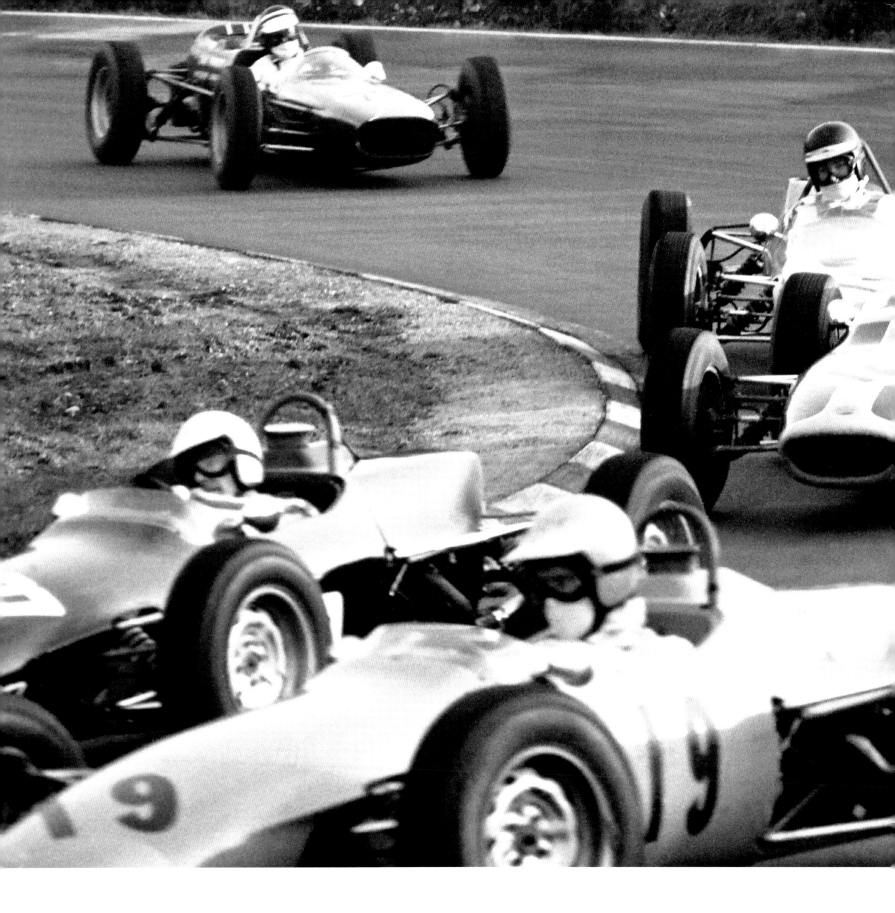

On the day James Hunt made his final, unremarkable appearance in the Mini, he took the time to wander around Brands Hatch's Formula Ford paddock, soaking up everything in this exciting new environment. He was attracted by the look of Formula Ford cars, a new category that had made its world debut at the same track three months before, on 2 July 1967.

Hunt was struck by the simplicity of these single-seater cars, with their basic Ford engines, road wheels and tyres, conceived as an entry-level formula for young hopefuls such as himself. Not only did they look like a racing car should, they also had the benefit of being standardised to keep cost to a minimum – unlike Mini racing, in which budget dictated performance. That, at least, was the theory.

The reality was that the price of a Formula Ford car had been set at £1,000 – a figure far beyond Hunt's means – and yet more money could be spent on tuning the 1500-cc, four-cylinder Ford Cortina engine. For the moment, though, extra performance was not a priority; James simply wanted to go racing in 1968.

Cue another attempt at a persuasive speech directed at his parents. A 21st birthday gift of £100 was given in advance, Hunt putting it towards a £345 down payment on a brand-new, Russell-Alexis Mk14 Formula Ford. He would worry about the £30 monthly payments later.

Keen to avoid hefty repair builds, J. Hunt turned in modest performances at first in which he failed to set the track alight but at least he was finishing races and gathering experience. And it was satisfying to do so at Snetterton in June, a year on from his mortifying experience, going nowhere in the scrutineering bay.

Prior to that race, James allowed himself the brief luxury of a test session on the Norfolk track. It was here that he would come to the attention of Max Mosley, who was taking his own racing equally seriously and about to step up from his U2 club sports car to F2.

Max Mosley

I had bought a Brabham from Frank Williams and found this was a huge step up from the U2, cornering as if on rails and with huge acceleration. I went testing at Snetterton and came up behind a Formula Ford being driven surprisingly, even irritatingly, fast. Back in the paddock, the driver got out wearing scruffy jeans rather than overalls and also wearing plimsolls, something we were always told never to do. Rubber-soled shoes were supposed to be dangerous because they slipped if the pedals were oily. This was my first encounter with James Hunt.

More aware of the broader racing picture than before, James would also have noted a certain Bruce McLaren scoring the first F1 victory for his team at Spa-Francorchamps in Belgium. But even allowing for Hunt's massive optimism, it's unlikely he would have dreamed of being responsible for wins 16 to 24 in what was to be the start of McLaren's hugely impressive record in F1.

Towards the end of the season, Hunt's competitive juices were growing to accompany his confidence, despite a massive accident that was not his fault. Lying third on the second lap at Oulton Park in October, Hunt found himself powerless to avoid the car in front when it spun at Cascades, a fast downhill left-hander so called because it bordered a stretch of water. If James hadn't been aware of the full extent of the lake before, he received a scary indoctrination.

The Alexis flew off the road and sank, upside down, without immediate trace. Seat belts had yet to become mandatory – ironically a good thing in this instance. James, who had been unable to afford the six-point harness, was flung from the cockpit before rising into view by standing up to his waist in water. Apart from understandable shock, he was unhurt. It was more than could be said for the written-off car.

James had been having difficulties raising financial backing and this latest setback could have been a disaster. He had begun to feel dispirited by potential sponsors failing to be convinced by his sales pitch. But there was to be one exception.

Previous page: Hunt's Merlyn (16) in the midst of a typical Formula Ford battle during the Boxing Day Brands Hatch meeting, in December 1968. James finished sixth.

Gowrings, a Ford main dealer based in Reading, liked Hunt's approach enough to ask him to outline a budget for 1969. When the figures tallied with the sum they had in mind, Gowrings dipped their toe in the water, as it were, by both sponsoring James for the final few races of 1968 and replacing the waterlogged Alexis. Together, they chose a new Merlyn Mk11A, a car that was to become a classic and one that James immediately used to good effect by finishing third on the Brands Hatch Club Circuit and scoring a win at the tiny Lydden Hill track near Dover. It sealed the deal that would be carried in a news brief in the 15 November issue of *Autosport*.

'James Hunt, who drove a Russell-Alexis FF car entered by Reading Ford dealers Gowrings [towards the end of] this season, will campaign a new Merlyn for them next year fitted with a Gowrings-tweaked unit. Gowrings can undertake all types of race preparation.'

The quid pro quo was in the final sentence. Hunt had backing in return for attracting potential clients to Gowrings. His motivation had shifted from racing purely for fun to satisfying the commercial needs of others. James was up for both. And Gowrings would receive their pound of flesh – although not necessarily through having their man on the top step of the podium.

Hunt made his intentions clear from the start of the 1969 season, winning heats and finishing in the top three during intensely close battles. The most significant of the early events in terms of exposure was the Race of Champions at Brands Hatch in March. Non-championship F1 races such as this were commonplace and well subscribed. James did his reputation no harm in front of such an influential audience by starting from the middle of the third row of the grid and finishing fourth. The same could not be said three months later, when he made an exhibition of himself at Vallelunga in Italy.

Formula Ford had been expanding rapidly and James was as keen as the organisers when plans were laid to promote races in Europe. In Austria he finished second and set the fastest lap when the series made its debut but the move to Italy, a month later, got off on the wrong foot when drivers were asked to produce medical certificates showing their blood groups. Hunt had not brought the required paperwork, claiming it had not been necessary in Austria

and no mention had been made in the pre-event regulations. The organisers stood firm; a driver without a certificate would not be allowed to take part. James was equally adamant; he would not be going home without a race and threatened to take his car onto the track, park it at an angle and leave it there.

News of this was poorly received by Stuart Turner, the boss of Ford Motorsport, and Nick Brittan, a public relations consultant: the two gentlemen largely responsible for Formula Ford and its debut in Italy. Brittan would go on to engage in many entrepreneurial motor sport activities – including his satirical 'Private Ear' column in *Autosport*. But, for now, he didn't see the funny side of his fellow countryman's extreme behaviour.

Nick Brittan *I was involved in running Formula Ford International, a spin-off from Formula Ford which I had been briefed by Ford to introduce to the European countries in which the Ford Motor Company was selling cars. I would present a package of 20 cars to race and support a major event at a particular circuit. The organisers liked it because, for very little effort, they had an exciting motor race delivered to their track. And the young drivers loved it because it was allowing them to race at places such as Zolder in Belgium and Hockenheim in Germany. The series caught on, the local drivers liked it and the next thing is they're buying Formula Ford cars and everyone, particularly Ford, is happy.*

So, I took 20 cars to Vallelunga. In those days you had to have a certificate stating what your blood group was; a meaningless thing, but that was part of the deal. J. Hunt Esq. had turned up without a certificate and he was ranting and raving with the organisers. I took him to one side and said: 'James, if you're trying to be a professional racing driver and you carry on like this, you won't make it as long as you have got a hole in your arse! Now get up to the hospital and have them give you a blood test.' He eventually did what he was told. Of course, several years later, after he had won the championship, he came up to me with a wicked grin and said: 'I've still got the hole. How am I doing?'

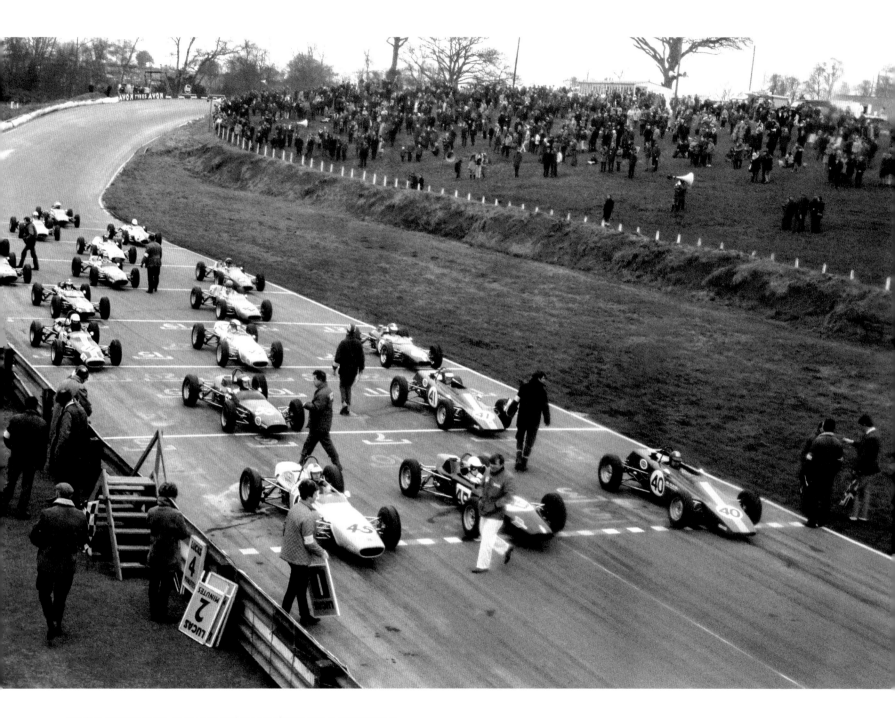

Hunt's Merlyn (number 11, on the third row) prepares for the start at Mallory Park in March 1969. He won his heat and finished fifth in the final.

Hunt, blood group duly provided, finished ninth at Vallelunga: not one of his better results but partly excused because of having to miss practice while he made the trip to find a doctor in Rome. His stubborn stance and subsequent fighting drive here and elsewhere were not lost on teams with more means at their disposal than single-handed James. One such was Motor Racing Enterprises, owned by the equally enterprising Mike Ticehurst and Gerard McCaffrey.

A problem arose with one of the MRE drivers and James was asked to act as a replacement in a Formula Ford race at Lydden Hill. The favourites had difficulties during practice but MRE were nonetheless impressed when Hunt took their Merlyn Mk11A to an easy win and set fastest lap. James recorded another fastest lap when the scene shifted to Mondello Park in Ireland, where he finished fourth, hot on the heels of a certain Emerson Fittipaldi.

The Brazilian, on course for a rapid rise to F1, was ready to step up to Formula 3 and, coincidentally, Hunt was about to do the same. MRE felt they had seen enough to give James a run in a Brabham BT21: not exactly state of the F3 art in 1969 but good enough to allow James to savour the move from a narrow-wheeled Formula Ford into a 'proper' racing car. He loved it. Fittipaldi astounded observers by winning his third F3 race and never looking back, but Hunt was drawing his fair share of attention.

James Hunt

Formula 3 was the right way to go, particularly at that time. It was the only place for an up-and-coming driver, the only serious route to Formula 1. So I naturally followed it and I started with the two-year-old Brabham and an engine that was three years old. But the BT21 was a hell of a good car and that one was well prepared. We only did half a dozen or so races towards the end of 1969. I had a very good time and managed to do very well in what was an old car. In fact, it was probably more competitive than people thought. It obviously impressed some of the right people, for it got me a Grovewood Award.

Initiated in 1963 by Grovewood Securities (then owners of Brands Hatch and other UK tracks), the prestigious awards were presented annually to up-and-coming drivers. Previous winners had included Chris Irwin, Piers Courage, Jackie Oliver, Derek Bell and Tim Schenken, all of whom had gone on to F1.

James impressed the right people thanks to an outstanding performance at Cadwell Park on 28 September. A combination of factors made this race stand out on the F3 calendar: the tricky and beautiful little track, twisting and turning through the Lincolnshire countryside; a full entry for one of only a handful of international F3 races in the UK and, more notable still, the racing debut of March, a hugely ambitious team established by, among others, Max Mosley. March was destined to enter cars in every category from F3 to F1.

On this occasion, Ronnie Peterson, a Swede with a fast, spectacular style that would elevate him to F1 within six months, drove the prototype F3 March. Many observers, including the astute Mosley, took note when Hunt raced wheel-to-wheel with Peterson as they fought for third place, the brand-new March edging the ancient Brabham by a whisker as they crossed the line side by side.

In his end-of-season survey, *Autosport*'s Justin Haler wrote: 'James Hunt's Cadwell drive ranked in the natural category.' And that was the extent of the coverage. The fact that Hunt's brief assessment was merely in the margins as one of 40 drivers worthy of mention gives a stark indication of the rivalry he faced in this ferociously competitive category if he wished to progress. Which he assuredly did.

The Grovewood Award had brought with it a £300 cheque that helped pay off some of Hunt's debts. It was, however, impossible to put a price on hard-won results and reputations. James had done enough to talk his way into backing from Molyslip in return for which the automotive lubricant company's logo would be carried on a Lotus 59 in 1970.

This brand-new car had been acquired through a deal with Lotus Components, the customer arm of Lotus Cars: in other words, a means of earning money to help Lotus founder Colin Chapman go motor racing. The Hunt deal may have been small beer for Chapman but it meant a great deal to James, who had abandoned the salesman day job to become a full-time racing driver, albeit a penniless one.

He was not alone. Being broke was the default for a hundred or so F3 hopefuls roaming Europe. They lived hand-to-mouth on starting money and, if they were lucky, prize money for doing well on race tracks as far afield – but sometimes as little as a week apart – as Hämeenlinna in Finland and Enna in Sicily. Character-building would be an understatement.

James Hunt

I didn't really have enough sponsorship but I managed to struggle through to Pau [a street race in the south of France], where I ran out of money completely. Not only had we run out of money but in common with some other teams, our petrol had been stolen, syphoned out of the tanks when the cars were in the paddock overnight. We had no alternative but to acquire some by the same means, which turned out to be easier said than done.

We discovered that most French cars had locking petrol caps, so we were creeping around on our hands and knees at night finding one car in ten without a locking cap and one in ten of the rest with enough petrol in it to make it worthwhile. We finally got to Le Havre after two days on the road with no food – that was bad – and when I got on the ferry I borrowed some money. Then I hitchhiked home.

I managed to scrape together enough to get to the next race and then started to live off income. In fact, we actually ran the team off income for the rest of the year, which was quite an achievement in 1970, just by plodding around, living in a tent and collecting start money. It was always a struggle and meant I didn't really have the best equipment or enough spares.

But what he did have was good enough for a trio of second places at the Österreichring (now the Red Bull Ring, Austria), Chimay (Belgium) and Oulton Park, the latter appearance making up for his underwater exit two years before. It was at Rouen, however, where driver skill – and luck – would make up for any mechanical deficiencies. It was also at this famous road circuit where James would experience both sides of the coin in a sport that remained thrilling and yet inherently dangerous.

Rouen had history. Used for the French Grand Prix, this magnificent circuit had produced superlative victories but, just two years before, claimed the life of Jo Schlesser, the local hero burned to death when his Honda F1 car crashed on the fast, downhill swoops. If these curves were quick in F1 machinery, they were absolutely flat out – much as the rest of the circuit tended to be – for the less powerful F3 cars. As a result, the field would be tightly bunched for all of the 20 laps.

Thirty-four F3 drivers had turned up for the Grand Prix Craven A Formula 3 on the weekend of 28 June. Fourteen would not qualify (and failed to earn start money) but James managed to scrape onto the penultimate row of the grid. This was not as bad as it seemed in a very closely matched field that prevented any one car, or group of cars, from breaking away. The race immediately developed into a frantic free-for-all from front to back.

There was much at stake as the F3 race supported a major international F2 Grand Prix on a narrow and fast circuit. It would not have been an exaggeration to say potential tragedy was lurking around each corner and along the one very quick straight. Haler's race report in *Autosport* caught the moment perfectly.

'At the end of the first lap, so close were the bunch that it was impossible to pick out a definitive leader as they streaked across the line, three abreast, trio after trio.'

Hunt was bringing up the rear after a spin at the hairpin – which, by the way, was cobbled! Five retirements on the first lap for various reasons – mainly contact – would leave 15 runners. And all of them in with a chance.

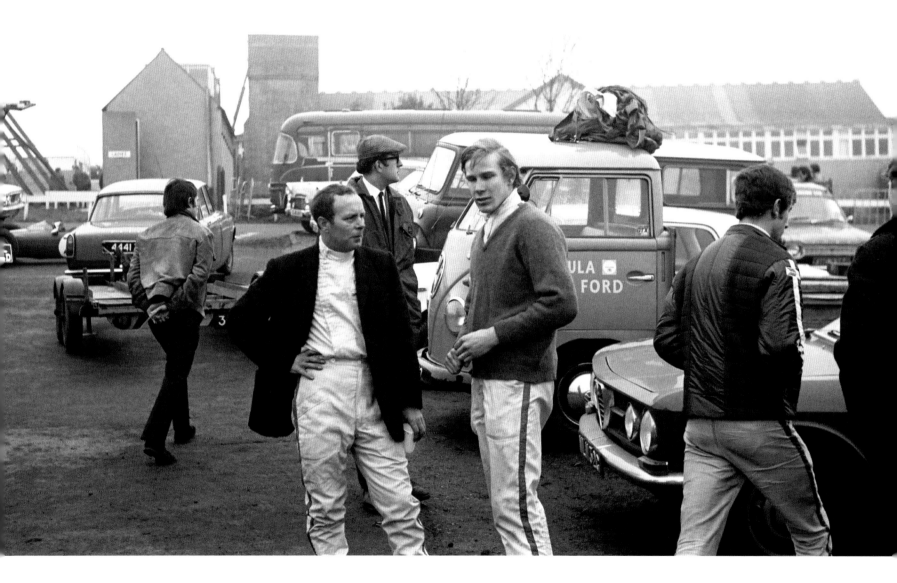

Hunt with Sid Fox in the paddock at Brands Hatch for the Formula Ford support race to the 1969 F1 Race of Champions. Hunt finished fourth, four places ahead of Fox, but the veteran FF campaigner would beat Hunt a month later to take victory at Aspern in Austria.

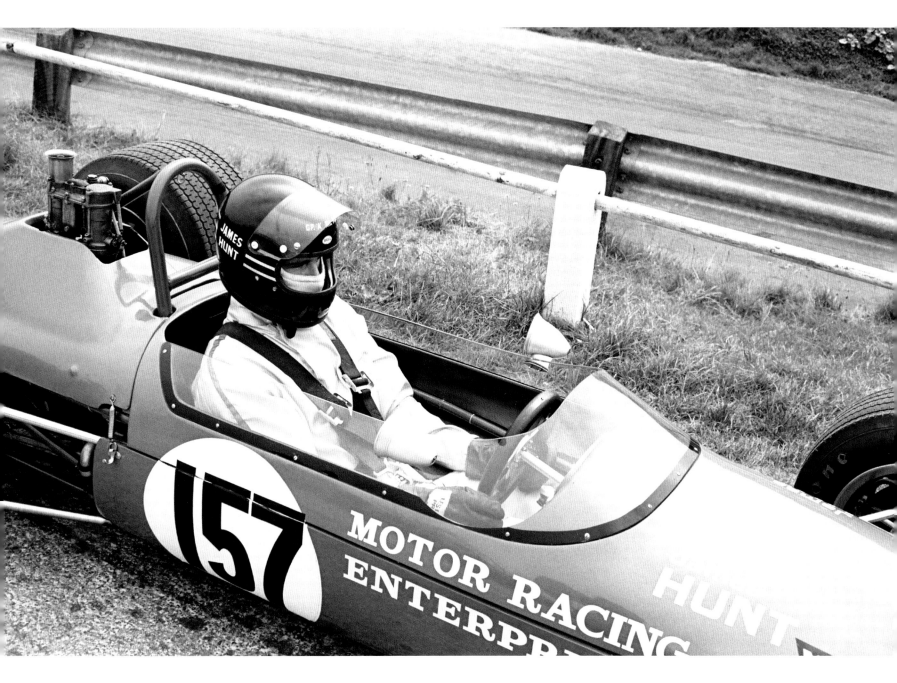

Ready for action in the MRE-entered Brabham BT21 at Brands Hatch in
August 1969. Hunt finished third against strong opposition and went on to
impress many with the elderly car.

Justin Haler, Autosport

Every lap, positions were zigzagging furiously. A really nasty accident befell poor [Denis] Dayan on unlucky lap 13. His Grac had been right up in the midst of the leading bunch but, going down the hill, he suffered a suspected suspension failure and ploughed at 120-plus mph into the Armco just on a joint between two barriers. His car was smashed and so too were his legs and an arm broken. He was rushed off by helicopter where his condition was serious. Meanwhile the great struggle carried on with cars weaving in and out of each other's [slipstreaming] tows and swapping places. Coming along the flat-out main road straight, someone had pulled out of the follow-my-leader slipstreaming bunch without looking in his mirrors. Hunt had to take avoiding action and [Bob] Wollek hit his rear wheel, launching himself skywards, somersaulting into the air and disappearing into the trees. He suffered chest injuries and a broken arm and joined Dayan in hospital, where his condition was said to be serious also.

Hunt's exhaust system had been broken in the fracas but nevertheless he pressed on as the final few and increasingly more hectic laps approached. There were 11 cars [including Hunt] in the leading group. As they set out on their final lap, the pack began to think out their own manoeuvres for the final drag home. It all happens into the final right-hander leading towards the finishing straight where the leader can usually manage to block the rest on the narrow road. However, there was a major calamity as the pack screamed down the home straight. Hunt, [Wilson, brother of Emerson] Fittipaldi and [Mike] Beuttler,

luckily for them, were fractionally ahead of it.

What exactly happened will probably never be known but it seems that [Jean-Luc] Salomon tried to find a way through the solid wall of cars in front of him. He was launched onto [Freddy] Kottulinsky, who headed for the ditch and Salomon's car landed upside down on top of Freddy. The result was complete chaos. [Richard] Scott, [Gerry] Birrell and [Cyd] Williams [three Britons] all touched each other, Scott's car charging the barbed-wire fence [!] backwards and being badly damaged. The others ended up in ditches although they were not hurt.

Meanwhile, Hunt had crossed the line first, a nose ahead of Fittipaldi. But the joy of such a hard-earned and significant maiden international victory would be tainted by the carnage and news that Salomon had died of a broken neck. The young Frenchman had been married just two weeks before. Dayan would succumb to his injuries a few days later. Wollek survived to establish himself as an outstanding sports car driver – only to lose his life in a freak accident in Florida, USA, in 2001 when struck by an elderly driver while riding his bicycle between the Sebring race track and his hotel. Birrell, considered to be worthy of following in the footsteps of fellow Scots Jim Clark and Jackie Stewart, would suffer a fatal accident on Rouen's downhill section during practice for a F2 race three years later.

Rather than think too deeply about the obvious perils of his chosen sport, James pressed on as best he could with the rest of his F3 season, picking up one more win among podium places – and becoming involved in a notorious incident at the small but spectacular circuit through the municipal park at Crystal Palace in south London.

James Hunt

Getting through that season was good for me because it taught me a lot of things about driving, and it certainly taught me to keep out of trouble. I had hardly any accident damage that year. My accident bill was about £600 and the one, well-publicised shunt at Crystal Palace accounted for about £400 of that.

The accident was also responsible for giving James a reputation for something other than driving a racing car. James had made the comparatively short journey to Crystal Palace fresh from victory at Zolder in Belgium and third place at Cadwell Park. He was keen to continue his momentum at a race that, highly unusual for the time, would receive live coverage on BBC TV.

What the viewers saw was Australian Dave Walker dominating the heats and final in his works Lotus carrying Gold Leaf tobacco identification identical to the Lotus Grand Prix cars. They also witnessed a typically close and dramatic fight for second between four or five cars, led a number of times by Hunt.

Going into the final lap, James was third and being pressed by the March of Dave Morgan who, at one point, had been ahead of Hunt and caused the Lotus to put two wheels on the grass as James tried to get the place back. Sweeping through the curves leading to the last corner, Morgan could be seen taking a run on Hunt's outside. Then the camera focused on Walker taking the flag. Suddenly, viewers heard commentator Murray Walker's voice go up even more octaves than usual.

'Walker wins… AND A TERRIFIC SHUNT! ALL THE WAY DOWN THE PIT STRAIGHT! There are bits of Formula 3 motor car all over the track!'

The camera swung right and, in the distance, Hunt could be seen climbing quickly from a car beached in the middle of the straight with both right-hand wheels missing. Seemingly oblivious to cars whistling by as they raced towards the chequered flag, James broke into a quick trot towards Morgan's damaged March, which had come to a halt against the wall on the right. By the time he got there, Morgan had climbed out and was clearly caught by surprise and a swift right hook as Hunt felled his rival with a single blow. And then strode off.

From the commentary box Walker, in a state of equal surprise and unable to believe what he had just seen – albeit in a rather fuzzy form given the distance of the camera and the technology of the day, made no reference to one driver thumping the other but continued to talk about the effect of his namesake's win on the championship.

Today, such a dramatic incident would have been trending on social media within minutes. But in 1970, it was hardly discussed. Or, at least, not straight away. *Autosport* carried no mention on the news pages while reporter Justin Haler dared to suggest this had been Morgan's fault by mentioning, almost in passing, that 'a justifiably enraged Hunt felled Morgan in the heat of the moment'.

That did it. The following week's correspondence column was headed by an indignant letter from Dave Morgan's mum. Curiously referring to her son as 'Morgan', Mrs B. H. Morgan of Purley in Surrey wrote: 'There was nothing untoward about Morgan's line and we can only assume that Hunt misjudged his speed and so hit him at the rear.'

An RAC tribunal saw it differently and chose to slap a punitive and thoroughly inappropriate 12-month suspension on Morgan. But not before the correspondence columns came alive with opinion, the verdict roughly split down the middle, suggesting one driver was as bad as the other. But perhaps the most unusual letter came from the mother of Mike Beuttler, who had finished second.

'On lap 18 at South Tower both Hunt and Mike Beuttler passed Morgan,' wrote Mrs L. B. B. Beuttler of Benalmadena in Spain. 'On lap 19, my son slipstreamed past Hunt and held second place to the end, leaving Morgan and Hunt to continue their dangerous antics together.'

Nothing untoward so far. But then Mrs Beuttler really got into her stride.

'I was quite horrified at the driving behaviour of some of the competitors, the boy Hunt being extremely beastly to my son who, as always, drove beautifully, although his father and I do wish at times he had chosen a more sedate occupation. As for Mr. Morgan, mere words fail me. A pity they didn't fail his mum...'

Setting aside that her son was affectionately known in the paddock as Blocker Beuttler, Mrs Beuttler's assessment of poor driving standards was supported by many who actually witnessed the last-corner incident. It was also clear that any support for Hunt was lost the moment he decked his rival and stomped off.

Mr Andrew Ganley of Richmond in Surrey summed it up: 'It was a great shock to see it [participants fighting] coming from men who are supposed to be a breed apart and I hope the two "gentlemen" who saw fit to indulge in fisticuffs are suitably punished because, if it is not stopped now there is no knowing where it will all end and it can only bring our sport into disrepute.'

Ian Phillips, later to cover F3 and F2 races for *Autosport*, happened to be watching the race from the outside of the final corner.

Ian Phillips
I saw it all happen and I'd say 50-50 is about right. I had got to know James a little bit at the time. Hot-headed isn't the right word, but he was probably best described as tense most of the time because everything was on a shoestring. Anything that went wrong at that stage was potentially the end of his career – and it's probably fair to say that Dave Morgan was in a similar position, financially. This race was being televised live, which was extremely rare for motor racing, never mind an F3 event and everything was on such a knife-edge, so much so that James's natural reaction would have been to go and thump somebody. And neither of them were small blokes! I think it's fair to say that, in many cases, any sympathy for James would have been lost when he threw that punch. I mean, you just didn't do that sort of thing at a motor race, never mind anywhere else! Dave was such a laid-back guy and James was perceived as being brash to the point of not really being anyone's particular favourite at that stage in his career.

For Hunt, the episode ended in an eloquent defence that obviously swayed the tribunal as he was found innocent. He did agree in private that Morgan's punishment did not fit the crime. Morgan later appealed and had his licence returned. He was later completely cleared of accusations over alleged dangerous driving during a F3 race at Silverstone in 1971 but, otherwise, Morgan was not involved in further incidents.

The same could not be said for his assailant, who was about to earn the title 'Hunt the Shunt'. The name stuck, regardless of the way exquisite driving dominated the occasional spectacular lapse.

GETTING THROUGH THAT SEASON WAS GOOD FOR ME BECAUSE IT TAUGHT ME A LOT OF THINGS ABOUT DRIVING, AND IT CERTAINLY TAUGHT ME TO KEEP OUT OF TROUBLE.
JAMES HUNT

On the weekend James Hunt walked briskly away from his wrecked F3 Lotus at Crystal Palace, Emerson Fittipaldi would step from his Lotus F1 car in the winner's circle at Watkins Glen. It had been one of the most remarkable and rapid rises in motor sport, the Brazilian's first Grand Prix win being an indicator of supreme natural ability and an ascendancy so rare that it was beyond even the most optimistic ambitions of James Hunt, who was wondering what to do next.

Having just two victories to his name in a season of 18 F3 races around Europe, James felt he should put his hard-earned experience to good effect and try to clean up the F3 championship in 1971 rather than attempt anything more ambitious. Besides, sponsorship might be easier to come by now that he was more of a known quantity. The feeling was that if he could do the business in F3, he would perhaps be in a position to step straight into F1 rather than lose a season becoming bogged down in F2.

The year got off to a promising start in the first week of January when motor sport publications carried news of Hunt being nominated as the works F3 driver for a fully sponsored drive with March Engineering. Max Mosley and his team had not forgotten that showing by James in the elderly Brabham at Cadwell Park in 1969, his subsequent performances with the Lotus indicating he was ready to win the title in 1971. The unseen catch at this stage was that March were not ready to fulfil their part of the bargain. In a classic case of a small company with big ideas being stretched to the limit and beyond, the March F3 effort was subjugated by F1 and F2, which were considered to be more important.

The F3 engine rules had changed, not necessarily for the better, as the exciting one-litre screamers were to be replaced with flat-sounding 1600-cc units. Not that James cared too much about that as he weighed up a package that included sponsorship from Rose Bearings, a specialist firm supplying 40 of the joints on the March 713. These were suspension components that he would be testing to the extreme during the course of the next 21 races.

Previous page: One of the most important races of Hunt's career. Pressing on with the rear wing slightly askew on his Hesketh-entered March 712M, James ran ahead of Niki Lauda's works March 722 at Oulton Park, where he finished a strong third in his fourth F2 race in September 1972.

Opposite page: A pensive Hunt, aged 23, considers the challenge of F3 at Barcelona's Montjuïc Park in April 1971.

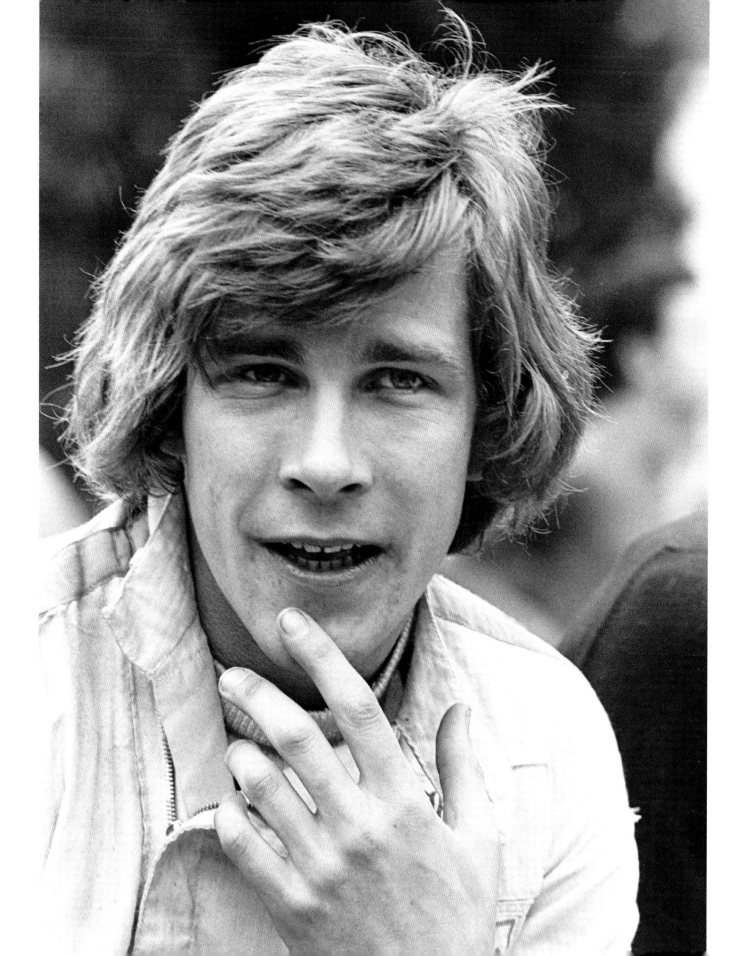

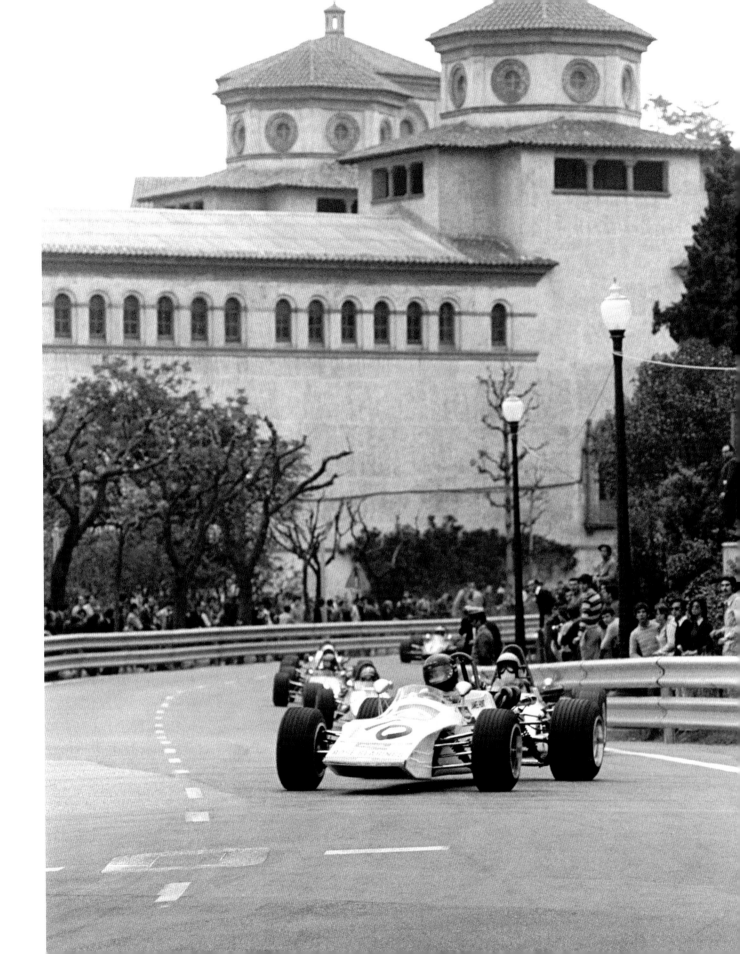

He would win just four of them and either crash or have incidents in twice as many. Although James got the season off to a flying start with victories at Montlhéry in France and on the Nürburgring *Sudschleife* (South Circuit), he was soon an increasingly frustrated driver: 'The March 713 was a disastrous car with a useless engine. I had a really big struggle with it all the time.'

That struggle would occasionally be self-inflicted, sometimes not. The second race of the season supported the BOAC 1000 km at Brands Hatch, a round of the World Sports Car Championship and a major international event. It was imperative that James should do well on home soil and everything was going according to plan until a sticking throttle caused him to spin out of the lead and into the bank at Druids.

There was even more pressure two weeks later when F3 supported the Spanish Grand Prix on Barcelona's magnificent road circuit through Montjuïc Park. Hunt led but was among several drivers to spin when rain made a challenging circuit even more tricky. The chaos was such that James was able to make a quick pit stop, check if anything could be done about a damaged front radiator and return to find himself in the lead once more. There may have been plenty of water outside but not enough was getting to the engine, courtesy of the broken radiator, the Holbay 4-cylinder eventually crying, 'Enough!'

Seven days later came another retirement when someone spun ahead of Hunt, leaving him no room to avoid breaking his car's suspension during the first lap at Pau. The event was won by the Alpine of Patrick Depailler, a name James would come to know well five years later during another street race in California.

Jose Ferreira and Hunt collided while fighting among the leading bunch during the last lap of a support race for the *Daily Express* F1 International Trophy at Silverstone. Hunt flew over the top of the Brazilian driver's Brabham and crashed heavily into stout wooden sleepers shoring up the spectator banking. Unlike the car, he emerged relatively unscathed. Ferreira was taken to hospital with a damaged wrist and Hunt was considered lucky, but that would be nothing compared to a truly remarkable escape eight days later.

The only good thing about the Silverstone shunt was its close proximity to the March factory in Bicester, where a hasty rebuild helped the car make the next race at Zandvoort in Holland. Hunt's weekend there got off to a bad start when his engine seized after two laps of practice, relegating the March to the back row of the 23-car grid. Running in the hectic midfield during the second of two heats, Hunt tangled with another competitor as they braked from maximum speed for the hairpin at Tarzan, the first corner.

Opposite page: Hunt's March 713M leads the field during the F3 support race for the 1971 Spanish Grand Prix at Barcelona. He was among many to spin off when the fast and challenging street circuit became wet.

HE WOULD WIN JUST FOUR RACES AND EITHER CRASH OR HAVE INCIDENTS IN TWICE AS MANY.

When you get a situation like that, touching wheel-on-wheel when the wheels are rotating in opposite directions means one car gets flipped in the air – which was mine. I landed on my head and was skating down the track at 70 mph when the roll-over bar behind my head broke off and I was being totally squashed in the car. By various miracles, I was very lucky and managed to escape largely unscathed from that by, somehow, being able to crouch down very low in the cockpit. During an accident like this, you're so busy; there's lots of noise going on and it's all sort of happening. You really don't have time to worry. But in that particular accident I had time to think when I came to a stop, still upside down and now buried in a sand dune.

The Dutch officials obviously decided it was wise to contemplate the car for about 40 seconds and have a puff on their cigarettes just to make sure the car wasn't going to catch fire. And they did do that because I've got photographs showing them all smoking cigarettes and standing around looking at my car upside down with no sign of me at all. They were checking it didn't blow up before deciding it was safe to go in. Those 40 seconds seemed like 40 minutes. I was perfectly all right except for being totally squashed with my head down in my lap and torn muscles in my back. I wasn't exactly enjoying it, but I knew no further harm would come to me so long as the car didn't catch fire. But I also knew – and this was really frightening – that if it did catch fire, these guys would run in the other direction. That was absolutely sure.

The car did not catch fire and Hunt was extricated. But his gloomy prophesy would turn out to be painfully close to the truth during the Dutch Grand Prix two years later, when Roger Williamson was fatally trapped beneath his overturned and blazing F1 car. Williamson, at 25, was one of Britain's budding young talents. During that F3 race in 1971, the young man from Leicester had been among the leading runners and would finish his first F3 season with nine wins.

Hunt's ability to put setbacks behind him was demonstrated a month later. After a break to allow badly bruised and damaged knuckles to heal, he returned to the scene of his pugilistic display eight months before at Crystal Palace, beating – this time not in the physical sense – Williamson into second place. The see-saw nature of the season, not to mention Hunt's progress, would come two months later at the same circuit when he spun while leading and was hit by another car – leaving victory to Williamson.

Hunt's March 713M dives down the inside of Alan Jones's Brabham at Brands Hatch in August 1971. Hunt went on to win the race after a close fight with Roger Williamson's March.

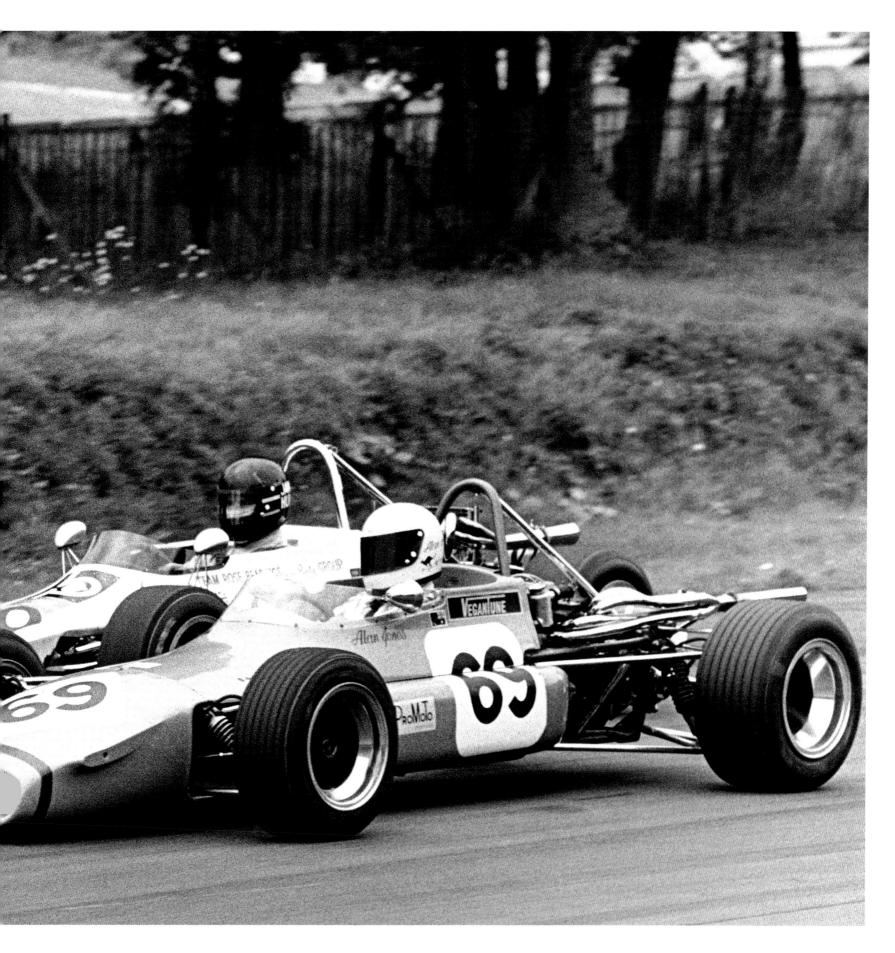

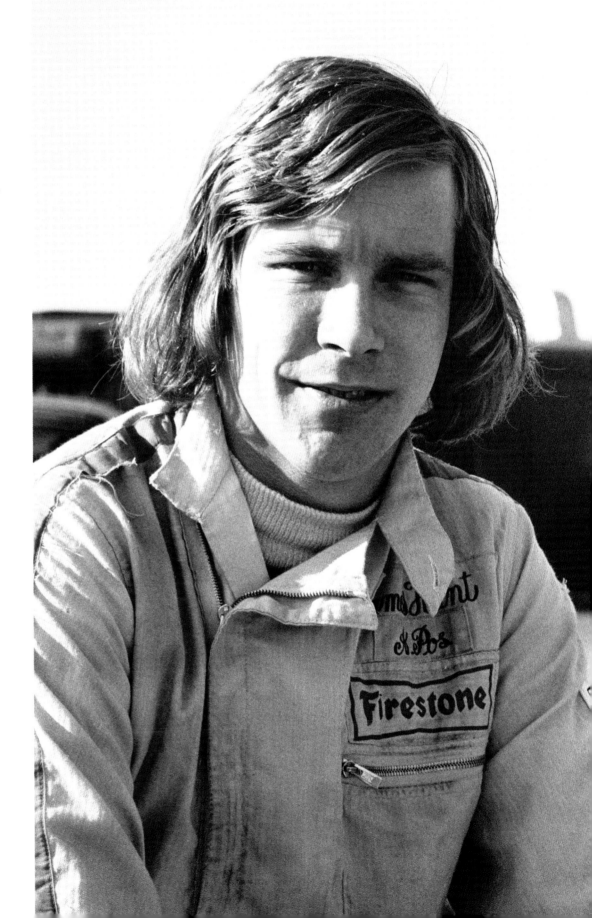

JAMES ALWAYS
HAD A VERY
CLEAR VIEW ON
WHAT HE WANTED
TO DO AND WHERE
HE WANTED TO GO.
JOHN HOGAN

Despite having a works F3 drive with March in 1972, Hunt
was hardly the picture of sartorial elegance with his
grubby overalls.

This, coupled with a heavy impact into a grass bank during testing at Snetterton, only added to his growing reputation for being a crasher, even though the latter incident was caused when a shock absorber broke at the very moment he took a very quick corner. He tore ligaments in his shoulder and right arm but went on to grapple manfully with the gearshift to finish a plucky second in the next race at Thruxton.

Hunt continued to feel pain from the Snetterton crash and had a second X-ray that revealed he had actually suffered a broken bone in his forearm and a broken shoulder. The diagnosis came too late to influence critics' reviews of the F3 season as J. Hunt was generally written off as 'disappointing'. There was just one glimmer of hope outside F3 at the end of August.

A one-off deal in a vacant F2 March, powered by a two-year-old engine, allowed James to take part in his first F2 race, a non-championship event at Brands Hatch. Troubled by an ignition problem throughout practice and most of the race, Hunt nevertheless impressed the assembled company with his speed and clean driving on the rare occasions the March was working as it should.

James had just turned 24 and this was his fifth full season of racing. In the eyes of those who saw beyond spectacular headlines covered with accident debris, it was high time he moved into F2. The view was shared by the man himself, particularly in the light of the progress being made by another driver who happened, for a while, to be sharing one of the many temporary resting places used by Hunt in London.

James had got to know Niki Lauda following a particularly energetic duel in a F3 race in Sweden. They had a heart-to-heart chat about the ways of the crazy motor sport world they were attempting to colonise.

James Hunt

Racing drivers never talk among themselves about death. But that night in Sweden, I did discuss it with Niki. We came to a practical rather than some philosophical conclusion. We both realised, because of the game we had chosen, there really was no point in leaving the celebrations until later. It was quite a simple rationalisation. The chances were pretty high that we'd both get killed. So we decided, there and then, that we'd celebrate as we went along.

It was a policy James would embrace with huge enthusiasm, with a casualty being the relationship with his long-standing, patient and loving girlfriend Ping. The pair decided reluctantly but mutually that it was best for both if they parted. They would remain firm friends.

Speaking of friendship, Lauda later described his fellow adventurer as 'an open, honest-to-God pal'. Despite similar philosophies on life, the one difference was that Lauda had acquired enough money – through the novel method of a £35,000 loan from an Austrian bank, covered by a life insurance policy – to fund a F2 drive with March and then move into F1. Hunt realised there was no chance of following his new-found friend. It was clear the only option was to accept another year as a works F3 driver with March. But if he thought 1971 was bad, the following season – or as much of it as either side could endure – would be much worse.

The March 723M handled badly, was down on power – on the rare occasions when it chose to run cleanly – and there were increasing rumours that March were in financial difficulties. It was said they might accept an offer from Ford of Germany to run their young protégé, Jochen Mass, in F3. The crunch, in every sense, came at Monaco, the most prestigious race of the year.

The car did not turn up until late on the evening before an early-morning practice start. One look inside the truck showed the 723M – damaged by Hunt in the previous race at Silverstone – to be far from ready and the sole mechanic, exhausted after the long drive to the south of France, in no mind or condition to finish the job. Sure enough, practice began without the presence of J. Hunt. When the car finally did get going, the throttle cable broke, leaving James to abandon the car and sprint the short distance to the pits. He returned with a mechanic and they found to their dismay that the parked car had been hit by an Italian in his Tecno, taking out a rear wheel from the March in the process. The hapless driver was at the receiving end of a stiff lecture as Hunt's mounting frustration exploded. The March works F3 effort was going nowhere in every sense.

In a state of some agitation, James went immediately to Chris Marshall, the man whose company had been given the job of preparing the F3 March cars during the latter half of 1971. Marshall was now running the same cars in his own team, named L'Equipe La Vie Claire in deference to a French sponsor. One of Marshall's French drivers had had his licence suspended after an unwise quarrel with the police. The car was offered to James: a risky proposal, considering Hunt was under contract to a team run by a lawyer.

James decided to accept if the works March was not ready for qualifying the following day. When the car, almost on cue, failed to appear, Hunt adopted Plan B, jumped into Marshall's car and qualified it for the first heat. He was unafraid to explain to anyone who would listen – including journalists – just why this was happening and what he thought of the 'bunch of bandits' ruining his career: a typically spontaneous tactic that did not go down well with Max Mosley.

Max Mosley *I have to agree, our F3 team in 1972 was not a success and, during the Monaco race weekend, James told the press (possibly truthfully) that the car was no good. I sacked him, telling him that a works driver should never say such things even though I understood his frustration.*

In fact, Hunt was delivered an ultimatum by a March mechanic as he sat in the La Vie Claire car, preparing to take part in the first heat. Mosley gave him a choice – race the works March or face dismissal. Yet the works car had not qualified. Hunt tightened his belts and fired the engine. At the end of the first lap, he lay in 15th place. A few minutes later he was parked against the barrier after the car in front spun and left Hunt with nowhere to go and nothing to do but curse his wretched luck.

Out of the race and out of the drive, Hunt gave his side of the story when contacted the following week by Ian Phillips of *Autosport*.

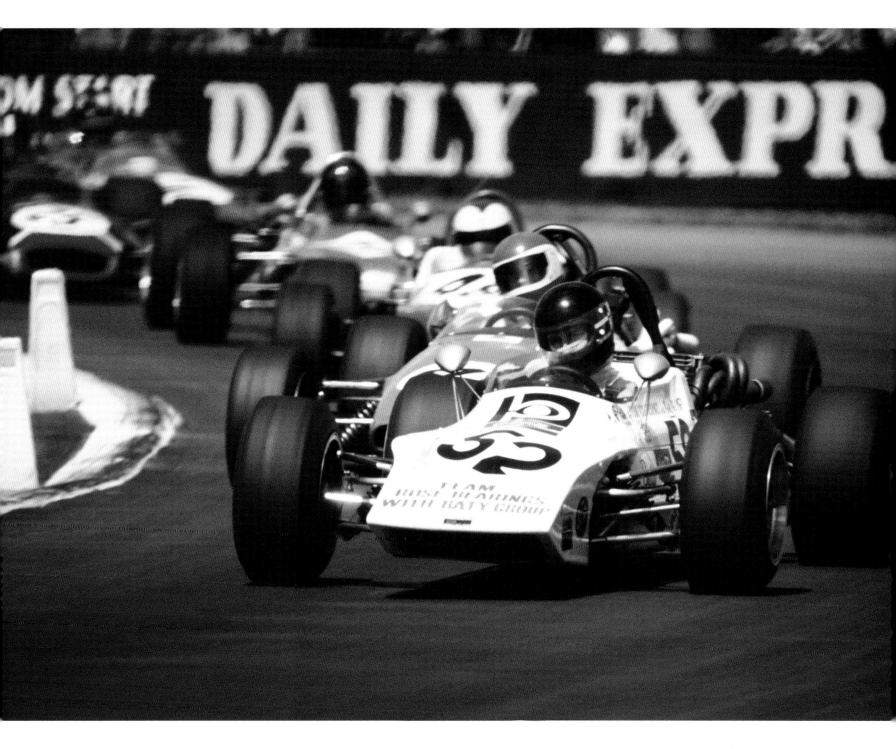

Furious action at Silverstone as Hunt's March 713M leads a typically tight group during the support race for the 1971 British Grand Prix.

James Hunt

The fiasco at Monaco was only the climax of a situation which had existed all year, and it stemmed from a variety of problems caused basically by a lack of interest and enthusiasm. I made every effort to inject either interest or enthusiasm but without success. March asked me to drive their car in the race, apparently not aware that they no longer had an entry because I had not been able to qualify an unprepared car. When the mechanic brought me that message from Mosley, it seemed they thought I could simply transfer the number from the La Vie Claire car – which I had qualified – to their car. This was a mistake because La Vie Claire had gone to considerable trouble to re-arrange the entry. I would like to point out that the enthusiasm of La Vie Claire was tremendous and I saw no good reason to let them down after their effort on my behalf. Thus I now feel that the interest of my career would be better served by racing on my own.

Ian Phillips

Contrary to one particular publication that I hear makes out Chris Marshall to be incompetent and irresponsible by allegedly leading Hunt astray at this time, I found him to be a really nice guy and a genuine enthusiast. He had raced a bit himself, probably decided he wasn't good enough and took to running his own team.

Regarding this episode at Monaco, you've got to remember that James had a pretty fractious relationship with Max. I can't remember the specifics but I suspect that much of that came because March were probably not able to pay James at the time and, one way or another, James taking the drive with Marshall and Max sacking him was a turn of events that suited both sides! I think everyone could understand why James decided he would be better off doing his own thing even if the parting of the ways with March was a complete mess.

Hunt agreed to drive Marshall's car the following weekend on a fast and ferocious road circuit at Chimay in Belgium. The event was notable for a front row start and a fighting fifth place despite a puncture, but one other, seemingly innocuous, event – going to the toilet – would have a profound effect on the rest of his career. Hunt's contretemps with March had been the talk of the paddock in Monaco and was followed up with more than passing interest by Anthony 'Bubbles' Horsley, an amateur racer who could best be described as an entrepreneur dabbling on the fringe of the motor

trade in London. Horsley, fancying himself as a racing driver, had attempted – and failed – to qualify at Chimay at the wheel of a Dastle, a workmanlike car that was the first effort at F3 by a very small British company. Aware of his limitations as a driver but enthusiastic about the prospects for his car, Horsley felt it would be a good idea all round if Hunt could be persuaded to race it.

More significantly for Hunt's future career, Horsley was working with Lord Hesketh, who wished to go motor racing and had contributed a small amount of financial support; small, that is, in terms of the young nobleman's family wealth.

When Horsley bumped into Hunt in the middle of the field that served as a paddock in Chimay, a conversation began that would quickly establish a bond between the two. Horsley liked the look of Hunt and liked the cheery attitude he had despite his calamitous season thus far. Horsley saw something of himself in Hunt – albeit a young hopeful who could drive much faster – since some of the Englishman's early exploits had a familiar ring.

Several years before, Horsley had been a habitué of a famous flat in Harrow occupied by, among other penniless racers, Frank Williams. Compared to his fellow flatmates, Horsley was better off thanks to a legacy which, with the help of Williams, he was to diminish in short order. Having bought a F3 Ausper to replace a broken Brabham, Horsley agreed to Williams driving the Brabham if he repaired it and acted as Horsley's mechanic as they followed the nomadic European trail during the summer of 1964.

Opposite page: Classic 1972 pre-season press release photo as Hunt poses with his team-mate, Brendan McInerney, and the ill-fated March 723 in the salubrious surroundings outside the team's workshop in Bicester.

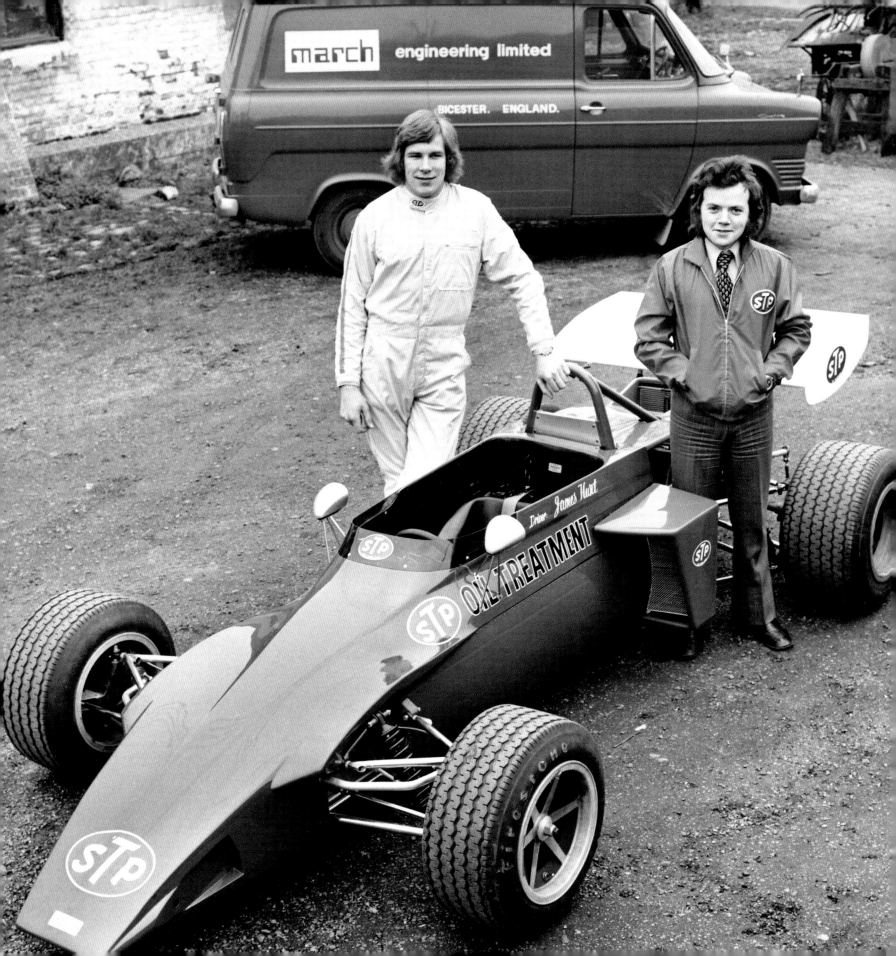

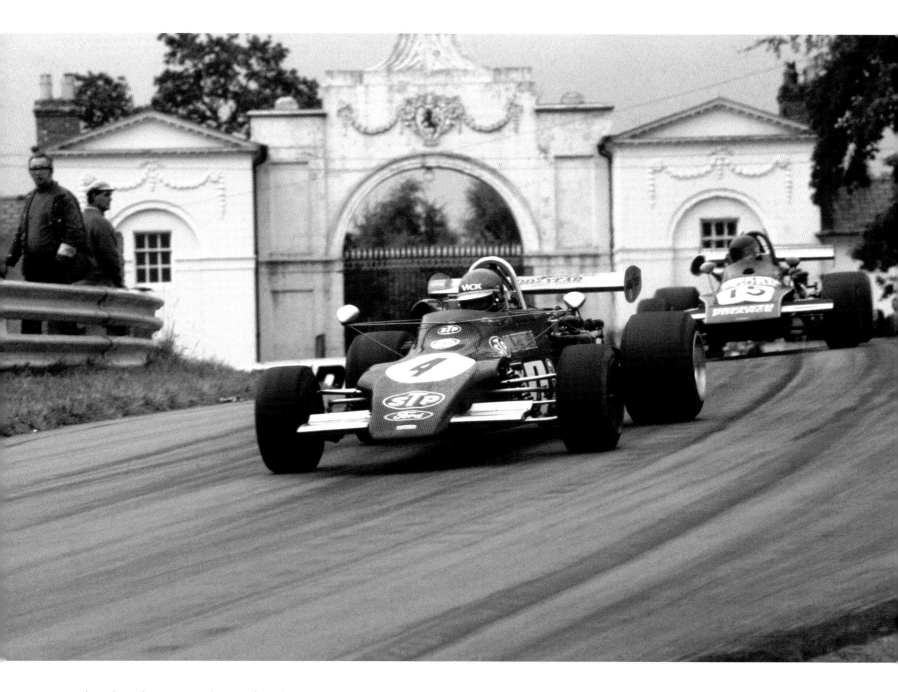

Hunt's March 712M hangs on to Ronnie Peterson's March
722 through Lodge Corner during the F2 race at Oulton Park
in September 1972.

The racing partnership reached a sticky end when Williams crashed at the Nürburgring Sudschleife. It was one thing for Horsley to round the corner and find half of his worldly goods deposited against the grass bank and quite another to see Williams grinning from the trackside. Horsley was so upset that he crashed at the next corner and was thrown from the cockpit.

In physical as well as mental pain, Horsley was lifted into an ambulance. Realising this might be an expensive trip, Bubbles discreetly made his escape through the back doors when the ambulance stopped at the exit. The alarm caused at the hospital can be imagined when the doors were opened to reveal the absence of the patient. Horsley would receive a severe dressing-down when the police caught up with him in the paddock.

With credentials such as these, it was little wonder he found a soulmate in Hunt. The next job was to persuade Lord Hesketh that James should be their driver. The introduction was apparently made later that afternoon in the grassy paddock's temporary lavatory. From such a humble beginning would flourish a spectacular relationship.

The fact that they all seemed to be motivated by *carpe diem* would be proved when James got no further than 100 metres into his first race for Hesketh before being caught out by a very wet track at Silverstone and putting the Dastle into the pit wall – right under his lordship's nose.

Worse was to come during practice for the support race to the British Grand Prix at Brands Hatch. When a car ahead suffered a puncture and got into trouble, James found himself upside down on the crash barrier before what was left of the car landed back on the grass verge in an upright position. When Horsley had a separate accident, Lord Hesketh and his small team were left with nothing to do that weekend but plan for their future. But not before Hunt had an accident on the way home when the Mini he was driving was in collision with a Volvo. The Mini and its occupants came off worst when pitched against substantial Swedish metalwork.

Ian Phillips

Everyone thought that James's move to Dastle was a bit desperate. We knew very little about Bubbles Horsley, nobody knew who Lord Hesketh was and Dastle were better known for making race trailers than racing cars. But it was a lifeline and James grabbed it. I think he could see that, despite Bubbles having this laid-back air, he was actually a pretty serious operator.

As Horsley and Lord Hesketh took stock, it was decided that the wrecked racing cars weren't worth the expense of rebuilding. Far better, it was reasoned, to simply step up to F2. Hesketh and Horsley could see through the 'Hunt the Shunt' reputation and had no doubt that their man was capable and ready to advance.

Max Mosley

James had a wonderfully laid-back attitude and was great company at the track and off it. He took the sacking at Monaco in his stride and we remained friends, even laughing about it later. He needed to keep racing for his career, so we lent him a 1971 March F2 chassis that was still a very competitive car but needed an engine. Lord Hesketh ended up buying James an engine and making him a serious rival to our works F2 team of Peterson and Lauda.

Despite the comparatively elderly car, James repaid Hesketh's faith and went a long way to reviving his career and reputation by finishing a very strong third behind Peterson and Lauda at a Formula 2 race at Oulton Park. Watching with close interest from the sidelines, John Hogan was pleased but not particularly surprised by the progress of a driver for whom he had decided to help find sponsorship the previous year.

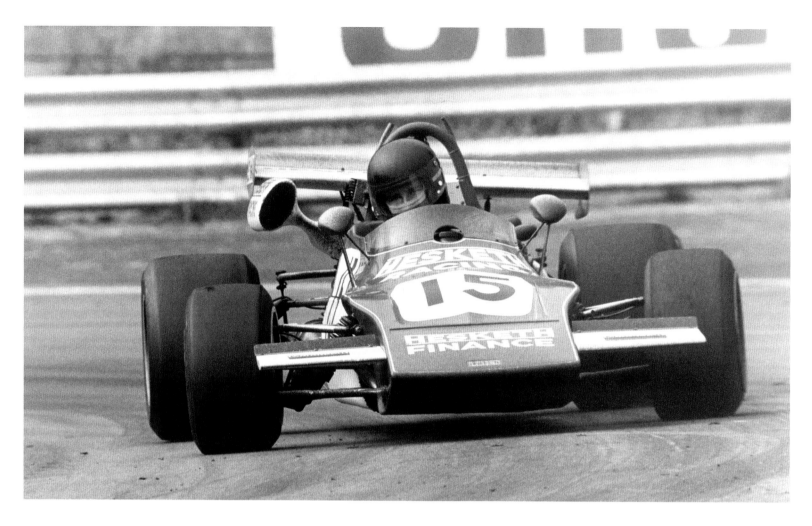

John Hogan

I was working for an advertising agency and a friend from another agency rang me up and said, 'Listen, I've got a bloke called James Hunt, he's a Formula 3 driver, I think. He wants to talk about sponsorship and management. Could you see him?'

I agreed and James came to see me with a young lady, who was somebody else's wife. He had a piece from one of the motorsport magazines listing future Formula 1 Champions. I've no idea who wrote this article but whoever it was said, in his opinion, James Hunt was the sixth best Formula 3 driver there ever was. Armed

with that one piece of paper, James was saying he needed help to get sponsorship. I eventually did a deal with Coca-Cola for James and Gerry Birrell and, through that, we became friends.

James always had a very clear view on what he wanted to do and where he wanted to go. We used to go out to dinner at a restaurant in Kings Road where you could get Shepherd's Pie for 10 [shillings] and six [pence]. He used to buy it for me. We'd talk about how you'd get to the top. To plan your future then was so much easier than the complexity you have to go through now. Certainly nobody knew

anything about sponsorship at all; not the first idea. It was all about putting a sticker on a car and how much could you get for it and so on, which is what we ended up doing with Coca-Cola.

The Dastle was a pretty evil car. When he took that drive, he was at his lowest ebb. We were having one of our shepherd's pies and he more or less said that motor racing was not the only thing in the world. That really shook me. It would be the only time I saw him lose confidence. Of course, with James, it didn't last long. That F2 drive at Oulton Park came at the perfect moment.

Ian Phillips, Autosport review of the 1972 F2 season

After a very unhappy time in F3, James Hunt set out to prove he was not finished. Nobody could have wished for such an overwhelming change in fortune. With plenty of power under his right foot, F2 suited his technique down to the ground. He put the year-old car on the front row of the grid in his first championship round at Salzburg and from then on didn't look back. Not only was his driving fast but also very tidy and his dice with Ronnie Peterson at Oulton Park will be remembered for a long time. His success brought the backing from Hesketh

Finance needed for a proper attempt at the championship next year and he is already tipped as a strong favourite.

The logic of Phillips's prediction could not be faulted. But it did not take into account the extraordinary whim of a fledgling racing partnership driven by huge ambition and a massive sense of fun. After, at times, a truly demoralising struggle, James Hunt finally had happy days ahead.

'Got room for me, chaps?' James jokes with the garlanded winner, Ronnie Peterson, and Niki Lauda, before setting off on the victory parade lap at Oulton Park. Hunt had made the works March drivers work hard with his more elderly – and fragile – Hesketh-run and financed March (opposite page).

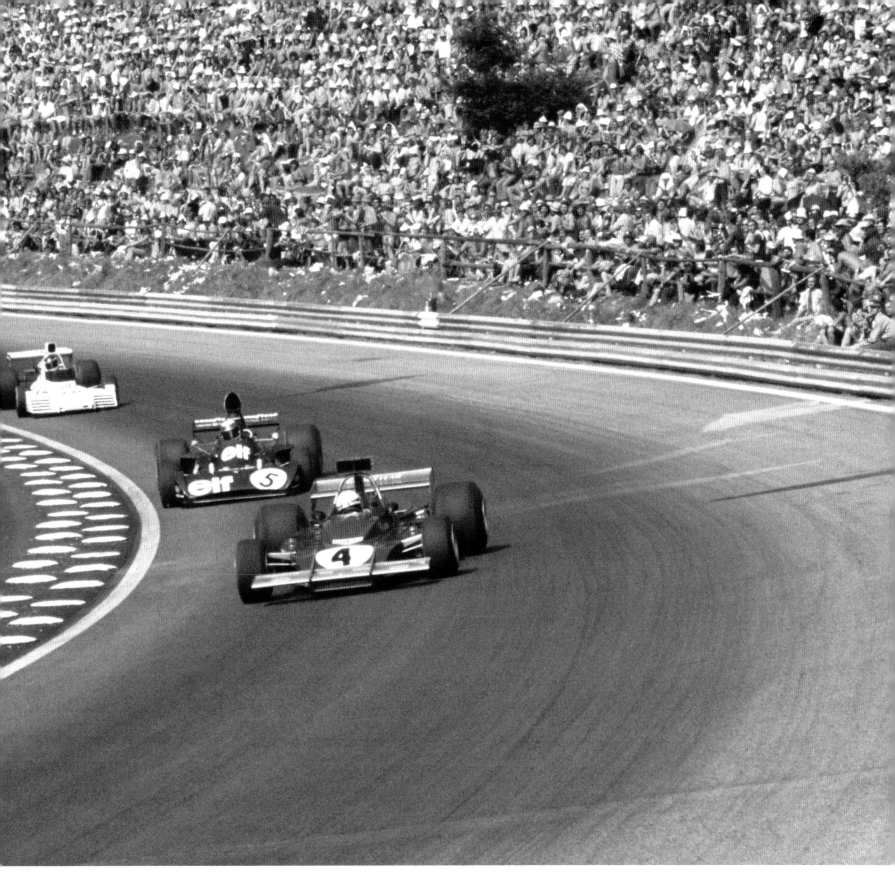

4. 1973: **GOOD LORD!**

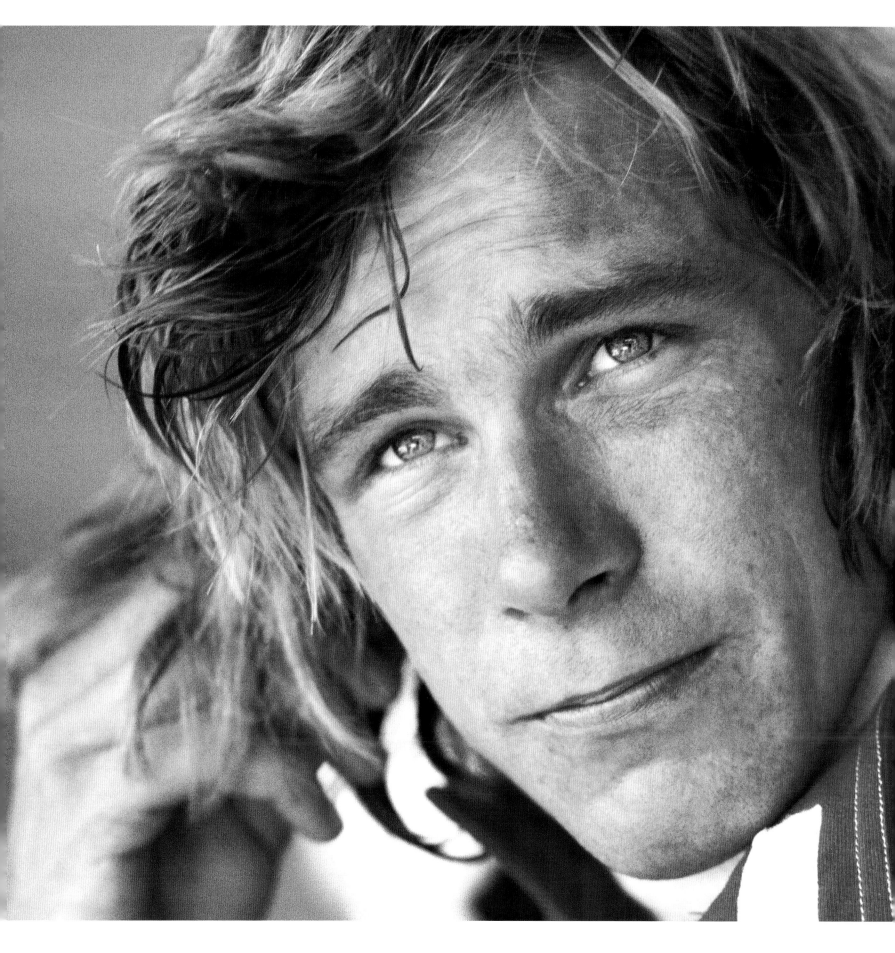

The manner of Lord Hesketh's retirement from his first and only motoring event had been as unusual as his background as a competitor. Sharing a Ford Cortina 1600E with a local milkman in a rally organised by the Northampton Motor Sport Society in 1968, Thomas Alexander Fermor-Hesketh, 3rd Baron Hesketh, hit a combine harvester operated by one of his tenant farmers.

Born in 1950, Hesketh inherited the family title on his father's death five years later. With a modest score of three O-levels (not helped by having run away from Ampleforth College), he turned his back on the family estate to move into the less noble but more streetwise business of selling used cars. With part of his inheritance due at the age of 21 and with it increased responsibility, the wise course of action seemed to be working for an investment banking corporation in the USA followed by a brief period with a ship-broking company in Hong Kong.

The eventual arrival of the first substantial tranche of inheritance funded the foundation of Hesketh Finance with forays into publishing, printing, construction, interior decoration and then motor racing, thanks to the meeting with Bubbles Horsley. The acceptance of Horsley's limited talent as a driver had led to the arrival of James Hunt and plans to launch an attack on the 1973 European Formula 2 title with the help of a Surtees TS15 chassis.

The ambition was deadly serious, as was the intention to have fun along the way. Mallory Park was not listed alongside the Grand National, Wimbledon and Lords as one of the great British sporting social venues but that did not prevent Hesketh Racing from starting as they meant to continue. The arrival of the colourful entourage at the tiny Leicestershire club circuit in March was like a group in Royal Ascot finery turning up at a winter point-to-point in the Brecon Beacons. The debut was no less welcome for that, as recorded by Ian Phillips in *Autosport*.

'James Hunt was in the Hesketh Racing Surtees, with sponsor Lord Alexander Hesketh, team manager Bubbles Horsley and many other camp followers very much in evidence and helicopters and limousines to-ing and fro-ing. It was all very colourful and extrovert and livened up the scene no end. James was suffering no ill-effects from his recent arm breakage.' James had inflicted the injury while 'playing on the lawn after lunch during a visit to friends in the West Country'.

Previous page: Opening lap of the 1973 Austrian Grand Prix. The fourth-place Ferrari of Arturo Merzario leads the Tyrrell of Jackie Stewart, Carlos Reutemann's Brabham, the Surtees of Carlos Pace and James Hunt's March through the Bosch Kurve.

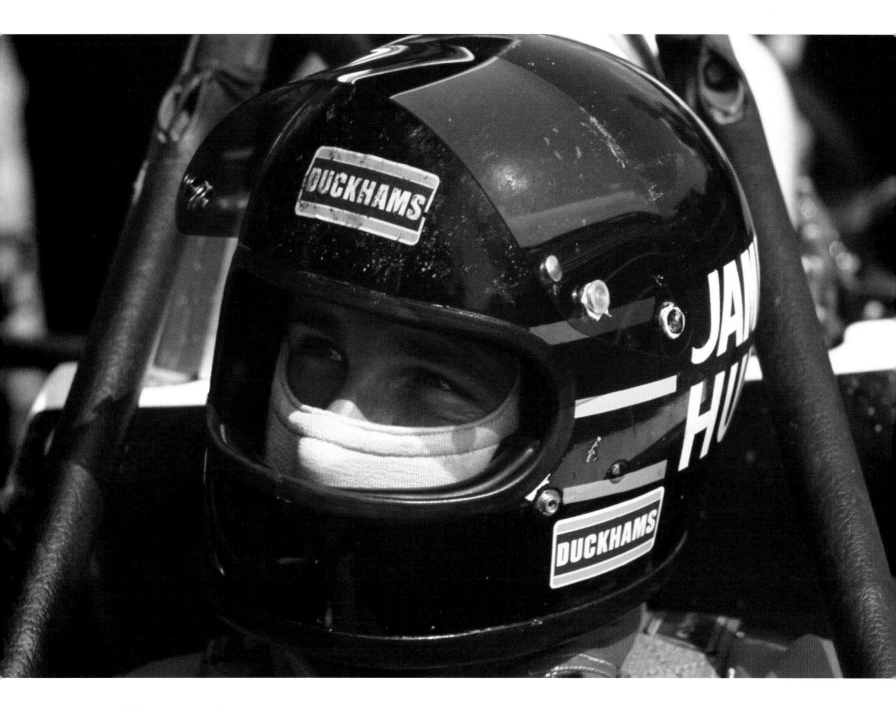

The colours of Wellington College on Hunt's crash helmet
received international exposure in 1973.

Scepticism continued over the motivation behind Hesketh's venture, with a liveried butler on hand to serve caviar to his guests. The majority of those invited would not have known one end of a racing car from the other.

James Hunt

Alexander would bring his mates and they'd have a huge party. But behind the smokescreen – because it was very difficult to see through – the team were very serious and professional. The combination of seriousness and fun suited me. When I was concentrating on the race, it didn't interfere or bother me having all the fun around. They were a jolly nice crowd and after the race, when it was time to stop work, I was able to join the party.

Hunt would be able to begin socialising earlier than planned when the front suspension broke while lying an impressive third ahead of Mike Hailwood, the reigning F2 champion driving a similar Surtees. But his performance was considered a suitable warm-up for Hesketh Racing's next major step; an entry one week later in the Race of Champions at Brands Hatch.

For his F1 debut – in a hired Surtees TS9B – Hunt did a respectable job, qualifying 13th on a grid of 29 cars made up of F1 and F5000 machinery. It took time to become accustomed to the increase in power, his first practice session not helped by a blown engine and sticking throttle. When he finished third (behind the F5000 Chevron of Peter Gethin and Denny Hulme's F1 McLaren) it mattered little that more than half the field had retired. The point was that

'Hunt the Shunt' had driven flawlessly over 40 laps and brought the car home – James and Hesketh were saving their crash until two weeks later.

Under the heading HUNT'S GOODWOOD PRANG, a news item in the 5 April edition of *Autosport* told a story of rudimentary values as the team tried to prepare for the next round of the F2 championship at Hockenheim. In a bid to improve top speed on the German circuit's very long straights, the nose of the Surtees had been stripped of all appendages and the rear wing set completely flat. On his first flying lap of the airfield circuit in Sussex, a strong crosswind at Madgwick left James with no steering going into the fast right-hander. The car ploughed straight into a bank before somersaulting and landing upside down in a spectator area – happily devoid of inhabitants, this being a private test. Miraculously, Hunt was unhurt, but the car was badly damaged.

The necessary repairs put the team on the back foot at the start of what would be a weekend of problems in Germany, culminating in the fuel-metering unit going wrong as James prepared to start the race. Further mechanical difficulties followed at Thruxton and Pau with, along the way, Lord Hesketh suffering injury when a wheel was dropped on his foot at the Hampshire circuit and a mechanic breaking an arm in France. Yet none of these setbacks would dim his lordship's enthusiasm for going motor racing.

Autosport, 31 May 1973

Hesketh Racing announced at the beginning of the week that they will be running a brand-new March 731 F1 car in all the remaining Grands Prix this year and not a Surtees TS14 as originally planned. Negotiations with March have been in hand for a couple of weeks and the car has already been delivered and tested. Its first race will be at Monaco this weekend. James Hunt drove the car for the first time at Silverstone last Thursday. Hunt's previous F1 experience consists only of the Race of Champions this year when he scored an excellent third place.

Hesketh Racing is running the car with support from the March factory. Joining the Hesketh team to look after the F1 development is Harvey Postlethwaite, the former clubman's sportscar driver who, for the past two years, has been chief engineer at March. At the moment, it is uncertain whether Hesketh Racing will continue to run their Surtees TS15 in any of the remaining F2 championship rounds. They have had a great deal of trouble with their car since the promising debut at Mallory Park.

Lord Hesketh

At a top-level conference in a Fulham Road restaurant [in London], *we had originally made a decision to go for a full-scale assault on the 1973 European F2 championship. We bought the Surtees but it was the wrong car and the wrong engine. The first race had been at Mallory Park and Jean-Pierre Jarier had walked away with it in a March powered by a BMW engine. James was the fastest of the Ford-engined cars but it was obvious that we weren't going to do much winning. So F1 seemed the natural thing to do.*

Bubbles had said there was no point in buying an F1 car unless we had somebody to improve it. Harvey [later to become affectionately known as 'the Doc'] *was not that keen on the idea initially, so we plied him with fine white Burgundy until he agreed.*

James Hunt

Alexander was very encouraged and excited when we came third in the Race of Champions, our first F1 race. His attitude was that we were doing pretty badly in F2 and for very little additional cost we could do badly in F1! He felt that there would be a hell of a lot more fun doing proper Grand Prix racing, so he said, 'Let's go and mess about at the back of F1.' Monaco happened to be the first race that we were ready for. But that suited his lordship very well. He could arrive with a bit of a flash!

That would be the understatement of the year. Hesketh Racing arrived at Monaco in the manner to which they would become happily accustomed. Even by the lavish standards of motor racing in Monte Carlo, the happy-go-lucky outfit caused a substantial stir. Despite being hugely patriotic, Hesketh eschewed the traditional British racing green (a throwback to the pre-sponsorship era in which each nation would be represented by a colour – red for Italy, blue for France, green for Great Britain, and so on). The chosen background colour for the Hesketh March was white with red-and-blue pin-stripes (later to become bold bands across the car) completing the symbolism of a team that could not have been more British if it tried.

The imagery would be particularly vivid in the shimmering harbour of the Principality. Sponsorship identification and team uniforms were not yet de rigueur and the comparatively bland outfits of the existing F1 teams were put in the shade by white jackets and shirts emblazoned with 'Hesketh Racing' in large letters on the back and individual names on the front. And even the names were unusual since the working members of the outfit rejoiced under the nicknames 'Ferret', 'Rabbit', 'Ball of String' and 'Thomas the Tank Engine', not to mention 'Doc' and 'Bubbles'. Lord Hesketh was known as 'Le Patron' and referred to his driver quite simply as 'Superstar'. The F1 columnists loved it.

Opposite page: 'Le Patron' presiding in the pits at Monaco.

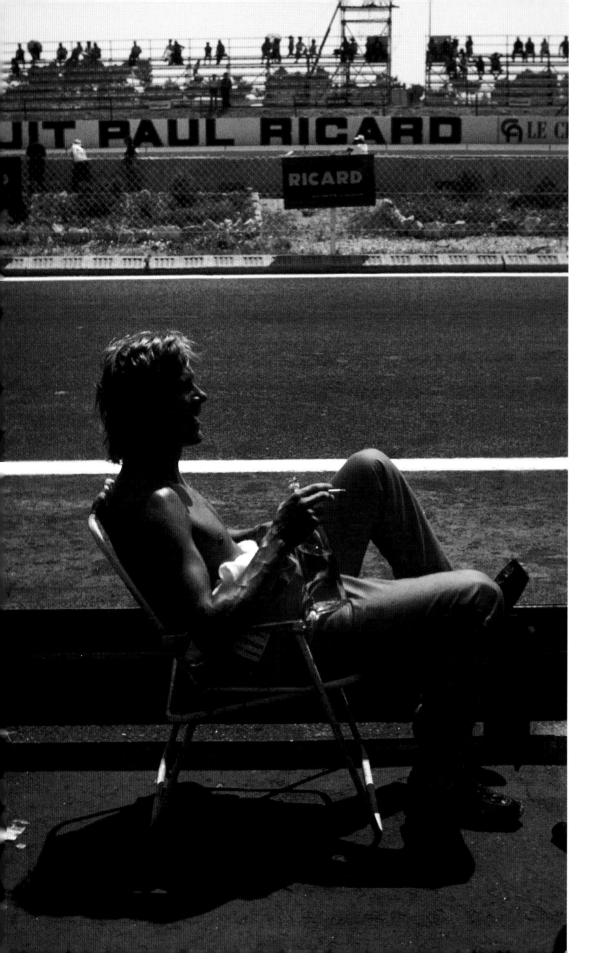

Eoin Young, 'Straight from the Grid', Autocar

The yachts in the harbour really gave the Grand Prix its social airs and champagne graces. There was something of a competition to see who could surreptitiously charter the largest yacht in the harbour for drinkies and have the most beautiful people on board. Lord Hesketh and his Greyfriars Grand Prix team were aced out of pole position on the jetty by Peter Cameron Webb with Yardley and Ford running a close third in the battle for hull inchage. The noble lord made up for his smaller vessel by stocking it with an excess of Dom Perignon, toted in by a screamingly inconspicuous, dark green, Rolls-Royce Silver Shadow with those darkened windows that immediately make you want to know who it is in there who doesn't want to be known.

Some people have been saying that Hesketh is a royal young ass and should be playing with polo ponies or something where his money doesn't stand out so much. I think he and his team are doing racing a lot of good. I mean, if we're going to get so deeply serious about our professional sport that we don't have time for people who are racing only because they enjoy it, perhaps we should reconsider our own position. At the very least it gives the colour writers something new to write about and gets racing a bit more ink.

The Hon Patrick Lindsay [an extremely competent driver in historic racing] was beaming away in the Hesketh pits explaining that he wasn't really a possibility as a second driver to James Hunt. It was just that Lord Hesketh was his

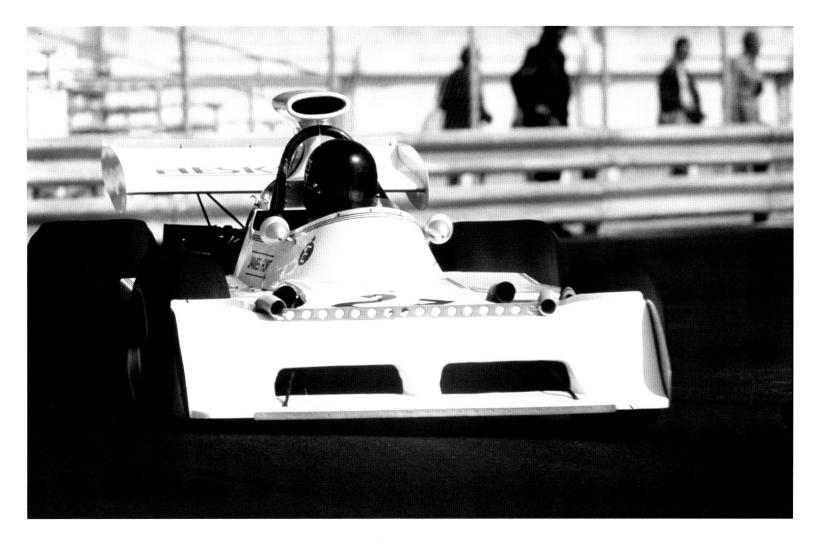

cousin and he didn't have anything to do that weekend...

I asked Bubbles Horsley how they planned to match their yacht as a hospitality vehicle at the other GPs and he said they would get a trailer. Did he mean one of those palatial American motorhomes? 'No, I mean we'd get a trailer and take the yacht along with us.'

Opposite page: Lapping up the sunshine in France. James relaxes in the pits at Paul Ricard.

Above: Engine failure in Hunt's first Grand Prix brought merciful relief at Monaco.

Beneath this schoolboy humour lay earnest ambition in an area other than the 162-foot yacht *Southern Breeze* with the now familiar back-up of the Bell JetRanger II helicopter, the Rolls-Royce and a Porsche Carrera. The most important car of the lot, the March-Ford 731, was quick. And so was the driver, even though the step-up in performance and on-track company he was keeping brought a sense of foreboding. Having qualified an excellent 18th, James now had to race this car for 78 laps on a track ready to punish the smallest of errors. James wasn't nervous; he was petrified.

James Hunt

Before any race I became nervous, particularly if it was important to me. And that race was very important. Monaco is a pretty tough place to start a Grand Prix career. The track is so narrow, you're shifting gears all the time and there is absolutely no room for error. Five hundred horsepower is a lot to tame in that confined space. Before I got into the car, I was puking all over the place. On the grid, I was just a shaking wreck.

Being sick pre-race was nothing new for

HIS ATTITUDE WAS THAT WE WERE DOING PRETTY BADLY IN F2 AND FOR VERY LITTLE ADDITIONAL COST WE COULD DO BADLY IN F1!
JAMES HUNT

James. He knew why it was happening and that the nausea would disappear once he let out the clutch in anger. But what was different and more worrying on this occasion was a persistent headache that had nothing to do with the surrounding razzamatazz.

I had gone home and stayed with my parents in order that I could become really fit before my first Grand Prix. I was as fit as a fiddle from the neck down but I had been having blinding headaches for four or five days a week. I was frightened to go and get anything done because I thought there might be something seriously wrong.

Later, I had it attended to and found it was a legacy of some of my shunts. I'd gone on my head so many times my neck muscles had sort of seized up from the abuse and the blood supply was restricted. I was as right as rain after treatment, but I was very worried about my fitness at Monaco.

Headache aside, that concern would have substance thanks to the relentless physical onslaught that was about to hit a driver who had done no more than half the distance in any previous race. And on circuits much less demanding than this.

Hunt stayed out of trouble, picking up pace and confidence as the race went on, capitalising on the mistakes of others to gradually move up the order. With seven laps to go, he had taken sixth place. Scoring a championship point on his debut – particularly at Monaco – would have been a massive achievement but it was not to be, with the engine failing two laps later. He was classified ninth. Not that James cared too much about where he had finished – just that this torture had come to an end.

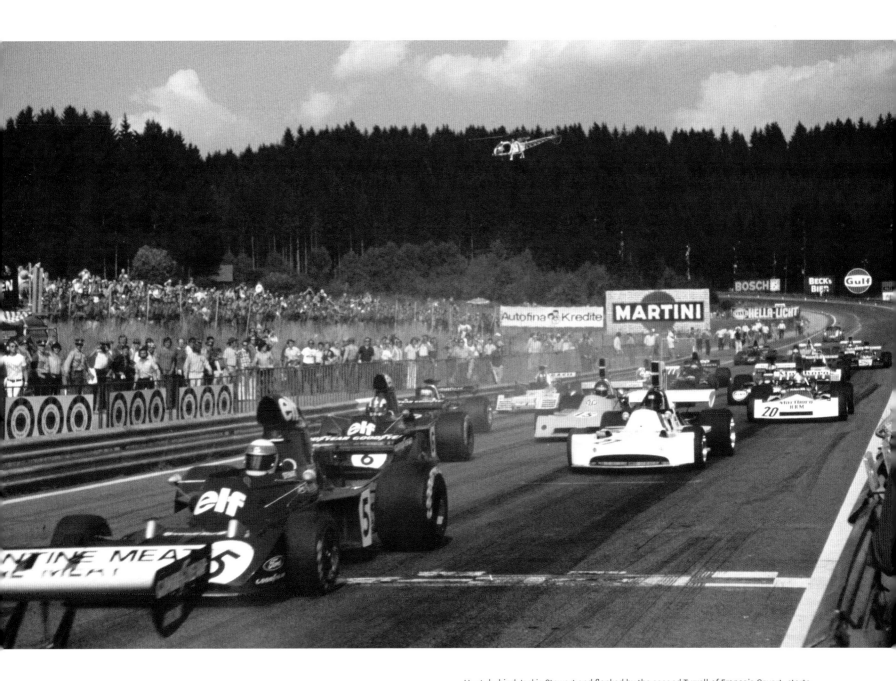

Hunt, behind Jackie Stewart and flanked by the second Tyrrell of François Cevert, starts what will be a short-lived Austrian Grand Prix thanks to mechanical trouble after three laps.

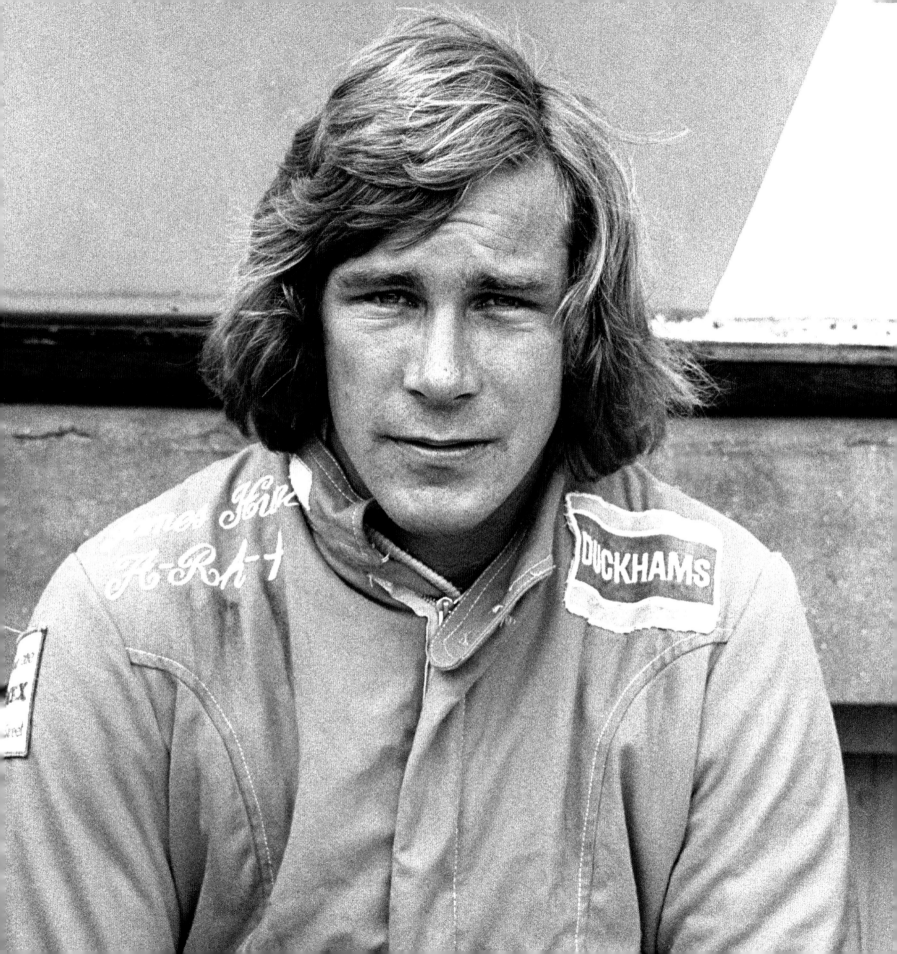

James Hunt

I was going well for the first third of the race, then suddenly it hit me. I couldn't drive at that pace any more. I was simply going to drive off the road. The heat plus the physical effort had me completely knackered.

Recovery was aided by the predictable party that evening on board *Southern Breeze*. Hesketh Racing had cause for celebration: they had arrived on several fronts and their driver had proved himself more than capable, just 12 months on from the desperate low of being fired by March at the very same circuit.

Proof that the Monaco showing had not been beginner's luck or a flash in the pan would come further along the Mediterranean coast a few weeks later. Having missed the Swedish Grand Prix to allow time to regroup, Hesketh turned up for the French Grand Prix at Paul Ricard. After qualifying 14th, James had a comparatively lonely race. It didn't matter in the slightest as the engine held together this time and allowed him to claim sixth place and the championship point owing from Monaco.

If that was a handy warm-up for the British Grand Prix, then so was a one-off event in a Chevrolet-Camaro Z28. He only drove it for a few laps of Brands Hatch before beating established saloon car and rally drivers to win the Tour of Britain. Hunt was sharp and in good form for his first Grand Prix at home.

This was to be a weekend to remember for several reasons, not least a multiple-car shunt when Jody Scheckter ran wide at the end of the first lap, lost control, shot across the track, hit the pit wall and rolled backwards as the pack of more than 20 cars powered blindly through the 170 mph Woodcote corner.

Hunt, having started 11th, was among the first to see the white McLaren take its scary course from left to right – and back again. When someone tagged Scheckter's rear wing and flicked it into the air, the aerofoil flew low over Hunt's head and knocked the March's tall airbox. James was lucky to emerge unscathed, as were the remaining drivers. The only casualty was Andrea de Adamich, the Italian suffering a broken ankle when his Brabham was one of nine cars wrecked in the incident. James had time to consider his good fortune when the race was stopped and the surviving cars regrouped for the restart.

Opposite page: Despite looking apprehensive, James found his pre-race nerves had been used up as he waited for the re-start at Silverstone.

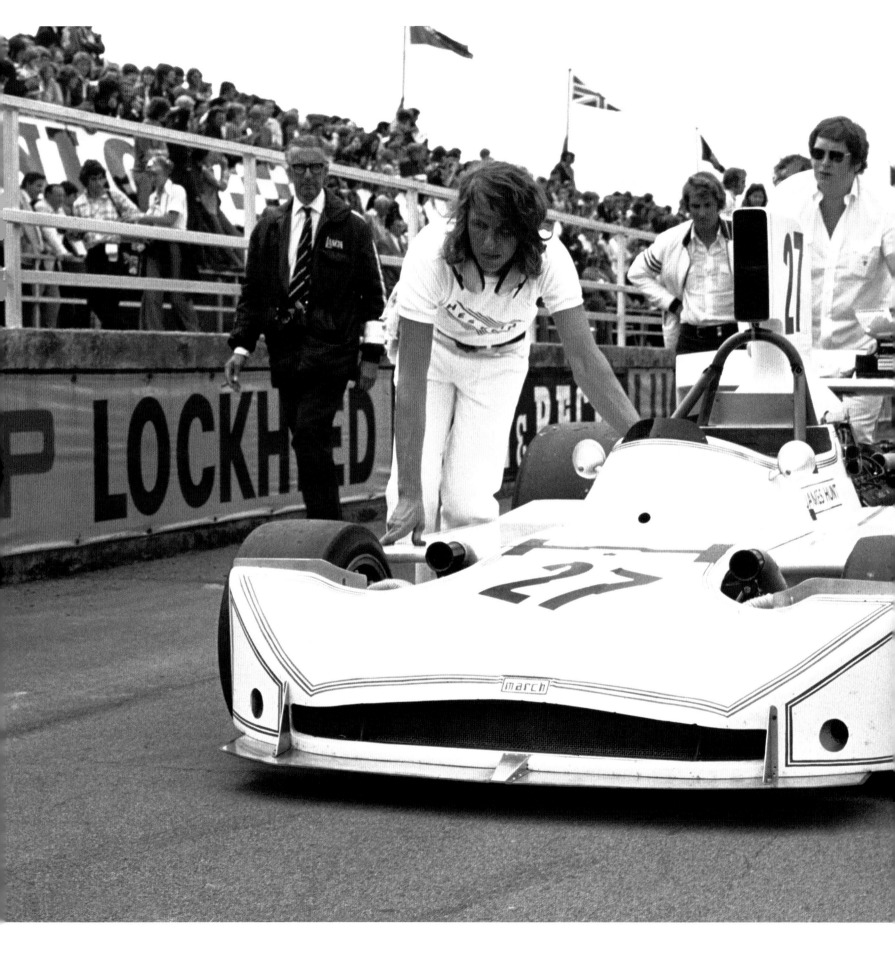

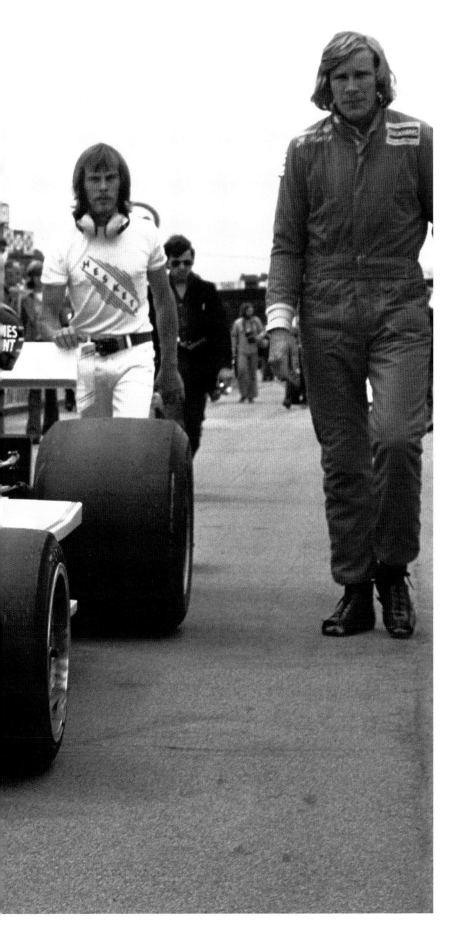

I had a very lucky escape. I'd suffered badly from nerves all morning; I'd really been in a terrible state. So I was very surprised to find that while we were waiting I wasn't at all nervous. I suppose in a sense the event as such had started, so I was no longer jumpy.

Nineteen cars were left in the running but Hunt did not need the improved odds to increase his chances of a good result (even though the March had to be fitted with an old-style airbox rather than Postlethwaite's taller version). By lap seven he was in sixth place and moving forward, getting into position for an epic four-way contest in the closing laps as Peter Revson's McLaren just about led an ever-changing battle between Ronnie Peterson's Lotus, Denny Hulme's McLaren and Hunt, who used the prodigious straight-line speed of the white March to keep everyone guessing. The quartet crossed the line in that order, Hunt just 0.4 seconds away from the podium but the undoubted hero of the moment, with fastest lap to his name for good measure.

Lord Hesketh

James said afterwards – and I'm sure he was right – that if he'd had the new airbox he would have won the race. It was giving us something like another 400 rpm which at Silverstone, of course, counted for a great deal on the long straights.

Just as Hunt's first point had been delayed by one race, so his first podium would have to wait until two weeks later and the Dutch Grand Prix. Despite the enormity of the achievement in only his fourth Grand Prix, the moment would be tinged with great sadness when James witnessed the death of his former F3 rival, Roger Williamson.

James walks alongside as Lord Hesketh helps push the March into position on the starting grid at Silverstone. It was at this very spot that a multiple collision would bring the 1973 British Grand Prix to a halt at the end of the first lap.

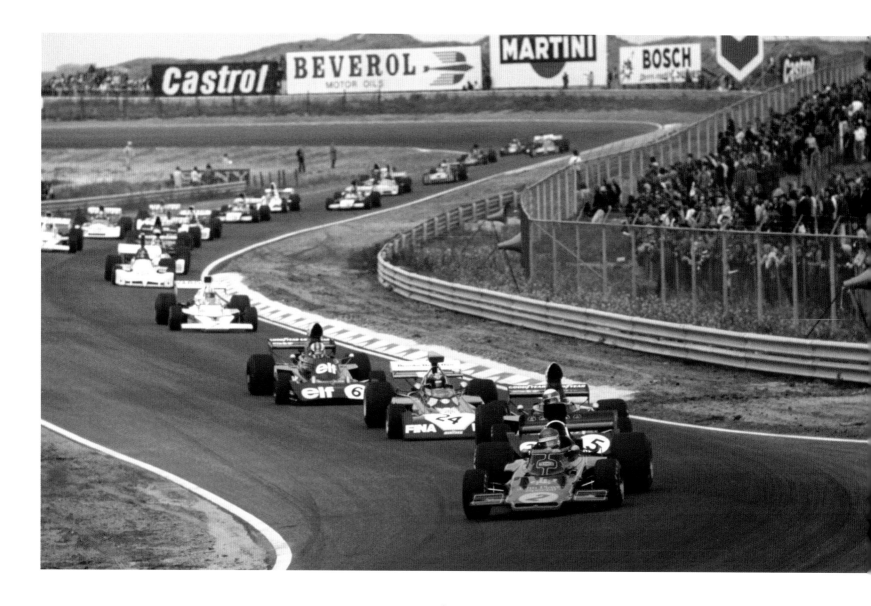

Above: Peterson's Lotus leads Stewart, Pace, Cevert, Hulme and Hunt during the opening lap of the tragic 1973 Dutch Grand Prix. Roger Williamson's ill-fated red March is near the back of the field.

Opposite page: James with his co-driver, journalist Robert Fearnall, after winning the 1973 Tour of Britain in a Chevrolet Camaro on a mix of race circuits and rally stages.

Driving a March similar to the Hesketh 731, the 25-year-old from Leicestershire suffered a suspected tyre failure coming through a fast right-hand curve leading on to Zandvoort's finish straight. The March hit the barrier, which bent backwards and formed a launch ramp that flicked the car upside down before it landed against the barrier on the opposite side of the track. There it caught fire.

The race continued – an unthinkable option today – and for several laps Hunt and his colleagues witnessed a desperate struggle by David Purley as the Englishman tried to rescue his mate. Purley was the only driver to have stopped. It was a scandalous episode, costing the life of a popular young hopeful in only his second Grand Prix. The entire affair would make its mark on F1 and have a profound effect on Hunt. Apart from mourning the loss of a driver he liked and respected, James could not help but think of his extremely lucky escape when trapped beneath his F3 car at the same circuit two years before. Others – particularly the winner, Jackie Stewart – recalled with despair the loss of Piers Courage at Zandvoort three years earlier, when his Frank Williams De Tomaso crashed and caught fire.

But James was back at Zandvoort just a couple of weeks later. He was taking part in a round of the European Touring Car Championship in an Alpina BMW CSL he would share with Australian Brian Muir. They finished the four-hour event in second place. This was part of an expanding programme that would also see Hunt venture into endurance racing, finishing second with Derek Bell in a Gulf Mirage in a nine-hour race at Kyalami.

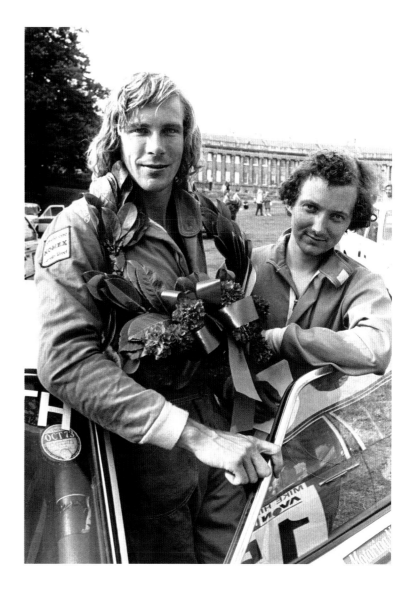

HIS FIRST PODIUM WOULD HAVE TO WAIT UNTIL THE DUTCH GRAND PRIX.

Such profitable and morale boosting diversions aside, the focus throughout was F1. After a dream start, the difficulties of racing at the top level would become evident in Austria, where a tyre deflated during practice at the Österreichring's very fast first corner. Hunt was extremely lucky to get away with no more than a damaged wing – it would be here that Mark Donohue, also driving a March, was to suffer a fatal accident for the same reason two years later. Harvey Postlethwaite was relieved that the March had also survived, as it had been tweaked in many directions, most notably with a totally new nose.

The problems would continue, however, with Hunt suffering from a down-on-power engine in qualifying, a broken metering unit then bringing retirement after four laps. It would be much worse in Italy two weeks later.

Hunt crashed again, this time because he made no allowance for fading brakes as he came into the Ascari chicane. The car was so badly damaged that the rest of the weekend was written off, Horsley preferring to get the car back to base in time for a rebuild prior to shipment to Canada. While Hunt understood the

logistics, he didn't follow Horsley's refusal to have a spare chassis, known to be available in the March factory, flown to Italy. The pair had a major row, Bubbles winning this one, much to his driver's disgust.

The rebuilding process was not limited to the car but also encompassed the trust between driver and team. James heeded instructions to avoid heroics in Canada by finishing a steady seventh at Mosport. Having done that, he made it clear he was going to try and finish the season on a high note at Watkins Glen.

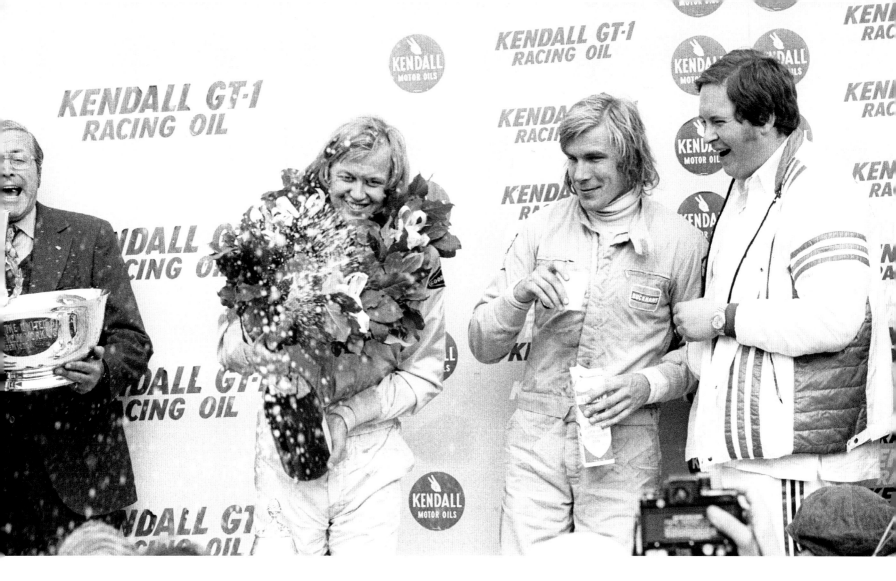

Much as he took an immediate liking to the road circuit in the beautiful Finger Lake district of New York State, James, along with the F1 community, was forced to pause and take stock when François Cevert was killed during practice. On the cusp of greatness and in line – although he didn't know it – to take over leadership of the Tyrrell team once Jackie Stewart revealed his plan to retire, Cevert lost control through the fast Esses at the top of the hill. The very popular and handsome Frenchman died instantly when the car smashed into the crash barrier and tore itself apart. Stewart withdrew

from what should have been his hundredth and final Grand Prix. For Hunt, this would be his seventh.

Putting the previous day's tragedy to the back of his mind, James was determined to make the most of his second-row grid position. He held third place at the end of the first lap, dispensed with the Brabham-Ford of Carlos Reutemann and set after Peterson. For the best part of an hour and a half, the black Lotus and the white March engaged in a superb contest, Hunt never putting a foot wrong as he sat in the more experienced man's shadow, willing

him to make a mistake and at one stage, actually pulling alongside. They crossed the line separated by 0.69 seconds. Peterson was full of praise for his adversary; the F1 fraternity was mightily impressed. James Hunt, at 26 years and 39 days, had finally come of age.

Above: James and Lord Hesketh join winner Ronnie Peterson on the podium at Watkins Glen.

Opposite page: Hunt prepares for the start of a foot race organised by Frank Williams at Monza. James collected £300 for finishing second – to Williams.

Hunt's preparations for 1974 were strengthened further by remarkable news arising from the wreckage of his bad weekend at Monza. Gathering himself to his full height, Lord Hesketh revealed expansion plans that were substantial in the extreme – rather like every aspect of the good lord himself.

Hesketh Racing would not only design their own car for 1974, but would also build an engine to power it. Had this been announced even a year earlier, Hesketh and his crew would have been laughed out of the paddock. But on the evidence of their four months' racing, the scheme was given due consideration and respect despite its undoubted ambition.

Hesketh reasoned that Hunt's now obvious potential would not be realised with a Grand Prix win if they continued with a customer car. He wanted Postlethwaite to design a Hesketh and already had a layout for an engine to be designed by Aubrey Woods and built by McNally Engineering, an independent company in Northumberland. The V12, in fact, would never race but the chassis, the Hesketh 308, most certainly would.

Not surprisingly with such a big plan, particularly in the hands of an inexperienced team, the new car was not ready for the opening races. Hunt instead relied on the March 731 in Argentina and Brazil – and to good effect. Surging through from the third row in Buenos Aires, Hunt picked up where he had left off in Watkins Glen, taking the fight to Peterson's pole-position Lotus. This time he got in front

– for half a lap. Sensing his rival might be overwhelmed by leading, Peterson feined a pass going into the hairpin, but with no intention of carrying out the move. Focusing on the image in his mirror rather than the braking point, Hunt ran off the road and picked up enough debris in the nose cone to warrant a visit to the pits – where a furious Horsley was waiting. Leaving his lecture until later, Bubbles supervised the clean-up and sent Hunt on his way, only for the March to retire a few laps later with predictable overheating.

James Hunt

I arrived at the hairpin in the lead and unexpectedly clutchless. Quite frankly, it freaked me into a mistake. I got confused and overshot the hairpin. There was no clutch, I looked down for a moment and off I went. It was a mistake of inexperience. I was over-excited at being in the lead – I had never led a Grand Prix before – and I was taken by surprise when the clutch went.

Chastened by Horsley's views on an opportunity lost unnecessarily, James was more circumspect in Brazil. In fact, he had little alternative, the March proving hard work on the twists and turns of the long Interlagos circuit as he came home one lap down on Emerson Fittipaldi's winning McLaren. Despite the effort involved, Hunt had not suffered physically in the way he would have done 12 months before. Now more aware of the pummelling his neck was taking, James had been training with Chelsea football club to address this potential weakness as well as to raise his overall fitness.

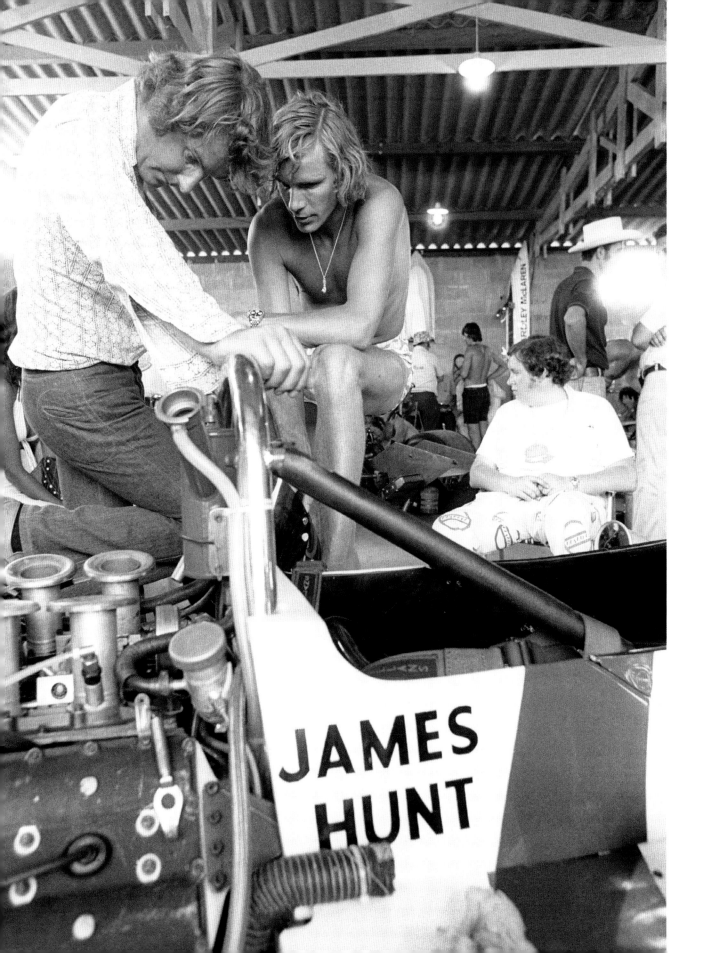

JAMES HUNT

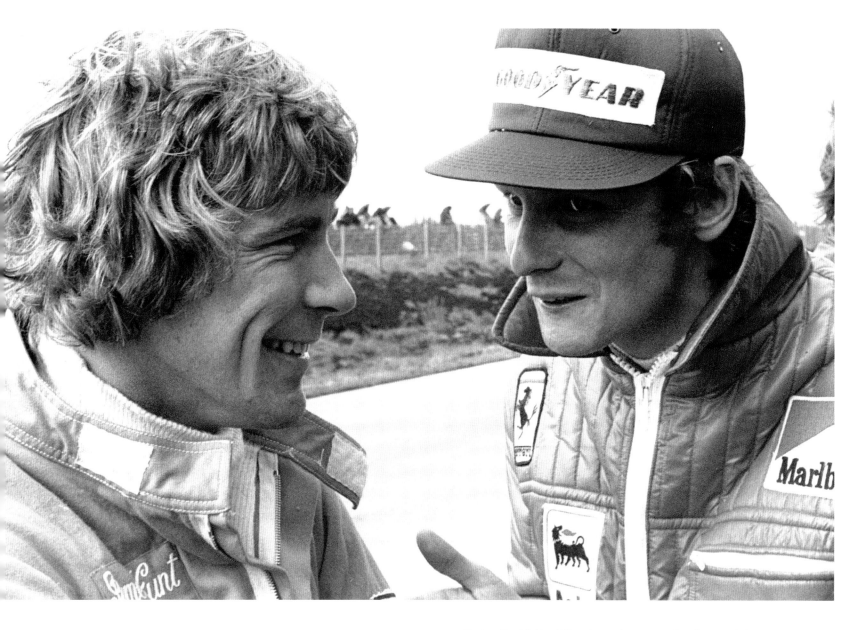

Hunt and Lauda's friendship and mutual respect continued to grow during 1974.

I carried my running kit with me wherever I went. In London, for instance, at seven in the evening or whenever, you'd see me padding out for my daily run, rain or shine. Even if I'd just done two good hard hours of squash or tennis, I always tried to follow up with a run. Maybe I didn't need it physically by then but I looked at it as being good for mental discipline. It can't hurt to do something that hurts.

I also think it's a matter of discipline not to drink around a race, I've got nothing against two or three beers or a glass of wine at dinner because I feel that it won't do any harm. Only a large quantity can because it tires you physically. But I feel that if you have rules then you ought to keep them, otherwise it shows a general weakening of the spirit. A racing driver needs to be in good physical condition but I don't feel he must go in for the frantic training of, say, an Olympic athlete. But because it's so important to have total concentration when racing, the right mental approach is so important.

When it came to a psychological advantage, Hesketh scored useful points by setting competitive times with the new car during a test session at Interlagos and, particularly, Paul Ricard, where James was not only fastest but also under the lap record.

The optimism and excitement that came with claiming pole position with the Hesketh 308 in its debut at the Race of Champions was swiftly washed away by a typical wet Sunday afternoon at Brands Hatch in March. The streaming conditions played into the hands of the Goodyear wet-weather tyre rather than the Firestones fitted to the Hesketh. James made contact with another car and retired – but not before Hesketh had earned more column inches.

HESKETH WAS A TEAM MADE UP OF RULE BREAKERS.
LORD HESKETH

IT WAS JUST A
SUPER DAY AND
IT WAS LOVELY TO
WIN IN ENGLAND.
JAMES HUNT

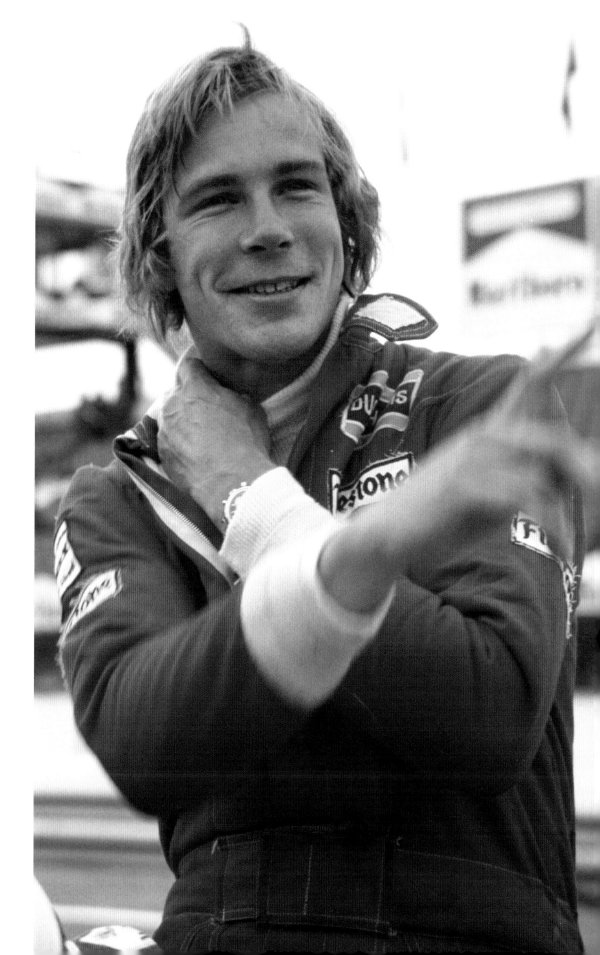

'The Hesketh team was beside itself when James Hunt put the new car on pole at Brands Hatch,' wrote Eoin Young. 'At the back of the paddock, Lord Hesketh was wrestling the cork from a bottle of Dom Perignon, which even life-long sippers of nothing more heady than draft mild can tell you is the very best bubbly you can buy. "It could have been most embarrassing if I'd been fastest on the first day when the prize was a hundred bottles of champagne, because it would have had to go in the dustbin," explained Hunt. "Alexander doesn't allow anything but Dom Perignon in the caravan."

'The caravan is a spanking new General Motors motorhome complete with self-levelling suspension (so necessary with paddock areas as steep as Brands) and the new team crest on the side, which looks like something from a toddler's book. I can't wait to see the noble lord stepping gingerly down from the motorhome in crested pyjamas last thing on the night before a race and leaving his order for the milkman. "One crate, Dom Perignon. No milk, thank you. A.H. (Lord)"'

The bubbly would be put on hold in South Africa where blissful weather would be the only good thing about a long trip that brought an early retirement with broken transmission. But it would be a sign of Hesketh's organisation – not to say determination – that steps were taken to rectify the problem with the car's CV joints with less than a week until the next outing – albeit an important one for the Northamptonshire team. A mere eight miles south of the workshops in the converted stables at Easton Neston, Silverstone hosted the *Daily Express* International Trophy. It may have been a non-championship race – as reflected in an entry of just 14 F1 cars bolstered by as many F5000 machines – but this would be a perfect workout for the team, both from a racing and social point of view.

The Bell JetRanger was in constant action on race day, shuttling back and forth from his lordship's estate, the passengers enthused by the news that their man was on pole position. The entry may have been comparatively sparse but that could not detract from a hugely impressive turn of speed from the Hesketh 308, evident from the moment practice began. No one, least of all the very quick Peterson, could get within a second of James. On paper, Hunt's first F1 win was on the cards.

Following page: A major moment at home for Hunt and Hesketh (holding the winner's cup) as James won the non-championship International Trophy at Silverstone in April 1974.

Within seconds of the start, James could literally feel that this might not happen. His left foot told him the clutch had gone and his right hand held a gear knob that was about to become separated from the gear lever. Somehow he managed to get the car moving, by which time 14 cars of various colours had swept past the stuttering white one. Once he had worked out how to change gear with what had become the stub and sensibly allowed the clutch to cool, Hunt put his head down and really started motoring. It was precisely the back-against-the-wall situation he relished in any game or sport. He had 40 laps to sort this out.

By the end of the 13th lap, he was second. Peterson was just over seven seconds up the road. As the gap closed inexorably, the 33,000 crowd sensed the moment that would come on lap 28. Tucked into the slipstream of the JPS Lotus and looking comfortable with it – Hunt chose one of the most spectacular points on the international racing calendar to make his bid. Powering into the long, lazy and extremely fast right at Woodcote, the Hesketh got alongside the Lotus, Peterson having left barely enough room and clearly not expecting an attack at this point. By diving for the inside line under such confined high-speed circumstances, James's trust in Ronnie was implicit. It was confirmed when the Swede did nothing unexpected or marginal, the pair of them keeping their right feet planted while dealing with cars bucking and sliding through the corner.

The sight of the jubilant grandstand overlooking Woodcote and the shrieking commentator left the Hesketh team in no doubt about what was happening just beyond their vision. Seconds later, it was confirmed as their man in the Hesketh 308 blasted past in the lead – and stayed there for the next 15 minutes or so, setting fastest lap on his way to a landmark win.

James Hunt *It was just a super day and it was lovely to win in England. The fun was in celebrating it – we were all staying at Hesketh's house and he had a lot of friends there as well as his family – but we were not really flattered in any way. We had no illusions. We knew it was not going to be like that in the Grands Prix and when it turned out not to be, we didn't get disappointed. We knew the moment we crossed the line it wasn't a Grand Prix, so we sat back and enjoyed it for what it was – our first win and a very popular one with the crowd and therefore something to celebrate. It was a great day.*

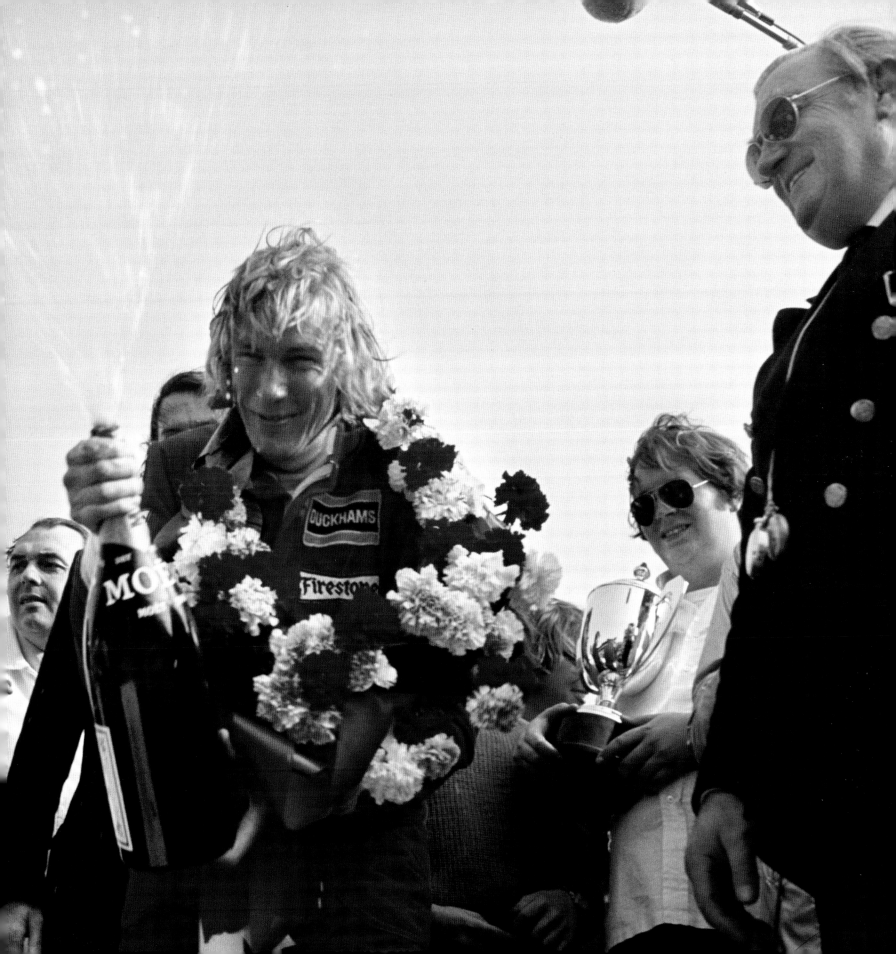

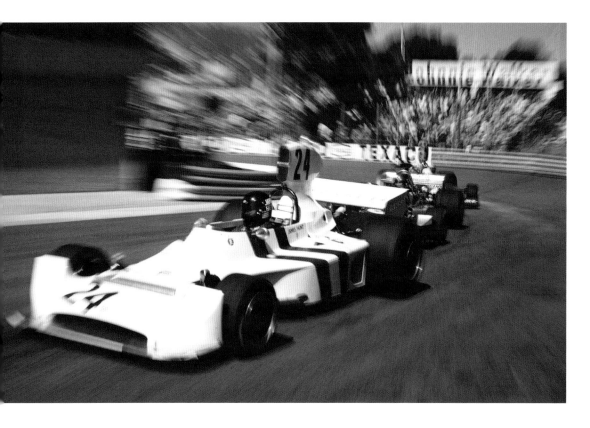

Above: Hesketh's first season with the 308 in 1974 was a difficult one with more retirements than finishes. At Monaco, Hunt stopped with driveshaft failure when running in sixth place.

Opposite page: Hunt had to wait patiently for the Hesketh 308 to become reliable and reasonably competitive in 1974.

It was good Hunt and Hesketh had no illusions about the status of this non-championship race, for it was indeed back to earth with a bump when the Grand Prix season resumed. In the next 12 races, Hunt would retire seven times, three of them due to collisions. The most spectacular occurred at the start of the French Grand Prix at Dijon. Tom Pryce, third on the grid for only his third Grand Prix, made a slow getaway and, in the ensuing confusion, the Shadow was struck from behind, sending it into the hapless Hunt. A furious James spent some time shaking his fist at Emerson Fittipaldi, who Hunt believed had instigated the chaos.

Fittipaldi would go on to take the championship at the final race in the USA, when fourth place at Watkins Glen gave the McLaren-Ford driver enough points over Clay Regazzoni. Hunt finished third that day at the end of his best race of the season, having held second place for much of the way until fading brakes (one of the many technical problems to have wrecked Hesketh's season) dropped him into the clutches of Carlos Pace's Brabham-Ford.

Apart from the brief half-lap with the March in Argentina, Hunt had not led a race, his position of eighth in the drivers' championship being indicative of the season as a whole. Hesketh were sixth (out of 12) in the Constructors' Championship: a reasonable effort in their maiden season but nowhere near good enough for a team whose ambition continued to be masked by what some observers wrongly believed to be a frivolous approach.

Lord Hesketh

Hesketh was a team made up of rule breakers. We had managed to break many of the unwritten rules; that you could never come into Formula 1 unless you had a completely professional team. You can't come in with no sponsors and only a rich young man who knows knowing about it, with a driver who has a reputation for crashing cars and with a team manager who's an ex-used-car dealer. For me, Bubbles was the man who made Hesketh Racing what it is. He was the guy who revved James up; he was the guy who stopped the Doctor from falling asleep, as he was prone to do, thinking about wings and ride heights and things.

We had a tremendous esprit de corps that didn't exist in other teams. We continued to be filled with childish enthusiasm. One of the essential ingredients of our team was to keep it funny.

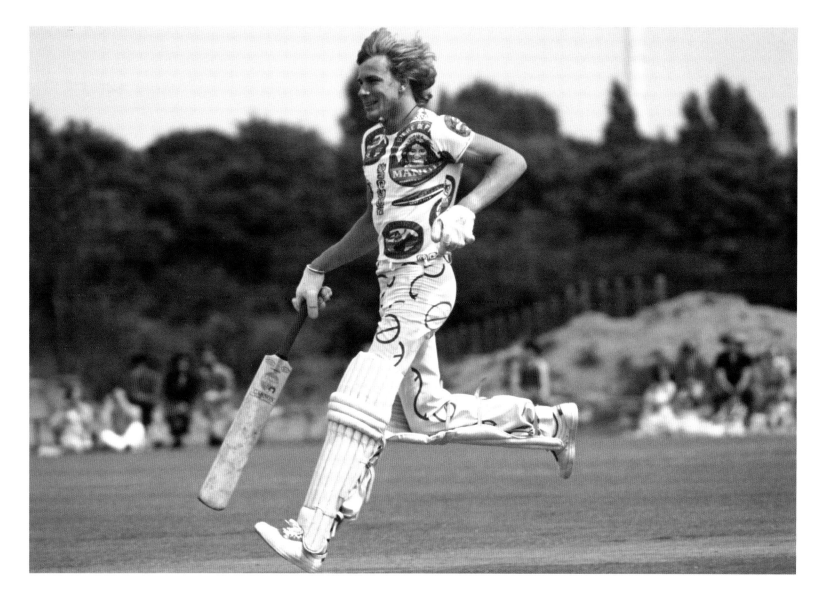

As flamboyant as ever on and off the track, James takes part in a charity cricket match on the weekend of the British Grand Prix. Hunt gets sideways on the sloping grid at Brands Hatch (right). His home race would be short-lived, the Hesketh breaking its rear suspension after two laps.

WE CONTINUED TO BE FILLED WITH CHILDISH ENTHUSIASM. ONE OF THE ESSENTIAL INGREDIENTS OF OUR TEAM WAS TO KEEP IT FUNNY.
LORD HESKETH

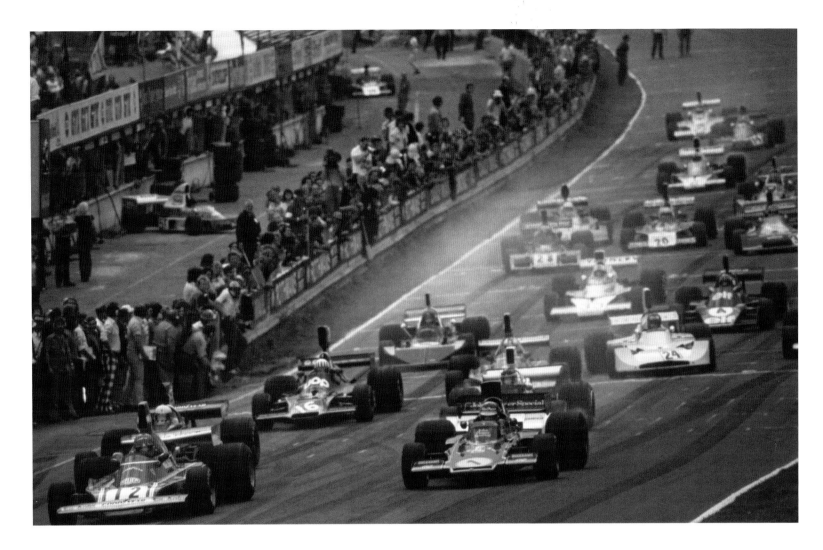

Part of the plan included a typically impromptu idea when Lord Hesketh spotted a postcard depicting a teddy bear. He picked up a pen and added a crash helmet with a Union Flag and then, with apologies to Superman, declared that this should be Super Bear, the team's emblem. In April, residents in the smart north-west London suburb of Swiss Cottage were puzzled to find a massive roadside hoarding in red, white and blue with the message 'Hesketh Racing – the biggest little racing team in the world' on one side of an image of the bear and on the other side, 'Racing for Britain and racing for you'.

At the same time, James was making a move out of Great Britain – thanks to the Inland Revenue and International Management Group (IMG). The company, founded by Mark McCormack, ran Hunt's

affairs and had advised him of the tax savings to be made if he moved out of the country. James chose Spain.

While the location could not be faulted for climatic or financial reasons, it quickly became a lonely existence for a man accustomed to the warmth and immediacy of friends and family circle. It was also apparent that a female companion – as opposed to the one-night stands which were fun and taken no more seriously than a jolly evening in the pub – would contribute to Hunt's need to form a strong foundation for his hectic and occasionally stressful life as a professional sportsman. The answer to his needs appeared one night as a vision of loveliness in a tennis club on the Costa del Sol.

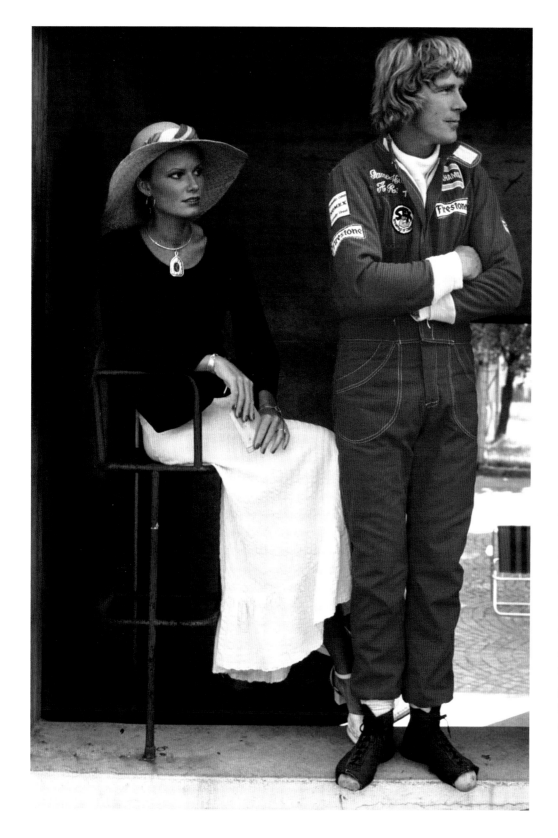

Suzy Miller was lithe and beautiful but wasn't attention-seeking despite being a very successful model. Being in a similar predicament, having just moved to Spain, Suzy and James may have had much in common but Suzy had the added attraction of her own flat on the coast. It soon became evident that Suzy did not share her new boyfriend's customary casual approach to this more formal arrangement, when James was thrown out of the apartment. When this happened more than once, Hunt figured a proposal of marriage would be efficacious. Suzy accepted, the engagement was announced in July with the wedding date set for October.

As the months rushed by, filled with racing, James began to have serious doubts about the commitment to 'until death do us part'. A man of huge determination and character, he nevertheless proved surprisingly weak when it came to calling off a ceremony that seemed to have an impetus all of its own. Lord Hesketh had funded a grand ceremony in the equally impressive Brompton Oratory church. For a couple of days before the wedding, Hunt went on a serious binge that had nothing to do with the traditional prenuptial celebrations. But it didn't make the wedding go away. By his own admission, James would remember little of a ceremony enacted before the good and the great of motor sport and London society. In the sober light of day, his answer would be to focus on winning races in 1975.

Above: Hesketh's decision to build their own car around James was seen as a bold step by such a small team.

Opposite page: James and Suzy continued to appear in the social columns throughout 1974.

6. 1975: BRILLIANT BUT BROKE

ALL I COULD DO WAS GET ON WITH MY OWN RACE AND DRIVE AS FAST AS I COULD. THERE WAS NO POINT IN WORRYING ABOUT NIKI BECAUSE WHAT WAS GOING TO HAPPEN, WOULD HAPPEN.
JAMES HUNT

The insular business of F1 continued in its bubble throughout 1974 but Lord Hesketh was aware of the hard world of finance beyond the paddock gates. A severe stock market downturn reached its nadir late in the year. It may not have been as devastating as the 2008 crisis that shook the world but it was serious enough to prompt his lordship to examine the accounts of his racing team. Hesketh Racing wanted the necessary budget to move forward and conquer the world as planned.

The forecast was so bad that it was necessary to do the unthinkable and consider finding a sponsor, to say nothing of getting rid of the helicopter and both yachts rented out as a base for the Monaco Grand Prix. Above all, the build quality and competitiveness of the revised Hesketh 308 was not to suffer through unreliability. And the driver must not make any mistakes. Yet there would be evidence of both in the opening races of 1975.

At the start of the season, Hunt appeared to have fulfilled his part of the bargain by arriving in Argentina fit and tanned after rigorous training in and around his rented villa high in the hills above Fuengirola. 'Doc' Postlethwaite appeared to be on the ball, providing two chassis, one running modified suspension as a means of comparison with the older car. Hunt used the new version to qualify sixth fastest and, remembering his short-lived tenure at the front 12 months before, played a patient game, gradually moving forward in the race to challenge Carlos Reutemann's leading Brabham.

Opposite page: Jody Scheckter would win his home Grand Prix in South Africa but otherwise have a disappointing season with Tyrrell in 1975, finishing 13 points behind Hunt.

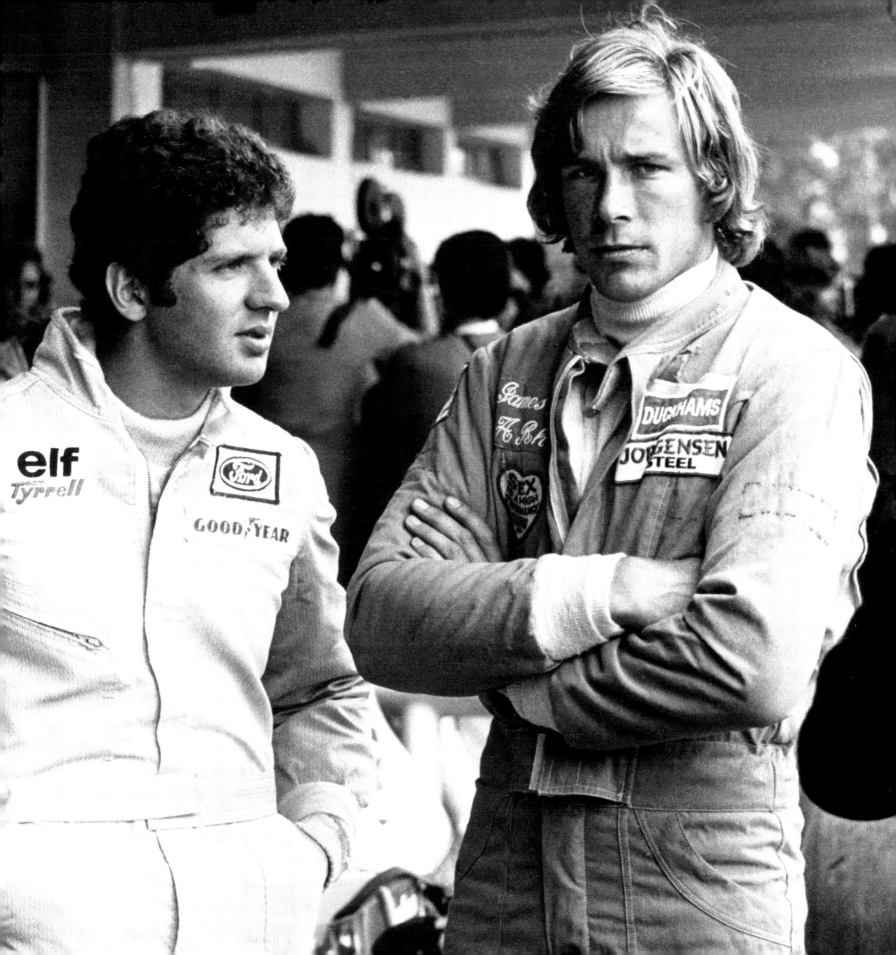

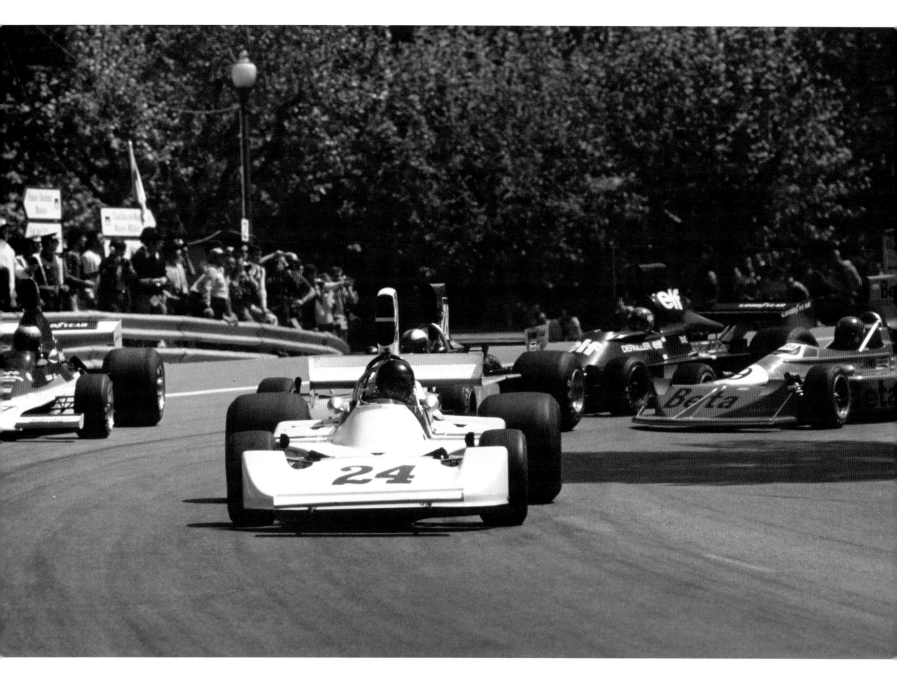

James leads the field out of the hairpin on the first lap of the Spanish Grand Prix at the fearsome Montjuïc Park. Mario Andretti (Parnelli 27), John Watson (Surtees), Vittorio Brambilla (March 9) and the blue Tyrrell of Patrick Depailler follow. Hunt would spin off before the race was stopped when a car cleared the crash barrier and killed four people.

The home hero made a mistake and the Hesketh took the lead, Hunt determined to stay up front in the Grand Prix, driving within his comfort zone despite the track breaking up in places. What James did not account for was the revised steering lock that came with the modified front suspension. He soon realised the difference when he failed to catch a slide. As the Hesketh ran wide, the waiting Emerson Fittipaldi gratefully accepted a lead he would hold for the remaining 18 laps. There was nothing a livid Hunt could do about it. He knew that he wasn't going to be congratulated for a podium, but was in line for a speech from his team manager, Bubbles, advising James of the shortcomings that had led to the loss of an almost certain first win.

James Hunt *I simply failed to cope with the pressure – but you learn. Things like that are good background; the experience is a good basis for not doing it again and you become very conscious of it.*

The sense that a vital opportunity had been lost would grow as the season progressed, sixth at the next race in Brazil being the only finish. Car number 24 went on to record five consecutive retirements due to a mix of driver error and mechanical problems. None of this was doing anything to assist his lordship's rapidly diminishing bank account. The team knew a win was possible, but not at this rate.

A serious get-together at Easton Neston fostered a fresh feeling of unity and an understanding of the need to get the job done. That sense of purpose grew when James qualified third for the next race at Zandvoort. But the thought of actually winning was moderated by Ferrari's Niki Lauda being fastest in the final three of the four practice sessions. He was clearly on for a repeat of his easy win in the Dutch Grand Prix 12 months before. Then the wind literally blew in the opposite direction.

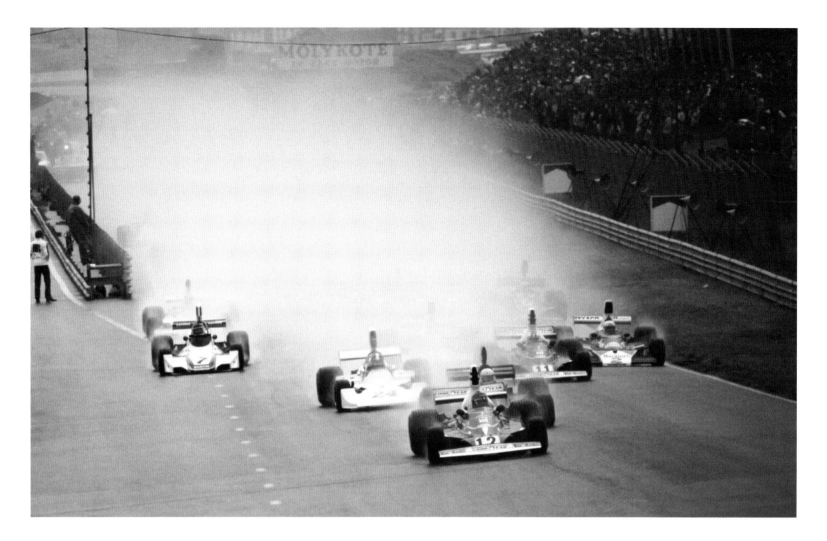

A stiff northerly breeze on race day brought rain, followed by much dithering as a lull made dry-weather tyres a possibility. But when the grid was at last covered by a light sprinkling, wets were the unanimous choice among the 24 starters, led by the Ferraris of Lauda and Regazzoni on the front row with Scheckter's Tyrrell-Ford sharing the second with Hunt.

Lauda made a perfect getaway, with Hunt fourth behind Scheckter and a slow-starting Regazzoni. Rooster-tails of spray emphasised that grooved tyres were indeed the only option. But not for long. The rain stopped as quickly as it had started and the stiff breeze produced a drying racing line in short order. Hunt was fully focused on checking out the changing grip rather than thinking about making a move on Regazzoni. Working on the adage that it's often better to make the change sooner rather than later, he and Jochen Mass were the first to head for the pits at the end of the seventh lap. Hunt rejoined in 20th place, buried among the back markers.

James Hunt

It was a tricky decision to make because, although the racing line may have been dry enough for slicks, you have only two very narrow dry strips in which to run and if you go only a few inches off line, you're on wet.

Hunt's move triggered a chain reaction throughout the field over the next few laps. Critically – and giving an indication of just how slippery the track remained – Lauda stayed out for another six laps. As the Ferrari headed for the pit exit, Hunt steamed by at top speed – and into the lead. At the end of the next lap, he was 10 seconds ahead. The question was, could he hang on in the face of the inevitable attack? There were 60 laps remaining.

Lauda leads the field into Tarzan at the start of the Dutch Grand Prix. Hunt shares his moment of victory with Lauda (left) and Regazzoni.

Hunt was mobbed by spectators, many of them British – having made the hop across the channel to Zandvoort.

The key would be how the cars were set up for the latest conditions. Ferrari had gone for a compromise between wet and dry whereas Hesketh had gambled on completely dry settings. The race was now going their way while, at the same time, Ferrari's inherent speed advantage had been lost. But Hunt knew that would not prevent the wily Lauda, a four-time GP winner, from trying to exploit the pressure Hunt would feel, unaccustomed to running at the front. First, though, Lauda had to fight his way past the Shadow of Jean-Pierre Jarier. It would be another 30 laps before the red car was ahead of the black one.

For several laps, Hunt maintained a lead of around six seconds. But then, inexorably, the gap began to close with 20 laps to go. The pressure was on.

James Hunt *All I could do was get on with my own race and drive as fast as I could. There was no point in worrying about Niki because what was going to happen, would happen. If he caught me up, he caught me up. There was nothing I could do to stop that, except to drive as fast as I could and delay it as long as possible, then if his car was faster than mine on the straight and he got by it would have been my tough luck.*

But the Ferrari wasn't quicker where it really mattered. Despite the Ferrari filling his mirrors, Hunt stayed calm, particularly when dealing with back markers as the Hesketh gave first warning of the leaders' arrival and, in the process, helped smooth the path for Lauda. Despite memories of Argentina – or, perhaps because of them – Hunt remained totally focused and unflurried. He did not put a wheel out of place; did not allow Lauda the break he needed. As the Hesketh powered down the long straight for the 75th time, James raised his right arm rigidly as the flag came down. The Hesketh pit went wild.

As he completed his slowing-down lap, Hunt was greeted by the unmistakable sight of Le Patron running towards him on the track. His joy was unconfined; a first for his team and Superstar. Pete Lyons, describing the scene for *Autosport*, summed it up as the victorious team set off on a victory lap: 'His lordship, Alexander, virtue triumphant incarnate, almost floated on the back of the flower-garlanded lorry,' he wrote. 'His face shining with effervescent ecstasy, he rode backwards along the entire row of pits saluting his rival Formula 1 teams with a particularly English digital gesture. In front, facing the right way and waving in a more sober manner, but his face similarly incandescent, James Hunt set off on his 76th lap of the Dutch Grand Prix – his first Grand Prix victory. It had been a long, long time coming. But every line of his face proclaimed what a worthwhile wait it had been.'

Hunt gave Lauda a tough time during the French Grand Prix.

Despite the team owner's exuberant victory salute, this result was well received in the pit lane, as is always the case with a maiden win.

It was also a break from the norm, three-quarters of the way through a fairly predictable season. More than that, the vast majority within the F1 world was delighted for a team that had proved they were very serious while having fun. It seemed James Hunt and Hesketh Racing were finally on their way.

A very strong second place for Hunt, inches behind Lauda at the end of the next race in France, disguised the fact that Hesketh had to ask for the Dutch prize money in cash to pay his mechanics and make sure the team could afford to make it to Paul Ricard. A more substantial diversion from the hidden truth would be rolled out just before the British Grand Prix when Hesketh unveiled a radical car, the 308C, in the stable yard at Easton Neston. To all intents and purposes, Hesketh and his entourage were set fair

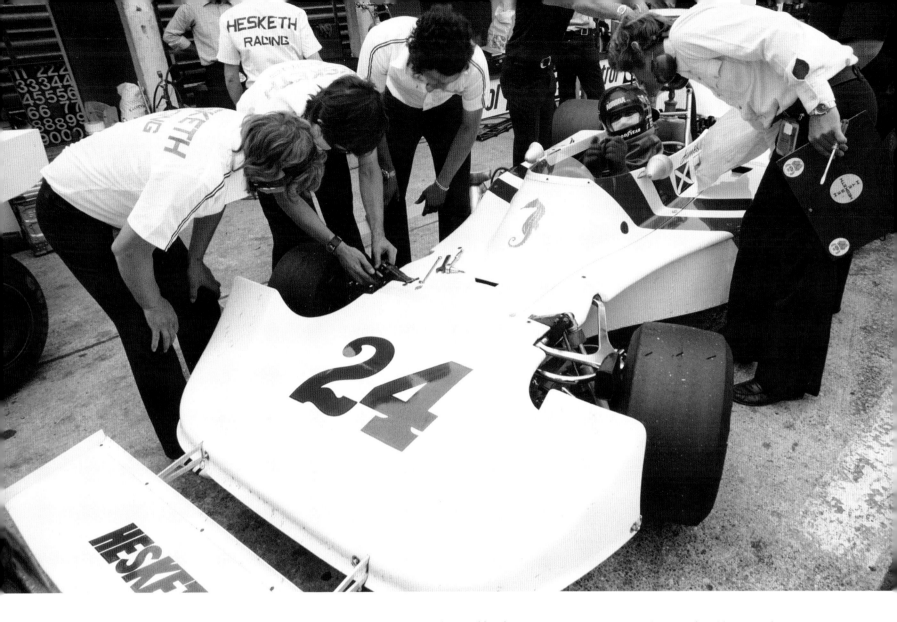

to consolidate on having become a member of that elite club of Grand Prix winners by having lavished £100,000 (approximately £800,000 in today's prices) on the new car.

There would be a more appropriate if unrecognised signal when James, having led briefly, spun off with other drivers when caught out by a sudden heavy shower at one end of the Silverstone track – rain also intervened and cost a possible victory in Austria in mid-August. By this time,

rumours had been triggered by the entry of a second car for new Hesketh driver Brett Lunger. Lord Hesketh sidestepped questions about the need for the American driver's financial input, plus income derived from letting out a car for a private entrant to run for Alan Jones.

Harvey Postlethwaite confers with James at the Nürburgring as the Hesketh 308 continued to be the favoured race car.

Above: The unveiling of the Hesketh 308C at Easton Neston in July 1975 masked financial worries for Lord Hesketh.

Opposite page: The Hesketh 308C made an encouraging debut at Monza.

But Hesketh recognised the uncomfortable truth when the quiet search for a sponsor proved difficult, despite a strong debut for the 308C in Italy, where Hunt finished fifth after recovering from a spin induced by handling problems. When he finished fourth at the final race of the season at Watkins Glen, James had also come to realise that this might be the last Grand Prix for Hesketh – and possibly himself.

Despite being fully aware of the difficulties – and contributing his prize money from France to the coffers – Hunt had not instigated a Plan B by speaking to rivals before the best seats for 1976 were taken. With his bank statement showing red rather than black,

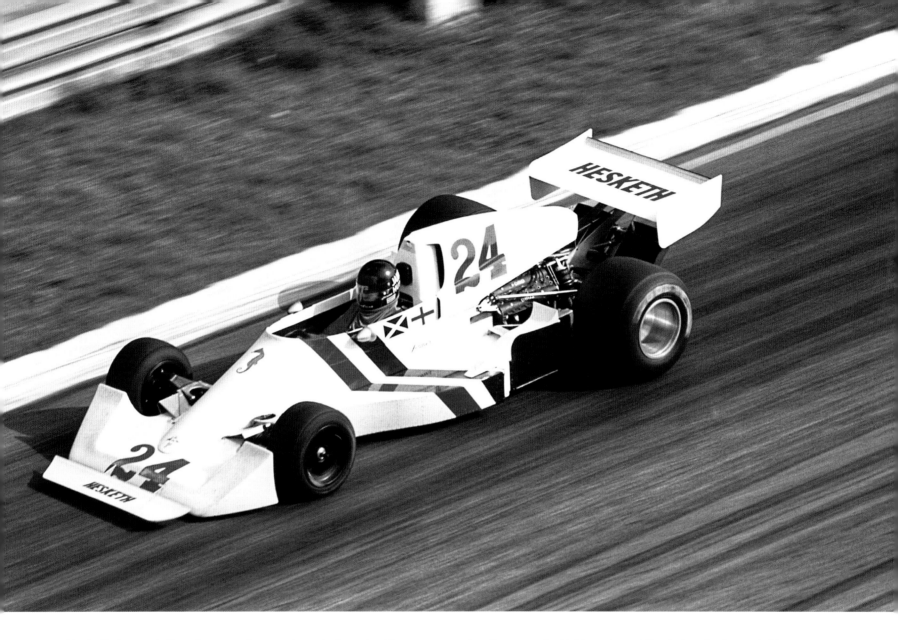

Hesketh dropped all pretence and came clean during a hastily convened press conference in London's Carlton Towers Hotel on Monday 10 November. It was revealed that £300,000 would be necessary to have the team continue into 1976. If a saviour was not forthcoming by the following Friday evening, the F1 team would be at an end. On the Saturday, interviewed by BBC television, Lord Hesketh confirmed the closure of his beloved team.

The following day, Sunday 16 November, the white Hesketh truck made its last journey to the Thruxton circuit in Hampshire for a farewell appearance during a race meeting for Formula 3 cars – which happened to be televised. But this last throw of the dice,

despite one potential investor getting in touch after watching on TV, would not produce the desperately needed double-six. As Hunt completed one lonely lap, the Ford-DFV on full noise rang across the flat airfield. It was a thrilling sound and a valedictory note at one and the same time. When the car stopped on the grid and the engine was switched off, a brief but hugely colourful era had ended. But James Hunt had absolutely no idea where or when the next one might begin.

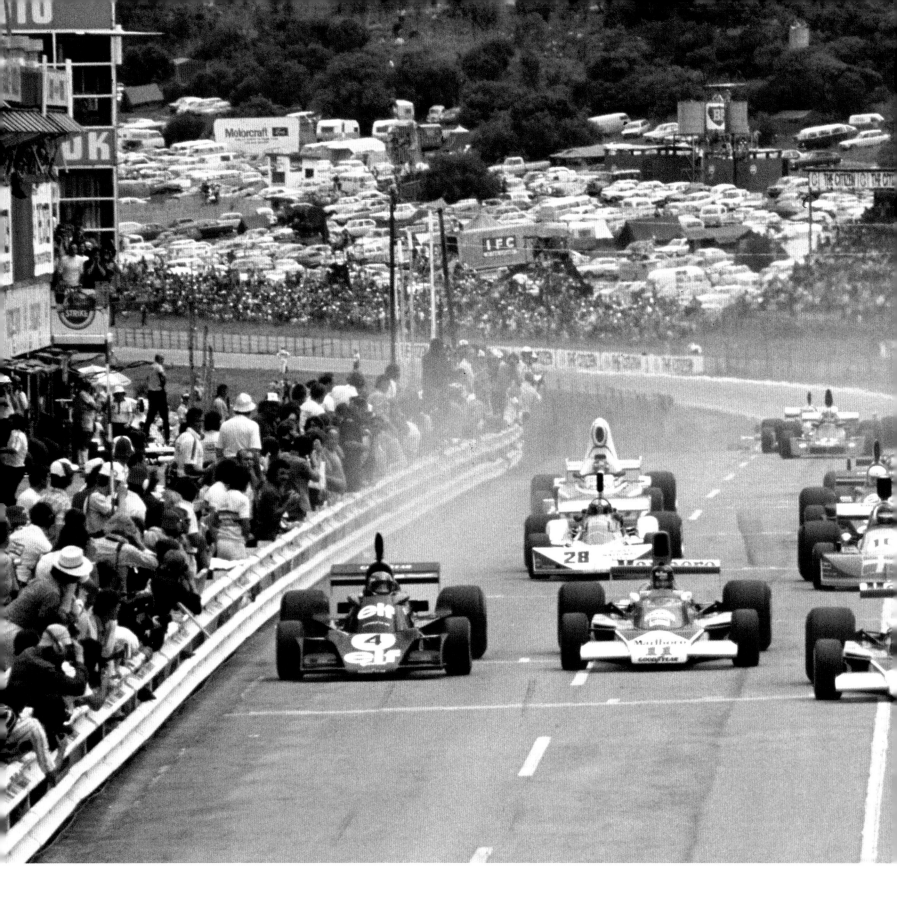

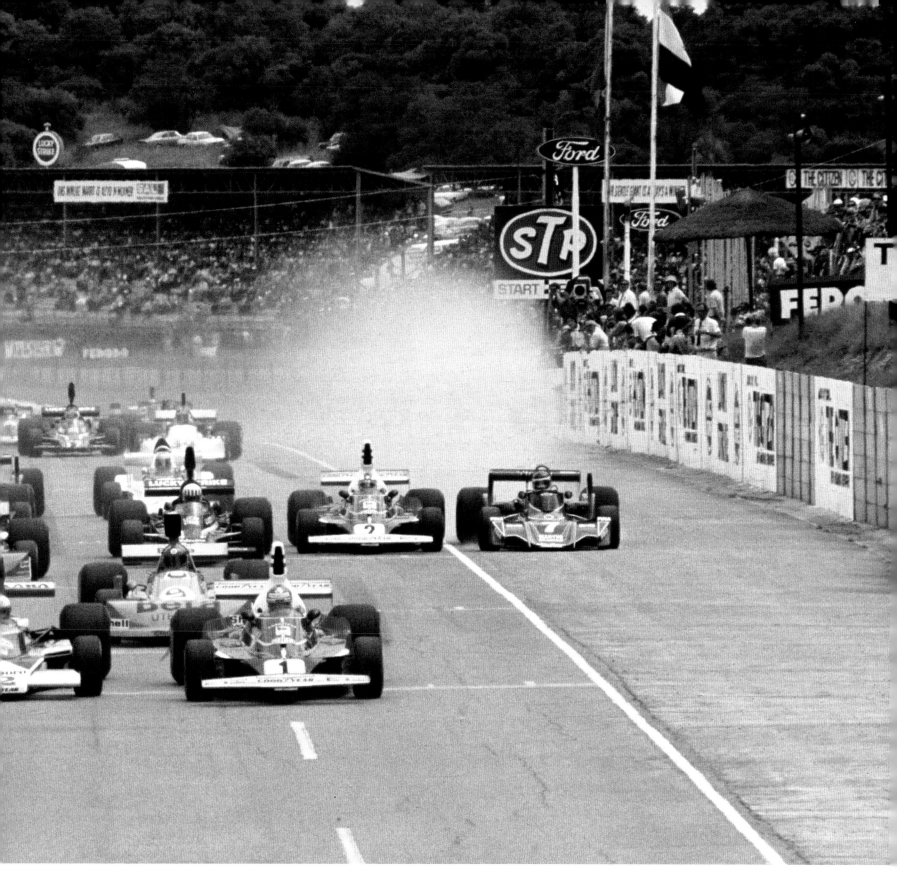

Once a seat at McLaren had become available for 1976, Marlboro would help ensure it was filled by Hunt.

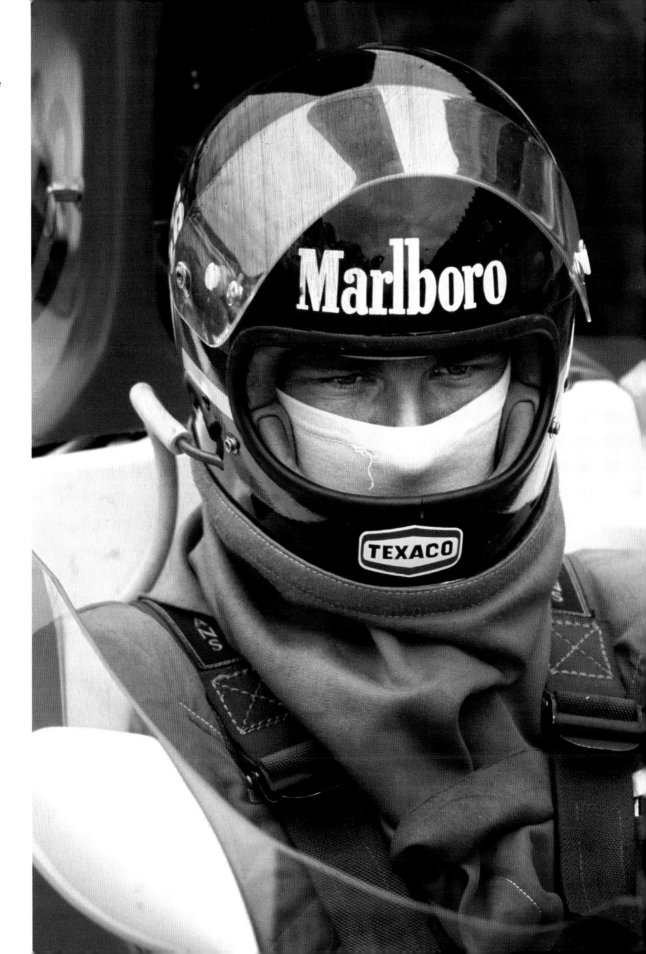

December is usually a time to relax and celebrate at the end of a long season. On the first Thursday and Friday of that month in 1975, Formula 1 did indeed pause and reflect – but for desperately sad reasons. The world of motor sport, and a wider audience beyond it, had been stunned by the death of Graham Hill and his young protégé, Tony Brise. Four other members of Hill's team perished with them when their light aircraft came down while attempting to land in fog at the end of a flight from Paul Ricard.

The test session in France had gone particularly well. The future looked bright for Brise as he prepared for his first full season under the mentorship of Hill, the double world champion having retired with full honours during that year. It had seemed a perfect partnership for many reasons; a reason for optimism as a long and sometimes difficult season drew to a close.

That summer, American Mark Donohue had died of a brain haemorrhage after crashing on the morning of the Austrian Grand Prix. Four months earlier, five onlookers had been killed when a car left the road during the Spanish Grand Prix. Motor racing was by no means immune from tragedy. But having six people involved on this November evening, when personal defences were lowered with the end of the season, served to exacerbate the profound shock.

As motor sport folk gathered on the Friday for Brise's funeral in Kent and at St Albans for Hill's service the following day, talk would have touched on the latest gossip, as it inevitably does while searching for something positive and reasonably cheerful.

Had social media existed, James Hunt would have been trending. Speculation over his future continued with Lotus and McLaren being seen as his most likely home. News of Emerson Fittipaldi's sudden departure from McLaren to join his brother's Brazilian F1 team had broken at the end of the previous week. Only a handful inside St Albans Abbey, however, knew the true facts.

Within hours of receiving the resignation phone call from Fittipaldi, a stunned Teddy Mayer had gathered his thoughts and prepared a short list that had just one name: J. Hunt. James was already one step ahead of even Mayer himself.

James Hunt *I knew before McLaren. As one colleague to another, Emerson told me before he told them. Domingos Piedade* [Fittipaldi's business manager] *called from Geneva – Emerson was in Brazil – on a Thursday afternoon and the story broke on Saturday morning. He simply told me that Emerson would not be signing, not what he was going to do; just that he was leaving McLaren. That was a fine gesture by Emerson and Domingos; from a business point of view it gave me warning, time to get myself ready because at that point it was obvious that McLaren would need me.*

A call from Mayer to James's friend John Hogan of McLaren sponsors Marlboro set in motion wheels that were only ever going to travel in one direction. Both sides needed each other. And quickly.

John Hogan

I get a phone call from Teddy on a Saturday night. I was a bit hesitant about James because he was always going to be a hard sell to Philip Morris for obvious reasons. Phillip, at that point, were very strait-laced. I knew Jacky Ickx was the one driver they would all buy – but I also knew he wasn't available. Pat Duffler, one of the management team at Philip Morris, was a good friend of Ickx – but he was also my boss and I knew I would have to duck and dive around that one. Once Duffler got to know James – it was a five-minute conversation – Duffler was totally sold. Some of the Italians in the company weren't too overwhelmed because they were Regazzoni fans. In a way, we were stuck with James. I'm reciting to James what he has to do, what he doesn't have to do. And he says he can't do any of that shit; he's not wearing a blazer or anything like that. 'I am what I am'. So I said to the lawyers to leave that paragraph out and just get going with the contract. Basically, we took a chance.

A deal was concluded within 36 hours, even though the formal announcement would not be made until three weeks later, on Wednesday 10 December.

Motor sport magazines carried a photograph of James in the cockpit of a McLaren M23 with Mayer sitting on one broad sidepod and crew chief Alastair Caldwell perched on the other. The car carried the colours and insignia of Marlboro, but not of Texaco, the deal with the fuel and oil company yet to be completed. On the nose was the no. 11 formerly carried by Niki Lauda's Ferrari. The two teams had swapped and Lauda, the new world champion, inherited the no. 1 given to Fittipaldi as reigning champion in 1975.

Such cosmetic details were of little interest to James as he tried and failed to feel comfortable in the car. The smile for the camera was through gritted teeth as Hunt realised a cockpit designed for Fittipaldi, 11 centimetres shorter, was impinging on his knees and elbows. He could barely sit in the car, never mind think about driving it quickly.

A brief test session in the wet at Silverstone did little to ease his concern. With the season just six weeks away, there was no chance of building a chassis to suit. Not only did F1 teams tend to keep a winning car and develop it rather than design a new one for the

coming year, but the M23 was actually entering its fourth season. After moving from a small, independent team, this was not how James had imagined McLaren.

For their part, McLaren had obviously noted their new employee's largely positive performances in the Hesketh but were unsure of how much baggage, if any, came with a driver who clearly played hard. But how hard would he work? And at the end of the day, was he good enough to win consistently for a team that had not been outside the top three in the Constructors' Championship for the previous three seasons?

Alastair Caldwell

The first test at Silverstone was not in ideal conditions but at least James got to drive the car. We realised he was too long in the leg; he had a short body and very long legs. We would have to move the front bulkhead and pedals forward to accommodate him and, to be honest, we really couldn't tell at that point how good he might be.

Simply making such a change to the layout of an existing car for the following season would be unheard of today. The McLaren M23, for instance, had evolved largely through words rather than numbers. There were no engineers or analysts specialising in the myriad details that contribute to the F1 car of today. There was chief designer Gordon Coppuck, his slide rule, drawing board and an open mind and office door ready to receive input from the rest of the factory – no more than a dozen or so mechanics, machinists and fabricators. Computers were in their infancy. Brainpower, experience and gut instinct provided the answers – such as they were.

Coppuck, a soft-spoken Englishman, had a reputation that made a noise through McLaren's success with Can-Am sportscars and Indycars in North America in the early 1970s. He would use much of the experience gained developing a wedge-shaped Indycar, the M16, to scheme out the M23.

Denny Hulme and Peter Revson won races with the M23 during its debut season in 1973, Fittipaldi arriving in 1974 to give McLaren their first world championship and finish runner-up to Lauda the following year – all with refined versions of the M23. The trend would continue into 1976.

Bubbles Horsley (centre) tells Teddy Mayer a few home truths about his time with James. Their troubles at Hesketh would be nothing compared to those about to land on McLaren during 1976.

WHEN WE GOT TO BRAZIL, IT WAS ALL WRONG.
JAMES HUNT

Hunt rolled up his sleeves in Brazil and impressed everyone with pole position.

Gordon Coppuck *The car had remained pretty much unchanged because we knew we had more downforce than the other teams, mainly because we were using a full-size wind tunnel. The major change for 1976 was a six-speed gearbox, which Alistair Caldwell had started working on in the winter of 1974–75 and had fully developed for 1976. The advantage of this was that the engine could be kept in the most effective rev band, within about 2000 rpm. The Ford-Cosworth DFV [V8] could match the Ferrari [flat-12] engine on the straights, but not in all-round torque and our objective with the six-speed box was to make the most of the useful engine speed range.*

Despite his concern over comfort in the car, Hunt had every reason to smile as his career, seemingly on the rocks, had been refloated on a high tide of optimism. James's mood was summed up by Eoin Young in his weekly column for *Autocar*, after attending one of the many motor sport social gatherings spread throughout December. 'James Hunt made a rather eloquent little speech,' he wrote. 'Talking about motor racing and the reason why people become deeply involved in what is, after all, a rather fringe occupation divorced from the mainstream of conventional business and sport, he said, "A lot of people in racing could earn more money doing less work elsewhere – but they do it because they love racing. What they forget, however, is to smile now and again and look as though they're enjoying it."'

Apart from reflecting financial and fundamental circumstances that would swing through 180 degrees as earnings rocketed in subsequent decades, Hunt's cheerful outlook formed with Hesketh would be put to the test as soon as he went racing with McLaren at Interlagos in Brazil.

It could hardly have been a more unsuitable venue for a driver in an ill-fitting car. Interlagos, in its original form, twisted and turned for 4.9 miles. Not only did it also rise and fall, the surface was extremely bumpy in places, a translation of *interlagos* – 'between lakes' – giving a clue to the cause. Hunt had to make himself reasonably comfortable before he could begin to think about attacking this track and setting up the car to suit. Tension inside the team quickly mounted, particularly when Hunt discovered within a couple of laps that a seat-fitting at the McLaren factory in Colnbrook had been a complete waste of time.

James Hunt *The big problem is that when you sit in a car in the workshop, you can get everything roughly right, but there's no way you can get it exactly right until you reach the race track. When we got to Brazil, it was all wrong. It didn't fit me, the steering was too heavy and I didn't like it, so the first day of practice was spent getting that car right for me to drive and we did nothing at all towards getting the car set up and sorted out for the circuit.*

Hunt's feet may have been too big for the footwell but he used the airing of his grievances to step on the team's sensibilities by declaring that McLaren was 'a rudderless ship and did not have any direction'.

If nothing else, Hunt's frustration came as a knock-on effect of moving from Hesketh, a team focused solely on James, to a larger outfit dividing their attention equally between Hunt and his team mate Jochen Mass. All of that made the cutting observation risky since James was the new boy and Mass an established member, Brazil being the German driver's 17th race with the team. If he was not careful, Hunt could swing McLaren's impetus towards Mass before either driver had turned a wheel in anger.

Even that was proving difficult to do in James's case, Mass ending the first day's practice 0.2 seconds faster. Hunt suffered the additional frustration of having his engine fail not long before final qualifying. As Hunt waited for the engine change to be completed, he had a row over how the car should be set up, Mayer disagreeing but eventually relenting to James's wishes which, by and large, were based purely on a hunch.

With 20 minutes remaining, Hunt took to the track knowing that its exceptional length would militate against a high number of laps. Now the chips were really down. The team had done the best they could by lightening the steering and enlarging the cockpit surround. It was up to James to cast aside all hardships and simply drive the wheels off the thing. Which he duly did. And won the first pole position of his F1 career. The mechanics and management were stunned and impressed in equal measure – although only the former reaction applied to Mass, over a second slower in sixth place.

Alastair Caldwell *Jochen had been with us since the end of 1974 and you could see he was thinking he should be the number one driver. We said the number one would be the quickest driver and when Jochen was out-qualified by James in Brazil, his world collapsed. James was presented with a good team and a car that had been developed by a very good driver, Emerson Fittipaldi. What we saw in Brazil was that he had the speed and he could get on with it.*

Dave Ryan *I was a very junior mechanic – a number two, I think – on Jochen's car. When we heard we were getting James Hunt, all we knew about him was his reputation as 'Hunt the Shunt'.*

When James's engine blew up just before qualifying in Brazil, we had to do the engine change in the pit lane. I remember James sitting on the wall, behind the car. The scene was like a bomb had gone off. Even I was embarrassed. It was just a mess; there were bits everywhere.

In those days, the engine was very much a standard engine with everyone doing cut and shut jobs on the oil and water pumps and so on to get the pipework where they wanted it. So, when you did an engine change, you had to do the water pumps, the oil pumps and all the rest of it. Unlike today, you didn't have anything prepared or built up. The engine was in bits, the car was in pieces and I'm standing there thinking: 'The poor bloke; he hasn't got a chance. He must be sitting there saying to himself: "I've got to get in this in half an hour!"'

We get it ready, he jumps in – and puts it on pole. And we're thinking: 'How did he do that?' It was as impressive as hell. That was my first proper introduction to James.

James Hunt *It was important psychologically because we immediately had each other's confidence and respect. I had to have a huge shouting match with the Wiener* [Mayer's nickname among the racing fraternity] *about how the car was set up with so little time remaining. I was guessing the settings and he said, 'You can't do that.' But I said since I was driving the bloody thing, I wasn't going*

to be pushed around when I knew what I wanted. I insisted and this was in the garage in front of all the mechanics. I went out and on my first flying lap I got the first pole of my career. I was rather proud about that and, of course, it impressed the boys. They like to see chargers and they'd seen me stand up to the Wiener. After that, I was very much number one.

The performance was significant for several reasons. Apart from the obvious advantage that comes with pole position, Hunt's actions on and off the track that day would set the tone for the rest of the season and encourage an otherwise more lenient view of his occasional indiscretions out of the cockpit. More immediately, the McLaren crew were still smarting over Fittipaldi's eleventh hour departure and quietly relished having James take what was effectively Emerson's car and give the Brazilian a good thrashing in front of his adoring public. It would be even better if Hunt could carry that through to race day.

Until this point, the F1 pundits had not paid a great deal of attention to McLaren and Hunt when discussing prospects for the season ahead. The combination was not mentioned until the 11th paragraph of a preview in *Autosport*, the talk being otherwise of how Lauda and Ferrari were likely to retain the championship with competition coming from the flamboyant and fast Ronnie Peterson in his Lotus-Ford; the potential of Carlos Pace on his home track in the Brabham-Alfa Romeo and that of his Argentine team-mate, the enigmatic Carlos Reutemann. There was also Jody Scheckter and Depailler to consider in their

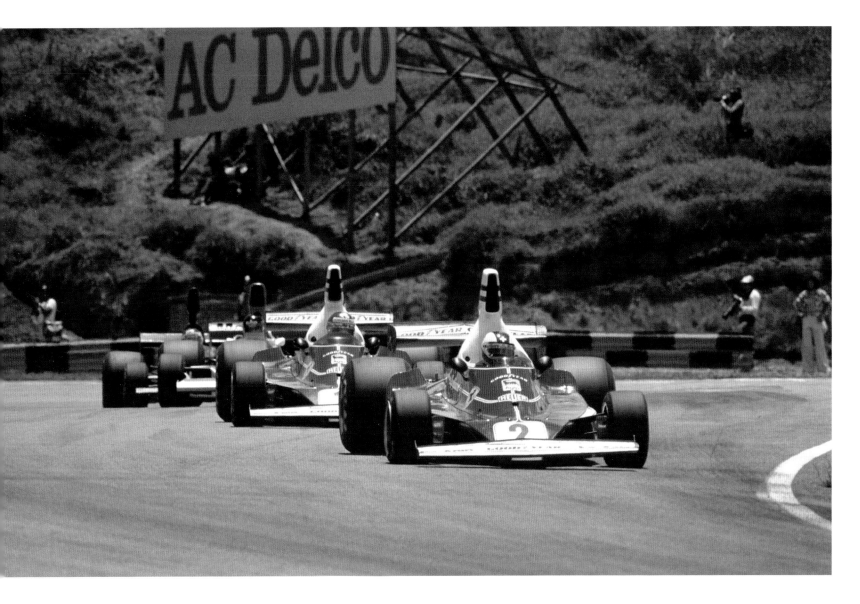

Tyrrell-Fords. And you never knew what Fittipaldi might achieve after promising tests with the all-new Copersucar Fittipaldi Ford. Reading between the lines, the feeling seemed to be that McLaren would miss the huge talent of Fittipaldi and Hunt might not be able to hack it at this level. In the space of two minutes and 32.5 seconds, pole position on such a sinuous circuit had suddenly indicated he might do much better than anyone guessed.

Typically, James was not one to allow disagreements at work to upset his life or sense of mischief outside the paddock. He accepted an invitation to play tennis with the president of General Motors, whose company was heavily sponsoring the Grand Prix in the light of GM's industrial presence in Brazil. Hunt was even more flattered to be offered the use of the presidential limousine for the return journey to his hotel and startled to be accompanied by four

armed bodyguards. When James climbed out, the heavies insisted on surrounding him as he walked into the foyer. For a brief moment or two Hunt entertained a mischievous thought.

The Ferraris of Regazzoni and Lauda lead Hunt during the opening laps in Brazil.

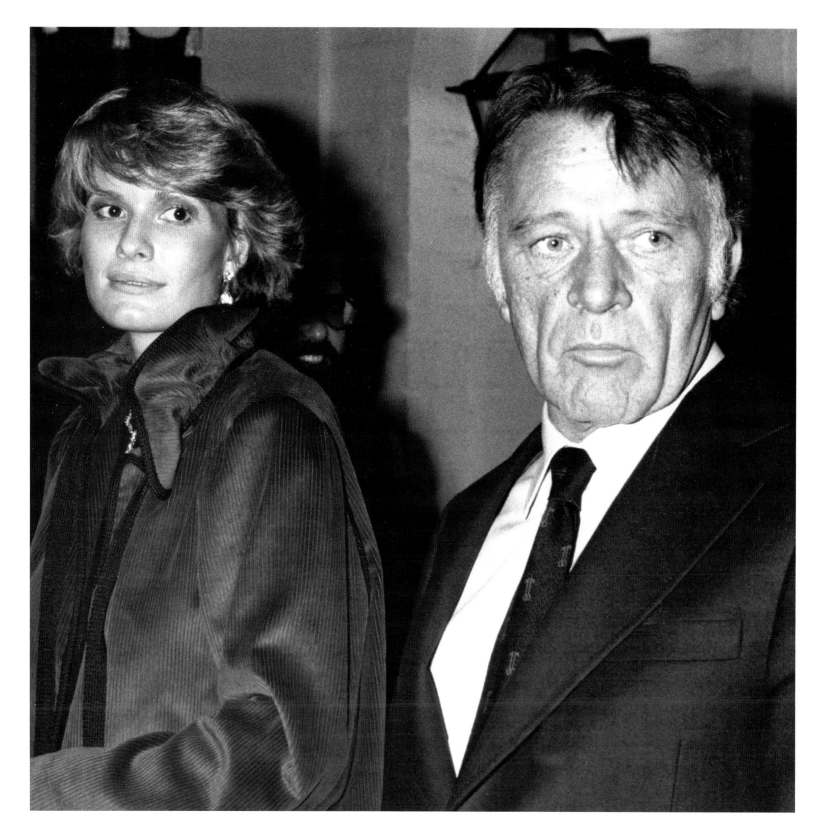

Scheckter was standing there and I thought it might be fun to throw a punch at him, just to see how the guys would react. But I decided against it. It could have been one of those jokes that misfired.

Hunt would also pull his punches at the start of the race. Never having completed a full-blown getaway with the M23 and anxious not to burn out the clutch, James applied caution on the slightly uphill grid and gave best to Lauda and his team mate, Clay Regazzoni. He chased the Ferraris and ran second to Lauda for much of the race once Regazzoni had suffered a puncture. With 13 of the 40 laps remaining, Hunt dropped back when a trumpet on the V8 worked loose before finally coming free, jamming the throttle slide and sending the McLaren off the road. It was a dusty ending to a weekend that had given a clear vision of Hunt's potential.

This just confirmed what we had seen with that lap during qualifying. It was good for the team because we knew we had a racer on our hands. If we could give him the car he needed, we were going to give Ferrari a hard time. That was a good feeling to have at the start of the season.

It would carry the team through the six-week wait for the second round of the championship in South Africa. When they arrived in Johannesburg, the media were waiting – but not for the racing.

James's private life was now infinitely more newsworthy than anything he might be doing in his F1 car, with stories that Suzy Hunt was keeping company with another man. That was intriguing in itself but when that rival turned out to be the actor Richard Burton, the story accelerated out of the sports and social columns and vied for a place on the front page of every tabloid newspaper.

Despite the unwanted press attention, it suited James very well that Suzy had met Burton during a stay in the upmarket skiing resort of Gstaad in Switzerland. Even though they remained estranged, James and Suzy had kept up the pretence all was well by travelling to the town before he went on to training. In truth, the couple had mutually agreed at least six months previously that marriage was not such a great idea after all. James could not afford the divorce at that point and, in any case, did not want to leave his wife in the lurch. His wish was for Suzy to find a suitable partner. It seemed it had happened sooner than either of them expected.

James had left Gstaad early to prepare for his next race. It was during the following days that Suzy was introduced to Burton, then going through the break-up of his second marriage to Elizabeth Taylor. Despite a 24-year difference in age, they hit it off instantly. Burton, reluctantly, had to leave the country to play on Broadway while Suzy went off to stay in another part of Switzerland. Quickly agreeing they could not bear to be apart, Suzy flew to New York, where she openly accompanied Burton on his round of social engagements.

Now the cat was out of the bag – except the American paparazzi did not know the identity of the elegant English woman Burton referred to as 'this gorgeous creature – about nine feet tall'. When their British colleagues enlightened them, the story immediately became headline news.

One of the first on the case was David Benson, motoring editor of the *Daily Express* in the days when motoring correspondents not only wrote about road cars but also covered motor racing, specifically F1, on their spare weekends. Benson, having realised Hunt was a good story from his early escapades in F3, had kept a close eye on the Englishman's progress. Too close, in fact.

The first hint of a fracture in Hunt's marriage had come from Benson's rival paper, the *Daily Mail*. Nigel Dempster learned about Suzy being among Burton's entourage in Gstaad during Hunt's absence but the gossip columnist swallowed the manufactured line that she was being entertained by Burton's personal assistant, Brook Williams.

Opposite page: Life for James at the race track became complicated when Suzy Hunt was photographed with Richard Burton in New York.

Benson followed this up by speaking directly to James's brother Peter and subsequently to James himself and allowed his friendship with the two to numb his journalistic urges. He accepted their reassurances that Suzy was indeed in the company of Williams but that it was entirely innocent and James knew all about it.

Benson was an affable man, but possessed a quick temper. His ire, not to say disappointment, can be imagined when the New York stringer for the *Daily Express* uncovered the truth and relayed the news back to London. Knowing the Hunts now owed him a favour at the very least after the paper had printed their denial, Benson went straight to Peter and James and demanded an exclusive – which was duly provided. Benson's typewriter keys must have been red hot as he pounded out his story for the front page of the *Daily Express* on Thursday 26 February.

Under the headline Susy to marry Burton, Benson thundered: 'Susy [sic] Hunt, wife of British racing driver James Hunt, is seeking a quickie divorce in America so that she can marry Richard Burton. This follows the actor's break-up with his second time wife, Liz Taylor. He and 27-year-old Susy are staying at the same New York hotel. Burton, too, was said to be in a hurry to get a divorce. Susy's plans were confirmed in London by Hunt's brother, Peter, who acts as the racing driver's manager. He said: "James would not stand in her way and stop her getting a divorce. All he is concerned with is her happiness."

'I telephoned James Hunt in Johannesburg, where he is preparing for the South African Grand Prix. He told me: "I have been in daily contact with Susy and am fully informed about what is going on. I wouldn't stop her getting a divorce. I am trying to help her as much as I can so that she makes the right decision. Obviously, if she wanted to come back to me, I would help her do that. At the moment Susy and Burton are literally barricaded in their suite in their New York hotel. I spoke to her on the phone for 40 minutes on Tuesday."

'Hunt, 28, said he hoped to see former model Susy in London soon, to talk things over. The couple married in October 1974. Among the wedding guests were racing stars Jackie Stewart, Emerson Fittipaldi and the late Graham Hill.'

On this occasion, the Hunt brothers had told the absolute truth and Benson had his exclusive. More important, the *Daily Express* had got one over the *Daily Mail* and their renowned gossip columnist. With the news having well and truly broken, James fed a suitable comment to the posse of journalists waiting breathlessly in the lobby of his hotel not far from the Kyalami race track.

'Naturally I'm perturbed about all the publicity about my wife in Europe and America but I must concentrate 100 per cent on the Grand Prix,' said James. 'If there is a problem it is just going to have to wait until after the race. Meanwhile, I'm far too busy sorting out the car and keeping myself fit.' To demonstrate the latter, Hunt could be seen pounding across the Highveld on regular runs.

That said, the McLaren mechanics noted that their driver did not appear to be deeply upset, as he went on to entertain various beautiful women almost on a daily basis. With the help of Caldwell and a few other old hands, this was subtly done to avoid the attentions of hacks with zero interest in F1. Hunt was more relieved than upset, as he later explained in private.

James Hunt *Suzy running off with Burton is a great relief to me. It actually reduces the number of problems I have to face outside racing. I am mainly concerned that everyone comes out of it happy and settled. Meanwhile, it is probably a good thing that I am still technically married. I have that as a safety valve. It will stop me from doing anything silly again!*

The new-found sense of personal freedom translated into full-on performance from the moment practice started on Wednesday 3 March. Hunt was fastest in all three timed sessions. Whereas Brazil's pole position had been won with a go-for-broke, nothing-to-lose lap by an angry driver, Hunt's cool performances in South Africa laid down a marker, much to the consternation of Ferrari and Lauda, at least 0.1 seconds slower in every session.

Opposite page: Putting apparent personal troubles aside, Hunt carries on undaunted at Kyalami after finishing second in the South African Grand Prix.

Time for fun with Hunt's sparring partner Lauda in the pit lane at Kyalami.

Unfortunately for Benson, he was not there to witness this latest development in the Hunt saga. Noting that Benson was their only representative in South Africa, the *Daily Express* ordered the motoring correspondent to rush north to Mozambique and provide a colour piece on a war in that part of the continent. At least the four-day Grand Prix schedule allowed Benson time to return for the race.

As difficult as it is to believe by today's standards, the South African Grand Prix marked the third anniversary of the M23's debut, the car having started off as it meant to continue by claiming pole and winning the race in the hands of Denny Hulme. Development, of course, had continued apace, particularly this weekend as the car carried (for practice only) Caldwell's pneumatic starter that would bring a reduction in weight and, hopefully, an improvement in reliability.

A novel starter of a different kind on race day saw the introduction of a green light to get the Grand Prix under way instead of a race official dropping the national flag. Reverting to tradition at the end, a man wearing a bush hat appeared 78 laps and an hour and 42 minutes later to wave the chequered flag as Lauda came home first with Hunt just 1.3 seconds adrift of the Ferrari.

The outcome had been more or less settled at the start as the McLaren had too much wheelspin and Lauda, followed by Mass (starting from third) and the March of Vittorio Brambilla, surged past Hunt. By the time James had worked his way into

second place six laps later, Lauda was eight seconds down the road. Which is the way it stayed until Lauda, fearing there was something awry with the rear suspension, backed off slightly, but never enough to allow Hunt within striking distance.

The uncertainty of having someone drop a flag to start a race would be demonstrated when Brands Hatch hosted the *Daily Mail* Race of Champions on 14 March. This may have been a non-championship race but 15 cars and 10 teams turned up at the UK track to launch the beginning of the European F1 season.

It would turn out to be a stuttering start when the man with the flag held it aloft too long. Gunnar Nilsson, fearing for the clutch on his Lotus on the sloping grid, let rip from the second row and briefly led the field into Paddock Hill Bend. That almost went unnoticed, which was more than could be said for the sight of Alan Jones leading the race at the end of the first lap. It was not so much that the Australian, a comparative F1 novice, was driving a Surtees-Ford but more about the lettering on the nose. The BBC had refused to televise the race because of the increasing influence of advertising in sport and the possible offence caused by Durex sponsorship carried on Surtees; a contention not only laughable now but also in 1976. No one saw the joke more than Hunt, particularly as he closed in on the white car and eventually took a lead he would not lose.

This was only Hunt's third F1 victory but, coupled with the promise of Brazil and South Africa, it was enough to catch the eye of UK sports editors, not to mention McLaren sponsors. Motor sport magazines began carrying full-page advertisements of a grinning Hunt holding a can of Texaco oil and Goodyear showing the winner in his M23.

Having created headlines at the front of newspapers, Hunt now looked likely to do the same on the sports pages at the back. It was the beginning of an awareness that would quickly mushroom, starting a week later thanks to the burgeoning British hero's colourful and controversial actions on a street corner in California.

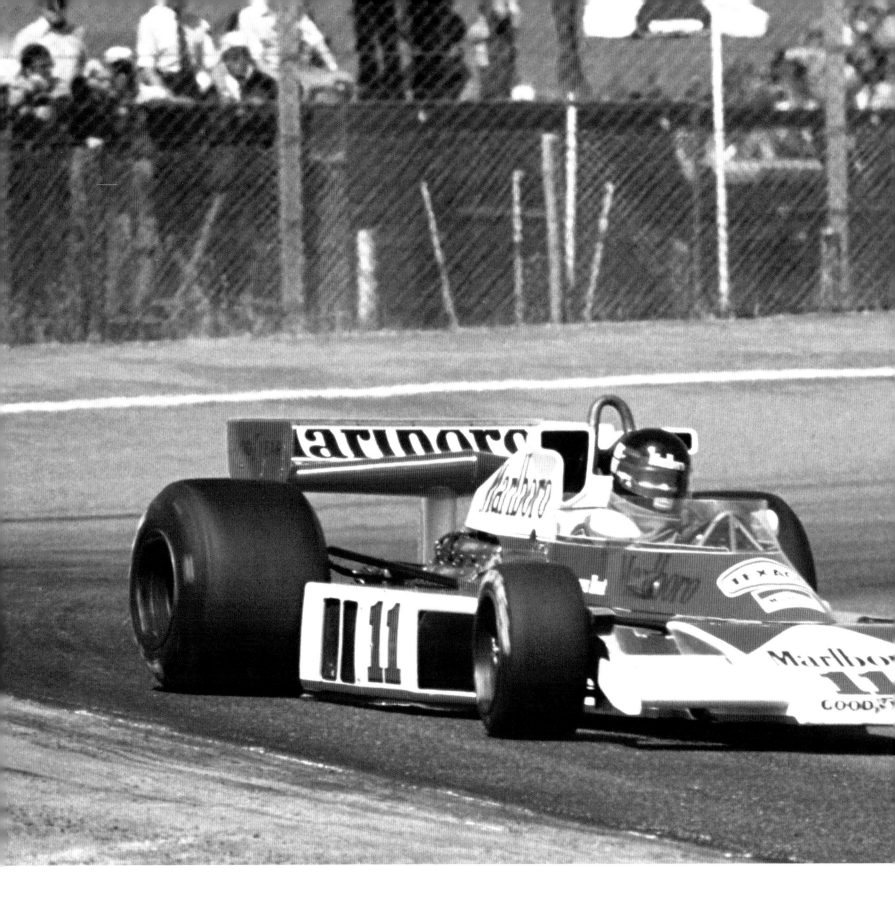

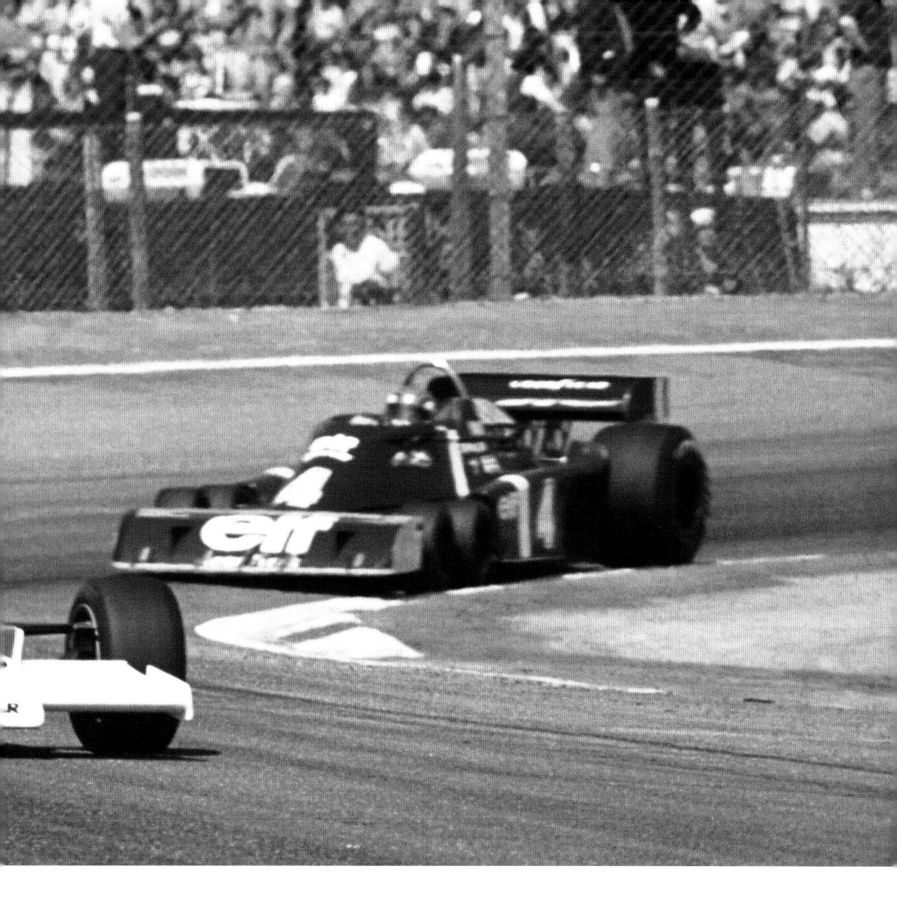

A race in sunny California in late March had a lot going for it, even if McLaren were reluctant about tackling the first ever F1 Grand Prix on the streets of downtown Long Beach. This had nothing to do with the shabby surroundings of a city in need of a reputational boost. The United States Grand Prix (West) was conceived to bring life to a drab seaport with an ageing population but McLaren knew the angular corners and bumpy surface would have the opposite effect on their elderly car.

The M23 was better suited to fast curves, of which there was just one – a mild one at that – along a track more notable for darting, weaving, rising and falling throughout its 2.02-mile length. On that basis, it was with some surprise that McLaren saw the list of qualifying times showed James third fastest behind Patrick Depailler's Tyrrell-Ford and the pole position Ferrari of Clay Regazzoni. Lauda was fourth, a couple of tenths behind Hunt.

The six-speed gearbox had helped but, equally, James had shown an ability to be precise on a circuit lined by concrete walls and high kerbs. It was not difficult to imagine the traps these obstacles would present during 80 tortuous laps on the afternoon of Sunday 28 March.

Sure enough, only 17 of the 20 starters completed the first lap, Carlos Reutemann and Gunner Nilsson having been deposited against the concrete; the former courtesy of Vittorio Brambilla forcing his March-Ford inside the Brabham-Alfa Romeo; the latter because of a suspension failure on the back of his Lotus-Ford.

Having jumped Depailler at the start, James had forgotten to turn off his electric fuel pump (no longer necessary once the mechanical pump had kicked in), Patrick regaining the place as the McLaren stuttered momentarily while accelerating out of the hairpin at the start of Shoreline Drive. Once into his stride, Hunt closed on Depailler and immediately showed serious intent about taking second place. That – to James at least – seemed entirely possible when the Frenchman clipped the wall and lost momentum slightly at the exit of a tight corner. Hunt seized the chance to draw level on what would become the outside for the following hairpin – only to find the Tyrrell easing the McLaren into the wall as they attempted to enter Shoreline Drive. Depailler continued; Hunt did not.

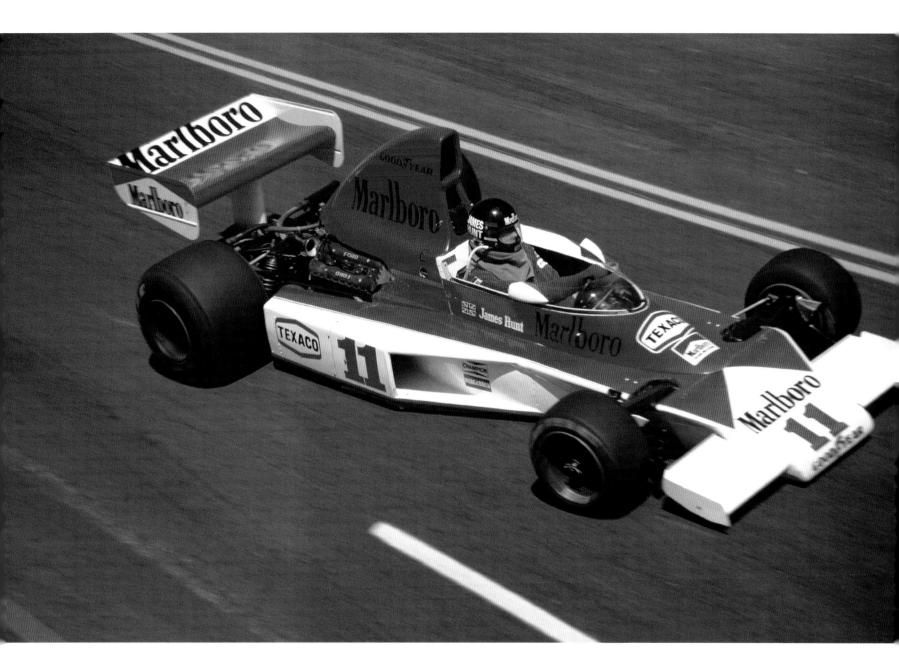

IT WAS WITH SOME SURPRISE
THAT McLAREN SAW THE LIST
OF QUALIFYING TIMES SHOWED
JAMES THIRD FASTEST.

James discusses events with Jochen Mass (left) and former
McLaren driver Denny Hulme.

James may have come to a halt in one sense but he accelerated in another as he leaped from the cockpit and began to demonstrate that his adrenalin was continuing to pump at full power. Hunt's purposeful stride along the edge of the track would be interrupted each time a blue Tyrrell came by, James ranting and gesticulating, his face the colour of his Marlboro red overalls. Hunt was not selective, the sight of any Tyrrell being enough to spark an outburst, as Depailler's team-mate discovered to his surprise.

'I couldn't believe my eyes,' said Jody Scheckter. 'I came round a corner and there was James standing in the middle of the bloody track, just off my racing line. It was very foolish.'

Once he had reached the pits, high up on Ocean Boulevard, Hunt continued to make his views known to anyone who would listen. Finishing third, Depailler was asked for his side of the story at the post-race press conference. 'Because my brakes were very bad, I was braking early,' said Patrick. 'James was exactly behind me when I braked and I think he had no alternative but to hit the wall. I was very sorry but there was nothing I could do about it.'

That was not a view shared by Hunt when he marched into the large conference room, much to the surprise of Depailler, never mind the bemused media.

'It was just flagrant stupidity,' roared Hunt. 'I came alongside you and you saw me but you just moved over and squeezed me out. You made a complete cock-up of that corner and the first thing you should do when you make a cock-up is to look where all the others are. The first thing you must do is bloody well learn to drive.'

Once the finer points of Hunt's furious tirade had been translated for Depailler's benefit, the bewildered Frenchman could only reiterate his version of events, before adding, 'James, I am desolate at what has happened. I am so sorry.'

'I'm bloody well sorry too!' retorted James, before advising Patrick to 'Watch it!' as he strode out of the room, continuing to complain loudly that this had been a major set-back because 'I had a sure second place.'

Hunt might have lost the potential six points that would have come with second but he could possibly have claimed a few points had he not been so hasty in abandoning his car. The team were not impressed to discover that the M23, when eventually returned to the pits, had nothing more than a crumpled nose cone. Hunt's cracked composure appeared to have caused the most damage. It prompted David Benson to adopt a personal angle in his report for the *Daily Express*.

'Later,' wrote Benson, 'Depailler and Scheckter dined together and the South African told me, "Patrick is very upset by the whole business. He and James were having a big go in the opening laps. We were all running very close, topping 185 mph down the straight and braking down to 25 mph for the bends. It was a fraught situation."

'Hunt allowed the pressure of recent weeks to get on top of him,' continued Benson. 'James's problem is that he has always been in the spotlight as the great new British hope. But in three seasons he has won only three Formula 1 races, only one a world championship Grand Prix.'

Two weeks later, that would become four victories at home in the International Trophy, named in honour of Graham Hill. In total command from the start of the weekend, Hunt abandoned qualifying halfway through and went off to have lunch, confident that no one would approach his best time. Ferrari were absent from Silverstone and Hunt's self-assurance continued into a race he would lead from beginning to end, setting fastest lap for good measure.

The race lasted for 53 minutes. According to Peter Windsor, sports editor of *Autocar*, the comparatively brief period of action was unlikely to help secure the future of non-championship events. Windsor cited Bernie Ecclestone's rising influence, as he began to marshal the F1 teams into a collective bargaining tool for everyone's immediate benefit and Ecclestone's substantial gain in the long term. Noting the lack of track activity during Saturday's practice, Windsor, a dyed-in-the-wool enthusiast, wrote: 'Spectators have paid £1 each to watch all this and, presumably, most of them will part with £3.50 to see the race tomorrow. These non-championship races are threatened by Bernie Ecclestone's quest to hold more Grands Prix. With entries like this one [16 starters, with Ferrari absent and other F1 teams entering just one car], that's no bad thing.'

Parked and ready to go. Hunt on the grid for the International Trophy race at Silverstone, where he would lead from start to finish.

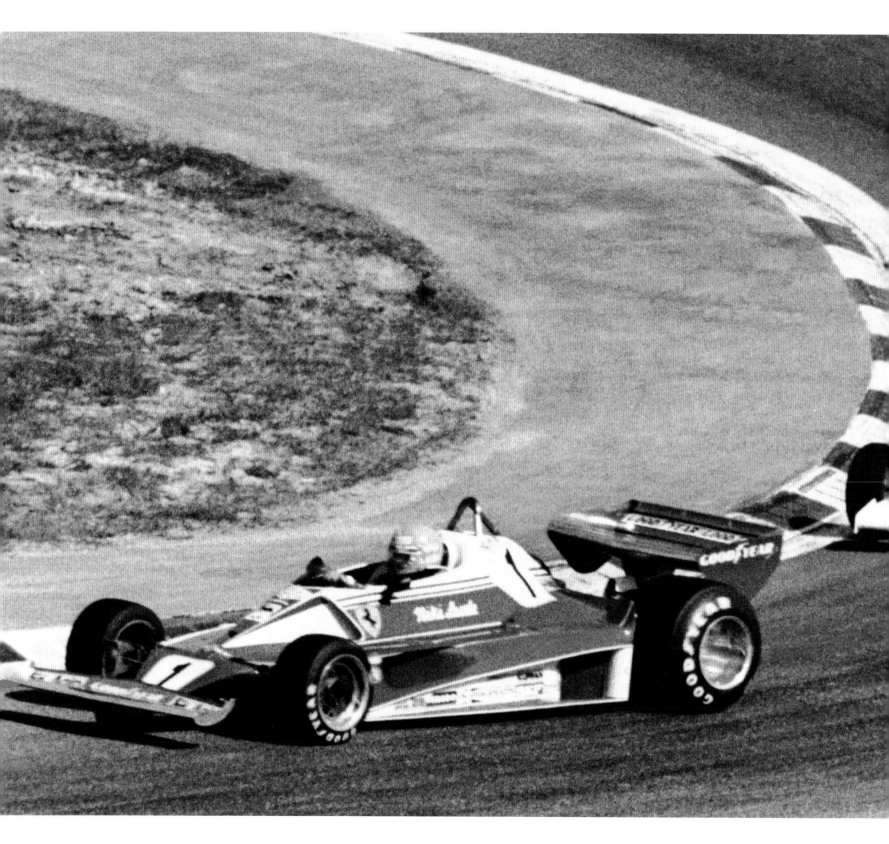

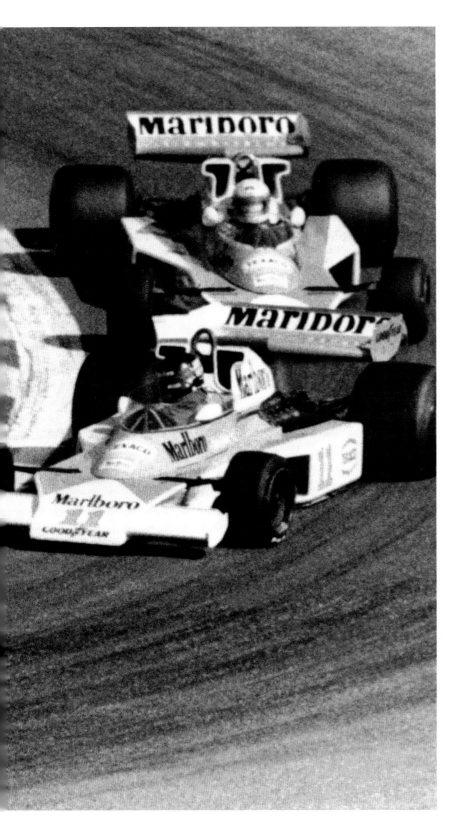

Hunt's performance not only set him up nicely for the next round of the championship in Spain but also accelerated the rising media interest in his exploits on and off the track. In the interim, James had an amicable meeting with Suzy. It was agreed he would not stand in his wife's way as she and Burton sought quick divorces from their respective partners. If anything, Hunt approved of a new arrangement that allowed him freedom to enjoy life in and around his Spanish villa and, when appropriate, focus on his racing. There may have been no immediate thought of winning the championship at this stage but Hunt was intent on reducing Lauda's 18-point lead at the earliest opportunity, starting with round four at Jarama near Madrid.

James's racing ambitions received an early bonus when news came through that Niki had broken two ribs during an accident when driving a tractor at his Austrian home. Initial reports suggested he would not be fit to race but that did not take into account their subject's bloody-minded determination. Not only did Lauda turn up at Jarama, he put his Ferrari on the front row, 0.32 seconds slower than Hunt. Nonetheless, when Niki jumped into the lead, James simply bided his time until the twists and turns took their toll. Sure enough, with less than half of the 75 laps completed, Hunt sensed his rival was tiring. The McLaren took the lead, eventually finishing half a minute ahead. The victory may have been tainted slightly by Lauda's physical handicap but, whatever the circumstances, the records would show that James Hunt had finally won his second Grand Prix and his first for McLaren.

That seemed to be the logical conclusion to the promise shown in previous races. But it did not take into account the findings of scrutineers and their tape measures as James and the team celebrated in the Marlboro/Texaco trailer. Just as Hunt's win had been a long time coming, so was the diligence being applied by officials. In fact, the teams had brought it upon themselves. It had been felt for some time that the sport's governing body, the

Hunt and Mass chase Lauda's leading Ferrari during the Spanish Grand Prix.

Commission Sportive Internationale (CSI), had been too lax in applying what were anyway sketchy technical regulations. Put simply, some competitors were thought to be cheating and getting away with it. The teams, through the Formula 1 Constructors' Association (F1CA), asked for certain parameters – such as wing positions and car dimensions – to be set, agreed and checked. Jarama would be the first race to be swept by this new broom.

When the dust settled post-race, the rear of Hunt's McLaren was found to be 1.8 cm too wide. The performance gain, if any, would have been negligible. But rules were, according to the teams' own request, most certainly rules. No matter which way the measurement was taken, the M23 exceeded the regulation. Hunt's victory was in doubt.

The tenor of the media's coverage in 1976 had nothing like the voracious urgency such a story would create today. Of the handful of British newspaper reporters on hand in Spain, most were spending the post-race period desperately trying to file their stories to London. The only means of communication was hopelessly inadequate phone lines in a noisy hallway leading to the press room. Because the reports had to be dictated to copy-takers in the newspaper offices, the calls needed to be by transfer charge to avoid the reporter being hit by a substantial bill. This process required the assistance of a single telephonist who had to cope with placing reverse-charge calls to newspaper offices across Europe. When the call eventually came through, the perspiring reporter invariably discovered

that the poor quality of the line – coupled with the general hubbub in the hallway – made the task extremely stressful, particularly as first edition deadlines loomed. The difficulty associated with attempting to bellow the story down the line would usually be made worse by a disinterested copy-taker operating under the misapprehension that the paper's correspondent was having a lovely time in the Spanish sunshine while he or she was slaving over a manual typewriter in a smoke-filled room in London. On such occasions, experienced hacks would bring plan B into play.

David Benson simply called his newspaper's correspondent in nearby Madrid, dictated the story and asked him to pass it on to the *Daily Express* in London; in theory, doubling the time taken but, in reality, actually faster and certainly more accurate thanks to a clearer telephone line. While his rivals continued the unequal task in the noisy hallway, Benson was free to walk briskly back to the paddock and investigate the rumour that Hunt and McLaren might be in trouble.

His first port of call was the scrutineering bay, where he found Peter Jowett, an RAC scrutineer and senior engineer at Farnborough's Royal Aircraft Establishment, acting this particular weekend as a consultant to F1CA. Jowett had been employed to see fair play when the CSI scrutineers went about the business of checking cars. Jowett would later explain the predicament in which he found himself to *Autosport*.

Peter Jowett

We measured the car three times. A pair of straight edges were pressed vertically against the outer sides of the rear wheels and the distance between them measured with a tape. In the McLaren's case, there was negative camber, so we also took the measurement across the bottom as well, between marks made on the floor at the bottoms of the straight edges. The measurements were identical all three times. There is no question that the car would not have been able to fit between two hypothetical upright posts 215 cm apart. The car would probably have passed had tyres not been mounted. It appears that it was the bulge of the tyres that caused the regulations to be contravened.

Ruing the fact that he had spotted the discrepancy and was duty-bound to point it out to the CSI officials, Jowett went on to explain the background to the new rule.

The CSI decided to have an overall limiting width last summer [1975]. *Their concern was that the wider the cars become, not only does it effectively make the circuit narrower, it makes the pit road more congested as well. Some of them are bloody dangerous already. At last year's German Grand Prix, a delegation of CSI members went round measuring the existing cars. The McLaren was accepted as being the widest and it was about 213 cm, 214 cm; something like that. So they rounded it off to 215 and said, 'Right. There's our limit.'*

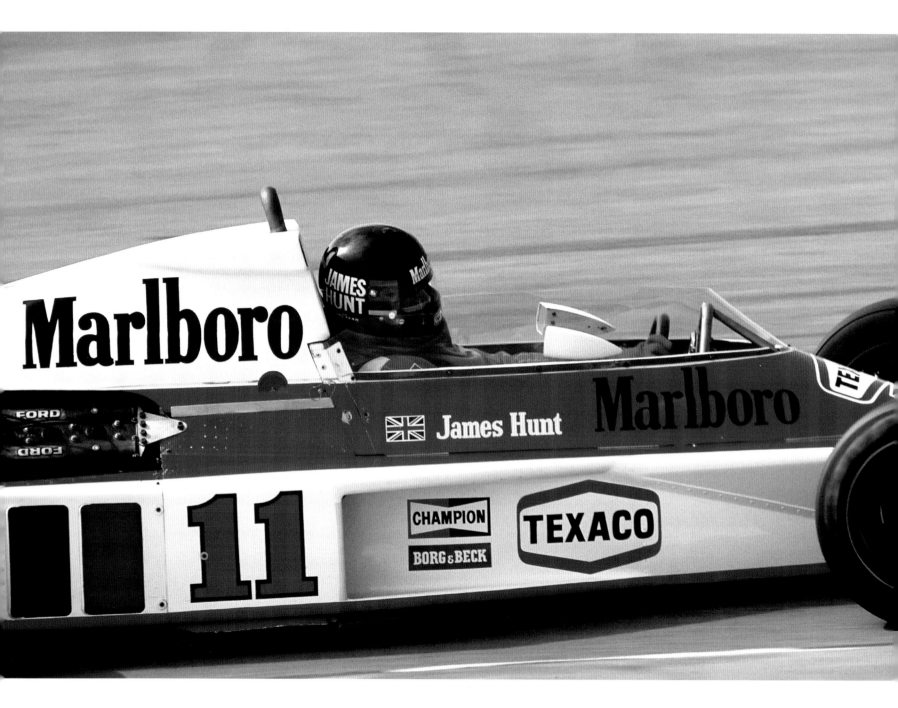

James drove an impeccable race in Spain with a car that was later deemed to be 1.8cm too wide.

Alastair Caldwell

That was the bloody irony: the measurements having been on the basis of our car being the widest. They put straight edges across the back of the M23 in Germany and everyone agreed 215 cm. There were other changes, which we made, but we never measured the width of the car [in 1976] because it was the same as before. For 1976, Goodyear had made tyres with bigger sidewalls which overhung the wheels. The year before, the rim was the width of the car. Since the rule measured the overall width of the car, we were 1.8 cm too wide.

With disqualification likely but not yet confirmed, Benson rushed back to the telephone and quickly revised his story, ad-libbing as he went because time was pressing and the deadline for the second edition of the *Daily Express* was looming.

The next move was to find Hunt and await the verdict. Benson joined a small group of journalists standing outside the stewards' office. Eoin Young was among them and recorded events in his column 'From the grid'. The diary piece not only describes what happened that evening but also captures a journalist's priorities and emotions in an era vastly different to our own. 'I take my hat off to Hunt for his performance both during and after the Spanish Grand Prix,' he wrote. 'As we waited at the foot of the control tower, a small knot of those who had waited until past 8 o'clock to hear the sentence handed down, Hunt was saying that he could perhaps accept disqualification if it was the result of a protest by another team, but he simply couldn't understand disqualification at the hands of an organising club for whom he had just turned on a splendid afternoon's entertainment. (But then maybe that's the Spanish way of doing things: killing the bull at the end of the afternoon.) I pressed James on the subject of the club disqualifying him as opposed to a rival team protesting, but he felt he had already explained his feelings on the subject, said so sharply and walked over to the fence, alone.

'Almost immediately an Austrian journalist brought Hunt the news that a decision had been taken and he was disqualified. It wasn't just being told the straight fact that his win had been taken away; it was something much larger than that, a personal tragedy that brought Hunt close to tears, a highly charged emotional situation in anyone's terms. He walked quickly into the empty paddock area, cursing and consoling with Teddy Mayer and designer Gordon Coppuck. It was that same eerie chilly feeling you have when the death of a driver is announced. We had just heard the death of a race win.

'Some five or six hours later, around 2 am, I met Hunt, Mayer and Coppuck in the foyer of the Barajas hotel and we discussed the incident in some detail. As they were leaving, Hunt came across and apologised for being abrupt at the control tower. I was amazed that he remembered, vastly impressed that he took the bother to make amends over a minor incident on the brink of what, for him, was a major calamity. A confusing measure of the man whose open-face habit of baring his soul in moments of stress called him into question following the Long Beach Grand Prix.'

Meanwhile, the McLaren mechanics were attempting to come to terms with what had happened. Among their number was Ray Grant, who had joined the team at the beginning of the year. Noted for his huge mop of hair that earned him the nickname Kojak (a humorous take on the bald character played by Telly Savalas in the US TV crime series), Grant worked on Hunt's car and had quickly gelled with his driver.

WE WORKED HARD AND WE PLAYED HARD, WHICH SUMMED UP THE ERA WE WERE IN.
RAY GRANT

Ray Grant

I was 25 then. I worked with Howard Moore on James's car and the relationship with James had developed pretty quickly. I think it was helped by me with the long hair and James being a bit of an extrovert – I wasn't as much of an extrovert as he was, but we all liked a good time. We worked hard and we played hard, which summed up the era we were in. People like Davy Ryan and Roy Reader [as mechanics with McLaren] *already had a season or two with McLaren and I was just feeding off these guys. I soon found out that what they liked and what I liked were exactly the same things. We worked hard but we made sure we made up for it in the evening, eating and drinking – with a lot of the latter.*

After the race in Spain, we'd finished our work and got ready to leave. We were told to go to the minibus out on the main road. We got there and we were sitting, waiting and waiting. There was a bottle of Scotch amongst our duty-free. I can't remember exactly how many of us were there, but we decided to neck a bit of whisky while we were waiting. Then someone came out to us and said we had to go back to the circuit because things were kicking off and we were being protested. So, we trekked back across the field and into the paddock and hung about for a bit. Nothing further happened until we were put in cars and taken back to the hotel. But we could tell from the way things seemed to be going and the general mood that we may have lost this race. As a mechanic, you never know the detail at that stage. The one thing sure is that we would have been told not to talk to anyone outside the team.

Whereas Mayer had said little in public after his driver's outbursts in California, this was different. It was unlikely that the McLaren boss, his legal brain working overtime, was going to stand by and do nothing. Within 24 hours he had been into Madrid to arrange the filing of an official protest against the Spanish Automobile Club's decision. Mayer was not disputing the scrutineers' findings; merely the severity of the sentence. He likened the disqualification to being hanged for a parking offence; an extreme comparison, perhaps, but one that indicated the strength of his resolve. This story was going to run and run – but not for as long as some of the controversies yet to unfold in this increasingly colourful and dramatic season.

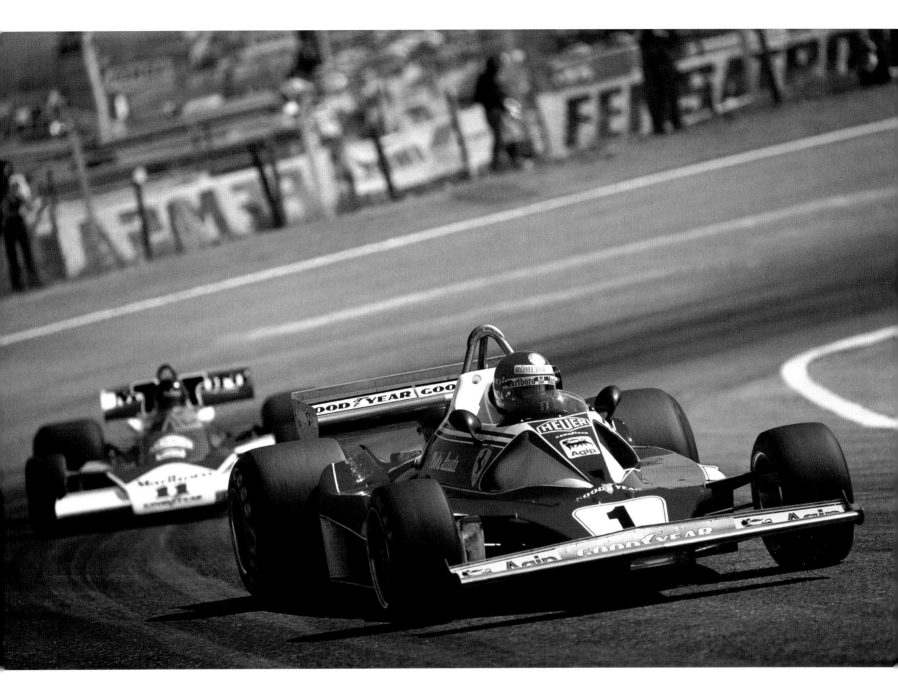

Lauda nursed broken ribs in Spain while Hunt would later nurse a grievance over his disqualification from first place.

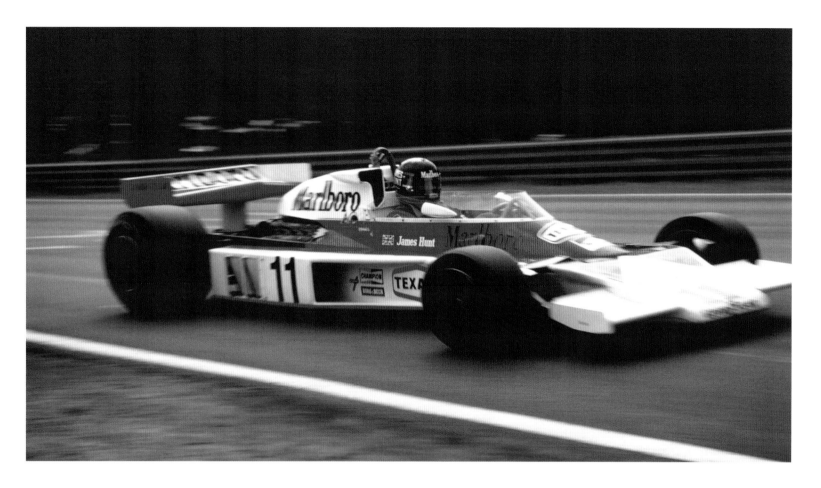

Above: A difficult race for Hunt and the revised McLaren at an equally gloomy Zolder.

Opposite page: Different cars and different times. James tries Lauda's Ferrari for size in the Zolder pit lane.

Its official title – *Omloop Terlaemen Zolder* – added little mystique to a race track much in need of it. Zolder had not been popular since its introduction to the F1 calendar in 1973 and James Hunt would not take kindly to it three years later.

Pete Lyons, one of the most colourful and entertaining reporters ever to cover F1, described Hunt thus in *Autosport*: 'You couldn't see him [Hunt] having much fun in Belgium. He did try to be smiling and clever, but his grins were brittle and his jokes were forced and altogether he was as jumpy as a stud horse with a bad tooth'.

The track's rather dull location, set on sandy heathland amid pine trees, did not ease pressure as the season got into its stride; a mood particularly evident within McLaren as the team worked hard to come to terms with events two weeks before in Spain. Above all else, the M23 had to be adjusted to ensure there could be no further questions over its dimensional legality.

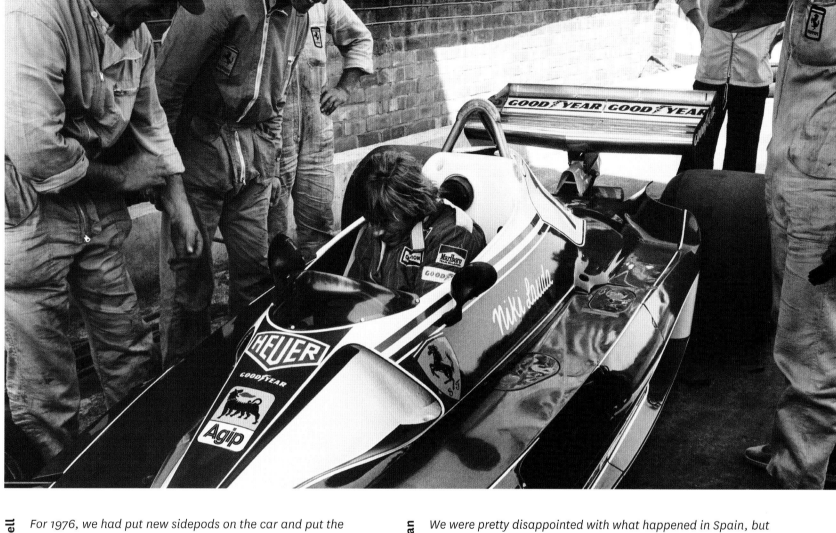

Alastair Caldwell

For 1976, we had put new sidepods on the car and put the oil coolers in the sidepods at the same time. The rules said you could not have oil fittings more than a certain distance from the centre of the car. We had put those oil fittings with tubes on them and put the fittings inside the car. They were completely legal but, just to be absolutely sure there could be no complaints about the position of the oil coolers, we moved them back, did a couple of other things and, of course, narrowed the car.

This included lowering the rear wing and moving it forward slightly. These changes were not much taken individually but collectively they would have a dramatic effect on the aerodynamics at the rear of the car; an outcome that was not immediately evident, particularly when the adjustments were made piece-meal throughout the two days of practice at Zolder.

Dave Ryan

We were pretty disappointed with what happened in Spain, but we took it on the chin. We were on a bit of a roll and the feeling was, Well, let's see what the next race brings. For Belgium, we made a sign which we hooped over the rear wing. It said: 'Caution. Wide vehicle'. That was the approach we took. It was just a lot of fun and we simply looked at this as a setback along the way. We had a really great group of mechanics, a great team. Everyone got on with everyone; it was terrific. There were just two mechanics per car and one on the spare. You have your car but you're all in it together. If one car has a problem and the other car is finished then everyone goes over and helps. It was a case of getting on with it. James was obviously under a lot of pressure but he just dealt with it.

Nothing seemed untoward when James set the fastest time during warm and dry conditions on Friday morning. It would turn out to be his best lap of the entire weekend, mainly because changes to the car had not been completed. The work was detailed and time-consuming.

Alastair Caldwell

We machined the insides of the wheels to bring them in towards the hubs a bit, and altered the inboard pick-up points for the lower links – that was a lot of work – and shortened the drive shafts a little. About the only thing we could just screw in shorter were the top links.

The shifting of the oil coolers took place between the two Friday sessions. When Hunt returned to the track for afternoon practice, the car suddenly felt nervous at the rear and no one knew why. Cue the brittle grin.

This was ominous, in view of Gordon Coppuck's prediction when the McLaren designer had been asked about his team's chances following the Spanish inquisition.

Gordon Coppuck

If we can get the next three races over without falling behind, we'll be happy. To be honest, we're a bit surprised with the way the car has been going. We really haven't done that much to it since the last three races of 1975. But, still, we've been working very hard to keep things where they are. James Hunt? We're surprised with him, too. He is a very good test driver in the sense that he knows what he wants from the car, rather than what he should be wanting. We're very happy with him.

Coppuck and his crew were certainly happy with third on the grid. Fortunately for James his Friday morning time was good enough for him to share the second row with Depailler, the McLaren and the Tyrrell lining up behind Lauda (on pole) and Regazzoni. A crisp start then allowed Hunt to split the Ferraris, Lauda settling himself in before pulling away at more than a second a lap.

That was the least of Hunt's worries, the McLaren proving hard work as he held off Regazzoni's increasingly threatening advances. The Ferrari driver made his move going into the first corner at the start of lap

seven. But when Jacques Laffite tried to make the most of Hunt's lost momentum, there was contact between the McLaren and the Ligier further round the lap.

This would trigger the first in a catalogue of complaints about Hunt's aggressive driving as the recalcitrant M23 proved frustratingly slower than many of the cars following. Among them, Depailler was quick to note the irony of Hunt's tactics when associated with his verbal outburst in Long Beach.

Opposite page: Serious work in the McLaren pit at Monaco as Hunt and Mass discuss the set-up for the M23 while Teddy Mayer (left) and Gordon Coppuck look on. Mayer (above, right) was just as perplexed as James when he could do no better than 14th on the grid.

'Hunt was driving very wild, holding everybody back,' Depailler would say later. 'You ask Jacques Laffite, who put a wheel into his car. You know, if Hunt says all these things about crazy French drivers like Patrick Depailler, he for sure should not drive in the same way himself!'

This cause for complaint did not end until just after half-distance when Hunt retired from fifth place with gearbox trouble.

Alastair Caldwell

James was holding people up and Ferrari were quick to say, 'See? They narrowed the car and now they're hopeless.'

Victory for Lauda gave him 42 points, Hunt's six points only being good enough for third on the table as Regazzoni made it a Ferrari driver one-two at the top of the championship. Lauda would extend his lead with another win in Monte Carlo to exacerbate an even more difficult weekend for Hunt. Fourteenth on the grid in Monte Carlo said everything about a car that disliked the tight corners to such an extent that a spin during the race dropped James to the back of the field, his struggle being brought to a merciful conclusion with engine failure.

James Hunt

Looking back, we were very fortunate to have our blow-ups and breakdowns at times when it didn't matter. It could have been very expensive for us if I'd had the Monaco engine blow-up when I'd been leading. You have to expect breakdowns during a season and any team that doesn't have at least one engine failure in a race has frankly just been lucky. You can prepare the engines just so well, but you can never guarantee them. So it's important to have your problems at the right time. The gearbox seized in Belgium when it didn't matter and the engine blow-up in Monaco was to be the only motor problem we would have all season in any race, other than the drama in Brazil when the fuel injection trumpet fell off.

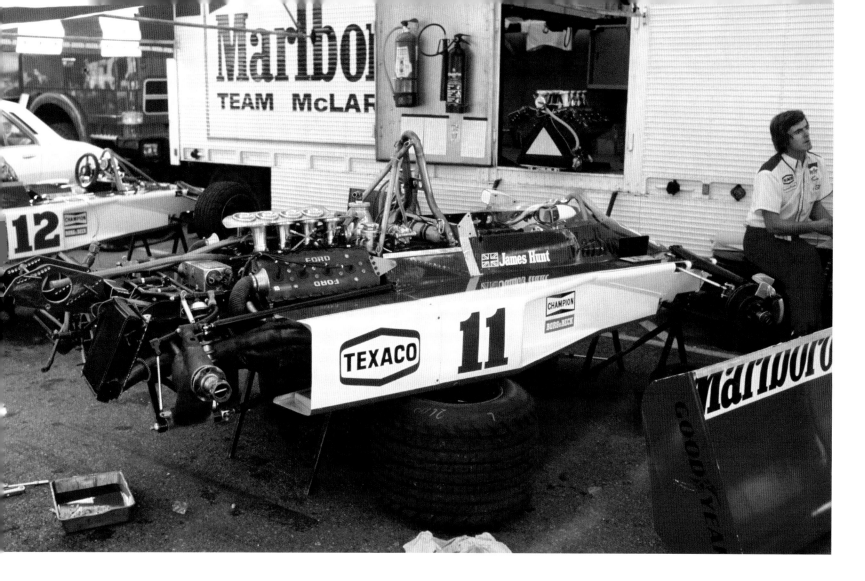

Alastair Caldwell (above) and the team worked hard on the problematic rear end of the McLaren, the M23 finally coming good again with victory at Paul Ricard (above right).

The difficulties continued at Anderstorp in Sweden when Hunt spun no fewer than six times with a car that was oversteering violently.

James Hunt *After the first day of practice in Sweden, we were really tearing our hair out and we decided in desperation to put the car back exactly to Spanish settings. One thing we knew for sure was that it had nothing to with the car being five-eighths of an inch too wide. Everyone else [outside the team] wasn't so sure but we knew it was absolutely nothing to do with that. The*

McLaren was set up exactly as it had been run in the Spanish Grand Prix with the exception of the oil coolers, which had to stay at the back under the wing because they didn't have the equipment to make the change in Sweden. It made no difference to the car, no difference at all. It was still evil.

Hunt persevered and finished fifth at Anderstorp to earn two points that would be vitally important at the end of the year. At this stage, however, with the season approaching its halfway point, no one gave James or McLaren a hope of winning the title. A (rare, as it would turn out) one-

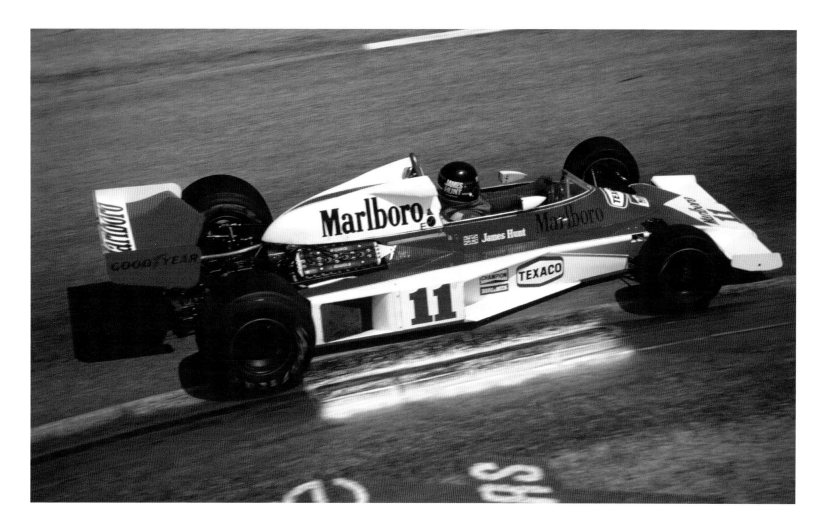

two finish for Scheckter and Depailler in the revolutionary six-wheel Tyrrell-Fords in Sweden had moved them both ahead of Hunt on the points table. Lauda continued his seemingly imperious way at the front, 47 points (five clear wins) ahead of James. All of that was about to change a few weeks later at Paul Ricard in the south of France, by which time McLaren had returned the oil coolers to their original position, despite doubts that it would make a difference.

James Hunt

We were pretty sure the mounting of the oil coolers wasn't the problem. There was nothing to suggest that it could be; there was no physical, apparent reason. Sure, we knew that the oil radiators at the back could affect the rear wing but they had only been moved so minutely from their old position relative to the wing that we couldn't believe it would be that.

Within a handful of laps of Paul Ricard, the stopwatch told a different story and Hunt confirmed it by saying the M23 had returned to the way it had felt before. The tiny change had made a disproportionate difference to handling as airflow was now permitted to move more efficiently beneath the rear wing. The car was evil no more.

Alastair Caldwell

It was high pressure in front of the coolers which was stopping the rear wing from working. We hadn't sussed the importance of aerodynamics over every part of the car.

Pole position for the French Grand Prix made the benefit of the change clear for all to see. And when it came to making a point, Hunt's earlier assertion about engine failures occurring at inopportune moments was about to be demonstrated – to his advantage.

Ferrari had been busy too, arriving in France with modified rear suspension and higher-revving engines to extract the advantage offered by the 1.11-mile Mistral Straight, Lauda joining Hunt on the front row. When the Ferrari jumped into the lead and pulled out a second a lap, Hunt was not unduly worried. From the start, he could see a fine spray of fluid coming from the back of the Ferrari. The oil or water tanks had either been over-filled or there was a crippling leak. It turned out to be the latter on lap nine when the Ferrari suddenly went silent with a blown engine.

Hunt may have been left to cross the line first but the result would not be confirmed until the finishers had been examined in the scrutineering bay. Given that McLaren had suddenly returned to form, rivals were hoping the official measurements might explain why – to the detriment of the winner.

Ken Tyrrell, eponymous team-owner, joined the other bosses standing on the sidelines as the scrutineers attempted to operate new and complex measuring devices. In theory, they were supposed to make the checking process unimpeachable but merely cast doubt on their veracity as officials fumbled and fussed. Should the McLaren be thrown out, Tyrrell would be the main beneficiary since Depailler had come home second in the six-wheeler. In the event, a thumbs-up signalled the start of a celebration for McLaren that would continue the following day.

Hunt and Mayer hitched a ride with Colin Chapman in his private plane to Paris, where the Lotus boss testified on McLaren's behalf during the appeal against the severity of the sentence after the Spanish Grand Prix. The words of Chapman and Mayer were sufficient to sway the judges and the disqualification was replaced by a $3,000 fine. In the space of two days, Hunt and McLaren had won twice. Even better, the reinstatement moved Lauda back to second in the Spanish results and narrowed the gap by another three points, in addition to the 18 gained in total in Spain and France. Lauda now had 56 points and Hunt had shot from eight to 26. A perfect prelude to the British Grand Prix.

Before travelling to Brands Hatch, however, Hunt was to show different sides to his personality. For the first, the Texaco Tour of Britain, James was engaged to share a Vauxhall Magnum with Noel Edmonds in a rally with a distinctly commercial and populist edge. Similar to a world championship rally insofar as competitors raced against the clock on closed roads known as Special Stages, the so-called Tour visited many locations more accessible to the public than the usual rally venues held deep in remote forests.

Hunt and Edmonds were destined not to get far. James hit a tree in the most spectacular of several incidents that quickly reached the front pages of the tabloid press. Hunt wanted to stop but Edmonds – a keen amateur racer – was of the view that they should continue for the benefit of his expectant audience on BBC Radio 1. Their difference of opinion had become a major row once the story had reached print. By this time James was also being accused of carving up motorists, being nicked for speeding, having an altercation with the driver of a Rolls-Royce and generally being regarded as a 'bad boy' of racing.

James caused controversy on and off the track when
sharing a Vauxhall Magnum with disc jockey Noel Edmunds
during the Tour of Britain.

James Hunt

I won't say I behaved very well on the Tour, but the outcome was a combination of circumstances and sensationalist reporting. Several small incidents happened; taking them into a combination made them quite big. That's really what happened. They said that Noel Edmonds and I had a row, which is complete and utter rubbish. We never had a cross word of any sort. We discussed the pros and cons and I thought we should stop. Noel thought we should go on. It was blown up out of all proportion. It was one of those days when it would have been much better if I'd stayed in bed...

A few days later, James performed on a different kind of stage. A televised Grand Prix Night of the Stars at London's Royal Albert Hall was laid on as a light prelude to the serious business about to be played out at Brands Hatch. Sponsors each paid £500 for a box at the concert in aid of the Graham Hill Memorial Fund, expecting to see Bruce Forsyth, the Brotherhood of Man and Lena Zavaroni performing. Not anticipated was the appearance on stage by James Hunt playing a trumpet. It took some work by his brother Peter, who explained to David Benson, 'I had a hell of a job convincing the BBC that James really was good enough. He learned to play at Wellington [College]. He was in the school orchestra and the school band and played solo at concerts.' Hunt's unexpected performance received a standing ovation.

Eoin Young, Autocar

James Simon Wallis Hunt is becoming something of a cult figure in modern Grand Prix racing; you either like him or loathe him. The extraordinary aspect of the Hunt cult is that he has perfected a way of having the same people like him one weekend and loathe him the next. Take the Texaco Tour of Britain, for example. By all accounts, the rally fraternity were most unimpressed by his antics. And yet, two days later, he had the packed audience at the Albert Hall in London eating out of his hand as he played the 'Trumpet Voluntary', all alone on stage with nothing but his cornet. I suppose Jeremiah Clark (who has been given credit for composing the piece) might have winced now and then during the performance but, like the dancing bear, it wasn't the quality of the dance so much as the fact that he could do it. So James walked away from the Albert Hall having regained all points lost on the Texaco Tour.

Hunt may have divided opinion during those eventful few days but it would be nothing compared to the extraordinary scenes of nationalistic fervour and Hunt Hysteria he was about to generate 25 miles down the road at Brands Hatch in Kent.

I WON'T SAY I BEHAVED VERY WELL ON THE TOUR, BUT THE OUTCOME WAS A COMBINATION OF CIRCUMSTANCES AND SENSATIONALIST REPORTING.
JAMES HUNT

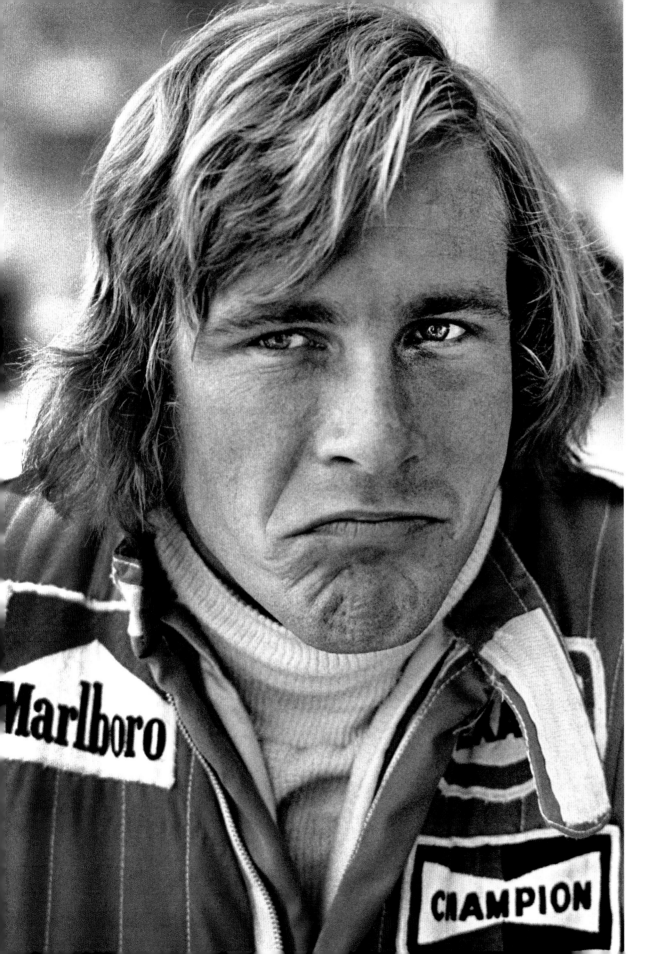

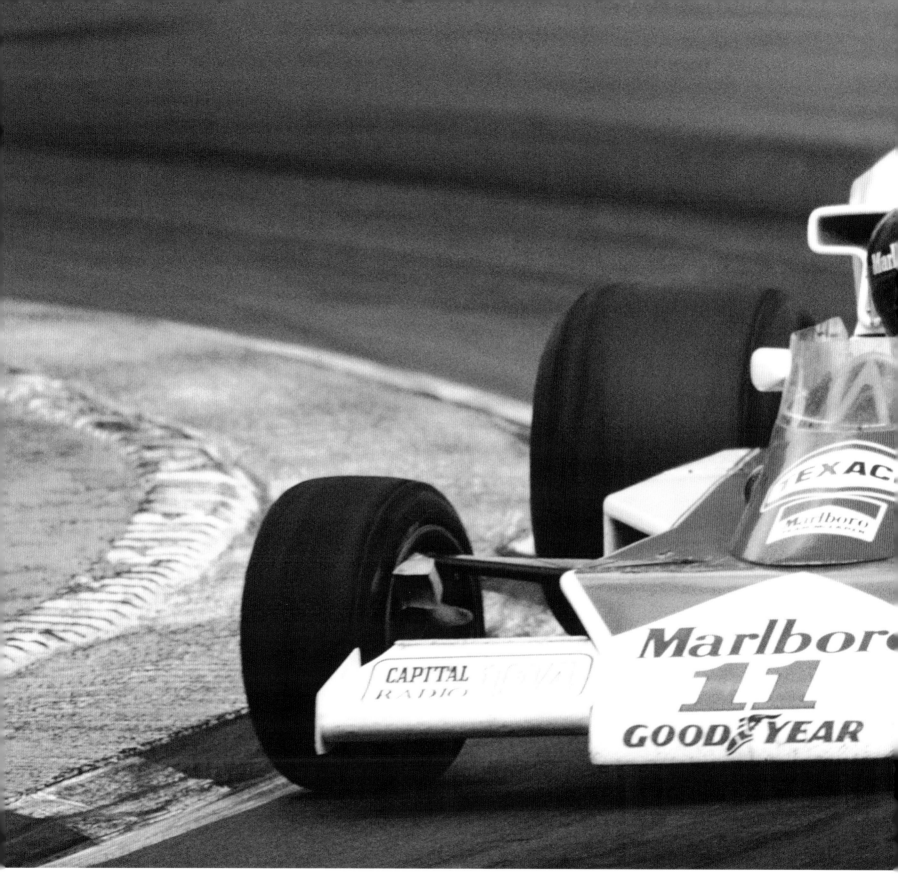

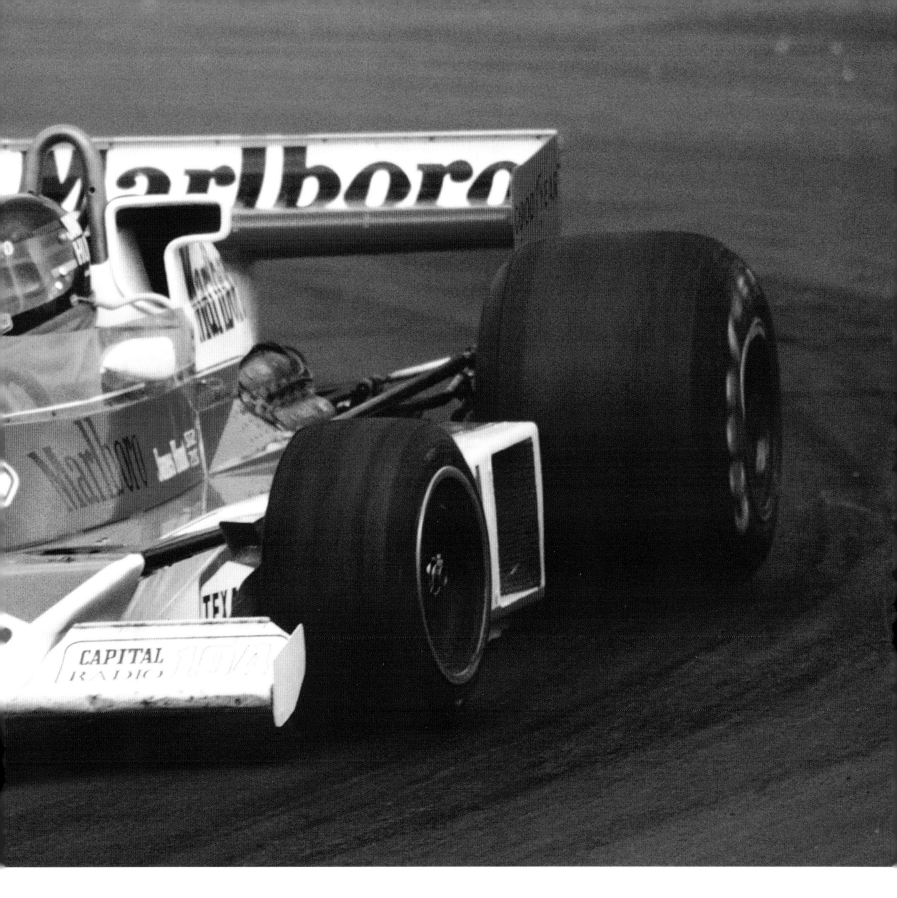

British motor racing flag marshals are considered to be the best in the world. When the Grand Prix Drivers' Association (GPDA) decided to recognise these unpaid volunteers by presenting an annual award to those who were responsible for the best Grand Prix, the British marshals were joint winners with South Africa of the first, in 1972, and went on to win the next three outright. The 1975 GPDA trophy was presented on race morning at Brands Hatch in 1976 in recognition of the marshals' handling of the previous Grand Prix at Silverstone. The timing was to be mildly unfortunate. Several hours later, officials running the British Grand Prix were being berated for their incompetence.

To be fair, this had nothing to do with the flag marshals even though the furore had been sparked by the appearance of a red flag. Again, to be absolutely correct, trouble had actually started when one Ferrari driver collided with another at the first corner, Paddock Hill Bend.

Niki Lauda had arrived in England with a modified car, the benefit of which he cheekily demonstrated by setting fastest qualifying time with 20 minutes remaining and then vacated the Ferrari to calmly watch his rivals attempt to go faster. James Hunt came closest, just 0.06 seconds adrift. Lauda then had the additional benefit of deciding which side of the grid to start from pole, a choice denied today's Grand Prix drivers.

This was particularly useful at Brands Hatch, where the start line featured a downward-sloping camber with the right-hand side being particularly steep at the point where, logically, pole position should have been located (the first corner being a right-hander). Time without number, the driver attempting to start from the right would go nowhere for a few seconds as the rear of his car slewed sideways under initial power. That's exactly what happened to Hunt while Lauda, having made the clever choice, enjoyed a clean getaway from the left.

The crowd were to have their say on a scorching hot summer's afternoon.

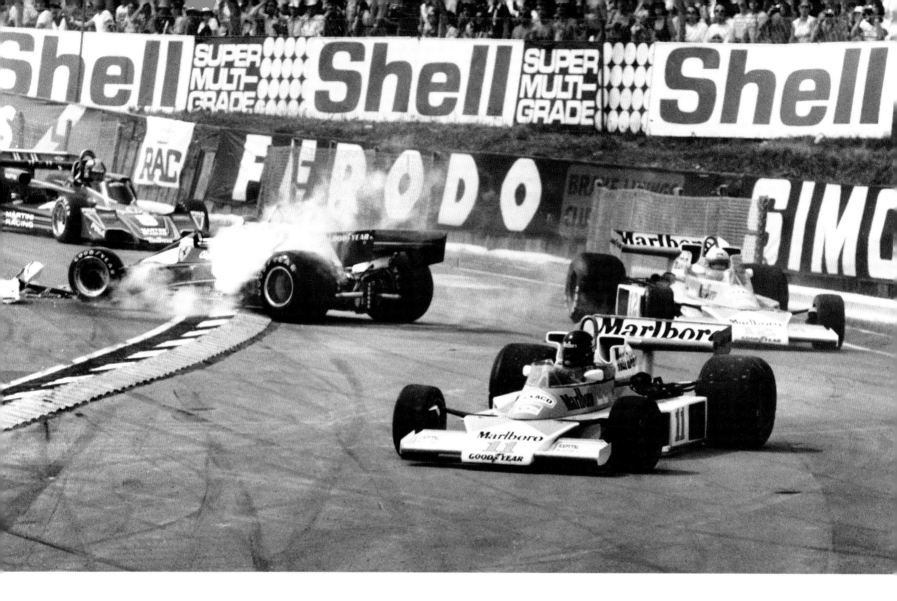

Not only was James giving best to Lauda, Clay Regazzoni took advantage with a flying start from the second row. In fact, his getaway was so good that he gave serious if flawed thought to challenging his team-mate into Paddock Hill Bend. Which is where the trouble started.

Carrying too much speed and ambition, Regazzoni locked his rear brakes after cresting the rise and immediately went sideways, hitting Lauda's right-rear wheel. Niki managed to catch his car, which is more than could be said for Clay and the Ferrari, now broadside in front of the remaining 24 cars barrelling into Paddock.

Confronted with chaos, Hunt aimed for the asphalt run-off on the left. Just after crossing the kerb – and almost reaching safety – the McLaren's right-front clouted the right-rear of Regazzoni's Ferrari, now pointing up the hill. But when Hunt's right-rear made tread-to-tread contact with the similar fat Goodyear on the Ferrari, the McLaren became airborne. For a terrifying moment, it seemed it was about to overturn before teetering on its left wheels and then thumping back to horizontal.

Meanwhile, the lemming-like backmarkers were flinging themselves over the brow and somehow avoiding what should have been a massive collision. In the end, a Ligier was the only major casualty after Jacques Laffite had been unable to avoid contact with the bank. The damage to Hunt's car may have been comparatively

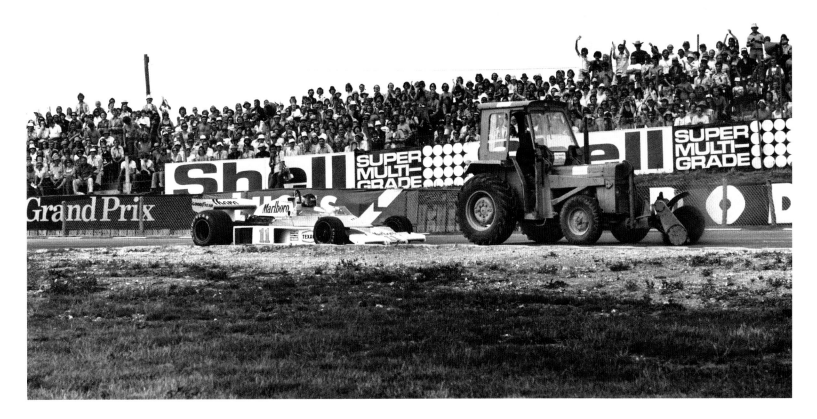

light, considering what he had been through, but faulty steering immediately told him his race was over. Lauda, disappearing up the hill to Druids, appeared to be unscathed.

James Hunt

With something like just three seconds covering the grid, it was going to be a really super race and – for 150 yards – it was. I'd made my usual lousy start, Niki had made a reasonable one and Clay had made a super start – a real stormer. He dived at the inside of Niki from way too far back. It was quite ridiculous. Niki was already turning into the corner and Clay dived in and hit him. I was able to enjoy it for, I suppose, half a second, because it was wonderful, extremely funny, for me to see the two Ferrari drivers take each other off the road. But it quickly became obvious that I was in on it too. My car was in the air, flying and then crashed down again on its wheels. I didn't have a chance to be frightened or to realise I could have been on my head. I was just heartbroken that I [had only] done 150 yards of a Grand Prix I'd hoped to win. I set off again but it was immediately obvious the steering was damaged because the car wouldn't steer properly. The front suspension was damaged too and it was leaping about, but still just driveable. I went up to Druids, wondering what the hell would happen now; wondering if anyone had been hurt in the melee.

Above: The McLaren limps towards the back of the pits, passing a recovery tractor on its controversial journey.

Opposite page: Hunt, his right-front suspension damaged by contact with Regazzoni's spinning Ferrari, thinks his race is over as he heads back to the track. Mass, unscathed, follows his team-mate.

THE SPECTATORS WERE ALMOST AT RIOTING POINT BUT THE MARSHALS ALSO STOOD THEIR GROUND IN SUPPORT.
HAYDN CHAPPELL

Faced with assessing the situation exploding before him and having to make a quick decision, the senior observer at Paddock advised race control that the race should be stopped. Given the cavalier approach to safety compared to the rigorous protocols of today, this was an unusual call and indicated the potential hazard presented by debris strewn beyond the corner's blind brow. While this was unquestionably the correct decision, it would create much debate in the minutes, hours and days that followed. For the moment, however, the driver of car no. 11 was delighted with the outcome.

James Hunt

When I saw the crossed yellow and oil flags [a signal for a driver to be prepared for a red flag at the start/finish line], I gave a whoop of delight. I thought all my birthdays had come at once. One second I was despairing of my luck and now it was all on again. I turned into the back road to the pits [located at the end of the bottom straight, just before Surtees corner] but, because the car wasn't steering properly and there were people crowding all over the place, I abandoned the car and ran down to the pit road to tell the lads to come and do something about it.

At which point, the event rapidly moved into the grey area of a rule book being thumbed by officials unfamiliar with the procedure in the event of a race being stopped. Should the restart be a completely new race (in which case, spare cars would be allowed) or a continuation of the existing race (in which case, they would not?) The conflicting points of view were embodied by McLaren and Ferrari through the state of their various cars. Regazzoni may have been in need of a spare car but Ferrari were more interested in Lauda being ready for the restart in his designated race car. With no clear-cut rule stating exactly where the cars should go, some drivers had stopped on the grid while others, such as Lauda, had returned to the pits to have their cars checked over. Angered by the 'stupidity' of his team-mate and ordered by officials to go to the grid, Niki stormed out of the pits – dragging the slave starting battery behind the 312T.

McLaren, meanwhile, did two things: while their spare car was pushed towards the grid, Teddy Mayer engaged in a debate with officials that would buy time and allow the mechanics to repair Hunt's damaged race car, thus conforming with the rules should the Grand Prix be continued.

When the officials confirmed it would be a new race, Ferrari, sensing McLaren's delaying tactics, threw a curveball by saying that only cars that completed the opening lap should take part. Hunt had taken the shortcut to the pits and McLaren's counter-argument was the race had been stopped by the time James had reached the rear entrance. Mayer quoted a specific line in the – sketchy – rule covering such an eventuality. The key words were: 'All runners at the time of stopping will be allowed to take the restart'. According to Mayer, Hunt was running when the race was stopped.

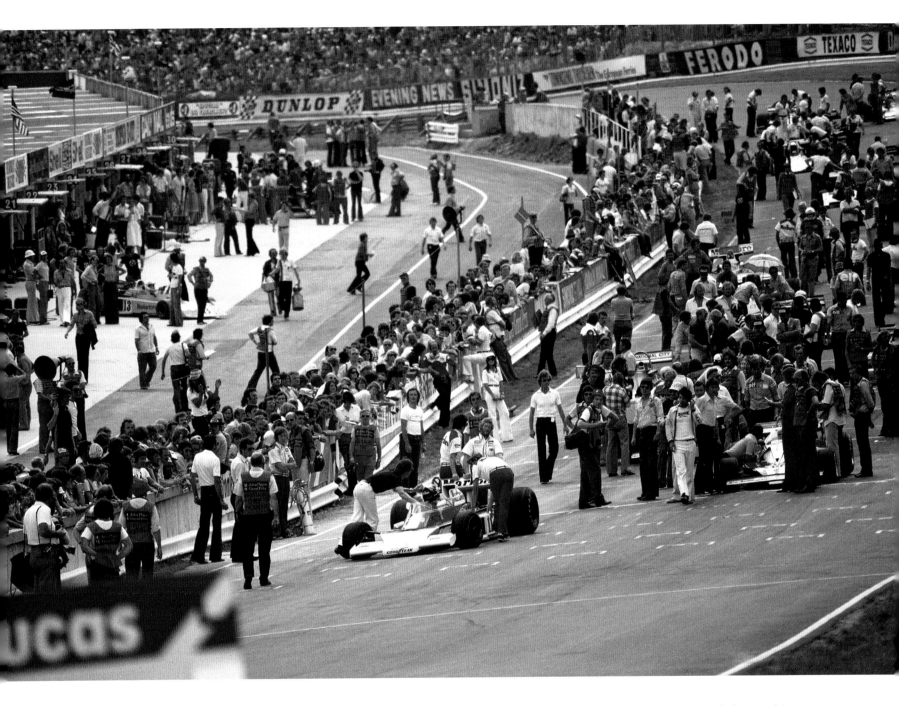

Hunt's spare McLaren is pushed onto the grid while everyone waits for news of the restart.

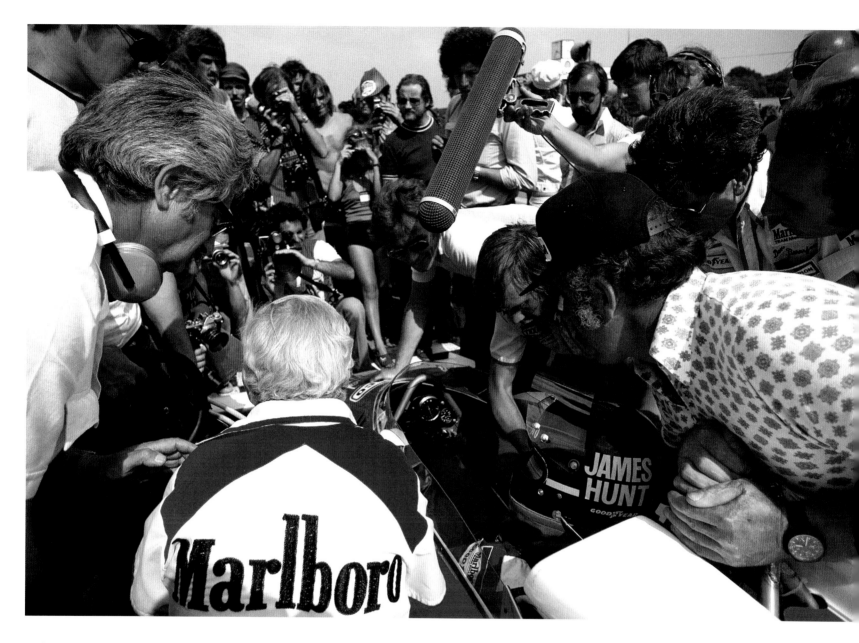

Pandemonium on the grid as James is strapped into his repaired car. Teddy Mayer (back to camera) and Denny Hulme (blue cap) look on.

So far, the argument had been between the teams and officials. But the debate suddenly acquired a wider and more startling dimension when spectators felt the need to have their say. James Hunt may not have been everyone's cup of tea but his detractors were a tiny minority among a crowd of 77,000 sweltering on an exceptionally hot summer's day. Whipped up by the media, fans had come to Brands Hatch to see their man win it. Or, put another way, to witness him thrashing that allegedly arrogant Austrian in the red Ferrari.

When the public address system imparted the news that their hero might not be allowed to restart, the reaction was immediate and dramatic – by the normally reserved standards of British spectators. Increasingly loud booing and stamping of feet in the grandstands was accompanied by a hail of crumpled beer cans onto the track. The mounting indignation was amplified in every sense by the Brands Hatch topography in which a valley of grandstands and spectator banks engulfed the grid and pits. These are memories from spectators and a marshal at different parts of the track:

Stuart Dent
It was an astonishing reaction. Apart from the 2005 US Grand Prix at Indianapolis [when 14 cars peeled into the pits, leaving just six starters – and more than 150,000 furious spectators], I've never experienced anything like it at a race track. It was just like a passionate soccer game. We were at the exit of Druids and so had the full effect of the racket bouncing around the Brands bowl. Chanting, slow hand-clapping, all manner of stuff being thrown on the track and word being passed around about a track invasion. I was a Lauda fan at the time but would certainly have joined in!

Sylvia Davis
We were so irate that we collected friends and were ready to run onto the track and lie down to ensure that the race could not be restarted without James. The noise from the crowds shouting 'James!' in unison was deafening. Priceless.

Haydn Chappell
The spectators were almost at rioting point but the marshals also stood their ground in support. I was on post seven [bottom of Druids] and we all took our fire extinguishers off-post and lined them up on the circuit edge. We then sat on the track with our backs towards the control tower. If James wasn't allowed to play, we weren't going to play either! I believe other marshals' posts also revolted in the same way.

The officials may have felt under siege but it was not an emotion shared by the McLaren team.

Dave Ryan
We had been flat out repairing James's car – to be honest, there wasn't a great deal to do; just changing the steering arm and suspension link – so we were not aware of all the arguing going on. But when the crowd started kicking off, we suddenly realised just how many people were on our side – and it was a nice feeling to have, really good.

Ray Grant
Davy is right. We didn't know what Alastair was doing with the other car up on the grid. We were just focused on fixing the race car because we knew our man was capable of winning this race.
Then we became aware of the noise and some sort of protest going on. It all became quite an adrenalin rush because of working against time. I was totally exhausted mentally by the time we had finished.

Murray Walker

I wasn't a regular commentator in 1976 – few of the races were televised – but I was acting as a pit lane reporter at Brands Hatch. If you look on YouTube, you will see a clip of James running down the pit lane, talking to Teddy Mayer and then someone sticks a microphone in front of him and asks, 'Can you tell us what's going on?'

And James says: 'There's a race going on, dear boy.' And he keeps walking. That was me – trying to interview him! It was impossible to know what was happening. The situation was pretty tense.

Over an hour had passed since the first corner collision. At last, officials declared the race a continuation of the original – but with spare cars allowed, the broad thinking being that this would permit everyone to start the race and any protests could be sorted later. Not that this affected Hunt now that the repaired race car was in its rightful (according to McLaren, if not Ferrari) place on the front row.

The drama was not yet over. With the 30-second board showing before the start of the parade lap, the M23 would not start. Half a minute came and went but, with the McLaren still silent, the commencement of the parade lap was delayed, Lauda's increasing annoyance being relayed by a blipping throttle. The Ford DFV burst into life soon after and everyone braced themselves once more.

At the second time of asking, Hunt made a better start with Regazzoni (in the spare Ferrari) behaving himself in third place, the field this time negotiating Paddock without incident. Finally, the British Grand Prix was well and truly under way – and both Lauda and Hunt had problems to contend with. James was struggling with the handling under a full load of fuel while, from the outset, Lauda felt the Ferrari's gearbox gradually tightening – possibly a literal knock-on effect of his team-mate's over-enthusiasm during the first start. The difference was that Hunt's understeer would reduce as the fuel burned off whereas Lauda's unpredictable gearshift was never likely to improve. Uncertain about which gear he might find while looking for fifth, Lauda frequently stayed in fourth and relied on engine torque as he dealt with the remaining tortuous laps. It was on the 45th of them that the performance curves of the Ferrari and the McLaren crossed – with dramatic effect.

James Hunt

Our lap times were coming down, down, down. It was quite fantastic. We were racing at the lap times we had qualified at when flat out with light loads of fuel. We kept breaking the lap record [it would eventually fall to Hunt] *and I was catching him steadily, but not enough. Then I was helped by a couple of back markers. Niki got the worst of that and I started stabbing at him.*

Through Paddock and up towards Druids on lap 45, Hunt dived inside the Ferrari on the approach, emerging from the 180-degree corner in front. As the pair swept down the hill and into sight of the main grandstands and the packed South Bank, school was out. Brands Hatch went crazy.

And so it would continue before reaching a crescendo 31 laps later, as the chequered flag welcomed an Englishman winning a home Grand Prix for the first time since Peter Collins at Silverstone in 1958.

As Hunt lifted off the throttle through Paddock and allowed the heady and physical momentum to carry him up towards the horseshoe at Druids, he raised both hands high in the air, the sun-drenched crowd in the enclosure on his left responding in a similar exultant fashion with a forest of outstretched arms. Arthur Partridge, an American enthusiast sitting high above them in the grandstand, caught the moment on his camera. The photograph not only formed the frontispiece for James's autobiography, it would also be the only racing photograph to adorn the walls of his home. With no other car or driver in sight, it was a magical moment of communion between the man and his followers. But for how long would the euphoria last?

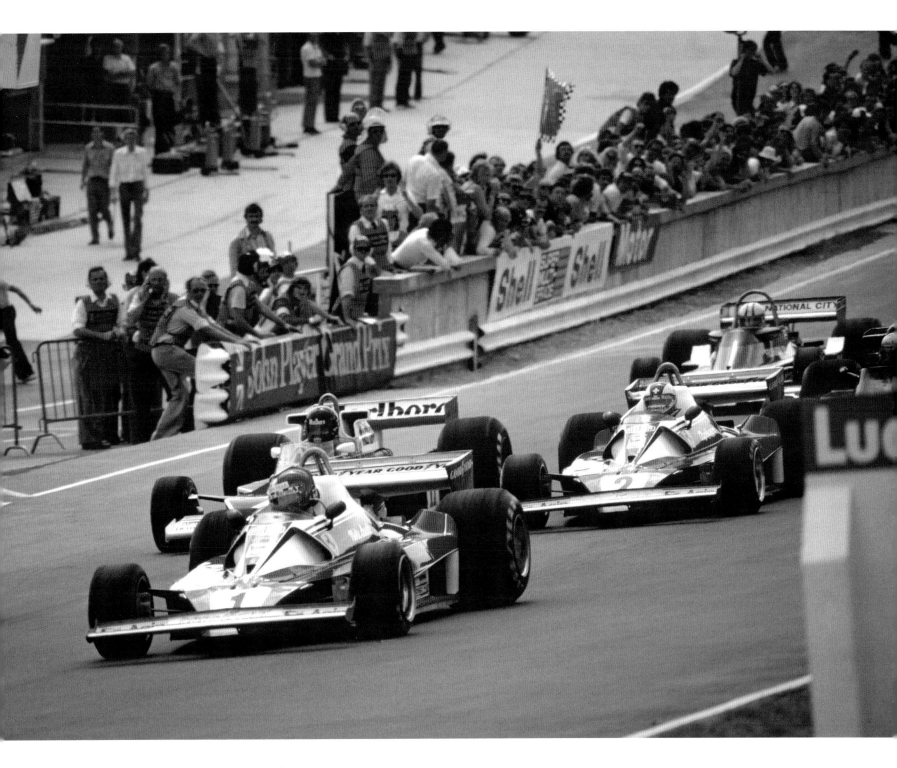

At the second time of asking, Lauda takes the lead while
Regazzoni (2) draws alongside Hunt.

Everything seemed normal as Hunt visited the podium, shook hands with a smiling Lauda and let fly with champagne. Down below, however, Mauro Forghieri was expressing his team's displeasure to Peter Windsor of *Autocar*, the Ferrari technical director eventually joined by Lauda as the tempo rose.

'I tell the stewards that we are going to protest,' said Forghieri. '"Protest about what?" they ask. Look, Niki drive the whole race fighting with a damaged gearbox – probably damaged in the accident – and Hunt wins in a car that was repaired. And he didn't complete the first lap of the race. I think it is disgusting, this race in England. Disgusting. Why they hold up the grid? Just so that Hunt can start his engine.'

'And why did they stop the race at all?' asked Lauda. 'All right, there was a lot of stuff on the track and someone might have been injured. But when I came round on the second lap of the real race there was just as much stuff on the road [caused by a collision between the March-Fords of Ronnie Peterson and Hans-Joachim Stuck at Druids]. Why didn't they stop it then? Because Hunt wasn't involved?'

Hunt stalks Lauda before moving in to attack.

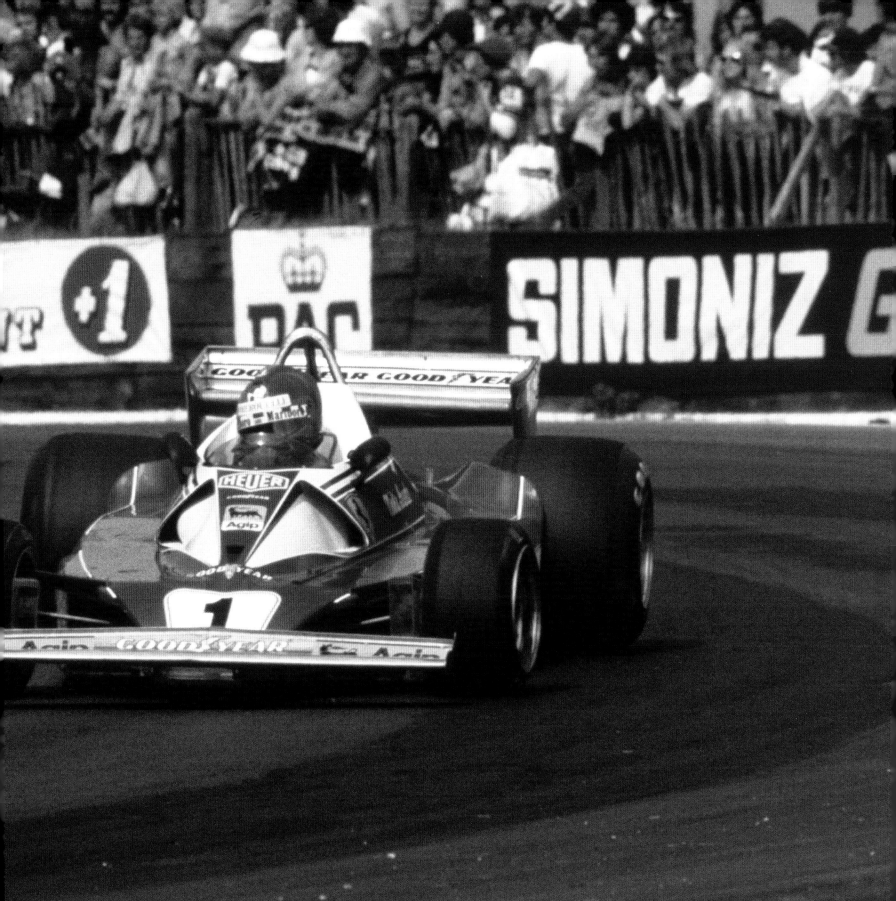

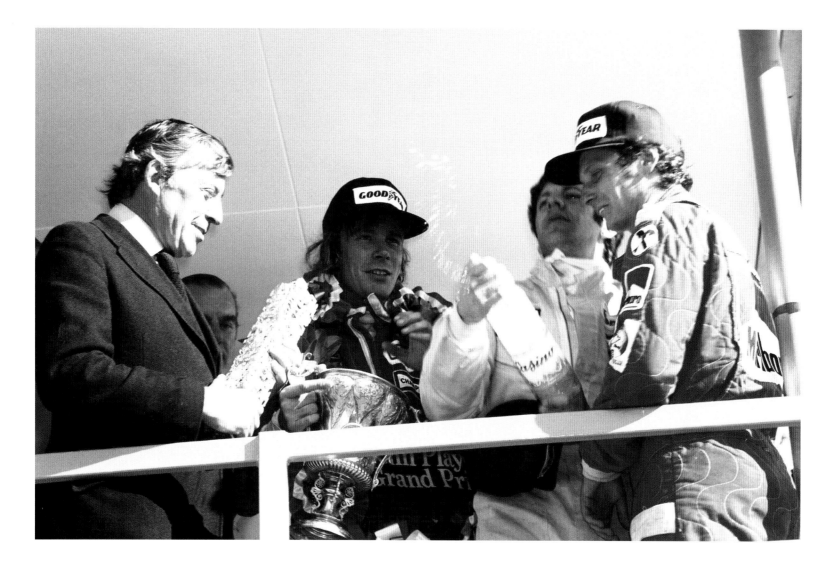

James Hunt

There were protests from Ferrari, Tyrrell and Copersucar [teams with the most to gain as Lauda, Jody Scheckter and Emerson Fittipaldi crossed the line second, third and seventh respectively]. They protested I wasn't running when the first part of the race was stopped. The enquiry was held in the control tower with evidence being given by the observers and marshals. They said their piece and it was quite obvious that I had been running when the race was stopped, albeit slowly and the stewards did

what I thought to be a generous thing. They offered the other teams the opportunity to withdraw their protests, to save face and save their protest fee. Tyrrell and Copersucar withdrew because there was no cause to protest on the evidence supplied, but Ferrari kept their protest in because I don't think team manager [Daniele] Audetto had the authority to withdraw a protest once placed without permission from Ferrari.

Spectators, many of whom faced a six-hour queue to get out of the car parks and join the equally congested local roads (the M25 had yet to be built), were pacified by an eventful day in glorious weather and, in their view, the right result. They knew nothing of Ferrari announcing their intention to appeal. This was serious – but hardly a matter of life and death. That would come two weeks later in Germany.

Hunt celebrates victory on the podium with Scheckter and Lauda.

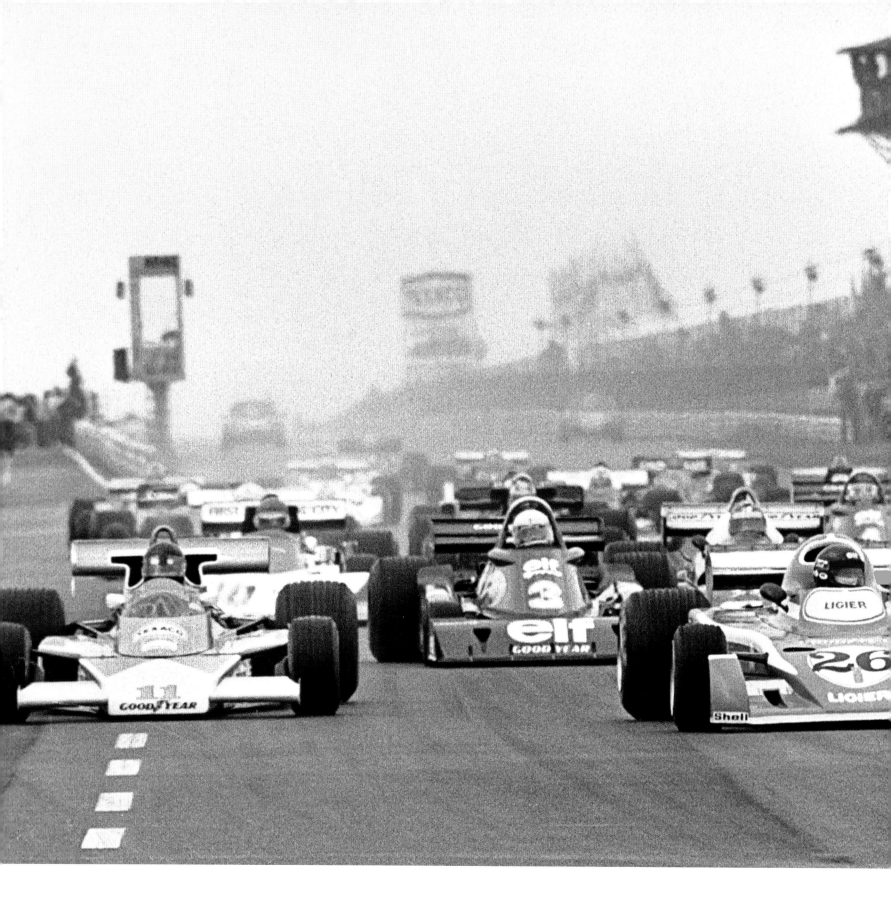

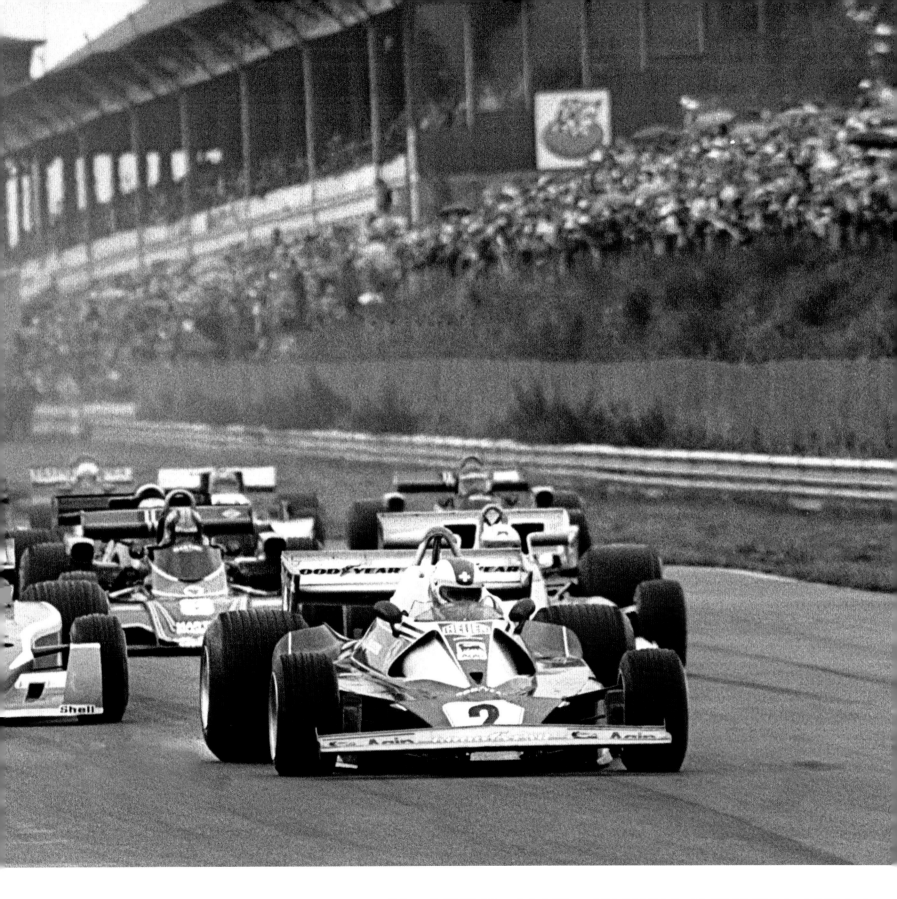

11. 1976 AUG: FIERY GREEN HELL

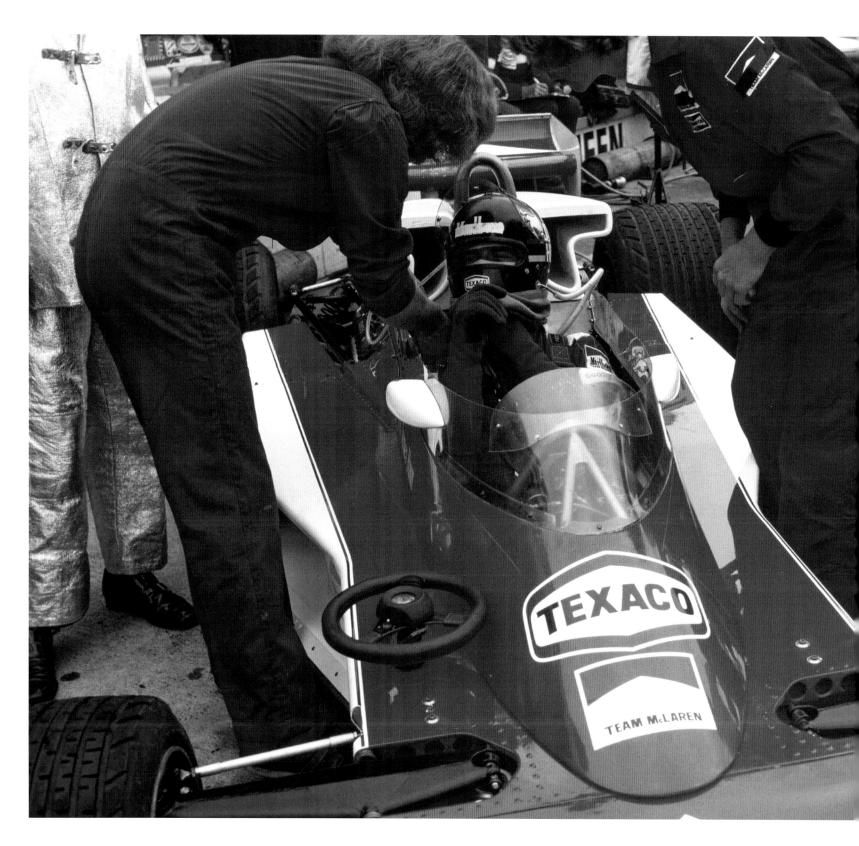

On 2 April 1976, Alex Wittwer was killed on the Nürburgring Nordschleife. The 22-year-old Swiss driver crashed during his first lap of practice for a round of the European F3 Championship. Wittwer was one of many young hopefuls making steps onto the lower rungs of the racing ladder, this being his first outing in F3 and his first visit to the Nürburgring. In terms of racing profile, he was virtually unknown. But in terms of statistics, Wittwer was yet another competitor among a vast number in car and motorcycle racing to have lost his life at the Nürburgring since the opening of the track in 1926. There would be two more fatalities in as many months on the circuit referred to by Jackie Stewart as 'Green Hell'.

Wittwer had crashed at Fuchsröhre (Foxhole), a very fast downhill section leading to a flat-out left-hander where cars would bottom out under compression before rising swiftly towards Adenauer Forst. In 1973, his last year of racing, Stewart described how his feet would momentarily fly from the pedals each time his Tyrrell thumped the bottom of Fuchsröhre at full speed. It was thought that Wittwer had suffered a mechanical failure which, according to *Autosport*, 'caused his car to vault a ridiculously low barrier and crash into the trees some way below.' Wittwer died of a broken neck.

This accident would focus further attention on the perils of the 14-mile track at a time when the F1 drivers were considering a boycott. While drivers loved the unique challenge of the Nordschleife, they were increasingly uncomfortable with the risks at a point in the sport's history when such talk was becoming acceptable rather than being dismissed as pathetic.

Controversy was not new to the Nürburgring. The F1 teams stayed away in 1970 while so-called improvements were made and returned to find that the removal of hedges and bumps had actually made the track faster in places without addressing the major problem of marshalling this leviathan throughout its colossal length.

Stirling Moss, winner of the German Grand Prix in 1961, went back in 1976 for the first time since the changes. Watching practice near the exit of Schwalbenschwanz, Moss was standing at an uphill right-hander, taken in fifth gear. Only a handful of drivers kept their foot flat on the throttle as the car, unsettled by the dip beforehand, wriggled and squirmed under power – much as it had done during the previous ten miles. 'I'm sure this was much steeper, much narrower and I'm certain it was much more enclosed,' recalled Moss. 'You can see the difference the alterations have made. This is bloody quick now, I can tell you. It sorts the men from the boys.'

Ray Grant (left) helps James get strapped in for the roller-coaster ride around the Nürburgring.

The drivers had faced a different sort of call for bravery in the months preceding the race. Wittwer's death intensified speculation that the German Grand Prix might not be held as planned on 1 August. But when it came to a crucial vote, the drivers had not been unanimous, the lack of unity leaving them weak and with no option but to toe the contractual line and perform.

Niki Lauda, an outspoken opponent of the race, was not going down without a fight. The Austrian made his views perfectly clear when talking to Pete Lyons of *Autosport*. 'My personal opinion,' said Lauda, 'is that the Nürburgring is too dangerous to drive on nowadays. Because, if I go to Paul Ricard or any other permanent circuit and something breaks on my car, the wing falls off, the suspension fails, I have a 70/30 per cent chance that I will be alright or I will be dead because of the circumstances of the circuit.

'We're not discussing if I make a mistake. If I make a mistake and I kill myself, then tough shit. If I have been so stupid to make a mistake, to kill myself, this is my risk in motor racing. I have to be fit. I have to be mentally free to drive my car, concentrated on not making mistakes. So, Nürburgring; if you have any failure on the car, hundred per cent death.' The view of his main rival in 1976 was less graphic and more accommodating:

Whether they're frightened of the 'Ring or not, everybody wants to win there. Our main problem is that people think drivers don't want to race there, but that's not true. What we say is that we don't want to drive there unless it is up to the safety specifications of every other track we race on. So we have the problem of making sure the track is safe, but we also have a political problem too because when we ask other tracks to do safety modifications for us they can say, 'Look, you go and race on that bloody Nürburgring without those precautions, so why should we bother?'

I don't particularly want to race under those circumstances but, politically, I feel it's the right thing to do because the drivers' safety committee did give the race organisers a three-year deal that included 1976. If we back down on our deal, our credibility would be seriously damaged at other circuits we have to deal with, which would be a retrograde step and much more serious than just one more race at the 'Ring. When it comes right down to it, you either don't go or you get on with the job of racing. The McLaren team want to get on with the job.

WHEN IT COMES RIGHT DOWN TO IT, YOU EITHER DON'T GO OR YOU GET ON WITH THE JOB OF RACING. THE McLAREN TEAM WANT TO GET ON WITH THE JOB.
JAMES HUNT

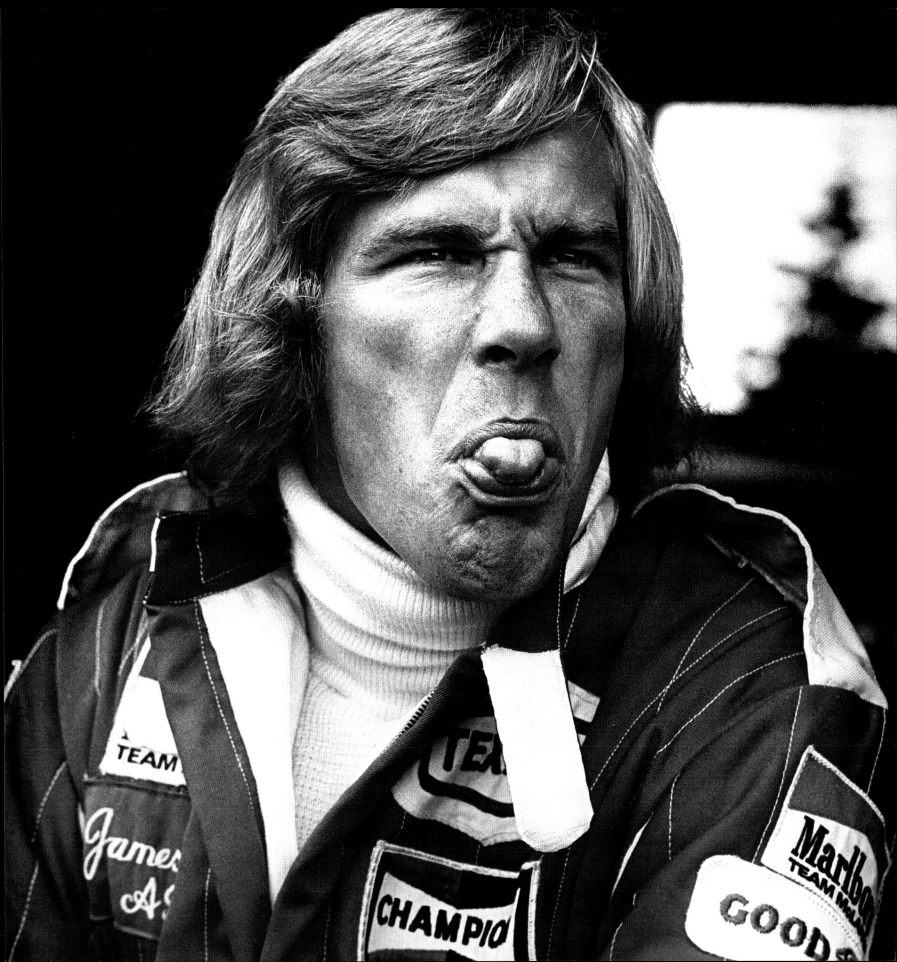

To prove it, Hunt took pole. Lauda, demonstrating that his thoughts about the place would not affect his driving, recorded a time less than a second slower at the end of a spine-chilling lap lasting for more than seven minutes. It was a classic case of mind over matter, a personal asset Lauda was shortly going to have great need of and one Hunt was not afraid to admit he had used during that incredibly brave lap. Hunt admitted he had been scared on at least one third of the circuit while he pushed as hard as he dared.

James Hunt *There are some parts, real fifth-gear sections, where I'm not absolutely sure of what the track is going to do next. But, of course, you've got to try hard at the 'ring. The laps are too long to think about doing anything but. I reckon there's not much more to come; not from me, at any rate.*

Lauda had the added difficulty of fighting his car as well as the race track.

Niki Lauda *The car over-steers like shit. I tried to change it with different camber and damping, but it was the same; worse, perhaps, in the second session. I tried hard, sure; but the car is difficult to drive. I know where I can go flat out, but I haven't worked myself up to that yet.*

The worst fears of Lauda (centre, in discussion with Scheckter and Hunt) were to be realised on race day.

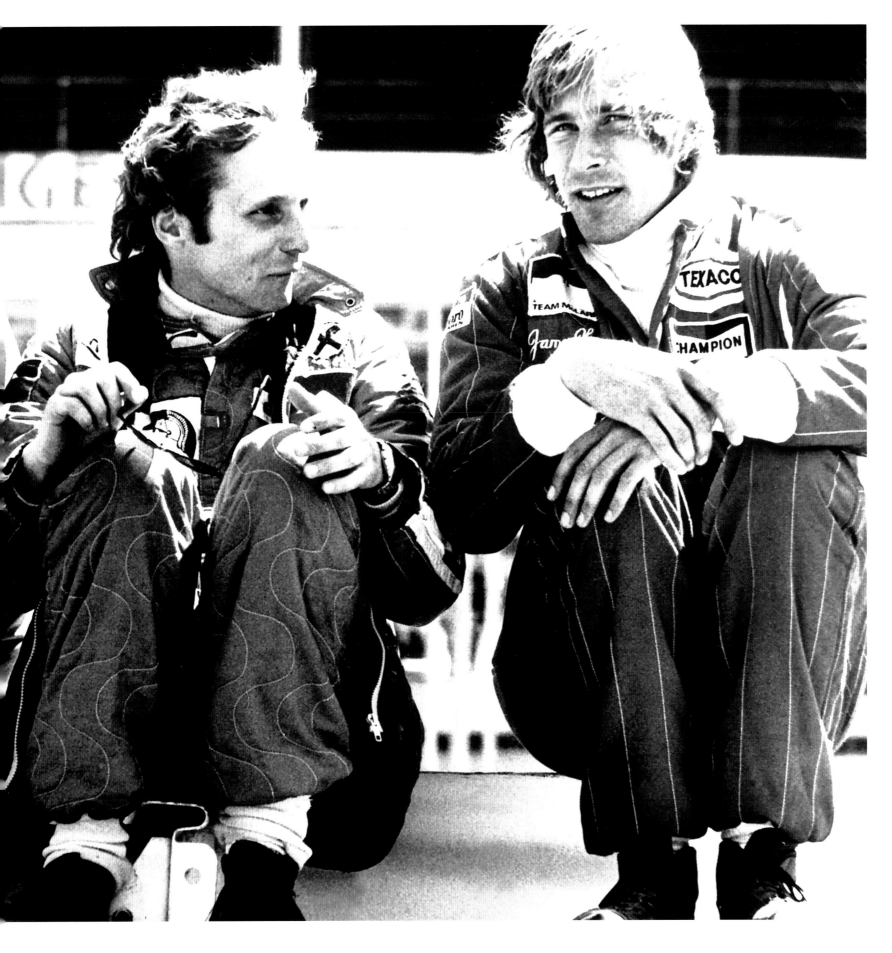

Race day brought an extra challenge, as if it were needed. The morning was dry but threatening clouds were given more time to gather when the 1.30 pm start was delayed. Incidents during a five-lap touring car race had called for repairs to the barriers, all of which cranked up the tension as the F1 drivers attempted to second-guess the weather.

There would be one long warm-up lap followed by a short period on the grid to allow for final adjustments and decisions. By the time the 26 slick-shod cars returned, a stiff breeze from the north-west had brought enough rain to have officials declare it a wet race. The grid was alive with the chatter of wheel guns around every car – except one.

With his knowledge of the Nordschleife and the extra surge of adrenalin produced by support and expectation from his fellow countrymen, Jochen Mass had been stunned by his team-mate's best qualifying lap, a full five seconds faster than his own. Now, as he sat ninth on the grid, he spotted a small patch of blue sky in the distance. This, coupled with a word from Herbert Linge, an experienced endurance racer now driving the official *Rennleitungswagen* (pace car), helped make up his mind. When Linge said that the majority of the track was drying quickly, Mass declined the change to wet tyres. As the race got under way and the field kicked spray on the dash to the first corner, it appeared to be a brave, almost foolhardy decision.

Other drivers understood the wisdom when they got nine miles out at Hohe Acht, where even the circuit's highest point was proving suitable for slicks. There had been much place-changing thus far, Hunt now leading from Ronnie Peterson's March with Mass up to third. A bad start by Lauda had dropped the Ferrari down the order.

Powering along the Tiergarten straight towards the start/finish area, Hunt knew a stop for slicks was necessary. Not wanting Peterson to think the same, James let the March through and then sat on Peterson's gearbox as they entered the final chicane. Focused on staying in front, Peterson was duped into another lap on wet tyres while Hunt dived right and into the pits, where the McLaren crew was ready and waiting.

James Hunt

I saw that Jochen had stayed on dries for the start and I wanted to do the same. But with everyone else on wets, I didn't want to make too big a mistake. Some years before in a Formula 2 race at the 'Ring, the weather had been similar and I was in the middle of the grid on dry tyres when everyone else was on wets. When you're in the middle of the grid, you're not going to win the race if you do the same as everyone else, so I gambled on dries. If it works, it works well. But on that occasion it rained and I came round miles last. This time, I reckoned that if we were all on the same tyres at the front of the grid, I could win the race anyway. But I hadn't bargained for Jochen's decision being quite as good as it was.

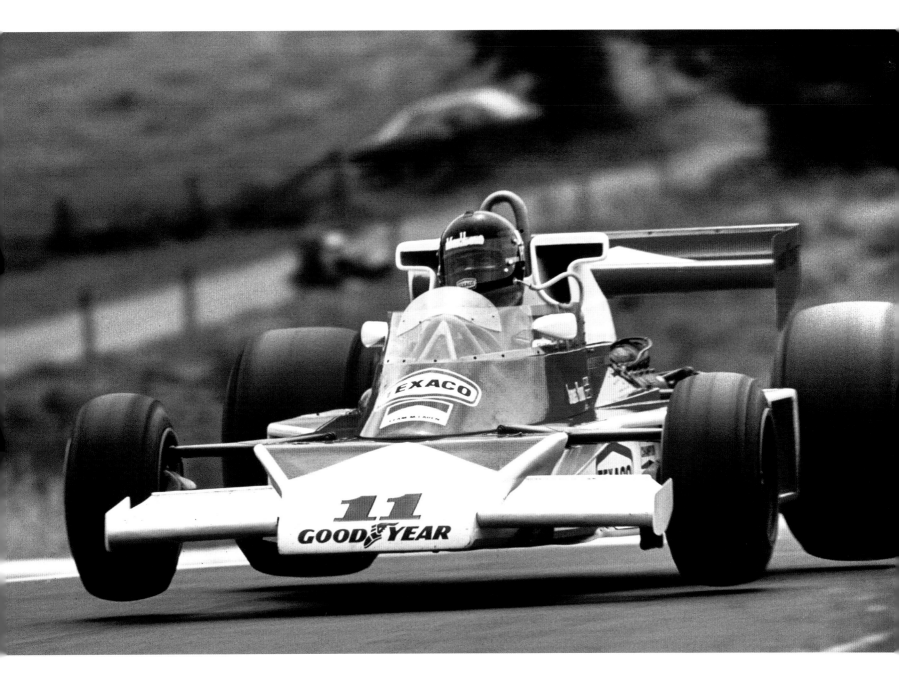

Cars were airborne on several parts of the 14-mile lap.

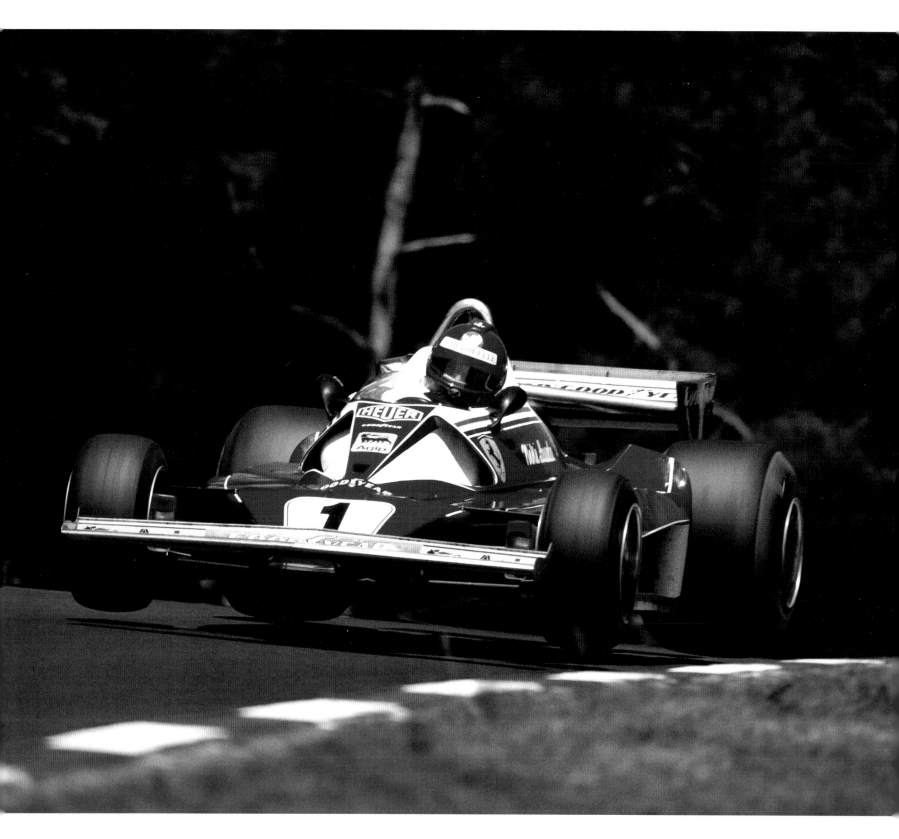

Mass shadowed Peterson for the first half of the second lap before taking the lead. He crossed the line for a second time, 29 seconds ahead of Gunnar Nilsson, who was pushing on with his Lotus still on wet tyres. In theory, the race unquestionably belonged to Mass. But this was the Nürburgring, where anything could happen – and, indeed, only 14 cars had completed that second lap.

Lauda was not among them. Barely recovered from his poor start, Niki had entered the crowded and narrow pit lane for dry-weather Goodyears before rejoining, even further down the field, to start his second lap.

Spectators and team members were accustomed to lengthy silences, a bizarre phenomenon during a motor race and unique to the Nordschleife. The public address system usually operated in fits and starts, commentators at various points barking out the order as the leading cars went by and then saying no more. Nonetheless, a longer than usual period of inactivity brought with it a sense of foreboding, triggering a thought no one really wished to contemplate.

Eventually those growing concerns were confirmed. According to an announcement over the tannoy, Lauda had crashed at Bergwerk, a tightening right-hander at the start of the long climb to Karrussel. In fact, it would later be confirmed that he had left the road while exiting a previous left-hand curve, one so innocuous among so many other tough corners that it did not have a name. But there was nothing mild or harmless about this accident.

The Ferrari had stepped out of line and, just as quickly, flicked right to spear Lauda into the barrier. The impact ripped off the car's crash structure on the left-hand side and sent the Ferrari, now on fire, with its fuel tank exposed, spinning into the middle of the track. The Hesketh-Ford of Guy Edwards managed to squeeze though on the left but Brett Lunger's Surtees-Ford could not avoid the Ferrari, slamming into wreckage now well and truly ablaze, its driver unconscious in the cockpit. And to add further mayhem, the Hesketh of Harald Ertl piled into the back of the Surtees.

Lauda's worst fears over safety at this track were realised when no marshals were present. Fortunately, a number of drivers had stopped and waded into the fire, eventually pulling Lauda clear. His crash helmet had come off in the process. Not only was he badly burned, but he had inhaled noxious fumes from the burning fuel and car. Hunt, having been about a mile ahead of Lauda, knew nothing about the accident. It would be no consolation to realise that the race being stopped had relieved McLaren and Hunt of a dilemma.

I KNEW NOTHING ABOUT THE ACCIDENT. I WAS INTO THE THIRD LAP WHEN I SAW THE 'RACE STOPPED' FLAG SIGNALS.
JAMES HUNT

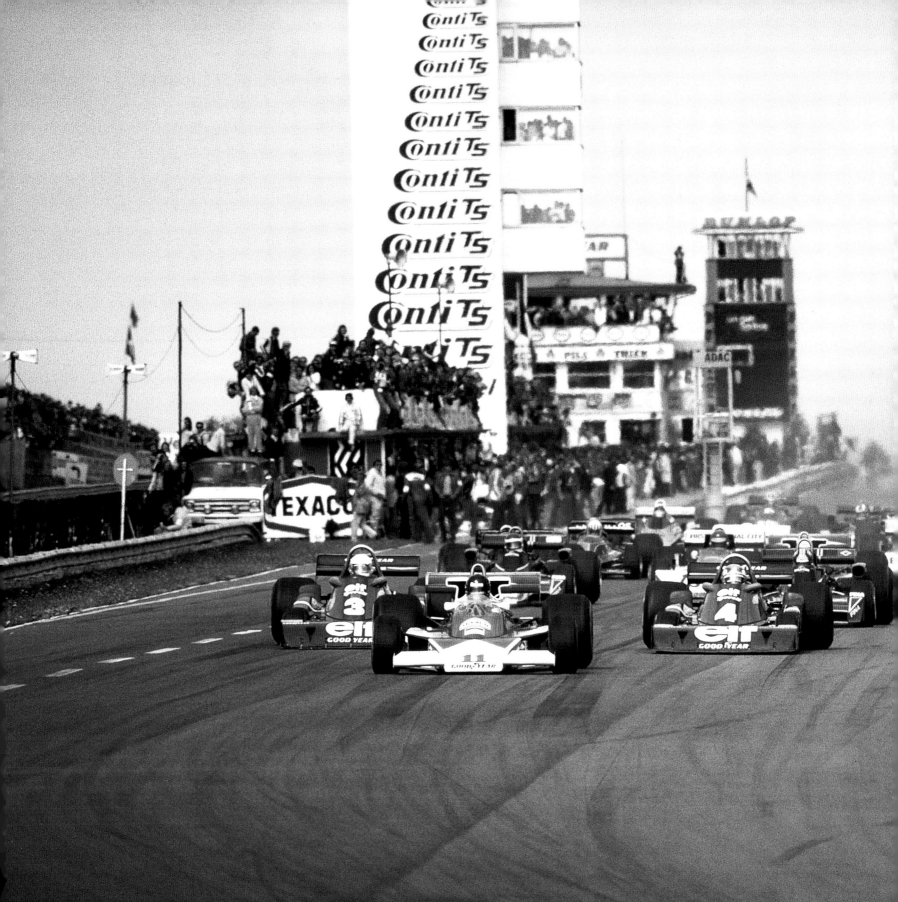

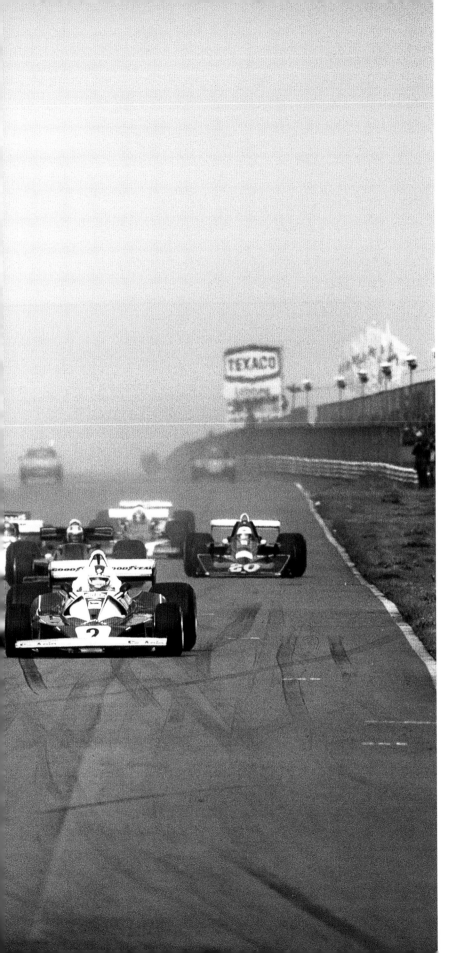

James Hunt *At the end of the second lap, I was 45 seconds behind Jochen. I was apparently lapping fast enough to catch Jochen before the end of the race and there was already a panic in the pits because I needed a win! Alastair [Caldwell] was asking Teddy [Mayer] how they could stop Mass on his home track. It was a waste of time for the pit crew to hang out a signal 'LET JAMES WIN'. You just couldn't do it. My sympathies were entirely with Jochen. He'd had a pretty mediocre season up until then, here was his big moment and he was really going well. In the same sort of situation, I wouldn't have slowed down for anybody!*

I knew nothing about the accident. I was into the third lap when I saw the 'race stopped' flag signals. I eased up and there it was, with all the cars stopped. Niki had gone by this time and I chatted around with the other drivers to find out what had happened. I was told the car had been on fire but he had got out of it, talked to one or two of the drivers. He was burned a little around his face and wrists but it didn't look serious and everything was fine. Niki was off to hospital and obviously wouldn't be racing again that day but he'd have his burns patched up and we'd see him [at the next race] in Austria. That was the story we had then.

It was still the story when we were getting ready for the restart. There was a suggestion that he had a broken cheekbone from a smack on the face and then it was said his helmet had come off and that was how he had come to be burned. But there were no alarm stories and, at the time, it was evidently not serious at all.

James was in good spirits as he climbed back into his M23 and prepared for the restart knowing there would no dithering over tyres since the track was completely dry. In the short time it took the remaining 20 cars to negotiate the South Curve and accelerate behind the pits before heading into the forest, Hunt had as good as won the race. He built on his flying start by driving as close to the limit as he dared for the remaining 13 miles. As the McLaren crossed the line, the team measured the ten-second gap to the Brabham-Alfa Romeo of Carlos Pace and then relayed the good news from a board as Hunt flashed past the back of the pits.

At the restart Hunt leads the Tyrrells of Scheckter (3) and Depailler, with Regazzoni's Ferrari on the right, into the first corner.

Ray Grant

We would be hanging the boards out over the back at the start of every lap. At one point, Lance Gibbs [a mechanic from New Zealand] dropped all the numbers onto the track and he just climbed over the fence to pick them up. After the race, Jody [Scheckter] came by and asked what one of our guys was doing down the track as he went by! You wouldn't get away with that now.

James Hunt

It was a good feeling to see the pit board at the end of the first lap. It feels good to have ten seconds in hand on the first lap of the 'Ring. When I went off at the start I had put in a blinding first lap and the others were mucking each other about, spinning and falling about all over the place, which helped me, so I virtually had the race won by the end of the first lap, unless someone was going to go immensely quickly after that. It was only a matter of controlling things from the front, which in fact was quite difficult because you've got to keep the pressure up at the 'Ring because the lap is so long and you don't get the steady feed of information you get at other tracks. The point is that if you ease up at the 'Ring, what was a ten-second lead could easily be five seconds by the end of the lap and five seconds isn't a lot for another driver to pull back in 14 miles, so you've got to keep pressing on. I felt sorry for Jochen [destined to finish third], as well as for Niki, because in the first part of the race Jochen had really done everything he could out in the lead and it was a sort of testimony to his luck that the one time he really put it all together, fate intervened and ruined it for him.

Looking back, that was a win I was very proud of, the one downside obviously being what had happened to Niki. I was pleased with the way I had won the race and that first lap really thrilled me. That's the thing about the 'Ring; I really loved that track. To drive a car that handled well around there was really a special joy.

Hunt had given McLaren their first victory at the Nürburgring but celebrations would gradually be muted as firm news of Lauda's condition finally became available. The Austrian was in a special burns unit in Mannheim, fighting for his life. James was not alone in believing he would wake on Monday morning to news that his great rival was dead.

James Hunt

We knew he was in a very bad way indeed. We were very concerned but there was little or nothing one could do. I couldn't visit him so I went home and sent him a telegram. I can't remember what it said but it was something provocative to annoy him and then it told him to fight because I knew if he were annoyed and fighting he would pull through. If he relaxed and gave in, he would probably die. You've got to stay conscious and physically fight it yourself and I knew Niki would be aware of that. It was suddenly very important to me that Niki should live, in a way that I hadn't realised and I felt awful because there was nothing I could do about it. There I was, sitting at home and enjoying life even when I didn't particularly want to … when I wanted to go and help or do something and I couldn't. It was a strange time for me.

In these circumstances, it was inconsequential to note that Hunt had reduced the deficit on Lauda to 14 points. The important question was whether or not Lauda would live, never mind defend his championship lead in the remaining six races.

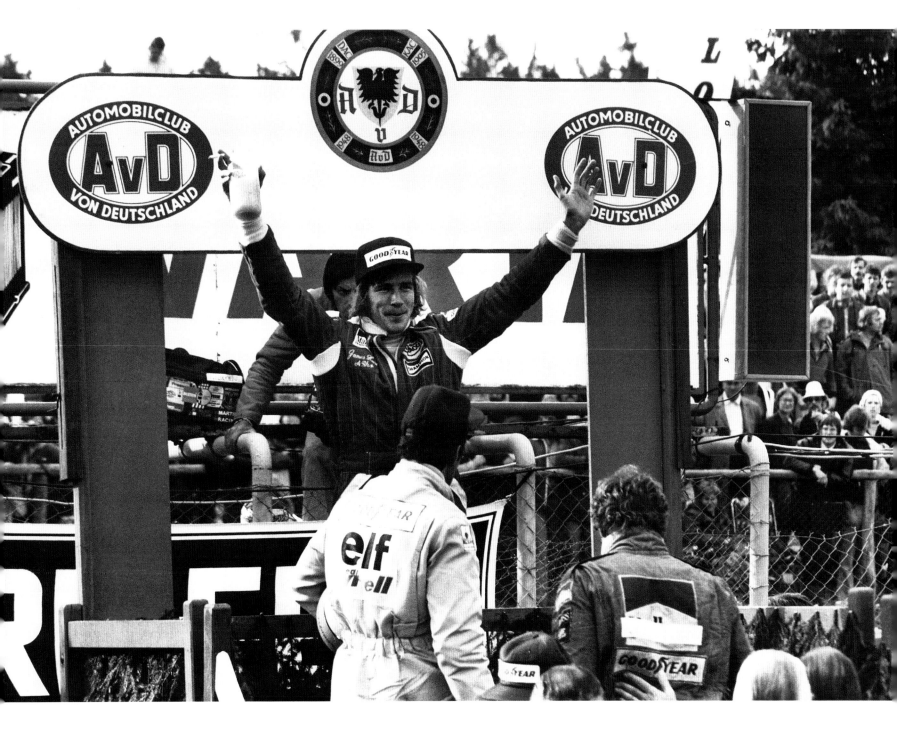

A cigarette and a very satisfactory win. The full extent of Lauda's injuries had yet to be realised as Scheckter (left) and Mass join Hunt on the podium.

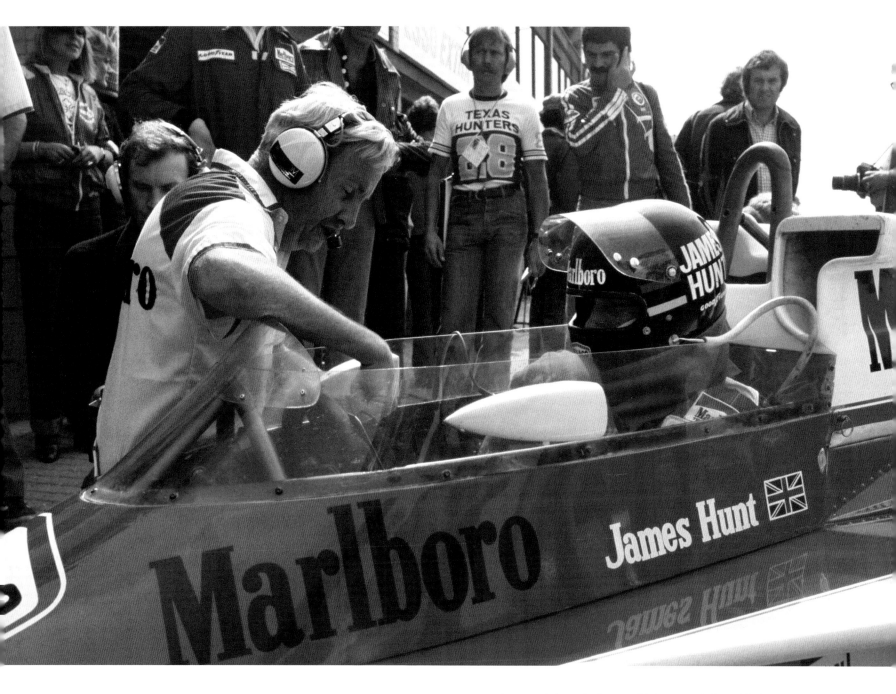

Mayer and Hunt needed to make the most of their opportunity in Lauda's absence.

Enzo Ferrari withdrew his cars from the next race in Austria. It was a classic move by the irascible dictator; another Machiavellian tactic contributing to the mystique Ferrari encouraged while asserting such decisions were perfectly rational. His claim that the move was in sympathy with Lauda's condition did not ring true, coming as it did from a team boss who regarded his drivers as mere employees – and sometimes not even that.

The 'Old Man' would be truly exposed as a mischief maker when he then suggested the Austrians should cancel their race altogether as a token of respect for their fellow countryman. The organisers of the *Raiffeisen Grosser Preis von Österreich* were outraged. Having the reigning world champion absent largely through no fault of his own was bad enough; a complete no-show from Ferrari would mean fewer racing fans would now make the trip from neighbouring Italy. The half-full spectator enclosures were then soaked by rain that fell almost continuously during the two days of practice.

The only break in the weather came during the first session on Friday morning. Hunt was fastest, which was no surprise since McLaren had been one of the few teams to trek all the way to the majestic surroundings of the Österreichring for a test session.

Much of the time at the 3.6-mile track had been taken up with testing the latest McLaren, the M26, a completely new design that was giving problems with the fuel pick-up. In the event, the M23 was proving to be handy enough even though James was continuing to complain about understeer.

With Ferrari absent and either Tyrrell or Ligier expected to come closest to the McLaren, it was a surprise – albeit a pleasant one – to find John Watson parking his Penske-Ford on the outside of the front row. Apart from Watson and Penske being a popular combination working diligently at making a success in F1, it was a timely performance for a small team that had suffered their lowest moment at this track 12 months earlier, when Mark Donohue died of injuries following a crash at the Hella Licht Kurve.

The first corner had since been modified to provide slightly more run-off at the point where the American driver's March-Ford had left the road. Since then, the British-based team had built their own car, one that was clearly well suited to the fast sweeps of this track in the Tyrol.

James Hunt

John [Watson] was one of the good drivers to race against. Fast, tough, always a competitor, a man to beat on his day. But one of his problems had been that the Penske team didn't have the reliability you need in F1. That usually cost Wattie valuable time in practice as well as results in the races. It was a problem of newness – we had it at Hesketh and we had it licked by the time they packed up. But we knew Watson and Penske would be a force when things came together.

That would prove to be true as Watson and Hunt sat it out on the climb to the first corner, the Penske leading as they completed the opening lap. By lap ten, James had been overtaken by Peterson's March and the six-wheel Tyrrell of Scheckter.

James Hunt *We had played with the car and I wasn't all that happy with it. We had an understeer problem on full tanks again. I thought we had cured that before the race started but it was getting worse and I was having a real struggle to stay on the road.*
Jody [Scheckter] *had an enormous accident at the top of the hill beyond the pits on the 14th lap when the front suspension broke on his car. I went skating through all the mud and debris from that, but it was obvious that whatever was wrong with my car wasn't anything to do with the debris from the crash.*

Hunt would hang on to finish fourth, and considered himself lucky to gain the three points. Proof of how hard he had worked came with fastest lap, 0.35 seconds ahead of anyone else. Examination of the car, post-race, would show the left-front wing had been hit from underneath with a force strong enough to flatten the nose tabs and create a hole. Mud in the hole suggested this had happened before running through the debris of Scheckter's accident. Hunt concluded he must have collected something during the busy first lap, battling with Watson.

The Ulsterman went on to win his first Grand Prix, a result that was well received, not only in the Österreichring paddock but also in a hospital room in Germany. Watching the race on television, Lauda was delighted that Hunt had not made more of the Ferrari driver's absence.

After four days in intensive care, Lauda was at the start of a very painful road to recovery that included extensive skin grafts and lung-searing suction. But as far as he was concerned, Hunt remained a championship rival in the sense that this battle was by no means over. The points tally showed Lauda 58; Hunt 47.

A more important number for James would be 29, the date of the next race in August and, coincidentally, his 29th birthday. Ferrari were back and the Italians brought more with them than a single car for Regazzoni to race at Zandvoort in Holland. From the back of the transporter came a set of tyres saved from the Nürburgring. Apart from going against a gentlemen's agreement among team owners to use only the standard tyre presented at any given race by Goodyear (suppliers to every team in 1976), the naughty tactic was exacerbated by the tyres from Germany being softer than those on offer in Holland. Irritation came close to outrage when the tyres were fitted for qualifying and Regazzoni shot from 16th to fifth on the grid.

Hunt was more concerned about Peterson as the Swede took his first pole position in more than two years. While dealing with the March, James would also need to keep an eye on Watson, brimming with confidence directly behind the McLaren, and not forgetting Tom Pryce in the Shadow-Ford. The Welshman made it three UK drivers in the top four but there could be no doubt that Hunt, pictured on the cover of the race programme, was the focus of attention, even beyond the UK. With stories emerging that Lauda might actually make a comeback, it was imperative that James had no distractions on his way to the hoped for maximum points.

With the top 14 drivers covered by a second, that might be easier said than done. The race was shaping up to be another close encounter. Peterson ensured that would remain the case as he took the lead on the short run to Tarzan corner, Watson and Hunt pushing the March through Gerlachbocht, up Hunserug and on to the dramatic, sweeping turns through the sand dunes. But the key to overtaking at Zandvoort would be a quick exit from the final right-hander, followed by a clean, slip-streaming run down the long straight, before late braking into the positive camber of Tarzan.

Watson made a couple of attempts, Peterson squeezing him wide enough on the exit on one occasion to allow Hunt to slip past the Penske and demote Watson to third. By lap 12, Hunt was in the lead as Peterson struggled with crippling understeer and an oily track, Watson forcing the March back one more place a lap later.

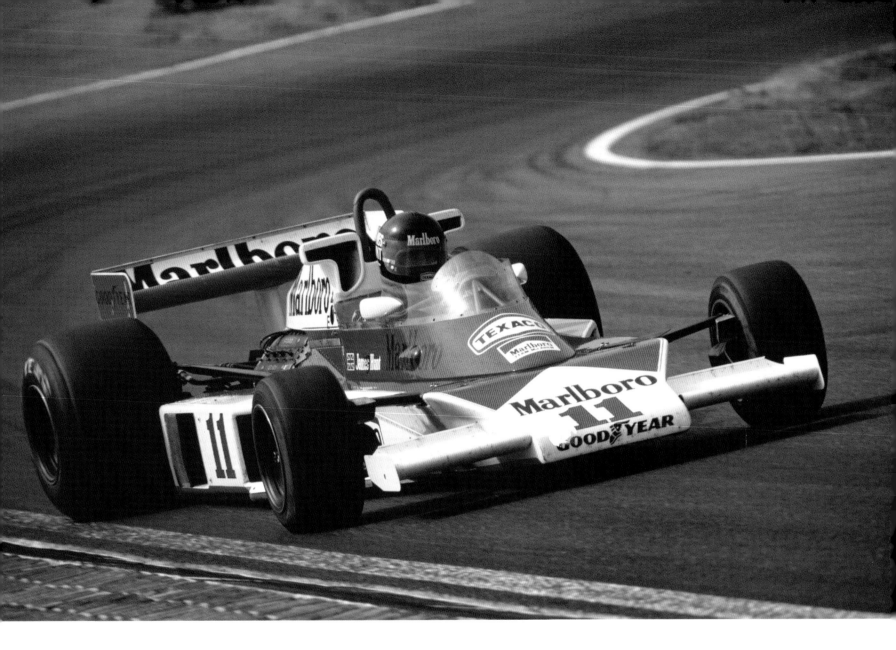

THE YEAR BEFORE I HAD FELT
I WAS UNDER PRESSURE
LEADING – AS YOU WOULD
WHEN TRYING TO WIN YOUR
FIRST GRAND PRIX.
JAMES HUNT

The stage was now set for a gripping contest as Watson, his Penske improving with each lap, took on Hunt, his McLaren doing the opposite as the dreaded understeer gradually returned. With Hunt defending the inside line, Watson attempted to run round the outside, only to find there was no grip to be had in the sand as he was forced up and over the kerb at the exit. Time and again, Hunt engaged in robust defence, before Watson chose to sit tight and wait for a mistake as James grappled with his handling problem. Watson's belief that he would eventually get by was shattered along with a gearbox bearing, causing the red, white and blue car to coast to a halt just before two-thirds distance.

Any hope of a respite for Hunt was compromised by a front brake duct coming loose and exacerbating his handling problem. As the final laps counted down, Regazzoni's Ferrari closed in, but Hunt took the chequered flag – by just 0.9 second. It was his fifth Grand Prix win and the second in succession at Zandvoort.

More Texaco fuel for Hunt's M23 while Mass runs the M26 in the background.

Opposite page: After a keen battle with John Watson's Penske, Hunt takes a much-needed nine points at Zandvoort.

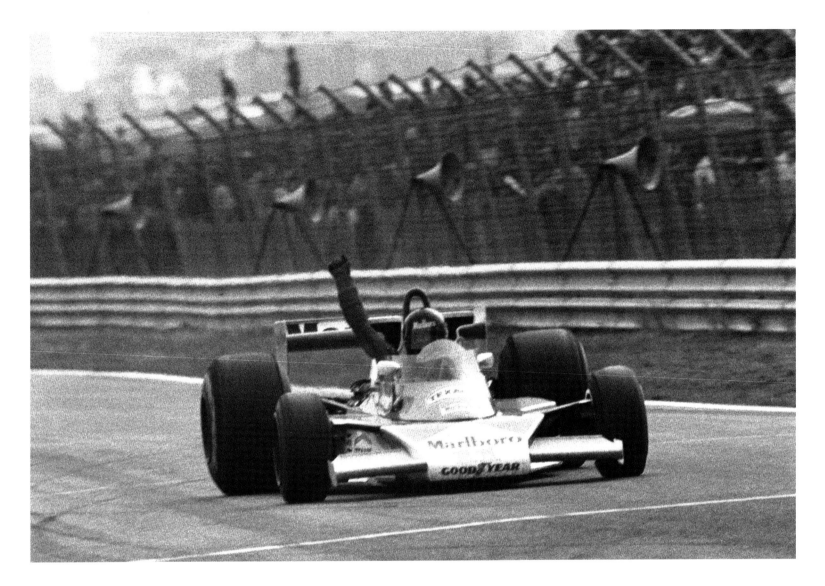

James Hunt

The year before I had felt I was under pressure leading – as you would when trying to win your first Grand Prix. But this time I felt relaxed leading and under pressure if I was not. That's a good way to feel because you're in command, in charge.

I actually didn't do any serious passing of anyone during the whole race. I had nipped past Watson while he was still recovering from a big go he'd had at Ronnie. Then, when someone [Conny Andersson in a Surtees-Ford] had blown up and dropped a lot of oil at one corner, Ronnie slid very wide and I simply drove quietly past him on the line. I didn't really overtake him at all.

That put me in the lead which was the best place to be because I had a real problem with understeer, now aggravated by the front brake duct flapping around and interfering with one of the front wings. It meant the onus was on Watson to get past me – if he could. I think if he had done

that, he would have left me. I was forcing him to go the long way round [at Tarzan] and he never quite made it. Past the pits I was tucking in close to the wall because if I'd given him room there he would have been down the inside and gone.

I then had a fight to the finish. I had been something like ten seconds ahead of Regazzoni and I didn't want him to get within reach. The handling was getting worse and I was in a panic. It was too close for comfort in the end – but I made it.

Familiar territory as Hunt returns to the top of the podium at the scene of his first Grand Prix win in Holland.

Lauda and Hunt were now separated by just two points. It was metaphorical icing on an actual birthday cake baked in the shape of the track at the behest of the race organiser. James's mother was there to share it, having made her first trip to a European race and joining thousands of British fans who were making the most of the following day being a bank holiday Monday.

There would be no respite for James, however, as recorded by Philip Tingle of Stockton in a letter to the correspondence page of *Autosport*. 'Further to the adverse correspondence regarding the attitude of Formula 1 drivers towards the paying public,' wrote Tingle, 'I have been driven to put pen to paper to write in praise of one of these drivers. I was present at the Texaco Battle of Britain race meeting on bank holiday Monday at Croft autodrome and was pleased to see James Hunt fresh from his triumph at Zandvoort on Sunday, starting races, doing a lap of honour, giving radio interviews and, most of all, signing endless autographs for literally hundreds of people, many of whom were obviously at their first race meeting purely because of his presence.

'While realising his contractual obligation to Texaco,' continued Tingle, 'I feel that this obvious effort on his part to please the crowd at a circuit which rarely hits the headlines any further south than York or Leeds, was a praiseworthy effort indeed and look forward to James becoming a very well-deserved world champion.'

Writing from a professional standpoint in the same publication, Nick Brittan carried a similar sentiment in his column. Under the title 'Private Ear' – based on the magazine *Private Eye* – Brittan employed the same mischievous sense of the scurrilous when poking fun at the good and the great of motor sport. On this occasion, however, acerbic prose made way for a flowing eulogy about Britain's latest sporting hero. Under the heading Anatomy of a superstar, Brittan wrote:

'James Hunt is a superstar. James Hunt is a folk hero. James Hunt is a cult figure. He's all of these things and more besides. He's the National Hunt, the instant headline-grabber. In two years he's rocketed from relative obscurity to become the most celebrated figure in European motor racing. He accelerated through the famous racing driver phase to become an international celebrity.

'Today he enjoys more fame, acclaim and notoriety than ever were visited upon Graham Hill, Jackie Stewart and Jimmy Clark put together. How has all this happened?'

Brittan goes on to describe a chain of events that 'could never be repeated', citing Hunt's time with Hesketh, the timely vacancy at McLaren and the headlines attracted by the break-up of his marriage. 'It was at that point,' wrote Brittan 'that he ceased to be a famous racing driver and became an international celebrity. Then came the front-page ink with the win and disqualification from the Spanish Grand Prix. Press, radio and TV dealt blow-by-blow reports for a week. The nation began to care about James. My wife's hairdresser knew and cared. My milkman asked for progress reports.

'Then came the Texaco Tour and James's arrogant and prima donnaish behaviour after his retirement and his run-in with the police made news yet again. Here was the element of [world No. 1 tennis champion Ilie] Nastase coming through.

'*The News of the World* took us into his bedroom and revealed the secrets of his sex life. It was [soccer star] George Best all over again – but better.'

Brittan then covered the Albert Hall trumpet solo when Hunt was 'the only one of the bunch capable of entertaining an audience', the British Grand Prix uproar, Richard Burton marrying the former Mrs Hunt, Lauda's crash and Hunt's appearance on posters at every Texaco filling station across the nation.

'It is possible,' continued Brittan, 'that this chain of events could have happened to any one of the other current crop of drivers. But none of them would have carried it off with the élan, the charm, the pizzazz and the style that James has. Whether you like or hate him doesn't matter. You have to accept that he is not only the cult hero of motor racing – he's the only one we've ever had. People must have divided opinions in order that you become worthy of discussion, adulation or ridicule.

'James is flash, he's arrogant; he's eloquent, intelligent and articulate. He has that confident cockiness that is the inheritance of the British public school education. Female fans queue for his autograph while other drivers provide scrawls for spotty schoolboys. Half the eligible women between Mosport and Malaga appear to want to get their hands on him.

'Unless I'm much mistaken,' concluded Brittan, 'he's your 1976 world champion too. And much luck to him with it. He'll enjoy being world champion. He'll do a good job. For too long our sport has needed a man up front who looks and sounds like the public expect a professional racing driver to be.'

Brittan may have been in the field of public relations and driver management (Watson and Scheckter from the world of F1) but he had no axe to grind; no hidden agenda to his message. The column was a genuine summary – but incorrect in the final paragraph. The 1976 championship would not be a given. Hunt's world was about to be turned upside down once more – and that was without the distraction of his increasingly respected rival, 'The Rat', making a truly remarkable comeback at the next race.

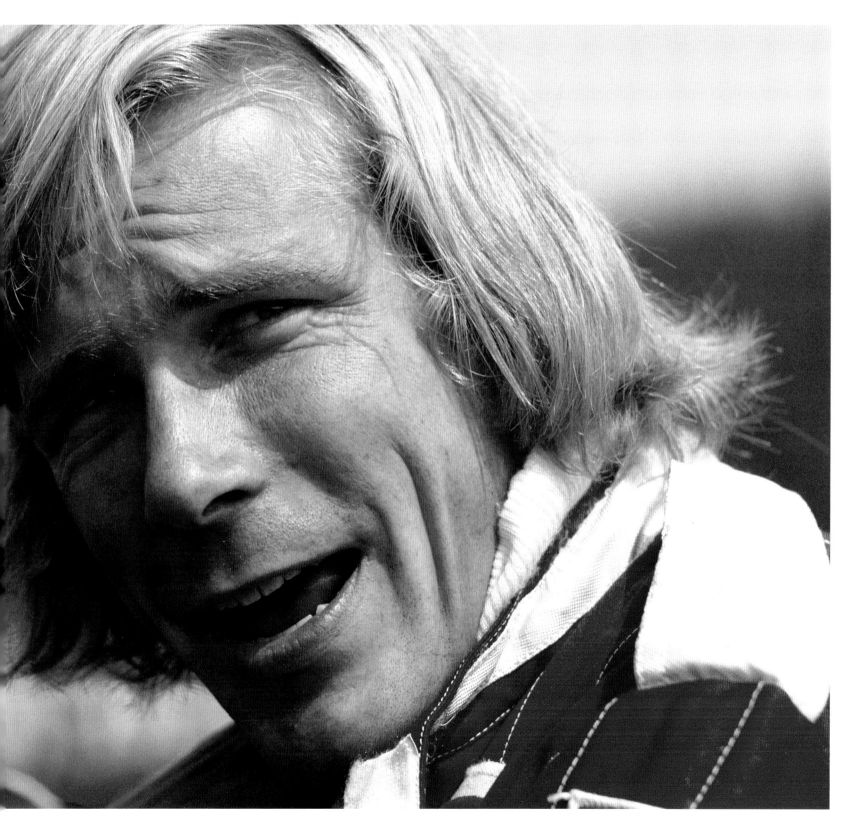

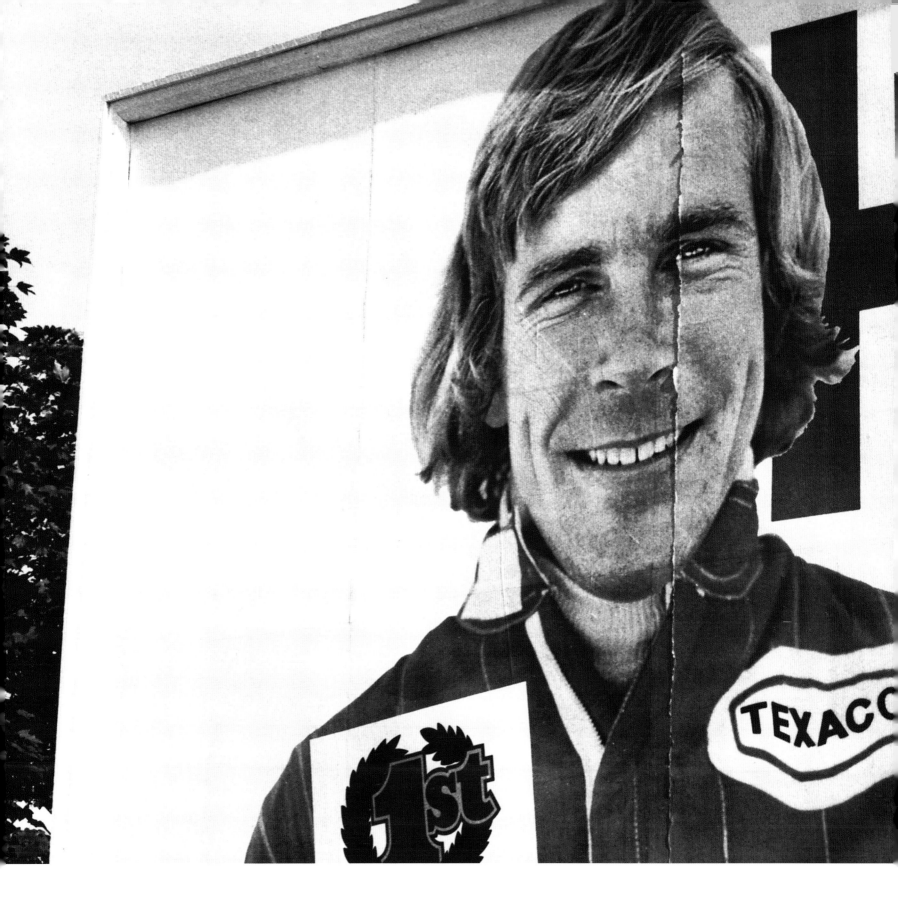

Grands Prix at Monza generate enough colour and drama to fill a book on a normal race weekend. In 1976, the Italian round of the championship went into overdrive. UK journalists did not know which way to turn. There was the continuing story of James Hunt's bid to win the championship but, better than that and with the greatest respect to the English hero, there was the return of Niki Lauda.

As comebacks go, this one was immense, charged with the emotive theme of a driver virtually coming back from the dead, six weeks after he had been given the last rites by a priest in a German hospital. Added to that, he was doing it in a Ferrari. At Monza. And, typically, Enzo Ferrari had added to the ferment by signing Carlos Reutemann to join Regazzoni in the belief that Lauda would not be back.

He was back – bloodied head bandages and all. Throw in a hugely partisan crowd and the crackle of tension, excitement and expectation could be felt a mile from this classic venue. It's fair to say that in all of Monza's many Italian Grands Prix, none had presented a cocktail quite as potent this one.

David Benson was quick to seize the moment once he heard rumours of Lauda's return. The *Daily Express* correspondent stole a major march on his rivals by joining Lauda on his eight-seater Golden Eagle II plane to fly from Salzburg to Milan. In an exclusive for the newspaper, Lauda explained how he was not the type to sit still. If there was half a chance he could drive, he would take it.

As if the return of the bandaged and scarred Niki Lauda was not enough, Enzo Ferrari added to the drama at Monza by having Carlos Reutemann (left) join the team.

James Hunt

When I heard this, I was not surprised. I could understand why Niki wanted to get back and race. You have a lot of time to think in hospital and, once he had decided to come back, he had to get on with it. He had a terrific amount of motivation, too, because he was leading still in the championship and he really wanted to win it. It was a massive stimulus to get back and get stuck in. Here was a challenge and he accepted it.

Lauda was aware of the reception that was waiting in Italy and at Monza in particular. With that in mind and needing freedom to go at his own pace as much as possible under such difficult circumstances, he planned to keep a low profile. Secreted in a small hotel far from the team and the crowds, Niki was doing his best not to dwell on Ferrari politics and the unwanted complication of entering three cars when two seemed more than enough for a team driven all too often by emotion rather than calm reason.

McLaren, feeling beleaguered and threatened, positioned the Texaco-Marlboro truck and motorhome in a fenced-off enclosure in the paddock and employed round-the-clock security guards, a move that accelerated rather than quelled an England-versus-Italy tension that seemed to have exploded out of all proportion. Then, just to crank up the drama another notch, James spun and damaged a nose cone during the opening lap of a wet first practice. News of this was broadcast loudly and engendered zero sympathy from the crowd.

This was part and parcel of practice and the team could deal with it. But they felt increasingly uncomfortable with the booing and catcalling from the stands each time Hunt appeared in the pit lane or out on the track. Above all, though, McLaren did not know what to make of word that officials might carry out rigorous fuel checks.

There had been increasing rumours, generated largely in Italy but also heard earlier, that McLaren and Texaco had been doctoring the permitted pump fuel over and above the allowed limits. One

suggestion (never proven) was that nitrous oxide, carried in a fire extinguisher, was being added to the mix.

Stuart Dent

Apart from the incredible crowd reaction at Brands Hatch, the other instance that sticks firmly in my mind about the British Grand Prix weekend is an announcement that came over the PA during practice/qualifying: 'Would anyone who has found the fire extinguisher which became detached from James Hunt's McLaren during the last session (around Dingle Dell, I think), please return it to

McLaren in the paddock where a reward of £25 will be forthcoming.' Pardon? An extinguisher, which has apparently bounced down the track at over 100 mph and wrecked itself in the process, is worth 25 quid to the team? It's struck me as odd ever since.

The hapless Penske crew look on as officials take fuel samples to join those extracted from the McLaren pit.

To put 1976 values in perspective: admission to Friday practice was £1; race day £5; programme 50p. The cheapest general admission ticket for the 2016 British Grand Prix was £135. There would be a similar incident at the US Grand Prix, when McLaren put out a public address appeal for the return of a wayward fire extinguisher, another curious request that would add to a sense of suspicion about the use of nitrous oxide which was subsequently denied many times over by the team.

Ray Grant *I don't recall anything like that and I can't see how that would happen. The fire extinguishers on our cars – including the M23 – were inside the cockpit. A lot of teams used to carry them at the back of their cars in the early days but ours were always in the car, under the driver's legs. There was a little, grey life-support bottle up on the roll-over bar. And because we were one of the first teams to use an air starter, there was quite a big bottle which was hung out the back. There was one occasion when that came loose and dangled along: I think it nearly took a Tyrrell out! But I don't recall anything like that to do with a fire extinguisher.*

With so much at stake at Monza, however, neither the team nor its fuel supplier were prepared to take even the smallest risk. A hint of what might be in store came when the Texaco truck encountered problems for no obvious reason at the Italian border. Then came more definitive action late on Saturday afternoon.

On the orders of the Italian Automobile Club, as part of what they referred to as 'a strong line on the regulations – in everybody's interest', fuel samples were taken from various teams in the pit lane. Among them were McLaren and Penske. The samples were taken away to be analysed at the laboratories of SNAM, a natural gas infrastructure company.

Nothing was heard until race morning, when the organisers called a conference in the tiny press office. They announced that the readings showed McLaren's fuel to be 101.6 octane; Penske's registered 105.7. According to the FIA, the highest permitted level for F1 was 101 octane. Ferrari had registered 98.6 octane.

James Hunt *We were all set for a grandstand finish and then the Italians attacked. We knew that the car would be checked and we knew that the fuel would be top of the checklist so we had gone to great pains and precautions in full liaison with Texaco to make absolutely certain that our fuel was legal. The Italians said ours was 101.6. In fact, when checked by Texaco in their laboratory it was 101.2 but it didn't matter because you work to units of one octane and we were within the same unit, so that was irrelevant apart from the inefficiency of the checking method. The rules stated very simply that you can use the top grade of commercially available fuel in the team's country of origin plus a tolerance of one octane. Now 101 octane was commercially available in Britain, was registered as such with the FIA and accepted as such by them, which allowed us to use 102 octane fuel.*

ON THE FRIDAY I COULD NOT DRIVE. I GOT OUT OF THE CAR BECAUSE I WAS FRIGHTENED.
NIKI LAUDA

Confused by their findings, the FIA's rules and the increasing tension – but obviously not admitting it – the race organisers (CSAI, the sporting branch of the Italian Automobile Club) told the packed press conference that the times set by Hunt, Mass and Watson on Saturday were disallowed. With Friday's times more than ten seconds slower because of a wet track, none of them had qualified. The matter would later be resolved with a shuffling of slower cars and non-starters at the back of the grid. But, for the moment, Hunt was out of the race.

Then came an even greater sting in the tail: the Italian club announced they would be backing Ferrari's appeal against Hunt's victory in the British Grand Prix. All hell broke loose in the press room with Benson leading the indignant thumping of keys on British typewriters.

'The press centre was jam-packed with newspapermen from all over Europe who had come to see the return of Niki Lauda,' wrote Benson in a diary piece. 'Most of them had never been to a motor race before and they could not understand the technicalities of the argument. I myself found the whole scene hard to believe. The Texaco competitions manager went to the organisers on behalf of McLaren. He suggested they could not have got an accurate analysis of the fuel in the time available between taking the sample at 6 o'clock the night before and 11 o'clock that morning. The Italians would not listen to him. There was no disguising the fact that Ferrari and the Italians were out to discredit Hunt completely.'

As it turned out, Hunt's best time from Saturday had only been worth ninth on the grid, following a failed gamble to try a wider rear tyre. Lauda, miraculously, had turned in a lap good enough for eighth. It was a remarkable display of mind over matter.

Niki Lauda *On the Friday I could not drive. I got out of the car because I was frightened. I went to the hotel, thought about it, took it easy on Saturday and then, finally, got going again. But there was a huge pressure and mess.*

Such personal detail may not have been widely known but Lauda's achievement made sports headlines around the world. How would he fare in the race? And how would Hunt get on from the penultimate row (Mass and Watson were behind him) of the 26-car grid?

Lauda may have been on the third row but the advantage was lost immediately. No one at Ferrari had thought to tell their driver that, in his absence, it had been decided to replace an official dropping the national flag with starting lights. Lauda, looking for a man on the rostrum, was not in gear when the green lights came on. At the end of the first lap, he was 12th.

Hunt, caught in the bottleneck entering the first chicane, made no significant progress in the first 3.6 miles. But then he got going. By lap 10, he was 12th, five places behind Lauda and very keen to get even closer. Between the Ferrari and the McLaren were the Ferrari of Reutemann, Hans Stuck's March-Ford, the Lotus-Ford of Mario

Andretti and Jacky Ickx in an Ensign-Ford. But the driver Hunt really needed to watch was Tom Pryce. Hunt had just overtaken Pryce's Shadow-Ford and was pulling away, intent on not losing momentum to catch Ickx. But the Ensign was as fast on the straights as it was slow through the corners, James losing pace overall and allowing Pryce to catch up. The Welshman saw his chance on lap 12 when Hunt missed a gear leaving the first chicane.

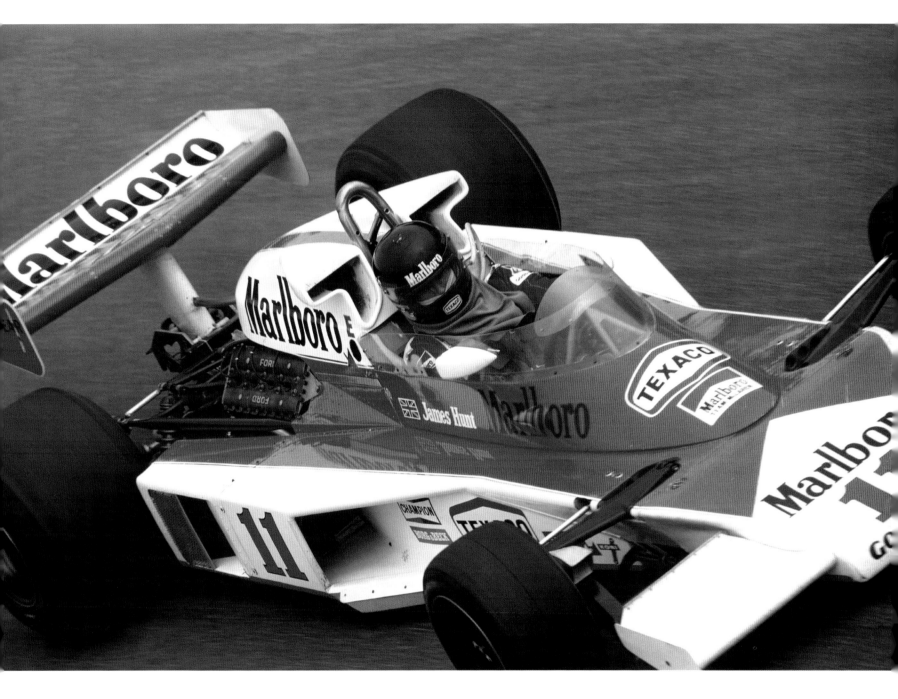

James leans on the M23 going into Monza's Parabolica.

James Hunt

I knew Pryce was going to come alongside me. But rather than fight him – we were all in a hurry and wanted to get on with the race – and take the inside line going into the next corner, I took the normal line. But he came hurtling up the inside, out-braking me, racing me into the next corner. That really took me by surprise because, if he got past me again, all he was going to do was hold both of us up. We would have both gone quicker if he had followed me. I had to fight it out with him then because I'd had a hell of a job passing him already, so I decided to go for it. When we did get to the corner, he was inside me, I couldn't get in and I went off the road of my own accord. It was my fault but at the same time I had to fight. I took the decision when he arrived alongside me to fight and it didn't come off. But I still think it was the right decision because had I let go, then I would never have finished in the points. It was a calculated risk. In different circumstances you adjust the size of the calculation. At Monza it was always a risk whether I would finish the race because I had to really try hard. If by half-distance you are getting into the points, the first six places, then you adjust yourself and reduce the amount of risk you take because you've got more in the bank to protect.

Pryce would continue and finish eighth. Correct decision or not, Hunt's car was stuck in the sandy run-off area, the trudge back to the pits from the Della Roggia chicane being made even longer by the vocal and largely hostile reception from Ferrari fans pressed against the fence.

James Hunt

The propaganda campaign against me in the Italian press was really quite incredible. A very heavy deal. Anybody would have thought that it was I who had caused Niki's accident. They really hated me in Italy, to an extent that was quite unbelievable. I'd be walking along and they'd be laughing and hissing but if I swung round suddenly, looked one hard in the eye and said, 'Boo' to him, he'd immediately smile, go all weak at the knees and thrust out a piece of paper for my autograph… pathetic. I was quite pleased to get out of Italy unscathed – and I'd managed to avoid getting in a fight with anyone all weekend.

Ray Grant

When James came off and left his car up at the chicane, Howard [Moore] said to me, 'Right, this is going to be difficult. We've got to go and get the car. Put your jacket on inside-out. Of course, the race was still going on and we had to walk through the middle of the circuit and what we didn't want to do was make it obvious that we were the mechanics on James's car. We saw it through the fencing and a marshal let us through. When the race was over, Howard jumped in the car and the marshals came along to push it. When the crowd realised who we were, rocks and stuff came flying over the fence. I'm standing at the back of the car, pushing it, Howard starts it up – and he's off down the circuit. I thought, He's not leaving me here! He pulled up, I got on the sidepod and we headed back.

Of course, typical Monza, the crowd had been released and were all over the track and into the pit lane. They were starting to fall over the front of the car and Howard aimed for parc fermé. *It was the only safe place to be. We eventually got in there. The crowd were trying to climb over fencing about eight to ten feet tall. There were security heavyweights on the inside with us. They were taking their belts off and swinging them to hit these people with the buckles. We had to spend an hour or so in there until everything calmed down and we could get back.*

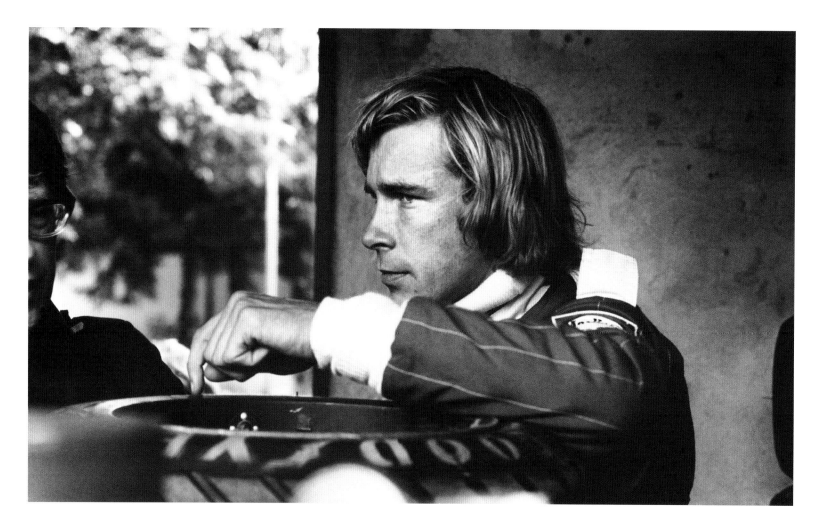

Plenty to think about in the pits and following retirement from the Italian Grand Prix.

The mood among the fans was ameliorated when Lauda managed to finish fourth, just 20 seconds behind the winning March of Ronnie Peterson. Hunt, perhaps more than anyone, could appreciate the astounding quality of such a personal performance.

James Hunt

Niki's race really spoke for itself. To virtually step out of the grave and six weeks later come fourth in a Grand Prix was a truly amazing achievement, especially as there wasn't much practice time. He just got in the car and had a go. It was bloody good. And he drove a typical Niki race, well contained within himself and within his new limitations, loosening up for the big battles later. He knew I was out of that race so there was no pressure on him from that point of view. He was just putting a few more points in the bag before he went into battle in earnest. He did a super job... a super job.

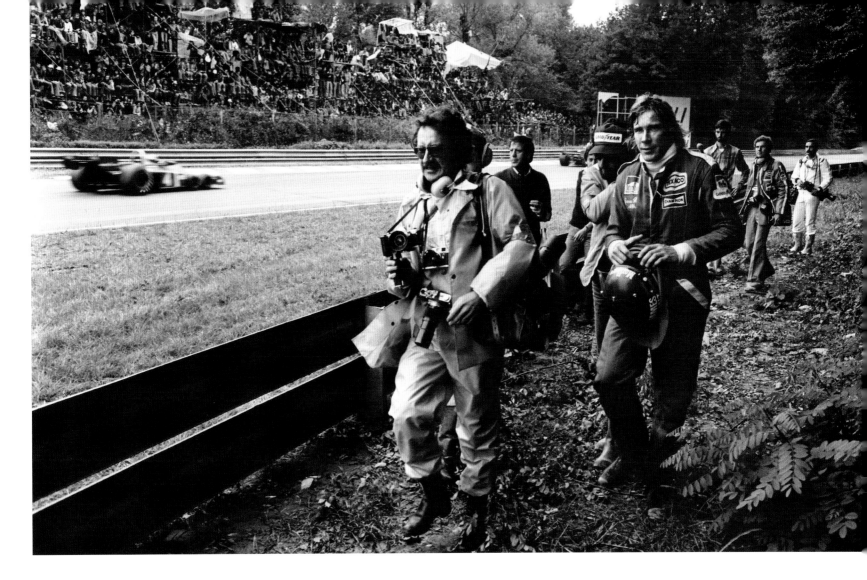

Hunt was less generous on the subject of McLaren's treatment at the hands of the Italian officials.

James Hunt

We had an appeal in but we all knew it was a waste of time and I was frustrated even more when the CSI [Commission Sportive Internationale] put out a press release saying that everything was all right and that the McLaren team hadn't been cheating. When people are throwing mud, some sticks. The rules are very complicated and they are difficult to understand. The implication that we had been cheating annoyed me enormously. Not only had we not been cheating, but running a high-octane fuel would not help unless we had increased the compression ratio of the engine to match the increased octane rating. You have to modify your engine accordingly and we certainly hadn't done that – we could have run 150 octane petrol and our engine would not have given an ounce more power. Our fuel was totally legal and we had gone to a lot of trouble before the race to make sure that it was, but to have that understood by the general public was more than one could ask. So this mud had been thrown and some of it was inevitably sticking.

Whatever the background, the points table now showed Lauda on 61 points and Hunt on 56. But that was about to change – thanks to the power of words, rather than whatever power some people imagined Hunt's engine had been producing.

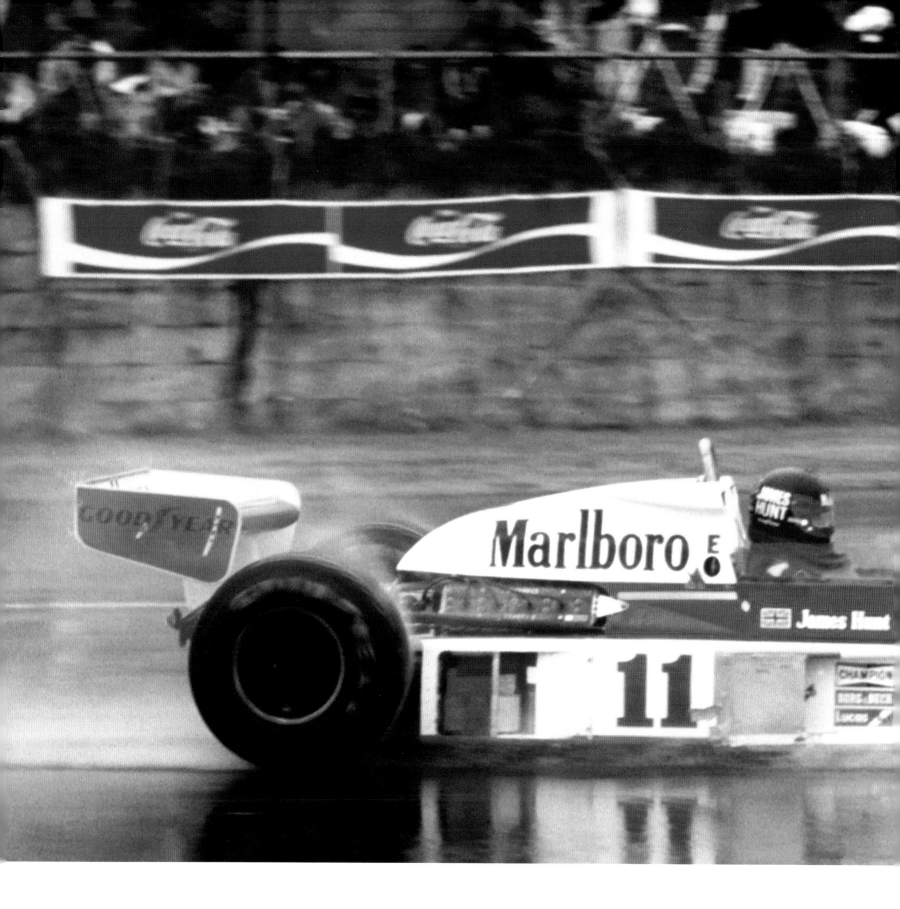

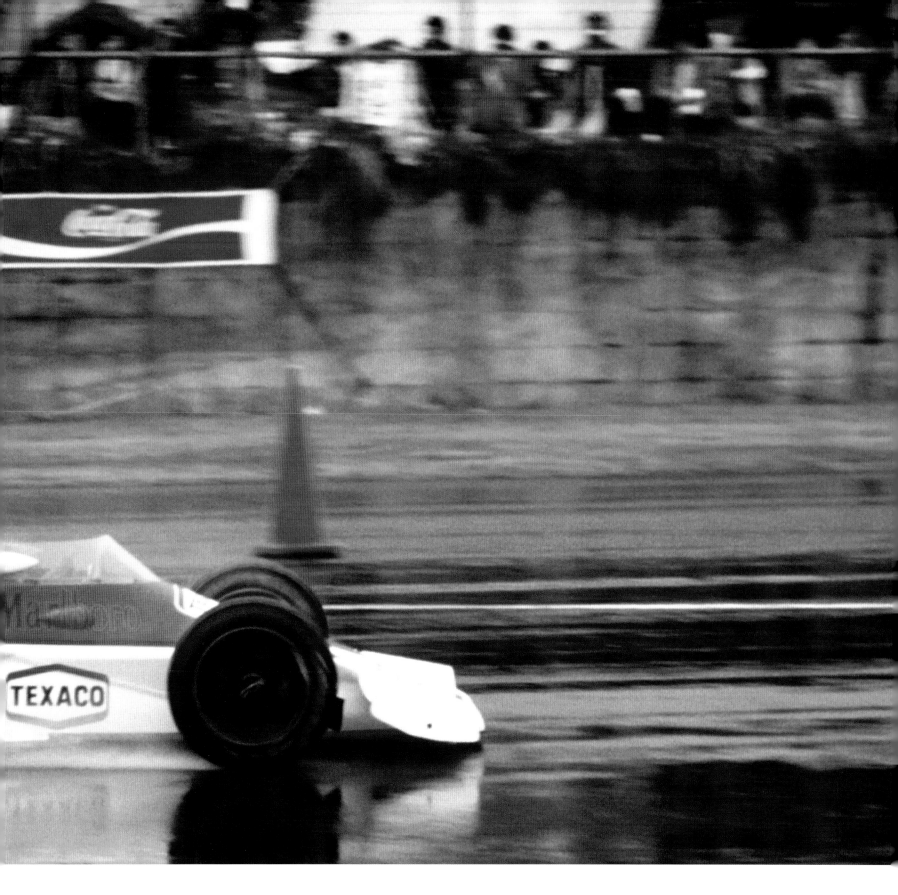

TEXACO

IT'S DOUBTFUL ANY OTHER DRIVER COULD HAVE TAKEN THE PSYCHOLOGICAL BLOW OF THE DISQUALIFICATION AT THAT TIME AND THEN GO OUT AND PUT ON A PERFORMANCE LIKE JAMES DID IN THOSE TWO RACES.
GORDON COPPUCK

There was a three-week gap between Monza and the next race in Canada, in which time McLaren and Hunt would make arguably their most serious misjudgement of the season. Notified that Ferrari's British Grand Prix appeal would be heard in Paris on 24 September, McLaren chose to rely on Teddy Mayer and a lawyer representing Britain's national motoring body, the RAC. The mistaken belief was that they had an open-and-shut case.

That did not take in account Ferrari sweeping into Place de la Concorde at their melodramatic best. Not only did team manager Daniele Audetto attend, with one lawyer representing Ferrari and another representing the CSAI, they also brought along Lauda, who was not averse to a piece of play-acting himself. Swathed in bandages and fresh from heroics at Monza, Lauda played the downtrodden role to perfection. To say the eminent judges representing France, Germany, Spain, Brazil, Switzerland and the USA were putty in Lauda's hands may be an overstatement further embellished by later, rose-tinted storytelling, but there can be no denying that it must have assisted the realisation of an unequivocal verdict: Hunt's win was thrown out.

Less clear had been the procedures involved, particularly when the same court, without prior warning, revisited the decision to reinstate Hunt after his initial disqualification from victory in Spain for having a winning car that was too wide. There was nothing that could be done about changing that verdict but, according to a stiff editorial in the following edition of *Autosport*, it appeared to have a major bearing on the decision over whether or not McLaren had been in the wrong at Brands Hatch.

Ray Grant looks on as James prepares to take to the track at Mosport.

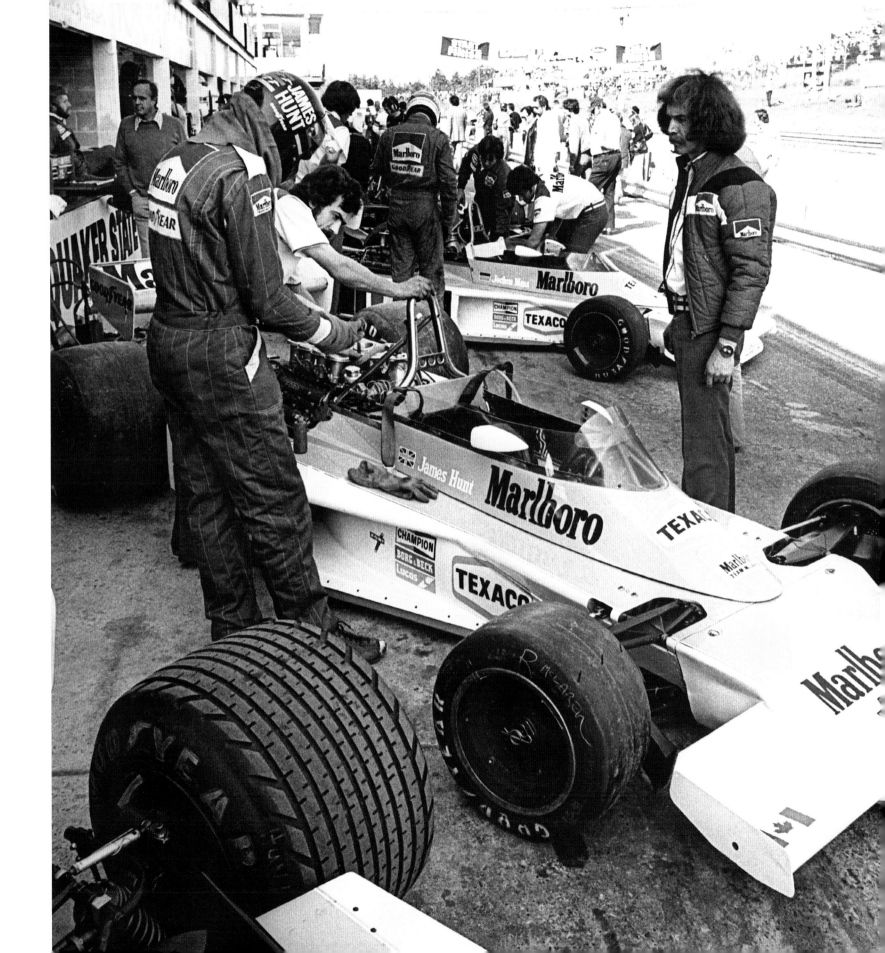

According to *Autosport*, the court was 'improperly constituted and conducted'. Furthermore, they 'restored what the French call *l'équité sportive*. We believe that the court dragged up the dreadful Jarama affair for no other reason than that the CSI had realised the decision reinstating James Hunt was blatantly wrong. Having established that no new evidence was available to allow it to reverse this decision, it decided that it had no option but to penalise McLaren in the matter of the British Grand Prix, thus satisfying both Ferrari and McLaren as best as it could. The Brands Hatch argument seems merely to have been a matter of interpretation of the rulebook. McLaren saw it one way, Ferrari the other. In a situation such as this there is no conceivable justification to impose a penalty as severe as total exclusion, especially when the world championship is in the balance. The Spanish situation was crystal clear, a straightforward proven matter of an illegal car. Not even the CSAI, though, can seriously believe that in perpetrating this double-wrong, it has made a right.'

The all-important bottom line showed that not only had Hunt lost nine points, Lauda had gained three. The gap between the two was now 17 points – almost two clear wins. Hunt received this news as he arrived at a squash court in Toronto – as recounted in the introduction to this book. The thunderbolt may have upset his game that afternoon but it was to have a galvanising effect on his racing during the following nine days. With his back firmly against the wall, James came out fighting and drove arguably two of the greatest races of his career, a fact fully appreciated by the team and the car's designer, Gordon Coppuck.

Gordon Coppuck

It's doubtful any other driver could have taken the psychological blow of the disqualification at that time and then go out and put on a performance like James did in those two races. He really was exceptional at times like that. He was very, very fast; no doubt about it. The problem was, he didn't like testing very much. We said at the time that we'd gone from a Brazilian driver with a British temperament to a British driver with a Brazilian temperament.

The brace of wins at Mosport and Watkins Glen meant Hunt was just three points behind Lauda going into the final race at Mount Fuji in Japan. The UK media suddenly became 'thoroughly over-excited' – to use the words Hunt once employed in describing an ecstatic fan who, whether by accident or design, had found his way into the McLaren pit at Watkins Glen.

Autosport provided a sounding board for Hunt fever. An editorial summed up the excitement of the moment by declaring: 'The BBC will actually be televising the Japanese Grand Prix next Sunday afternoon and devoting nine (that's *nine*) separate radio broadcasts to the race. This is the kind of exposure normally reserved for the likes of [Mohammed] Ali versus [Joe] Bugner [fighting for boxing world heavyweight championships].'

The sales of colour televisions had just overtaken black-and-white sets for the first time. As a further sign of the times, it should be pointed out that the television coverage would actually be highlights, hosted by Murray Walker in London with support from Barrie Gill in Japan. ITV also planned a highlights programme, linked by Dickie Davies in London to recorded commentary from Andrew Marriott in Japan. The only live coverage would be broadcast on BBC radio, with commentary from Fuji by Simon Taylor, ably assisted by Barry Sheene. (His producer in London first had to persuade the reigning 500-cc motorcycle champion – a good friend of Hunt – to avoid swearing on air. It was apparently not going down well as the British public took breakfast early on a Sunday morning.)

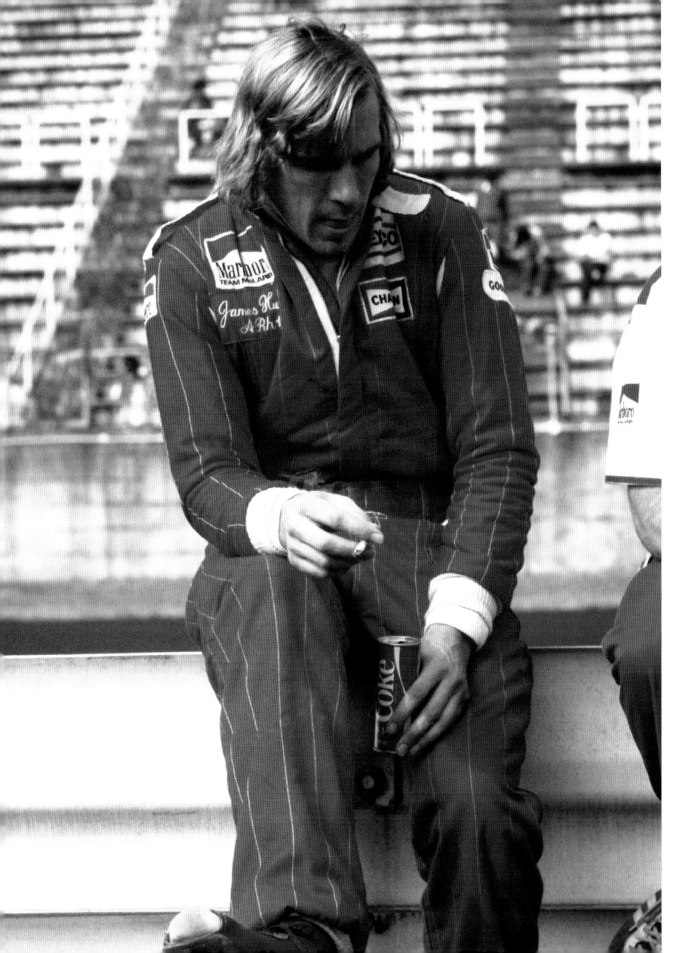

A more telling indication of how F1 was being perceived in light of the Spanish and British Grands Prix furores came further down in the *Autosport* editorial. Commenting on the range of broadcasting coverage, editor Quentin Spurring wrote: 'For that [coverage] we not only have the emergence of our new superstar to thank, but all the dissension, too. One can only draw the conclusion that the various wrangles which, the purist feels, have done his sport irreparable damage have, in fact, done it an enormous amount of good in terms of public interest.'

It would be fair to say that not much has changed in 40 years, considering the hand-wringing over some of the political nonsense providing fodder for F1's extensive media coverage today.

Just as it seemed the drama of the remarkable 1976 season had reached its height, F1 took another step into what seemed like it could have been film-script fantasy-land. And Hunt played his part to the full.

Alastair Caldwell

Towards the end of the season, I couldn't control James – so I let him misbehave. But after we'd won in Canada and the US, we suddenly found ourselves in with a shot and got very serious. Saying that, we were staying in a Tokyo hotel where all the Air France and British Airways aircrews would stop over. Every morning, there would be 15 new stewardesses in the lobby and James would bound over and say, 'Hello, I'm James Hunt!' to which they'd all reply, 'Oh, we know who you are!' And he happily shagged himself to death during the week before the race.

Almost every race has a home hero but that seemed unlikely in Japan as the F1 teams prepared for the country's first ever World Championship Grand Prix. The entry of 26 cars boasted three local drivers making their F1 debut but no one expected any of them to venture beyond the back quarter of the grid – that was assuming they even qualified. The stunned reaction can be imagined when Masahiro Hasemi proved to be fourth fastest at the end of first practice on the Friday morning. It certainly caught the attention of Goodyear, their two-year domination threatened by the Dunlop tyres fitted to Hasemi's locally built Kojima-Ford.

The message says it all about the simplicity of the Fuji circuit layout as Hunt is advised to bed in new brake pads.

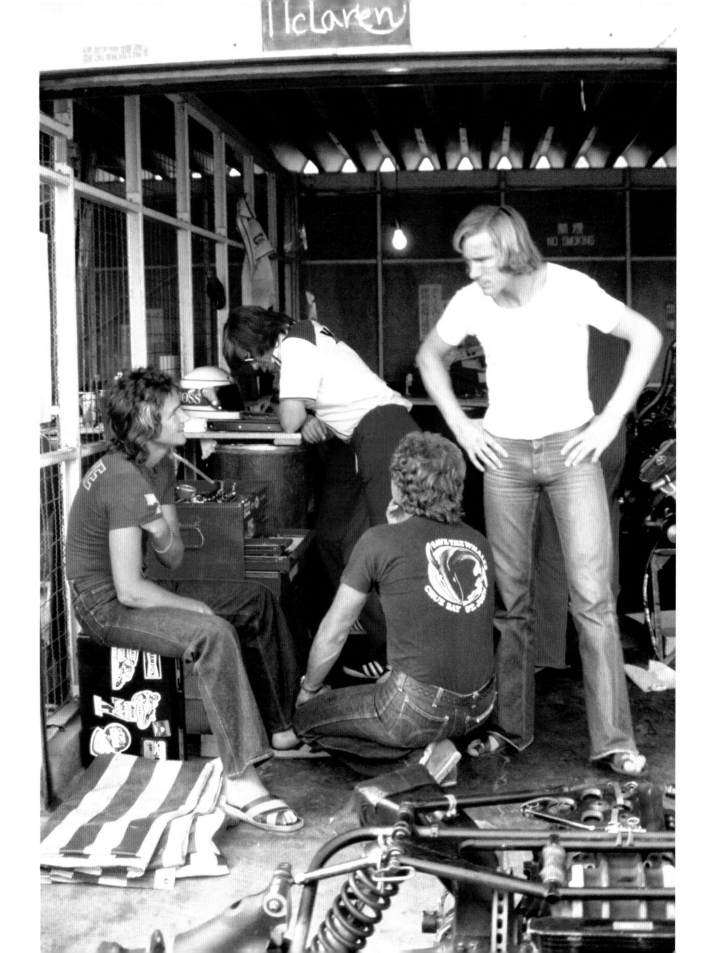

Cue the urgent rolling out of sticky Goodyear rubber – and another row in keeping with the confrontational mood of F1 throughout 1976. Tyrrell, Lotus and others wanted to know why these tyres had been given to Ferrari and McLaren without consultation and in disregard for an agreement that they be shared equally. Goodyear pointed out that the so-called agreement only applied if there was no tyre competition. And now there most certainly was. In which case, the sticky tyres would go to the teams likely to serve Goodyear best.

It was another way of saying that Ferrari and McLaren were bound to be on top form – and that seemed to be the way of it, based on Hunt and Lauda leading first practice (without the aid of quick Goodyear rubber). There had been worries over the track surface breaking up, a concern that was cured by resurfacing at one particular corner. But Caldwell and his crew made the most of the fears by wrong-footing the opposition.

Alastair Caldwell

Our mechanics got up to a little mischief. The track wasn't breaking up that badly at all but we fabricated mesh guards for the sidepods, radiator ducts and airbox. Niki was a good mate of James and spent a lot of time socialising with the McLaren boys. When he saw those gauze meshes, he ran back to the Ferrari garage looking worried.

So Ferrari spent the whole of Friday morning chasing around Tokyo looking for the correct gauze when they really should have been focusing on the gear ratios and first practice. Of course, we simply removed the gauze. Afterwards, I remember Niki coming up to me and saying, 'You bastard!' and walking back to the Ferrari mechanics saying, 'They were taking the piss out of us.'

Hasemi brought relief for Goodyear by crashing heavily on Friday afternoon. Meanwhile, Audetto flicked a curveball across the paddock by requesting an extension of practice. It was the Ferrari team manager's contention that McLaren had gone against another agreement that none of the teams would test at Fuji beforehand by air-freighting a car direct from Watkins Glen purely for this purpose.

The Japanese officials refused to be intimidated. In any case, Hunt's so-called advantage had made little difference. When the car did get to run for the so-called test, the gearbox broke. That said, James made the most of his first visit to Fuji by running around the track – not that there was a great deal to learn.

Planned as a banked 2.5-mile superspeedway in the hope of staging NASCAR-style races in Japan in 1963, the original project had run out of money. One banked turn had been completed but proved so outrageously dangerous in a road course that the corner had to be flattened. The final circuit had the longest straight in F1, ending in a long right-hander. The track then ran gently downhill before swinging right into a loop and beginning an arcing climb towards the straight once more. And that was it.

Regardless of McLaren's perceived advantage, it was unlikely that Ferrari could match a resolve that had been strengthened rather than weakened by a succession of decisions going against McLaren.

Dave Ryan

The whole team had belief. When we were wrongly disqualified on a couple of occasions, that just gave us a reason to dig deeper. All the boys just felt the title was coming to us. The facilities were pretty basic in Japan. We were in some rotten hotel somewhere and you'd go to one of the mechanics' rooms and the drivers would be in there drinking beers with the rest of the lads. F1 was a much smaller, tighter group back then.

At the end of the first day of official practice, Hunt edged Lauda by a mere one-hundredth of a second and would go on to continue what had become a perpetual struggle with understeer. Ironically, the situation was being complicated further by the variety of tyres being thrown at the M23, Hunt declaring himself 'very confused' on Friday evening.

Hunt had support in the cramped Fuji garage from Barry Sheene (left).

His mood was lightened on Saturday as the understeer was lessened: good enough to put the McLaren on the outside of the front row. On pole sat not a Ferrari but the ever-improving Lotus 77 of Mario Andretti. Lauda, 0.28 seconds slower than Hunt, shared the second row with Watson's Penske. The scene was set.

Dinner-table conversation that evening was about one thing: could James score three more points than Niki to take the title? Twelve hours later, talk was dominated by a completely different question: would there be a race at all? The magnificent edifice of Mount Fuji had disappeared, along with just about everything else, behind a cloak of unremitting grey and relentless rain. The morning warm-up took place as planned. Drivers discovered that conditions were even worse than anticipated.

James Hunt

It was ridiculous. Approaching the first corner, there was a huge puddle and you had to brake for the braking area. But the main concern was the spray. This, combined with the mist, meant you couldn't see a thing. It was madness.

Hunt, Lauda and six other drivers crammed into the Brabham caravan and agreed not to race in the conditions as they were. The organisers responded by delaying the start time by a couple of hours in the hope that the rain would ease.

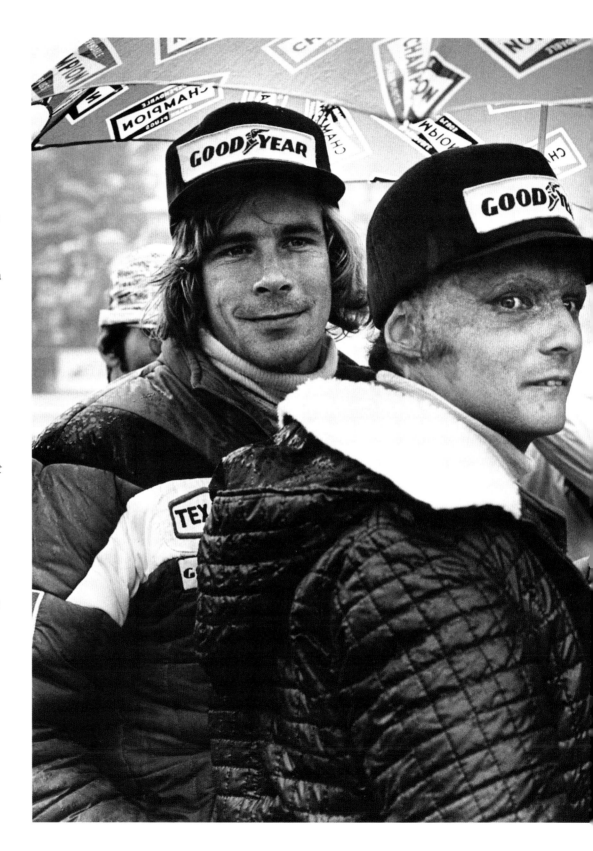

Dave Ryan *The whole event was a nightmare. There was another Kiwi guy – Lance Gibbs – who I'd been to school with and got him a job as a mechanic at McLaren. When the race was delayed, he was out the front with the pit board and a whistle – an Acme Thunderer – getting everyone going. He had the whole crowd excited, which was pretty unusual in those days, given that this was Japan and they normally just sat there and watched without saying a word or showing much emotion.*

There would be plenty of emotion in the paddock when the organisers suddenly announced the race would start at 3 pm – come what may.

Niki Lauda *We were all sitting together when the Japanese race director came in and said, 'Okay, we're going to start the race now.' I was the leader of the pack and got up and said, 'What the fuck's going on? The rain is the same as before.' The weather was completely unacceptable – even the biggest idiot could see it was impossible to race. He told us that it would be dark by six so we had to start because of the television deal. I think Mr Ecclestone probably had something to do with this as well...*

Hunt, Lauda and Peterson discuss the conditions at Fuji with Bernie Ecclestone, the boss of Brabham.

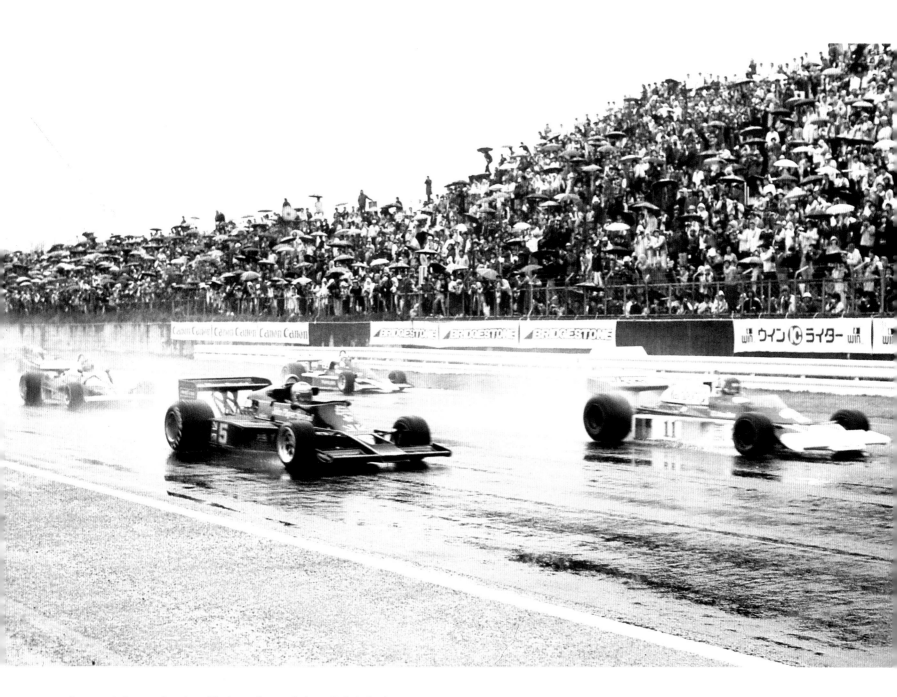

Hunt gets the jump on the pole position Lotus of eventual winner, Mario Andretti.

Lauda's reference to Bernie Ecclestone was made more than 30 years later with the benefit of hindsight following the phenomenal growth of the F1's supremo's empire. It was founded largely on the management of television rights. Events at Fuji in 1976 were to have a major influence on his thinking. Until then, Ecclestone could scarcely give away televised rights to Grands Prix. Now, with Hunt and Lauda, plus Ferrari and McLaren squaring up to each other at the end of a hugely dramatic season, the media wanted to serve an eager market of readers and viewers. Having relieved broadcasters of their money, Ecclestone knew it was imperative that they had a race to cover. He was also aware that the drivers, despite their best intentions, would individually feel there was no option but to race thanks to a lack of unity among the stars.

The continuing uncertainty did little for Hunt's peace of mind, hardly one of his strong points before any race, never mind one that was presenting a chance to clinch the championship.

Jochen Mass *James was definitely more keyed-up than usual. He was so absent-minded, he walked out of the back of the pits and took a pee against a fence post. He was totally oblivious to the crowd of spectators on the other side of the fence. All the Japanese girls were very shy and turned away! James would never normally do that but on that day his mind was somewhere else.*

James and I had no real plan for the race. I just knew that he needed to finish at least fourth and that I would help him if he needed it. I was happy to help – James was a great guy and we all really wanted him to win.

By the time the cars lined up on the grid, the conditions – mist, in particular – were actually worse. The officials announced a further delay of five minutes. And then, without further ado, started the race. By today's standards, this beggars belief.

Hunt realised he faced the most important start of his career, not just because it was the championship deciding race at the end of a long and dramatic season, but because it would be imperative to create the wall of spray rather than be forced to run within it. Happily, he made the a perfect getaway, James leading Andretti into the first corner.

Mario Andretti *They were the worst conditions I'd ever seen at the start of a motor race. There was so much standing water, it was terrible. The main straight was one of the worst places. There were huge puddles – I was moving the steering wheel more on the straight than I was through the corners.*

As the field tackled that long straight for the first time, Hunt was a couple of car lengths' clear. The rest were hammering bravely through a horrifying miasma of swirling mist and churning spray. Lauda was in 10th place.

A lap later, he was in the pits. The Ferrari was immediately surrounded by mechanics and Audetto leaned into the cockpit. After a brief conversation, Lauda got out and walked slowly towards the back of the car, Audetto anxiously at his side. They spoke once more. Lauda shook his head and continued to walk away; it was clear he had decided his race was over. Audetto offered to say there was something wrong with the car. But Lauda would have none of it. He was not prepared to race in these conditions. His life was worth more than this. In the light of his experience at the Nürburgring, who would argue with him? Three other drivers made the same decision.

The only thing remaining clear in the fading light of this murky afternoon was that James Hunt had to score three championship points. It was a case of surviving rather than racing. That would be graphically demonstrated on lap 22 when Vittorio Brambilla moved alongside Hunt under braking and, in the excitement of getting the nose of the orange March momentarily into the lead, promptly spun and narrowly missed the McLaren.

With fewer than 30 of the 73 laps to go, the breeze stiffened and the rain eased enough to allow the racing line to dry. With the wet-weather tyres beginning to overheat and discard small chunks of rubber, drivers were now actively searching for standing water instead of avoiding it.

Aware of both the state of his tyres and the championship-winning strategy required in Lauda's absence, Hunt offered no resistance as Depailler's Tyrrell and the Lotus of Andretti went by, the folly of such a furious pace telling a few laps later when one of Depailler's tyres failed. Hunt was now second. Six points would do it.

But would his tyres last the distance? James feared not. The team sensed it too but each left the other to make the decision to stop, the mechanics using the pit board to keep James informed as best they could.

Lance Gibbs, wearing a serious face now, hung out the board at the end of lap 67 with one arrow pointing to the word 'tyres' and the pits above '+45' (seconds ahead of the next man) and 'L6' (six laps to go). The arrow was a prearranged signal for the driver to decide, which infuriated this particular driver. He felt the team ought to have a significant take on what was happening with tyre-wear through judging by the actions of competitors. Mayer and Caldwell felt the decision was too important for them to make, rather than display 'IN' – an order to stop.

Alastair Caldwell *When a track starts to dry, the most important thing is to keep those rain tyres in the wet. We hung out a pit board with the word 'Cool' on it and Jochen immediately splashed over into the puddles to look after his tyres. But James didn't respond. He steadfastly drove on the drying line – I was so angry with him. We held out another pit board with an arrow pointing to the pits – we would be ready for him if he wanted to stop, but we stopped short of holding out an 'In' board because we knew it would be his decision. He ploughed on.*

James Hunt *I was desperate to stop for tyres but I could not make any sense of the pit signals. There was a breakdown in communication. I didn't want to make the decision. I just kept going until I had my mind made up for me by a flat left-front tyre.*

Lying second and with five laps remaining, Hunt veered into the pits.

Dave Ryan *There was one mechanic to each corner and I was on the left-front. In those days, you had a little jack that hooked under the wishbone, then you undid the wheel, put on the new one and removed the jack. But, with the tyre completely flat, the jack wouldn't fit underneath. Everyone else was busy changing their wheels and I'm standing there like a proper dipstick. When they realised what was going on, they raced round, lifted the car up and I got the wheel changed. Our pit-stop operation was actually pretty slick for the day, but the fact that we hadn't thought about the jack being no good if the tyre was flat tells you a lot about how little went into the pit stops back then!*

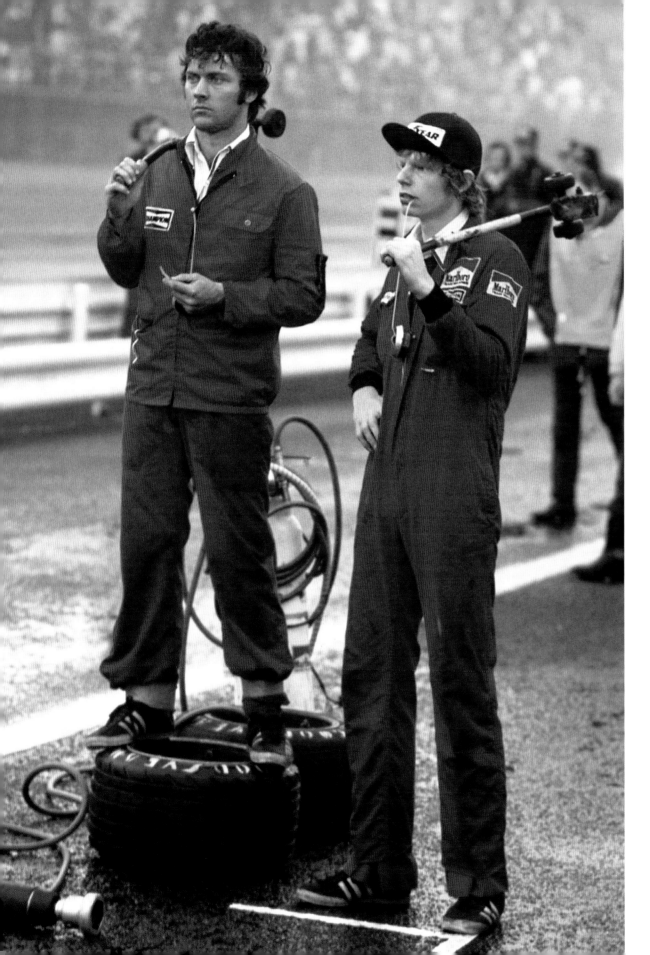

Mechanics Dave Ryan (left) and Steve Bunn hold front jack devices in readiness for a pit stop.

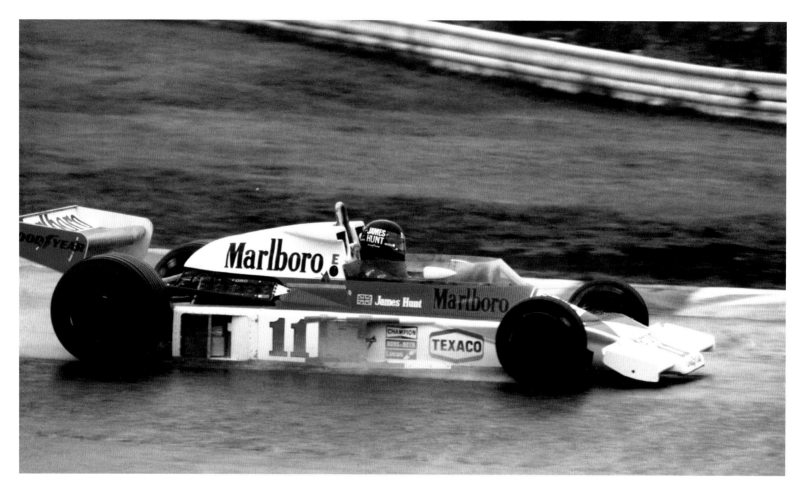

Ray Grant *For us, it was not about who was where in the race, the permutations of championship points and all that. It was just do your job properly, be ready for whatever's thrown at you. In those days, there was not a lot a mechanic could do. Once the car's gone at the start, you didn't want to see it again until the end of the race.*

So, we're standing there and suddenly Teddy is gesturing. What do you want, Teddy? He's coming in! OK! I'm on the left-rear; the rears were the killer wheels because of their size and weight in those days. I managed OK and then realised Davy was having trouble on the left-front, so I went and helped him. We got it up and away we went.

The stop took 27 seconds, James adding to the indescribable tension by furiously blipping the throttle as if to say this would not have happened had the team done the right thing and brought him in earlier. He rejoined in fifth place – not that Hunt had the first idea about where he was, who was leading or how many laps remained. But, for the watching world, the championship was gone. For the moment.

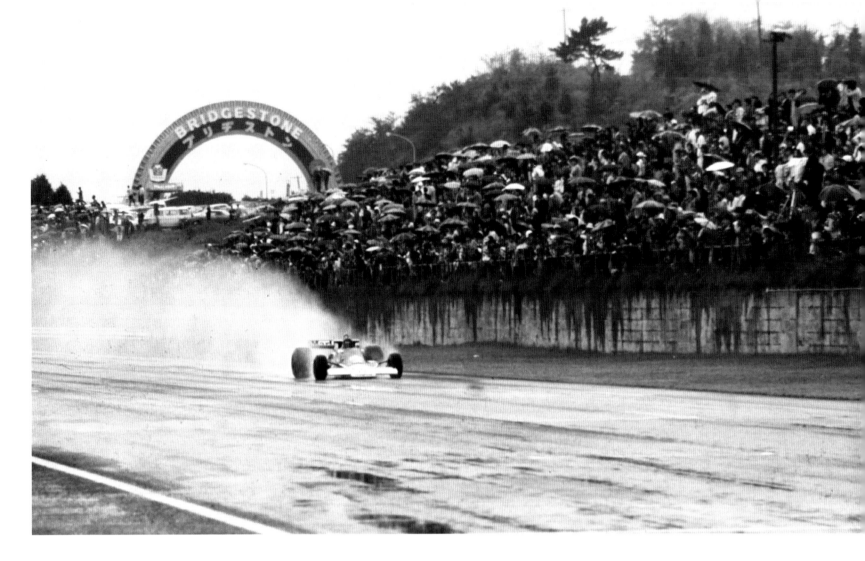

Hunt powers through the spray on the long main straight.

Driving like a man possessed and making full use of fresh, wet-weather tyres as everyone else laboured with rubber long past its best, Hunt overtook the Surtees of Alan Jones and Regazzoni's Ferrari (crippled with a soft tyre) in the space of a single lap. He was third. But didn't know it.

As he crossed the line after a race of 1 hour and 44 minutes that seemed twice as long, the sight of the chequered flag caught James by surprise. He thought he had lost. As for the mechanics, they were just as much in the dark.

Ray Grant

After the pit stop, James had gone out there and did what he had to do. That was when I thought this guy is really a good driver and he's going to deliver. He was wound up because he thought we'd shafted him over not bringing him in to change tyres. All I knew was he would have given it everything. When the race finished, we were standing in the pit lane and Frank Williams came by and he said: 'Do you know you've won?' We didn't know. And neither did James. He was going to rip Teddy's head off.

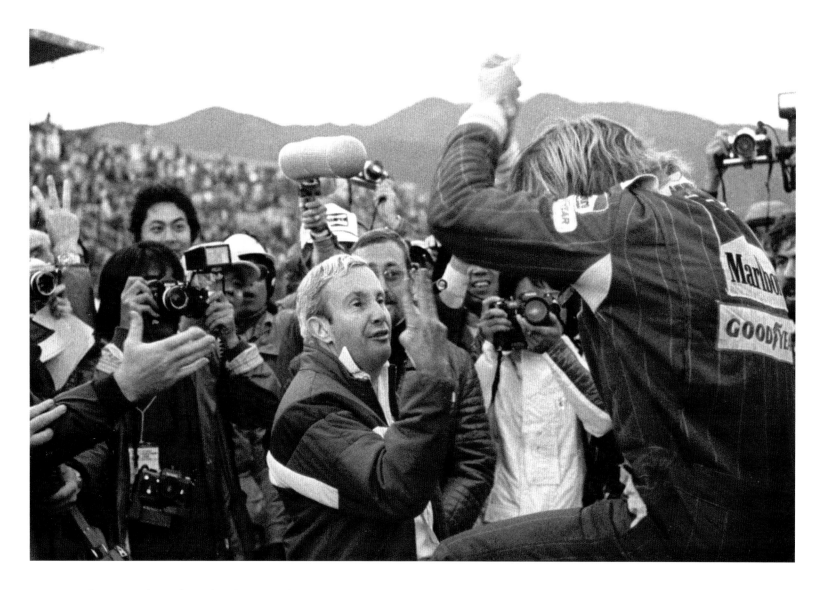

An outraged Hunt vacates his car and takes some convincing by Teddy Mayer that he has finished third, good enough to become World Champion.

Not even when Hunt drove down the pit lane and was brought to a halt by a delirious mob of mechanics and hangers-on did the penny drop. Flicking off his belts, Hunt rose from the cockpit, pulled off his helmet and balaclava and loudly berated his stunned crew for the absence of instruction about tyres. It was only when the diminutive Mayer held up three fingers and kept shouting – along with everyone else – that James had finished third and scored four points did the truth slowly begin to dawn.

James Hunt was the 1976 Formula 1 World Champion. By 69 points to 68. And yet, after the post-race disappointments at Jarama and Brands Hatch, he refused to believe it. Even if the result were true, someone would surely come and take it away?

He joined the winner, Andretti and Depailler on the podium, accepted everyone's congratulations – and waited for the bogeyman official to wag his finger and say it was a dream. It was not until darkness had well and truly descended and everyone was clearly packing up, the race and the season finally over, did Hunt allow himself to believe it. After that, the rest of the day became a crazy, euphoric blur.

Sally Jones, James's sister

I'll never forget that day; it was so exciting. I'd got married the previous year and we lived in Battersea. I was listening to the radio and when the start was delayed I went to bed, set the alarm and got up again as the race finally started. I remember going to the loo with the radio clamped to my ear! We listened right to the end and to hear that James had become world champion was absolutely amazing. We all knew what he had been through and it meant so much to everyone in the family.

It meant a great deal to the man himself. In the middle of the post-race excitement, James assessed the full import of how this championship had been won in interview with BBC radio.

James Hunt

I feel really sorry for Niki. I feel sorry for everybody that the race had to be run in such ridiculous circumstances because the conditions were dangerous and I fully appreciate Niki's decision; after an accident like he's had, what else could he do?

Quite honestly, I wanted to win the championship and I felt that I deserved to win the championship. But I also felt that Niki deserved to win the championship – and I just wish we could have shared it.

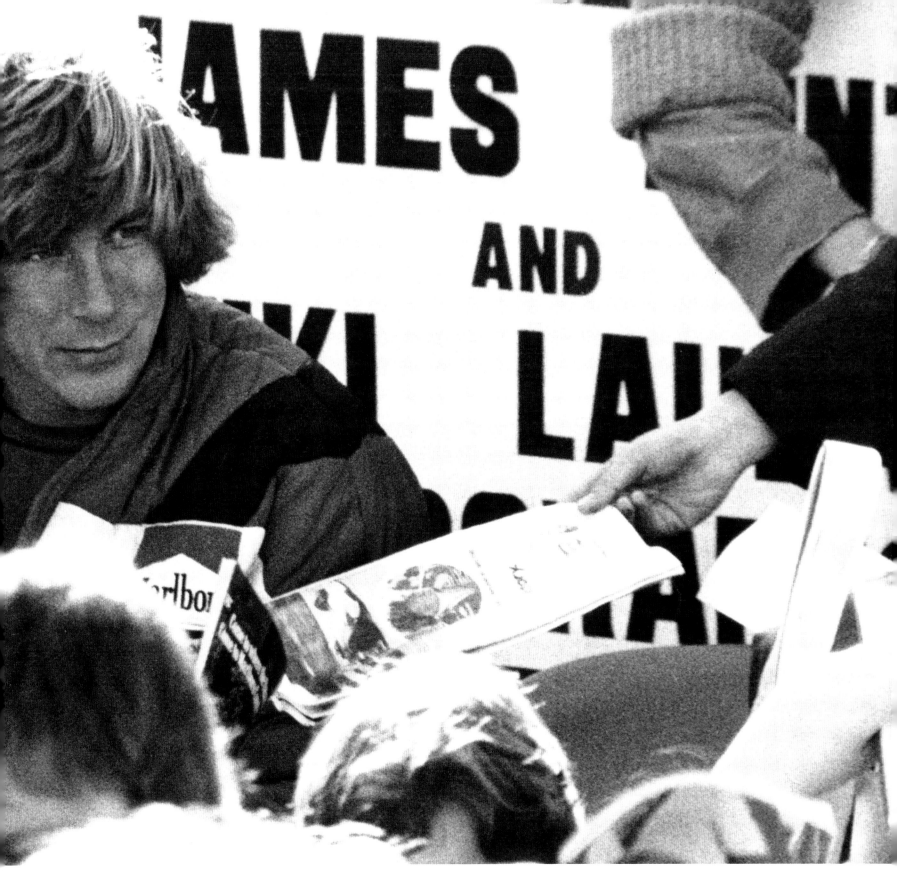

15. 1976 NOV-DEC: THE HANGOVER

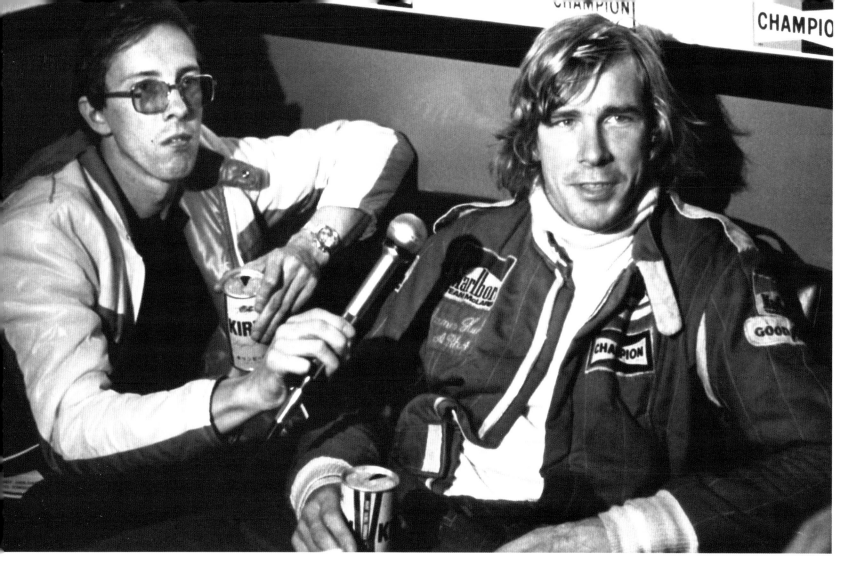

Above: Peter Hunt helps out with his brother's interviews post-race in Japan.

Opposite page: Hunt, with his friend Chris Jones, grabs some rest during the flight home. John Hogan and Alastair Caldwell continue celebrating in the row behind.

Alastair Caldwell On Sunday night, the mechanics had a good time. They somehow got hold of a cable-laying truck with a huge roll of cable. They drove it round and round the hotel, barricading up every door and all the ground-floor windows. Then they clambered through a first-floor window and went to bed!

Ray Grant All hell broke loose once James realised he was world champion. I can't remember much of what happened in the evening. I know we had an interview with Japanese television and I could hardly talk. It was just manic.

Dave Ryan It was pretty difficult to have a good time in Fuji then; it was a fairly remote place. But we managed it! We went back to someone's room in our hotel and partied so hard that one of the lads lost his plane ticket. We still managed to get him through immigration and onto the flight without it! There was so much confusion throughout the next 24 hours and on the long flight home.

The Japan Airlines Boeing 747 was scheduled to leave Tokyo at 10.30 on Monday evening. Hunt spent part of the afternoon with Ian Wooldridge, one of

the great British sports writers of the day. Wooldridge's first love was cricket and he knew little about motor racing. But he grabbed the chance to fly to Japan and meet Hunt as part of an exclusive deal the *Daily Mail* had made to have first call on James in the event of his winning the title.

Interview completed, Hunt joined many from F1 for a cocktail party arranged by Marlboro between 6 and 8 pm in the Tokyo Hilton. A fleet of coaches then transferred the increasingly rowdy ensemble to Narita airport, the waiting JAL jumbo and a continuation of a party that would be

fuelled by bottles of Beefeater gin, skilfully removed from the party by the mechanics.

Along the way, James acquired a chauffeur's cap that he wore at a jaunty angle while circulating among the throng at the back of the aircraft during the early part of the first six-hour leg to Anchorage in Alaska. Hunt then joined David Benson for dinner in first class. Buying space in the top tier had been the enterprising Benson's only means of finding a seat and speaking to Hunt on the over-booked flight. Keen to foil his rival from the *Daily Mail*, Benson filed his story on landing for refuelling at

Anchorage. He called the New York office of the *Daily Express*, knowing that the difference in time zones would result in his paper carrying a Hunt inside story on the same day as Wooldridge's 'exclusive'.

I HAD GUESSED I WOULD BE BUSY, BUT I NEVER REALLY THOUGHT IT WOULD BE POSSIBLE TO SQUEEZE SO MUCH INTO SUCH A SHORT TIME.
JAMES HUNT

Hunt, meanwhile, was in the transit lounge, signing autographs as word of his presence spread among passengers from other aircraft being refuelled. Back on board, James (politely refusing the aircraft captain's offer of a seat in first and travelling in economy) slept for a couple of hours before rejoining a party gathering pace once more at the rear galley.

There would be no respite at London Heathrow, a phalanx of photographers waiting at the ramp, followed by a reunion with his family before a press conference. For everyone else in F1, it was time to step off the merry-go-round, go home and crash out. For the new world champion, this was a foretaste of the crazy pace that lay ahead.

James Hunt

When we got to London I wasn't feeling too bad – a bit shattered but my mind was still working. I wasn't feeling ill, just exhausted. My family was there as well as the press and that threw me completely. I hadn't expected my family to be at the airport and that unnerved me, having to say hello to them in front of two thousand people. It was a bit of a heavy deal, with Mother freaking out and everything; that's what really threw me.

The press conference was a brief ordeal, but it was an ordeal. It was overwhelming. In most situations I feel in control but when I get out of control I'm not sure whether I'm doing or saying the right thing. Not because of what people want to hear, so much as the difficulty of what I want to say to them. That sort of thing makes me feel uncomfortable.

Ray Grant

As we were coming into Heathrow, Teddy got us together and said don't go near James. The press are going to be there; we don't want all you layabouts being part of it. So, I got home and heard this press conference on the radio. In Tokyo, James had been given this toy monkey that you wound up and it continually smashed a pair of symbols together. It was going all the time on the flight back. So, I'm listening to all these serious interviews on BBC radio – and all you could hear was that bleeding monkey clapping its symbols in the background. And there's Teddy telling us that we wouldn't be presenting the right image!

The driver relaxes in suitable style.

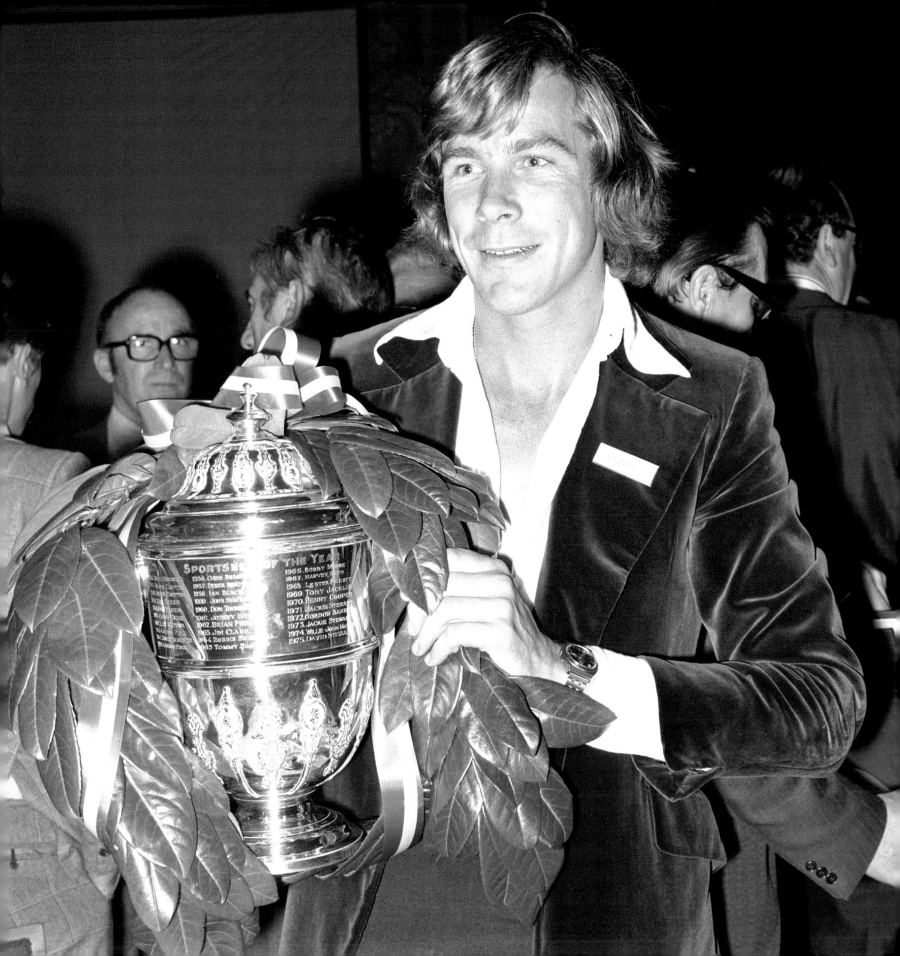

The trophy is inscribed:

SPORTSMEN OF THE YEAR

1956. CHRIS BRASHER
1957. DEREK IBBOTSON
1958. IAN BLACK
1959. JOHN SURTEES
1960. DON THOMPSON
1961. JOHNNY HAYNES
1962. BRIAN PHELPS
1963. JIM CLARK
1964. ROBBIE BRIGHTWELL
1965. TOMMY SIMPSON
1966. BOBBY MOORE
1967. HARVEY SMITH
1968. LESTER PIGGOTT
1969. TONY JACKLIN
1970. HENRY COOPER
1971. JACKIE STEWART
1972. GORDON BANKS
1973. JACKIE STEWART
1974. WILLIE JOHN McBRIDE
1975. DAVID STEELE

Formalities over – for the moment – James slipped away with his friends for a champagne breakfast in a flat where his latest companion, Jane Birbeck, was staying. The couple had first met earlier in the year at a backgammon tournament in Marbella when Hottie (as the photographer's representative would become affectionately known) was being escorted by Mark McCormack, the founder of International Management Group (IMG). Jackie Stewart was a client of IMG, as was Hunt until Peter, James's younger brother, took over the running of his business affairs.

Today, the return of a British sporting hero would be stage-managed down to the last second. In 1976, the new world champion was more or less left to wing it.

James Hunt *Finally it all packed up about lunchtime at Hottie's and I crashed asleep, right there. I slept for a bit in the afternoon and then for a few hours in the evening before going out to dinner. That was Tuesday. On Wednesday morning, I went into the office with Peter and in the afternoon I had another session of television and newspaper interviews. I was booked on a 9 o'clock flight to Malaga that night and I nearly missed it. Iberia* [the Spanish airline] *were very good to me in London and they held the flight for a few minutes. I know they can't do that officially but if they hadn't held the plane, they would have been 50 per cent short on payload since two newspaper reporters were travelling with me and there were only six passengers in total on the DC9 that night.*

There would be several times that number waiting to greet Hunt at the airport and start yet another celebration, followed by another when he finally got home, this one lasting until the early hours.

Two days of very welcome respite ended when friends flew in from England and ensured the festivities would still be running a week after a moment in Japan that now seemed so very far away in time and space. His life was changing – and not always for the better.

Through November and the weeks before Christmas, Hunt's time was consumed with end-of-season presentations, sponsor functions and motoring shows around Europe. It was while attending a Philip Morris lunch in Milan with John Hogan that their car was broken into. Hunt lost some of his awards, his passport, cheque book, credit cards, travellers cheques, diary, address book and a Polish visa, due to be used for travel the following day.

Winner of the Daily Express Sportsman of the Year, among many accolades at the end of 1976.

The Italian police did not seem interested and the British consul was not able to help much, so we left Italy 'illegally' the following morning and luckily were able to get new passports and visas in Geneva. The most annoying loss turned out to be the diary, which contained the exact dates and times of my visits to the UK, which meant that I had to sit down and try to reconstruct the last year with the tax man.

John Webb, the ever-resourceful Brands Hatch supremo, had been quick to capitalise on Marlboro's association with the Formula Ford Festival by renaming the race meeting 'Tribute to James'. More than 12,000 fans turned up to see Derek Daly receive the winner's trophy from James at the end of a day in which he also demonstrated the McLaren M26.

Hunt would test the car twice before the end of the year, time spent wearing overalls and crash helmet being a welcome diversion from jumping through commercial hoops on more formal occasions. Or, at least, they were supposed to be formal.

James would quickly earn a reputation for turning up in T-shirt and jeans. On the rare occasion when he wore a jacket, the ensemble would usually be completed by a pair of trainers. In 1976, this was considered improper and even worse than, heaven forbid, turning up without a tie.

'Bill Jupe, long-time competitions boss at Ferodo, told me the story of Hunt in the dining room at the plush Villa D'Este [in Italy] wearing a T-shirt when all around were dressed for the occasion,' Eoin Young wrote in his *Autocar* diary. '"I called the head waiter over," said Jupe, "and told him that I wasn't paying fifty quid a mouthful for my dinner to have some character at the next table in a T-shirt and jeans. Throw him out. The head waiter protested that it was Mr James Hunt. I said I was Mr Bill Jupe and I wanted him thrown out!" Hunt stayed and presumably Jupe finished his meal at £50 a mouthful. It was a reflection on our world champion that was going to become very familiar.'

James Hunt *I had guessed I would be busy, but I never really thought it would be possible to squeeze so much into such a short time. Those two months were the most hectic of my life. I had never been so relieved to get to my home and my dog [a German Shepherd called Oscar]. I had a very quiet Christmas as I started to work up towards Argentina and Brazil. I was still very new to this. Everyone is gunning for you if you are on top, and the massive invasion of privacy is worse than being at school. My personal freedom is something I had worked on for so long and it seemed that just as I was getting it, it was sort of removed.*

That freedom was unlikely to return any time soon as the 1977 season, with all its expectation and demands, loomed just days away on 9 January.

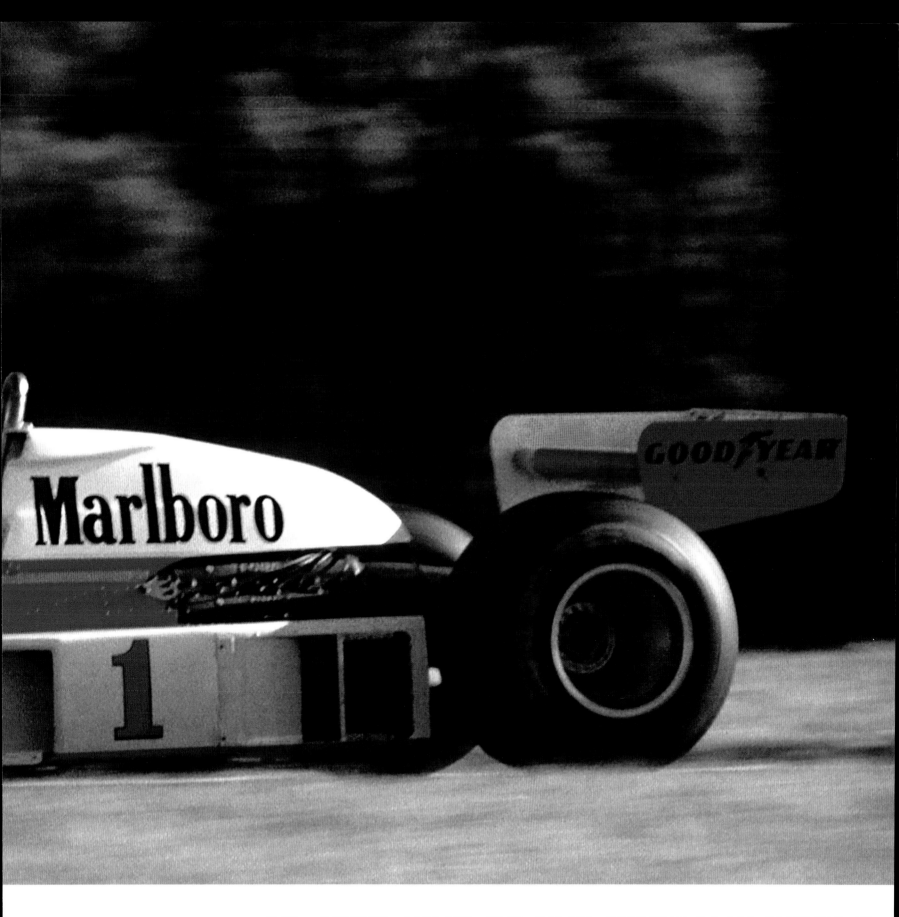

16. 1977: **KING OF THE GODDAMN WORLD**

Early in 1977, Peter Windsor received a call from James Hunt. The sports editor of *Autocar* had been less than complimentary about the new world champion in both his magazine and a summary of the previous season for the F1 annual, *Autocourse*. The tone of each piece made clear both Windsor's dislike of Hunt as a person to deal with and his view that, in simple terms, Lauda would have been a more deserving champion. Hunt was not impressed – and said as much in a typically direct manner. Windsor, never a man to shy away from a good argument concerning matters of motor sport, stood his ground. At the end of a robust debate, they agreed to disagree and no more was said.

Hunt would say he didn't care what the media thought. But calls such as this to journalists he respected would indicate he quietly cared very much indeed. It was just that his increasingly frantic schedule allowed little time to ponder over perceived injustices as he dealt with being a champion born of a series of extraordinary events that had caught the world's imagination.

Hunt's deeply competitive spirit urged him to win races and defend his title against all-comers. Along the way, he had to deal with the world wanting a piece of a personality who, for all his colourful exploits and exhibitionism, paradoxically remained someone protective of his privacy. He explained his predicament in the launch issue of the *James Hunt Magazine*, published in April 1977 and one of the first fanzines in F1, if not in sport as a whole. His column also gives an interesting insight to the financial values of the day.

James Hunt

Short of locking myself in a room, I can't get away from it. It just doesn't work. If I'm with friends, they get pushed out of the way and the problem is that the nice people don't come up and talk. It's always the pushy ones who want to come up and make you perform. You feel like some sort of mechanical toy. When they speak it's like throwing the switch and then you're supposed to perform. You're supposed to do or say something clever.

The problem is that, contrary to what people think, motor racing isn't all glamour and excitement. It's a serious business – and a profitable one. My brother Peter looks after the office side of the world championship and, this year, we're aiming to earn one million dollars – that's some £600,000. It's also the reason why I live in Spain!

So, the earnings are high but so are the costs. Our Marlboro-McLaren team spends getting on towards £1 million fielding two cars in each race for Jochen Mass and me to race. It costs nearly £15,000 for just one engine!

There was a time when I would say I was a racing driver and people would say: 'Yes, but what do you really *do? What do you do all the time between races?' These days there is hardly time to pause for chit-chat like that. There are appointments you have to keep all over the world. I can tell you, the business of being champion is almost as tough as trying to stay champion on the race track.*

I CAN TELL YOU, THE BUSINESS OF *BEING* CHAMPION IS ALMOST AS TOUGH AS TRYING TO STAY CHAMPION ON THE RACE TRACK.
JAMES HUNT

Opposite page: A rare moment of relaxation with Oscar in Spain.

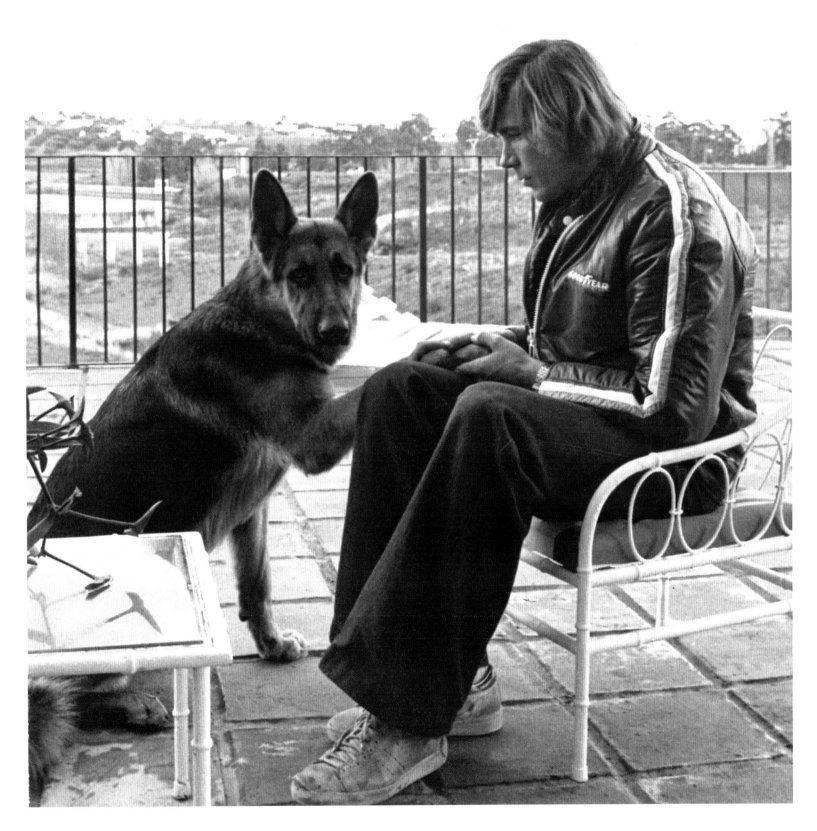

IT WENT WITHOUT SAYING THAT THE WIN COULD NOT HAVE COME AT A BETTER TIME.
JAMES HUNT

James, in the doghouse in Argentina, uses the rudimentary changing facilities in the McLaren pit.

Despite – or perhaps because of – the additional pressure, Hunt's sense of fun seemed to be even more finely tuned, the additional problem being an expectant public failing to fully appreciate the sometimes blunt tone of their hero's humour. James was unaccustomed to being taken seriously by a wide audience that, whether he liked it or not, expected a certain amount of respect.

It was a contradiction that would frequently raise negative headlines, starting with the season's opening race in Argentina. Hunt, an important guest supposedly helping promote the forthcoming Grand Prix, arrived barefoot and haggard for a press conference in a downtown Buenos Aires hotel. Rather than write about the race and its prospects, local journalists penned pieces on the insouciant attitude and dishevelled state of the sport's leading representative. Reading between the lines, very few observers wanted the man in McLaren no. 1 to win the 13th *Gran Premio de la Republica Argentina*.

They got their wish when Hunt was forced to abandon his car with broken suspension after 31 laps. He had been leading at the time. The failure was unexpected, if only because the M23 design was entering its fifth season (the M26 not yet considered to have a significant performance advantage).

Mechanical problems were commonplace, particularly in sapping heat, John Watson dropping out of the lead after having used the Brabham-Alfa Romeo to fight Hunt in the early stages. Starting from 11th on the grid, Jody Scheckter would go on to

unexpectedly prove the wisdom of his move from Tyrrell by scoring a dream victory for Wolf on the debut of a team James would to come to know well, if briefly.

For now, Hunt was more than happy to stay with McLaren, the team of 50 employees enjoying the momentum that came with winning their second drivers' title in three years. The fact that the Constructors' Championship arithmetic had favoured Ferrari at the end of 1976 merely strengthened the resolve to put that right.

Despite the emotional and at times unsympathetic reaction in the Italian media following his decision to pull out of the Japanese Grand Prix, Lauda had remained with Ferrari. But the atmosphere was no longer the same as Lauda now partnered Carlos Reutemann, a quiet and introspective Argentine who was the complete opposite to Regazzoni, the Swiss with the bandit grin.

If Reutemann had been disappointed with third place during his first race for Ferrari at home, he would more than make up for it across the border two weeks later. In similarly torpid conditions, Reutemann drove a canny race, nursing his car and tyres around the tortuous Interlagos track to score his fifth career win. A pit stop for tyres cost Hunt the lead, but he opened his championship account by finishing second, ahead of Lauda. Along the way, however, he had won few friends among the Brazilian media.

John Hogan

*James was big stuff in Brazil. In 1977, all hell broke loose. James was very twitchy when he was driving a car. He'd just come in from qualifying and a Brazilian journalist stuffed a microphone straight under his nose. James said, 'Don't be a c***. Wait until I'm out of the car.' The guy went berserk, said it was outrageous that James should call him that. It turns out this bloke was a serious journalist from one of the big papers in São Paulo. Next thing, we had faxes and cables and goodness knows what from Philip Morris New York. Now I have to bring them gently together to have James apologise and be nice. The deal is that the journalist will ask a couple of simple questions and James will give him a couple of straightforward answers. And, of course, the journalist goes straight in with a really antagonistic question, to which James replies, 'See? I said all you Brazilians are c***s'. So much for my diplomatic efforts.*

Retirements in F1 were commonplace. Only seven of the 22 starters had still been running at the finish of the Brazil race, no fewer than eight of them having flown off the road at the same treacherous spot where the track was disintegrating. Scheckter failed to finish due to a broken engine and others stopped with a variety of technical problems. But there would be no more a bizarre or heart-breaking retirement than the one listed at the start of the 23rd lap of the next race in South Africa.

Carving through the field after a bad start and running in the slipstream of another car on Kyalami's main straight, Tom Pryce crested the brow at more than 170 mph to encounter a fire marshal running across the track. Nineteen-year-old Jansen van Vuuren was killed instantly, as was Pryce when struck on the head by the marshal's 40-lb extinguisher. The Shadow, its driver's foot jammed on the throttle, would career down the straight, rubbing along a wall on the right-hand side before colliding with the Ligier of Jacques Laffite and smashing into an earth bank on the outside of the first corner.

Neither Hunt nor eventual winner Lauda were aware of any of this. Seeing the wrecked cars buried in what remained of the catch-fencing, it was assumed they had simply collided and the drivers were OK. James, having led initially from pole, spent most of the race struggling with a handling problem as he slipped back to an eventual fourth. Lauda, who had taken the lead from Hunt after six laps, had everything under control until the Ferrari picked up a substantial piece of debris from the Pryce accident.

Such had been the violence of the impact, the fire extinguisher had broken off the Shadow's roll-over bar. The tubular structure had flown onto the track and become wedged in the Ferrari's left sidepod, causing a water leak. With the oil warning light showing, Lauda nursed the car home, the Ferrari engine expiring just after he had crossed the line. Lauda's justifiable sense of achievement at scoring his first victory since the Nürburgring fire was deflated completely on the podium when he learned about Pryce.

On Thursday 10 March, Hunt was among the mourners attending the funeral of Tom Pryce at St Bartholomew's, the small church in the Kent village of Otford where Pryce had been married less than two years before. It was probably the first and last time in 1977 that Hunt would wear a suit, collar and tie.

Neither Lauda nor Hunt had any inkling of the severity of Pryce's accident at Kyalami.

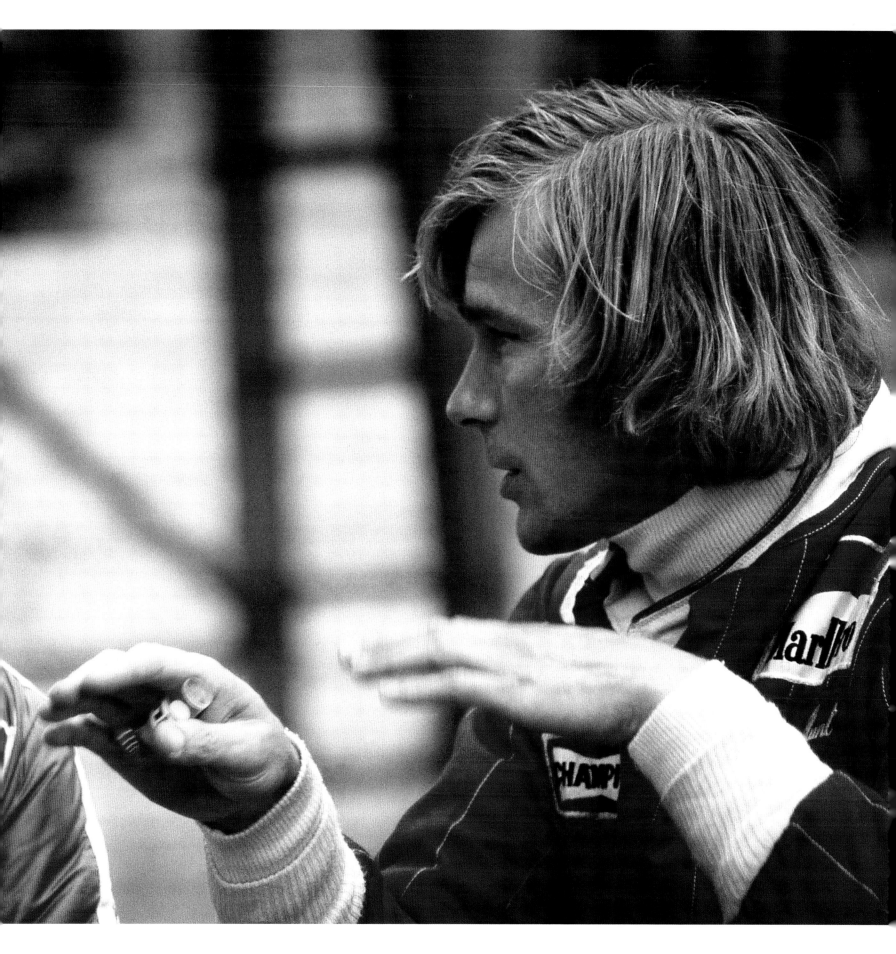

Hunt and Pryce had been colleagues and acquaintances, but they had not been close. Yet James was as deeply shocked as anyone about the circumstances of the accident and its appalling outcome. A week later, Hunt's newly established column in *Autosport* carried a call for a professional band of marshals to travel from Grand Prix to Grand Prix, a proposal that was denounced by Nick Brittan in his column in the same magazine. 'Can you see the job brief and the advertisement?' asked Brittan. '"Wanted, 30 marshals, fluent in eight languages, available for 16 weeks a year, all expenses paid, no wages." Heaven preserve us from such plots hatched by emotionally involved men.'

Emotional or not, Hunt would have little time to follow the idea through as he travelled to Sweden, Denmark and Finland doing promotional work for Vauxhall and Marlboro before returning to England to shoot a TV commercial for Texaco and then prepare for the Race of Champions at Brands Hatch.

Victory for James in the non-championship race would come at the expense of Mario Andretti, whose Lotus led until stopping with an ignition problem seven laps from home. Hunt was the first to admit he had never been likely to get on terms with the American, a disclosure that would be proven two weeks later when Andretti won at Long Beach in California. It is true that luck was on Andretti's side this time as he took advantage of a slow puncture for the otherwise dominant Wolf of Scheckter, but at no stage had Hunt been anywhere near either of them.

For the second year running, James was once again gathering headlines in California for all the wrong reasons. A collision had sent the M23 briefly into the air at the first corner, resigning Hunt to a pit stop for repairs and a strong recovery to finish seventh, out of the points. According to James, he was also out of the money following an alleged dispute with the race organiser over unpaid fees for promotional work the week before.

After four Grands Prix, Hunt was fifth in the championship but UK newspapers were tending to focus on the world champion's activities away from the race track. After the Buenos Aires promotional snub, he had continued to provide gossip rather than sports material. On the flight to South Africa, an upgrade had led to an over-indulgence of complimentary drinks and loud singing that was not considered in-flight entertainment by fellow first-class passengers, some of whom brought their influence to bear once the South African Airways 747 landed at Johannesburg. James was detained by customs officials, a thorough search of his minimal belongings producing a copy of *Penthouse* as the only material worthy of confiscation. The magazine and its full-frontal images contravened the country's strict obscenity laws.

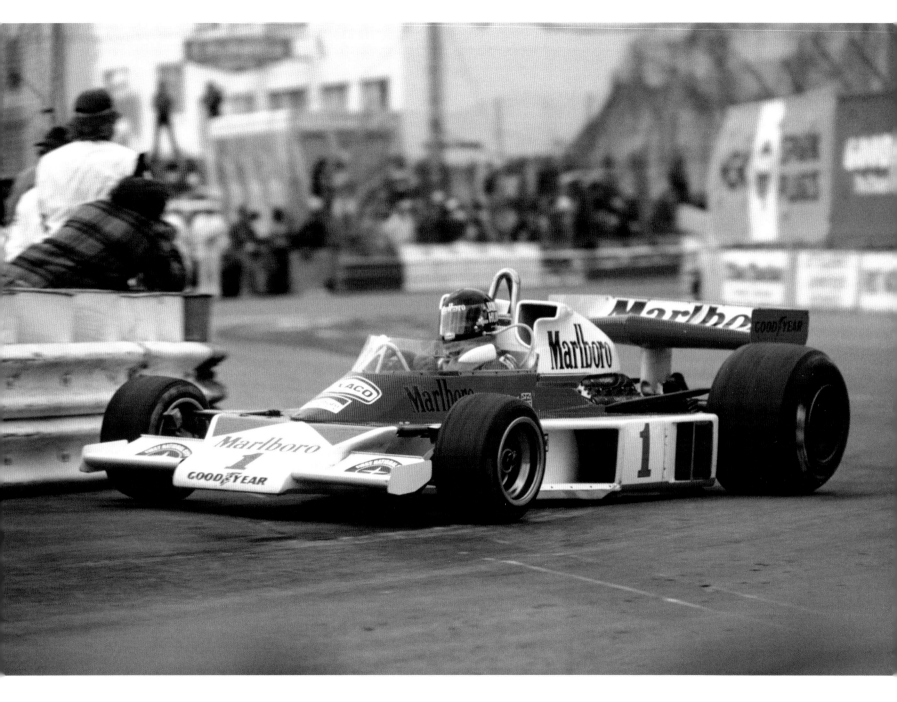

With the M23 pressed into service for a fifth season, James produced a strong recovery drive following a collision to finish seventh at Long Beach.

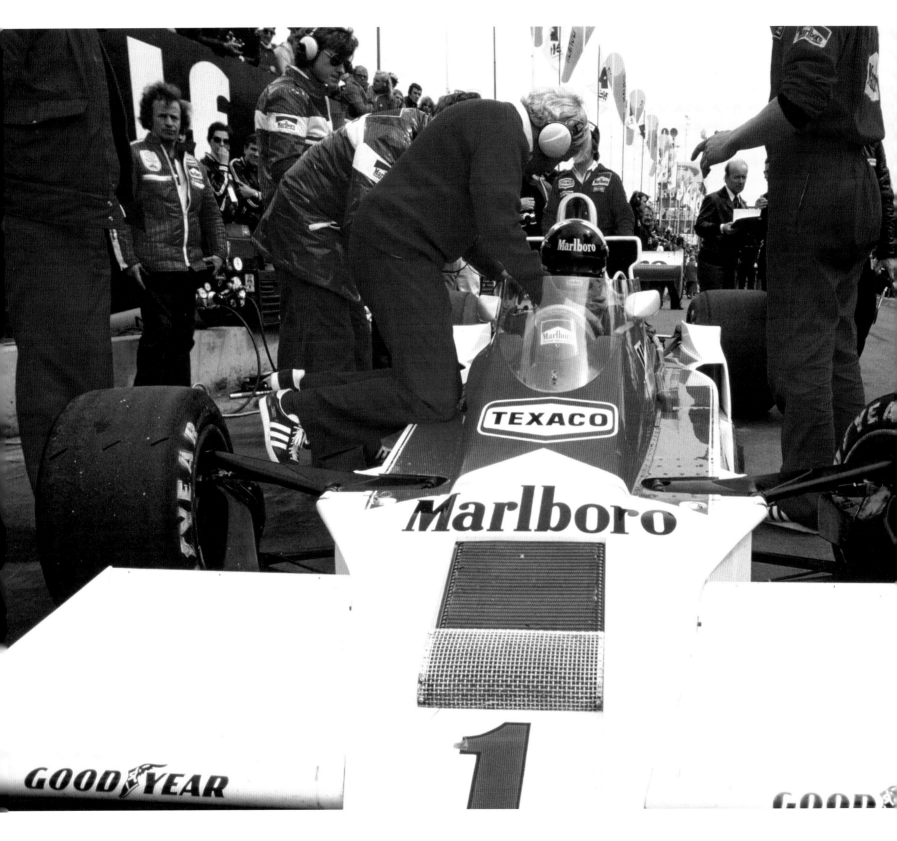

The incident received tabloid coverage at home and Hunt was increasingly being considered grist to a mill that he not only provided but for which he did the grinding. He was not in the least abashed when, as the subject of an exotic sting, a model from Holland bedded him after posing as an interviewer on motor racing but whose mission was to make love to famous men and report her findings for a Dutch magazine. It was a matter of some pride for the so-called victim that the testimony in this case was positive.

The same could not be said for his progress on the race track. The Swedish Grand Prix on 19 June would be his fifth consecutive race without scoring points. Ninth on the championship table (23 points behind the leader, Scheckter) was a result of a combination of factors, most notably the distraction caused by continuing work with the McLaren M26. Hunt raced in the latest car in Spain (qualified seventh; retired with a misfire), Belgium (out-qualified by Mass and lapped by the M23 after a gamble by James to start a wet race on slicks had failed spectacularly) and Sweden (qualified third, finished 12th after stopping for tyres). With the season approaching the halfway mark, the suggestion grew that Hunt might be a one-trick pony – and a naughty and unkempt one, at that.

The struggle to make the McLaren M26 race-worthy continued in Belgium.

Not that it bothered Hunt unduly as he kept up his social and business engagements between Grands Prix. Before Sweden, James partnered Belgian tennis champion Guy Drut in a sports personality doubles match against a French Olympic hurdler and an Australian tennis professional. Hunt and Drut won.

James Hunt *This was part of a tournament organised by Texaco. We only played one set between the men's singles and men's doubles finals. The whole thing was a lot of fun and I thoroughly enjoyed watching the finals. The night before I had been extremely well entertained by John Goossens of Texaco and some of his friends. We then decided to play golf before going over to the tennis club. Unfortunately, none of us felt very well after the first couple of holes, so we retired after nine 'for health reasons'. All in all, it was a nice diversion. After Belgium, it seemed that things could only improve. I was wrong for Sweden but hoped it would go a bit better in France.*

The tide did indeed begin to turn at Dijon-Prenois, where Hunt qualified on the front row before deteriorating handling meant a third place that was distant but nevertheless welcome. Hunt had taken a back seat to a race-long chase between Watson and Andretti, the Ulsterman seemingly heading towards his long-awaited second F1 victory when the Brabham-Alfa began to stutter and run out of fuel on the last lap, handing victory to the Lotus.

If Watson was disappointed in France, even worse would occur during his home Grand Prix and this time Hunt was the beneficiary. The capacity Silverstone crowd, enjoying a glorious summer's day, was torn between choosing which British driver to support as Watson and Hunt fought it out. James had qualified on pole but a troublesome clutch cost him places and he was fourth at the end of the first lap. He worked his way past Scheckter and Lauda and chased after Watson. For 25 laps, the pair were in a league of their own; a game of cat-and-mouse that could have gone either way. It ended 28 laps from the end when the Brabham was afflicted by fuel pressure problems. It would be Hunt's first win since Watkins Glen the previous October.

James Hunt

It went without saying that the win could not have come at a better time. We were relieved more than anything else because we were pretty convinced the M26 was capable of winning a race or two. We knew we had to win one soon before the critics totally wrote us off and it was particularly gratifying to do it in front of the home crowd.

The British Grand Prix period had been the obvious time to launch *Against All Odds*, a book covering Hunt's championship year put together with Eoin Young. Young had to cover for the late arrival of the star guest and author at his own party.

James Hunt

Before the launch, I had been due to go to Monte Carlo to take part in a Philip Morris backgammon tournament but was allowed leave of absence so that I could get some golf and tennis at home. Niki Lauda happened to be in Spain while I was there so I was able to play host to him for a few days.

I had a disastrous journey to England because the airline I was flying decided to go on strike while we were mid-air between Madrid and London. Apparently the airline staff at Heathrow refused to accept any further flights and so we were diverted to Paris. Unfortunately, we had to land at Orly airport and it is difficult, if not impossible, to get a flight from Orly to Heathrow or Gatwick. There were a lot of people on the flight who were extremely irritated and becoming punchy, to say the least. Fortunately, I remained fairly relaxed (I sometimes get quite cross with airlines!) and was lucky enough to get on a Varig flight. Even so, I was five hours late arriving in London for the launch party of my book, which was a pity because a lot of people were kind enough to turn up.

The day after the Grand Prix [Sunday 17 July], *I played in a cricket match for the Lord's Taverners against the Duke of Gloucester's XI in aid of the National Association of Boys' Clubs. Unfortunately it poured with rain for most of the day. My bowling figures were at one stage rather impressive (two for two), thanks to some superb catching by John Taylor, the British Lions rugby player and John Conteh* [boxing's World Light Heavyweight Champion]. *But then Mike Smith of Warwickshire and England came in so I rapidly asked to be taken off. Batting was a problem because the pitch was so wet but I managed to score about 17 runs before being caught by the same Mike Smith. Personally, I thought it was rather bad manners of him to take the catch, but I suppose his reputation was at stake as well!*

Opposite page: All my own rearranged words. Hunt checks out his autobiography, ghost-written by Eoin Young.

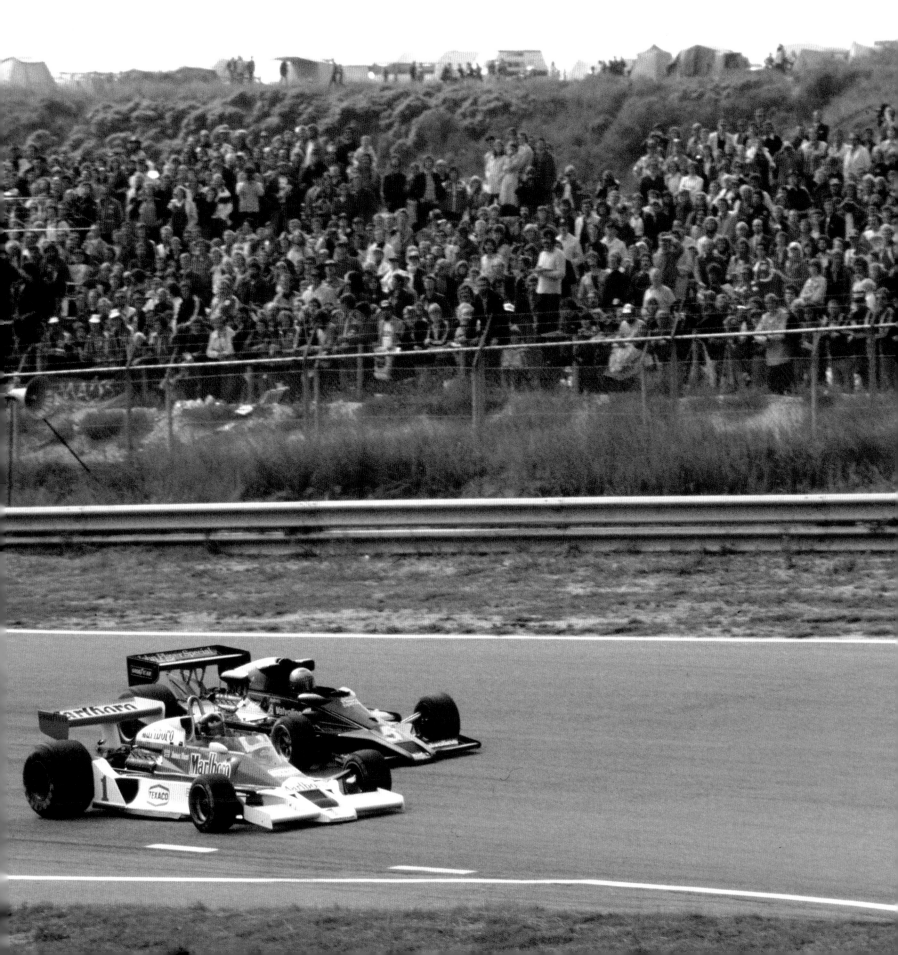

Despite the British victory moving Hunt to fifth on the points table and mathematically giving him a chance of challenging for the championship (now led by Lauda), a failure to finish the next four races would spell the end of that slim hope. And just for good measure, a controversial retirement in Holland would brighten the lives of his detractors.

Andretti had put the ever-improving Lotus 78 on pole, with Hunt starting directly behind in the M26. James made a scintillating start, diving down the inside of Andretti into Tarzan and then easing the Lotus towards the grass at the exit. Secure in the lead, Hunt began to employ the same legitimate defensive tactic he had used when keeping Watson's Penske at bay 12 months before. The difference this time was that whereas Watson had eventually given up trying to run round the outside of the McLaren at Tarzan, Andretti had come from the tough school of dirt racing in the USA where cars ran side-by-side, usually sideways and never backed off.

The inevitable happened on the fifth lap. The black-and-gold car and the red-and-white McLaren were dead level midway through the banked 180-degree corner. Having the shorter distance to run and moving gradually towards the outside, James found Mario's right-front wheel alongside the McLaren's cockpit. Hunt could have eased slightly to the right or Andretti could have lifted off marginally. But there was nothing marginal about this.

Hard on the power, both continued until the left-rear of the Lotus found little traction on the sandy grass and the similar wheel on the McLaren made contact with something other than asphalt. The M26 flew into the air and the Lotus spun. Andretti continued but Hunt stopped a few metres later thanks to a water pipe torn off and a radius arm bent. The subsequent cloud of steam could just as easily have come from within the driver's helmet.

James marched across the infield and into the pit lane, where he shared his views with Colin Chapman about the quality of his driver before doing the same to the man himself when Andretti retired with a blown engine. The stubborn refusal to back off continued, Hunt citing his fight with Watson as the perfect approach to racing; Andretti retorting that if Hunt wished to block the inside line – as he was entitled to do – then the only place to try was the outside. It was a view the laconic American expanded upon when questioned by reporters after the race had finished.

'The first lap he put me on the grass coming out. That was all right,' said Andretti. 'It was legitimate. He was ahead of me. But the time we hit, I was more or less alongside him and he's moving out and moving out. I mean, I can't just disappear. I'm there, man. Does he want me to drive through the catch fences or what? I don't ask for an inch more than is my due. He says to me, we don't overtake on the outside in Grand Prix racing. Well, I got news for him. I'm a racer and if I get blocked on the inside, I'll try the outside. James Hunt, he's the champion of the world, right? The problem is he thinks he's king of the goddamn world as well.'

The last line in particular was seized by British newspaper writers looking for something to say, even on a day when victory for Lauda had almost assured him of his second world title; an extraordinary achievement just over 12 months since he had been given the last rites. Meanwhile, the lack of support for Hunt had not gone unnoticed.

Opposite page: Hunt dives down the inside of Mario Andretti's Lotus during an intense battle for the lead of the Dutch Grand Prix.

UNFORTUNATELY ACCIDENTS ARE ONE OF THE HAZARDS OF MOTOR RACING AND THE GUILTY PARTY ALMOST ALWAYS KNOWS WHO HE IS.
JAMES HUNT

James Hunt

As far as I was concerned it was a clear-cut case of Mario trying to overtake when the manoeuvre was not possible and the inevitable accident happened. Unfortunately accidents are one of the hazards of motor racing and the guilty party almost always knows who he is. That is why the thing that upset me more than anything about the whole incident was the way in which it was reported in the press. When I was interviewed after I came back to the pits I gave my version of what happened and asked those who had seen it to make up their own minds and those who had not seen it to watch it on the televised replay. Mario, on the other hand, talked about it prodigiously and seemed to imply to the press that the whole thing was my fault. That, at least, is how it appeared in most of the newspapers on Monday morning. If they actually did see the incident either live or on television and still drew the conclusion that I was to blame, then I have to say they know less about motor racing than I know about writing.

The gradual change in media attitude may have been the typical deconstruction of a British sporting hero by the same people that had built him up, but the enmity was clearly set to continue after Hunt's review of the papers. Not even two fine wins for James in the USA and Japan ensured positive reportage when so much sensationalism was supplied so readily by the out-going champion. Events in Canada and Japan produced two classic examples. Given the bitterness between Hunt and Andretti, the highly charged atmosphere in Canada could be imagined as they shared the front row of the grid at Mosport. Andretti led from pole with Hunt his constant shadow for 60 enthralling laps. Their pace was such that the leaders had lapped everyone bar the third-placed McLaren of Mass. Anticipation was at fever pitch as the trio swept past the pits to start lap 61.

Bernie Ecclestone listens in as Mass and Hunt chat. The McLaren drivers' relationship was to be put to the test in Canada.

Mass was not about to make life easy for Andretti but, whether intentionally or not, the Lotus driver found himself with two wheels on the grass and losing enough momentum for Hunt to snatch the lead for the first time. What should then have been a simple move by James to lap his team-mate became confused when a misunderstanding led to both McLarens going the same way at once and colliding – much to the amazement and delight of Andretti.

Hunt did not see the funny side as he eventually extricated himself from a very badly damaged M26. With his adrenalin at peak revs after more than an hour of intense racing, James lashed out when a well-meaning marshal tried to move him away from the trackside from where he clearly wished to remonstrate with his team-mate the next time Mass came by. The marshal was stunned in every sense as he fell to the ground. Realising what he had done, Hunt immediately reached out to the stricken official, but his genuine remorse was not enough to avoid a $2,000 fine for punching the marshal and another $750 for crossing the track in an unsafe manner.

There was serious talk of imposing yet another fine in Japan when Hunt failed to appear on the podium, the winner saying a quick exit was necessary because of the organisers' failure to provide a police escort to the airport. Reutemann also failed to appear on the second step and newspapers carrying pictures of a bemused Depailler, alone in collecting a trophy, seemed to show that F1's out-going world champion cared little about his hosts.

It was an inappropriate end in more ways than one. Despite finishing fifth in the championship, Hunt had arguably driven better than ever. Certainly, his racing bore the hallmark of a driver who had proved himself by winning the title and could now bring that race-craft and experience to bear in an impressive way – when the equipment allowed it. Three times a technical failure had cost a certain victory. Coupled with driving errors and bad luck, Hunt's wins had been limited to three – which happened to equal the tally of Lauda, the 1977 world champion.

Examining such detail, however, appeared to be beyond the remit of the International Racing Press Association (IRPA). Established by Bernard Cahier, a French photographer, IRPA gave the media a means of collective bargaining with race organisers at a time when there was no official standard or accreditation offered by the sport's governing body. IRPA issued red leather armbands to responsible journalists and photographers meeting the criterion of regularly covering Grands Prix. Race organisers approved of dealing with IRPA. Hunt did not share their enthusiasm.

Each year, IRPA would award the most helpful drivers, teams and circuits with a *Prix Orange*, those voted the most unhelpful earning a *Prix Citron*. Hunt had been the unanimous winner of the 1976-77 Prix Citron but declined the invitation to receive the prize (a life-like but unflattering cartoon). McLaren had also won a *Prix Citron*. When Teddy Mayer collected his award, the McLaren boss referred to the media as 'chauvinistic, emotional and inaccurate'. The clipped comments summed up an insular attitude within McLaren that would degenerate to siege mentality in 1978 as both McLaren and their star driver went into serious decline.

Opposite page: James was viewed by the specialist media as F1's bad guy.

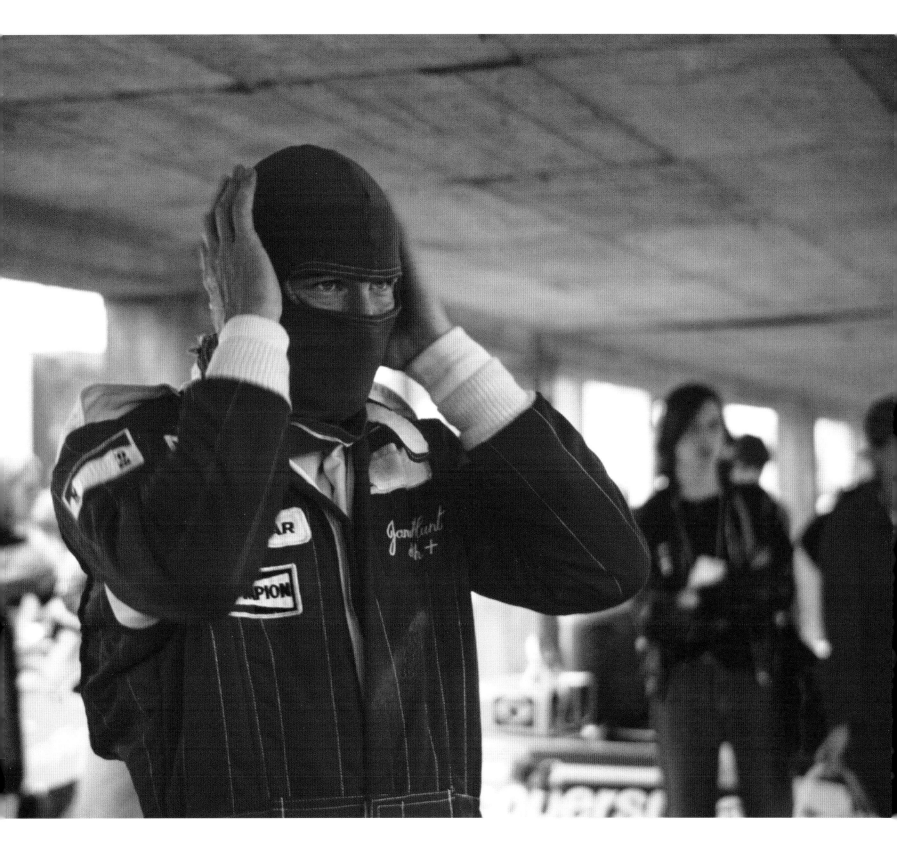

During the weekend of the 1977 Dutch Grand Prix, Hunt took part in an interview with Stirling Moss. In a deal with the sponsors of the Tyrrell team that employed Moss as an ambassador, the meeting had been set up to provide material for the *James Hunt Magazine*. Moss carried the company logo on his white T-shirt and the publication gained an exclusive as the winner of 16 Grands Prix in the fifties and sixties quizzed his contemporary British counterpart.

The edition of the magazine was never published in the end but, four decades on, the interview in a Zandvoort hotel room provides a compelling insight into Hunt's mind. Moss began by comparing earnings and saying there appeared to be greater pressure on the drivers in the mid-seventies.

James Hunt: I don't think there is much pressure from within the sport. I think that pressure is what you make it within yourself. Pressure to win is as strong as you want to make it. Pressure to do with work is a matter of not swapping it for the money because I get very well paid for it.

Stirling Moss: What about the pressure of the sponsor on you to, if you like, pay lip service or go and work for him or do this for him or do that for him? We didn't have that because we didn't have sponsors.

JH: Well, there is very little pressure. For instance, when I signed with McLaren, I had never really been in a sponsored situation before. With Hesketh Racing, the few deals that I had were of no

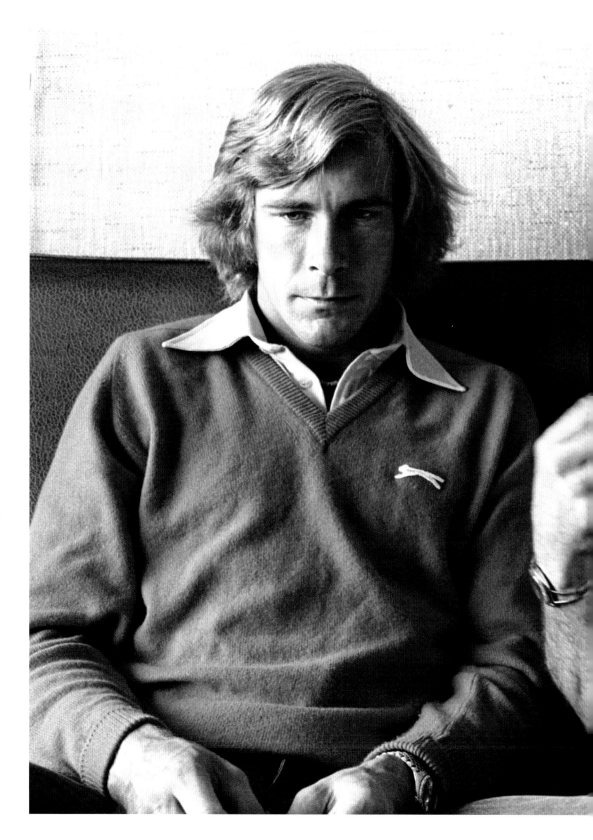

consequence and didn't really affect me very much.

I said to McLaren, I intend, as far as Marlboro is concerned, to behave exactly as I normally would. I'm not going to do anything different for you because I believe that your interests will be better served, publicity-wise. I'll get the publicity by being myself and you can get the mileage. If you want me to put on an act, I'll do it worse and I can't do that – wear a suit, a uniform and all that sort of shit. I scrubbed out the clauses about uniforms in the contract and I said that I would carry on as normal because I believe that both our interests will be better served like that, and they agreed with me. And so I've always worked on that basis with them and with all my other sponsors.

The only thing I find a heavy pressure – and it's a small price to pay – is the fact that I really would prefer just to race and have nothing to do with press or publicity or anything. But, of course, I have to do that because it's my income and 75 per cent of my earning power is what I do in relation to the public, or rather, for my sponsors, and 25 per cent is what I earn as a skilled driver. For that I have to work but, at the same time, it's a worthwhile exercise financially and I think that it's good for people to work. I think that it's good for your soul and I want to work. Doesn't mean that I like it!

James and Stirling Moss sat down for a frank discussion during the weekend of the Dutch Grand Prix.

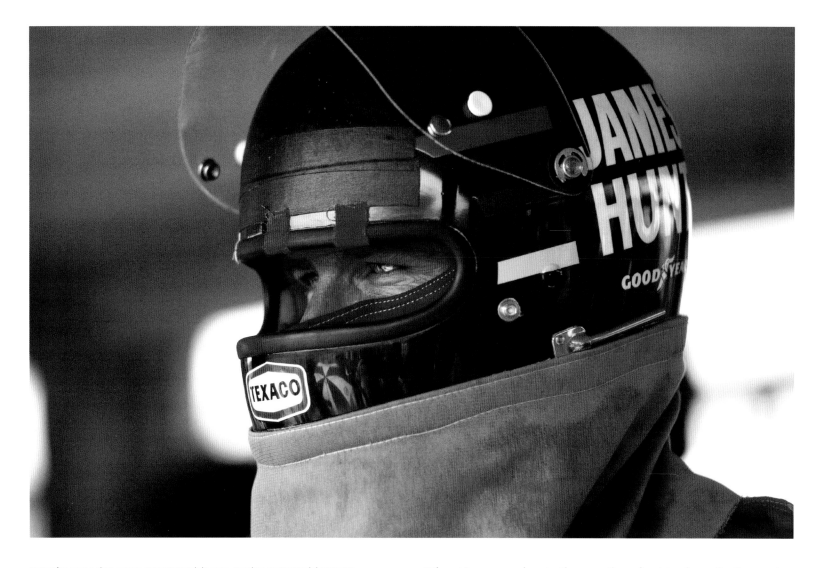

When Moss moved on to the question of a driver's motivation and attitude to safety, Hunt's replies were disarmingly honest.

SM: When you get into a car, do you get tremendous exhilaration, pleasure out of physically driving that car round a good circuit? We won't say any circuit. Do you get genuine pleasure where you say, 'I'd like to take that car out and really have a go with it if racing wasn't there'?

JH: Very rarely because I'm too frightened of it.

SM: In what way?

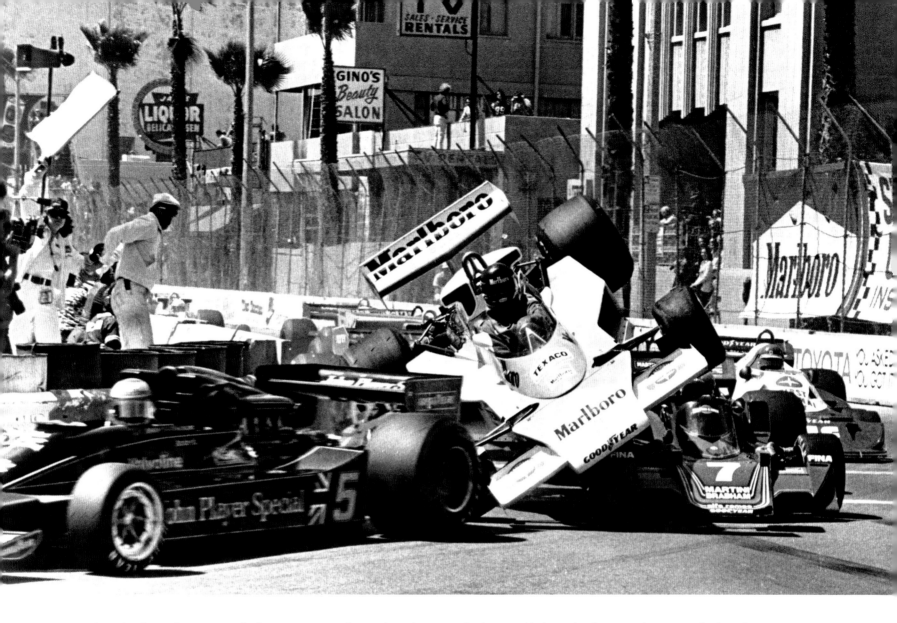

JH: Of getting hurt. If I saw a really fast car on a really good track, I would maybe like to go out and have a crack at it with nobody watching and get a lot of pleasure out of driving it round. But I'm of the conditioned opinion that every time I put my arse in a racing car, I'm risking my life.

SM: You've conditioned yourself?

JH: Well, it's a fact.

SM: Sure, it's a fact. When you do anything dangerous, it's a fact. It's a very interesting point to me because this is what I'd rather felt – that you don't get the pleasure. The cars that I was driving were

far less sophisticated – I'm not going to say far less dangerous, because danger is where you are going to make it. Let's face it, there's nobody making you go fast. The safest car in the world is a racing car until you race it, isn't it?

JH: That's right.

SM: It's got the best brakes and all the rest of it until you go fast; until you switch the engine on; until you put some twat inside it! So, it interests me as to just what has pushed you to the point where the pleasure is taken away.

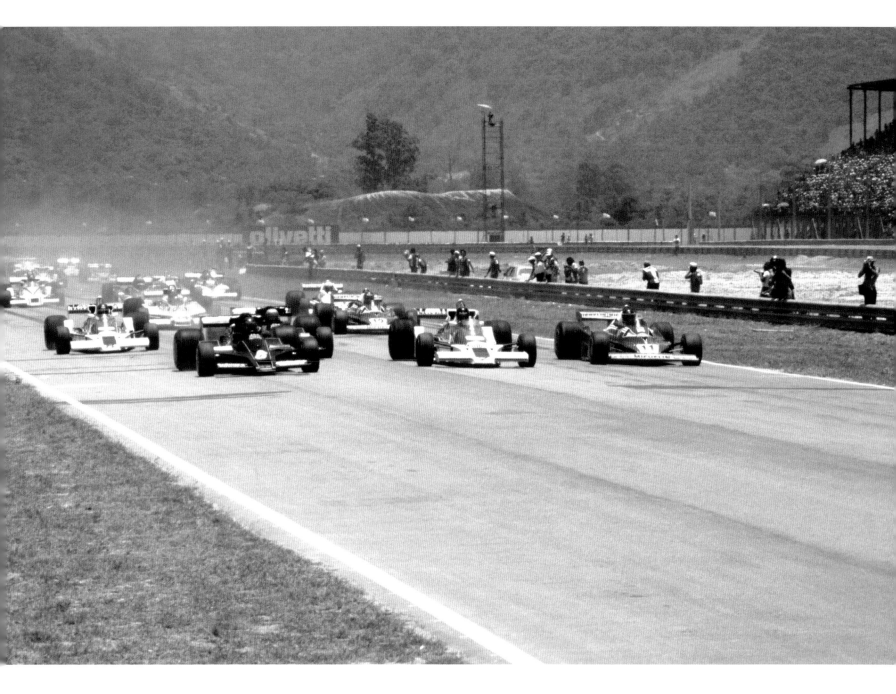

Ronnie Peterson's Lotus and Hunt's McLaren are neck-and-neck at the start in Brazil but Carlos Reutemann is already storming through on the right of the picture to take a lead the Ferrari driver will not lose.

JH: I'll tell you why, Stirling. My theory on the safety thing is that the danger is not how you drive the car, it's whether you get in or not because the modern car – for instance, the McLaren – is a very strongly-built car, built out of years of experience and, except in extraordinary circumstances, a driver can't break it because it's strong enough not to. Therefore, how fast you drive is utterly irrelevant to whether it breaks or not.

The only time that it ever breaks is when there is a mistake. I'm talking of mechanical failure first because mechanical failure is the most likely thing to kill me. Secondly, if I kill myself with my own mistakes or make an error or something like that, then that's down to me. That's a risk that I take anyway. Thirdly, I'm no more likely to make a mistake or hurt myself driving flat out than I am at seven-tenths because at seven-tenths I concentrate worse and that's a fact.

It's the mechanical failures that tend to kill and the driver errors that cause no problem because the driver makes his mistake at the slowest point ie, on a corner where things are happening. The cars make their mistakes when they are under the greatest mechanical strain when they're doing 180 mph on the straight – and the straights are not as well protected as the corners.

Therefore, I believe it's the physical act of getting into the car where you take the risk. What you do once you are in it is really pretty irrelevant. It's just that every mile you drive is another mile of risk; it doesn't matter how fast.

SM: What a dreadful philosophy to have. I'm not saying that you're wrong. I'm sure that I would probably feel that way if I was with you now in these cars.

JH: It doesn't worry me when I'm driving. It worries me much more when I'm sitting here. I haven't got time to worry about it when I'm driving. Getting back to the original point: that certainly detracts from the pleasure. But I like racing the others very much once I'm into a race and getting into it.

But the other thing is that all through my career, in just about every race I've done in my life, there's been a really major reason that I should do well or there's something that I should achieve. There was more pressure before I got into F1 because I was always on my last five quid with the car and, if I crashed it, I couldn't race again. And if I didn't win, I wouldn't get the step up in my career. Every time I got in the car, it was a critical moment in my career.

SM: Yes, but now you've got a much bigger spotlight on you.

JH: All right, I don't have that pressure. But I've put the pressure on myself because I want to win. So I can't get into a race and have fun. Saying that, because the pressure is really off me now with regards to the championship this year, I'm having more fun than usual this weekend [a view that would change following his clash with Andretti] because I can get in and enjoy it. But I still want to win races very much and I get more pleasure out of winning and getting the result than I do out of physically driving the car.

Hunt's state of mind through the early part of 1978 would depend heavily on the competitiveness of the car at his disposal. McLaren's optimism, based on the performance of the M26 in the final two races of 1977, was further justified at the Brazilian Grand Prix when James qualified on the front row for the first race at the new Jacarepaguá circuit near Rio. But that was to be the height of it. For a very long time.

Accidents and engine failures accounted for most of the many retirements, the pervading sense of gloom being made worse by the ground-effect Lotus 79 rapidly reducing the M26 to obsolescence. The highlight would be third place for James in the French Grand Prix at Paul Ricard. Reporting for *Autocar*, Peter Windsor gave the reason.

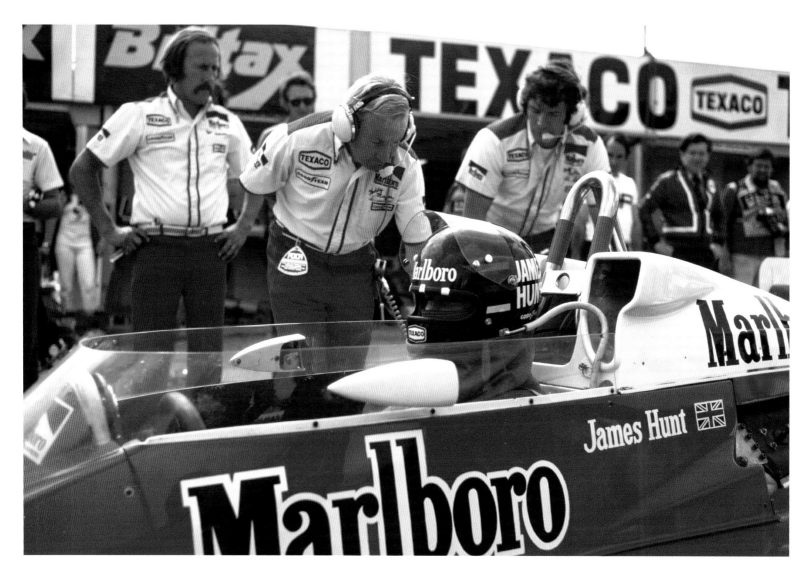

Mechanics Ron Pellatt (left) and Gary Anderson look on as Teddy Mayer plugs in during a poor weekend for Hunt at Brands Hatch.

'James Hunt saw the Lotus drivers' advantage being smaller than usual,' wrote Windsor. 'In the ageing McLaren chassis, which is admittedly a good car for [the smooth surface of] Ricard but hardly a classic down-force car in the modern sense, Hunt drove hard and well, staying with the Lotus drivers through the medium speed corners and sometimes catching them through the two white-knuckle corners that are amongst the fastest in racing. With the three cars circulating, literally, nose-to-tail, or as near as the adverse effect of turbulence allowed, James would catch them on the last part of the lap but lose them through the three corners before the straight. Out of the first hairpin, through the second-gear corner and then onto the straight via the fourth-gear left, Hunt's

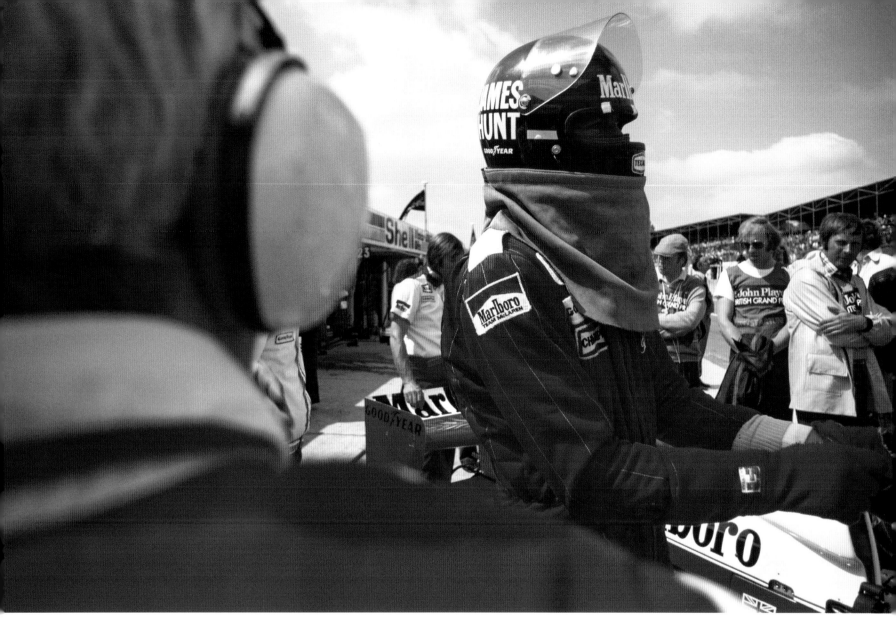

McLaren was left standing by the Lotus' superb traction and general rear-end grip. And then, on the straight, the Lotus edged away.'

Given the technical strength of the opposition as described above, Hunt's first podium finish since Japan the previous year was well worked and a welcome boost for driver and team. Two weeks later, on 16 July, morale throughout McLaren would plummet at Brands Hatch when Hunt crashed on the short, gently curving piece of track behind the pits. It was close to where he had pulled off at the start of the same race two years before. There would also be controversy this time, but not of the kind likely to engender fulsome support from the crowd.

When no obvious reason was given for the McLaren leaving the road, various theories emerged about Hunt's mind no longer being on the job, thanks to extra-curricular activities. The car had gyrated through 360 degrees before hitting the barrier and one suggestion was that Hunt's head might have already been spinning of its own accord. It was well known that he enjoyed smoking a joint and, in recent times, he had not been averse to snorting cocaine. Writing later in his autobiography, Max Mosley casually referred to an incident while discussing his friendship with his former F3 driver.

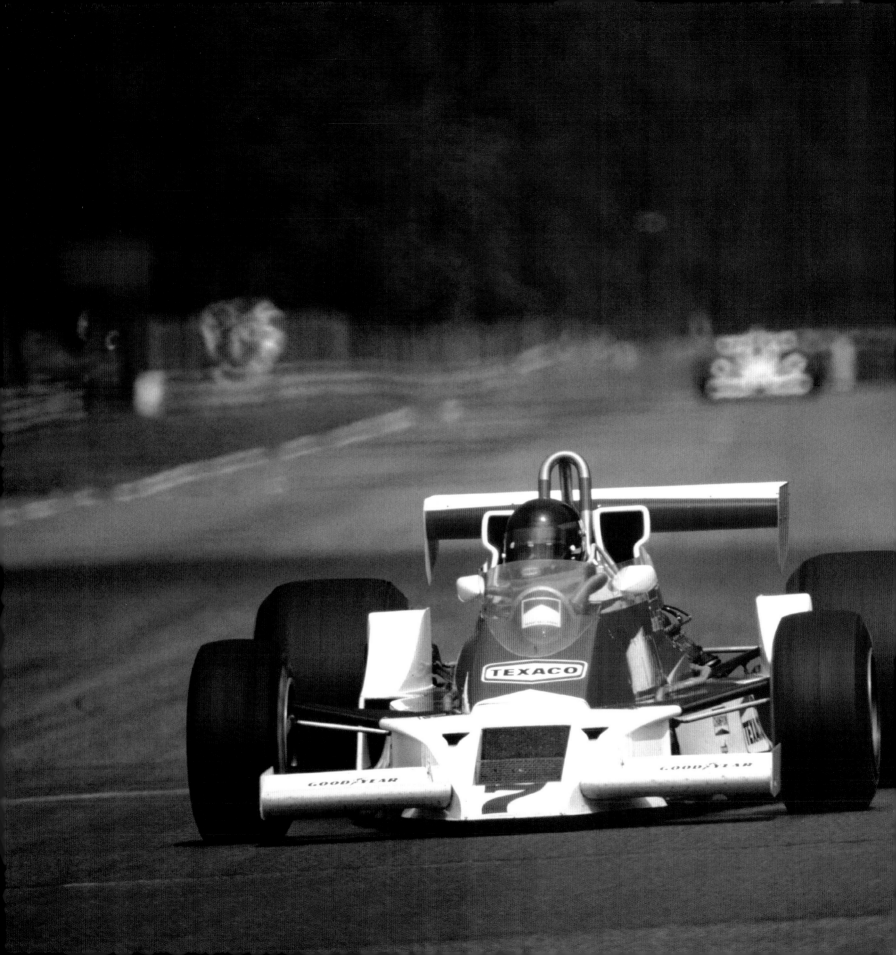

'James was always up for some fun and would liven up even the most boring sponsor's party,' wrote Mosley. 'On the way to one in Brazil we were sharing a car and he asked if I'd mind if we dropped in on a friend of his on the way. We arrived at a very grand, modern apartment block and took the lift to the top floor. The flat had wonderful views over Rio. James's friend produced a piece of polished stone and laid out three lines of white powder. Knowing I was a bit of a prude about such things, James turned to me and said, "You don't want yours, do you, Max?" I confirmed I didn't and he had mine as well. It certainly put him in a good mood for the party.'

No one suggested that Hunt had been indulging on race day at Brands Hatch. Muted theories concerned what appeared to be impaired judgement brought on by the lingering effects of some previous social engagement.

There would be no question about a misjudgement a fortnight later, when Hunt deliberately slowed in front of Vittorio Brambilla during qualifying for the German Grand Prix. Incensed that his best lap had been spoiled when he came across the Surtees driver as Brambilla slowed while running out of fuel, James pulled in front of the Italian and gave him a so-called 'brake test'. Brambilla failed the test in so far as he hit the back of the McLaren when caught completely unawares. But he had gathered his senses sufficiently to later remonstrate with Hunt in the pit lane by the simple expedient of calling him a 'crazy man' and bringing a substantial fist down on the Englishman's head as he sat in the McLaren – while, fortunately, still wearing his crash helmet.

Hunt's stock by this stage was in such decline that there would be little sympathy on race day when he was disqualified for taking a shortcut to the pits to change a punctured tyre after having held fourth place at one-third distance.

Hunt presses on in the M26 at Hockenheim before being black-flagged for taking a short cut when returning to the pits with a punctured tyre.

The saga continued through Austria and Holland but the following race, in Italy, highlighted the more fundamental of the concerns voiced by Hunt in his talk with Moss – injury in a racing car.

Troubled with brake balance problems, Hunt had qualified tenth on the grid at Monza. The track was very wide on the main straight before narrowing considerably at the point where banking, no longer used, veered off to the right. It was a potential bottleneck at the start of any race and was made worse on this occasion by a local official who, intimidated by urgently blipping throttles on the front row, let the field go prematurely.

Several drivers were still rolling into position when the green light came on. Riccardo Patrese, in his second F1 season and being Italian, seized the moment and floored the throttle on his Arrows-Ford as he prepared to line up behind Hunt. Meanwhile, Peterson made a slow start from the third row in his Lotus. This combination of factors became lethal as the jostling field piled into the bottleneck. Peterson's car was spun sideways and speared into the crash barrier on the right, ripping off the front end, exposing the fuel tanks and erupting in a massive orange ball of flame.

Ten cars were involved in the subsequent pile-up, among them Hunt's McLaren. James leaped from the cockpit and sprinted back to the Lotus, so badly damaged at the front it was immediately obvious Peterson had suffered serious leg injuries. The overhead helicopter camera showed Hunt and Clay Regazzoni pause briefly while a marshal with one small extinguisher did his best to contain the fire around the cockpit area. James dived into the smoke and flames, Regazzoni helping Hunt pull Peterson free. Once he was sure that Ronnie was being attended to, Hunt walked briskly away.

Peterson was eventually removed to hospital. His badly broken limbs were not considered life-threatening, which was good news for Lotus and Andretti as they later tried to quietly celebrate the American becoming world champion after finishing sixth in the restarted race. It seemed that disaster had been averted.

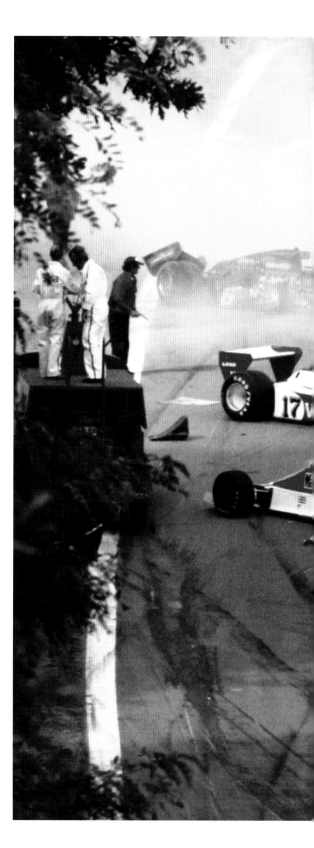

The scene of devastation at Monza. Hunt walks towards doctors attending to Peterson lying on the track. To Hunt's right, officials attempt to extricate the injured Vittorio Brambilla from his Surtees.

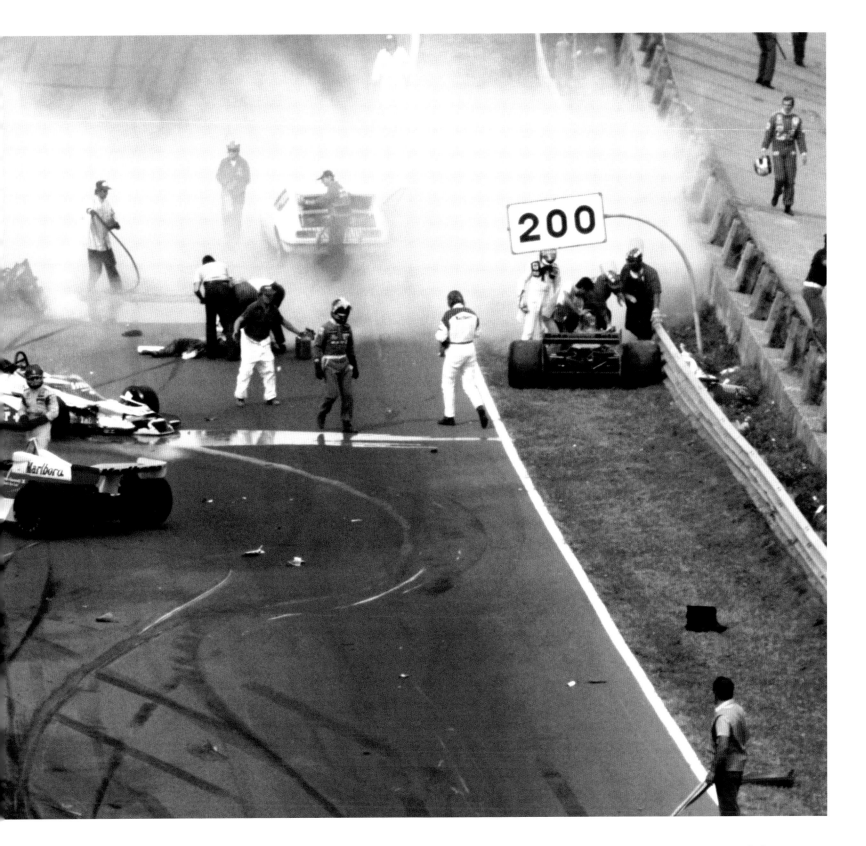

The following morning, while en route to visit Peterson at Niguarda hospital, Andretti learned from a toll-booth attendant that his friend and team-mate had died from an embolism that followed the emergency operation on his legs.

The desperate sorrow within motor sport led to inevitable recriminations – with Patrese being branded the culprit, particularly when Hunt claimed the Arrows had hit the McLaren and forced it into Peterson's Lotus as cars ran four abreast into the bottleneck. Patrese countered that he was ahead of the McLaren before moving across. He suggested Hunt had swerved and hit Peterson of his own accord.

Television pictures, taken from a distance and from the rear as cars headed towards the scene of the accident, appeared to show a merging of the Arrows and the McLaren before all hell suddenly broke loose. *Autosprint*, the Italian weekly, published an overhead photograph supporting Patrese's claim, showing the Arrows to be clear and ahead of the McLaren as it ran directly alongside the Lotus. But James remained in no doubt about who was at fault.

James Hunt

A lot of people pinned blame on the starter, Gianni Restelli, but this is rubbish. True, the start was messy but the drivers were guilty of taking advantage of the situation. The hard truth is the root cause was dangerous driving.

We had just completed the warm-up lap and were taking up starting positions when the red light came on – even though only the front couple of lines were actually stationary. The remainder of the pack held back and when the green came on, were still rolling. This certainly contributed to my excellent start. Riccardo Patrese made what can only be described as an Italian home start and was right up alongside me – except he was on the part of the track that leads to the old banking. I was slap in the middle of the pack with Ronnie Peterson on my left. As we approached the funnel where the tracks divide, Patrese, with nowhere to go, without warning barged over on me, pushing me into Ronnie.

News of Peterson's death and Hunt's heroics was carried on the front and back pages of Monday's newspapers. Some editorials blamed the track. But the majority followed Hunt's lead. The outcry became so loud that drivers took it upon themselves to have Patrese banned from the next race at Watkins Glen. The Italian was quoted as having been involved in several previous incidents that had suddenly shifted from being relatively unimportant to dangerous examples of disrespectful tactics by a comparative novice.

THE HARD TRUTH IS THE ROOT CAUSE WAS DANGEROUS DRIVING.
JAMES HUNT

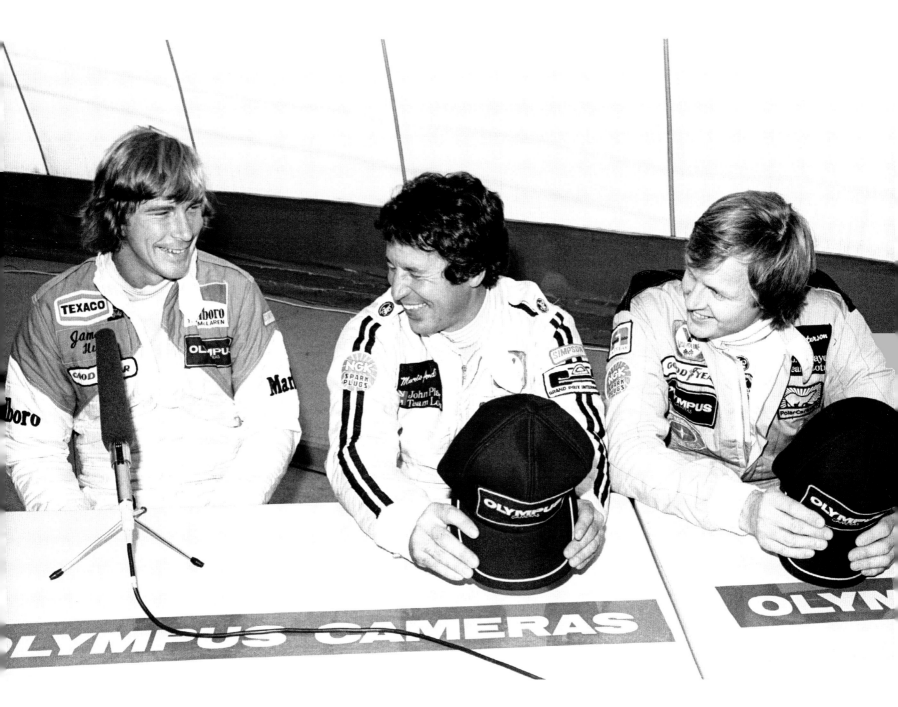

Happier times as Hunt, Andretti and Peterson hold court at an Olympus
Cameras press function in Austria.

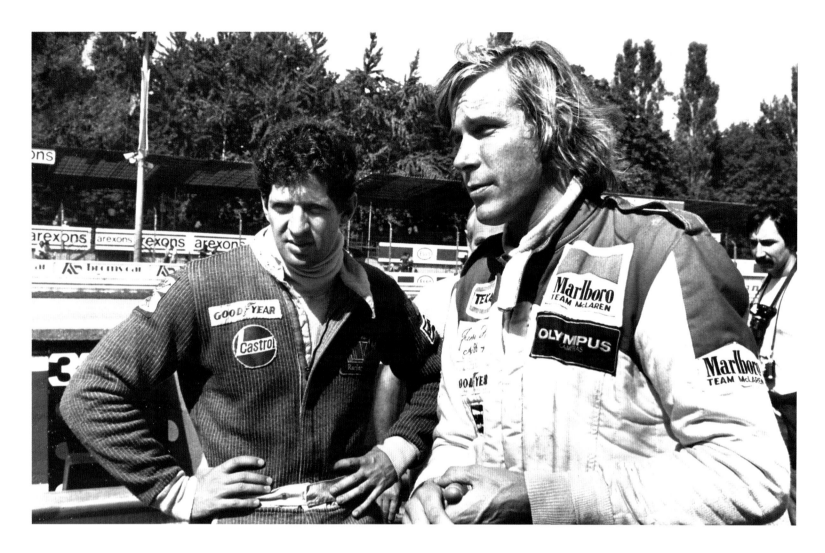

The Formula 1 safety committee – comprising Hunt, Andretti, Scheckter, Fittipaldi and Lauda – asked the organisers of the US Grand Prix not to accept Patrese's entry. The drivers claimed they would not take part otherwise. Faced with such an uncompromising situation, the officials felt they had to bar Patrese, even though the drivers' decision was outside the sporting code of the governing body and their deliberations effectively amounted to a kangaroo court.

Patrese would go on to become one of the most dignified and respected drivers in F1, competing in 256 Grands Prix and winning six of them before retiring at the end of 1993. Andretti would later say he was ashamed of his actions, the Patrese ban being the most discreditable incident he had been involved in during a long and distinguished career. Hunt, meanwhile, would continue to see Patrese as the guilty party, a view that appeared to colour his frequently critical assessments of the Italian in later years when working as part of the BBC television commentary team.

In the meantime, James Hunt was still a racing driver – and planned to continue being one in 1979, despite the dismal season that was about to end with him joint 13th in the championship with just eight points. However, in the light of the frank admission to Moss about fears of being killed in a racing car, there can be no doubt about the one thing on James's mind as he walked back to the pits at Monza on that September afternoon.

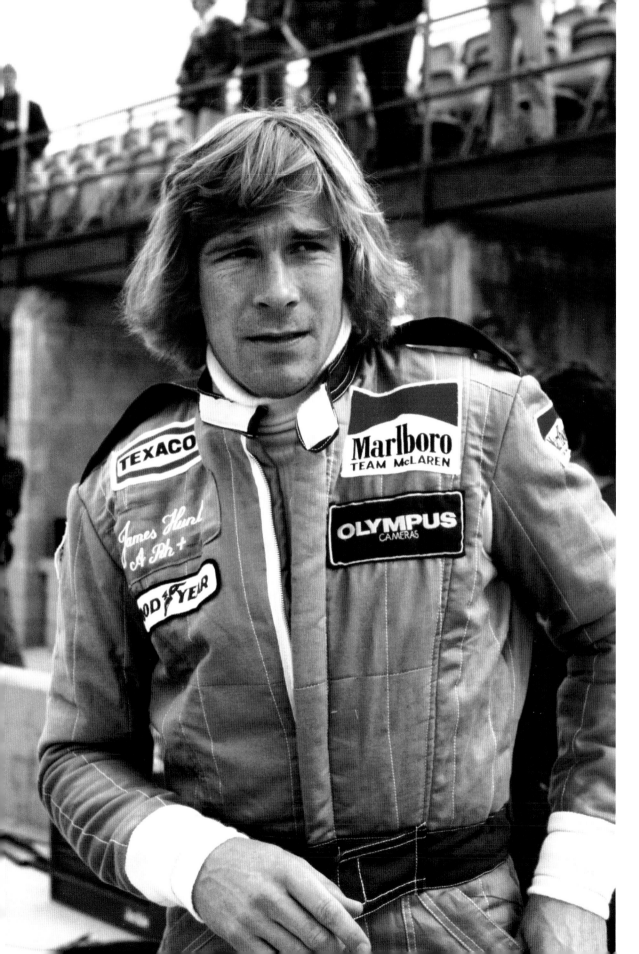

Opposite page: Hunt with Scheckter at Monza, the driver he had second thoughts that weekend about replacing at Wolf in 1979.

Left: James wore blue overalls at Watkins Glen in deference to McLaren receiving sponsorship from Lowenbrau for the United States Grand Prix.

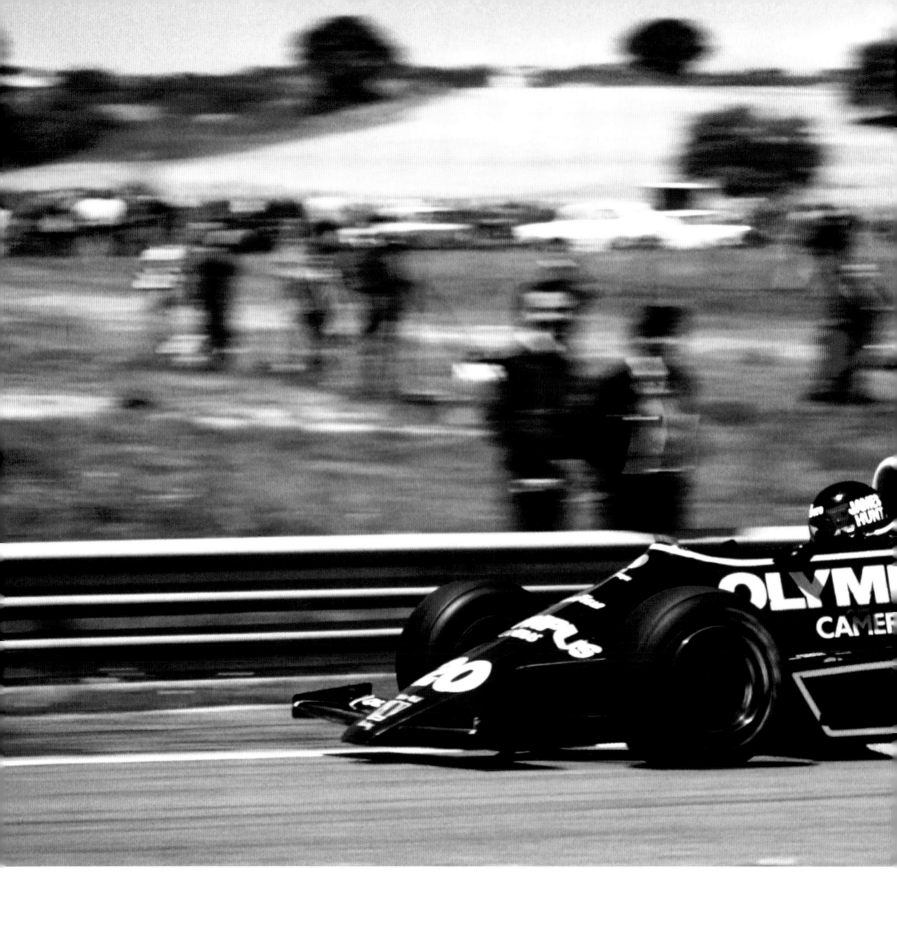

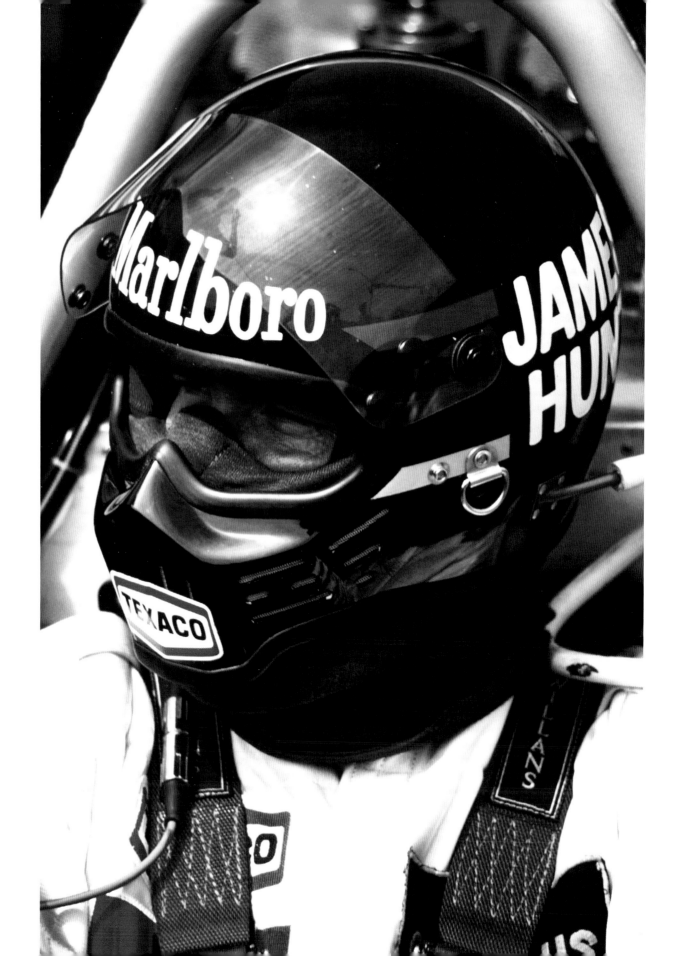

James Hunt battled through the chaotic mass of officials, team members and hangers-on milling around that always characterised the aftermath of a major incident. His destination in the Monza paddock was the Wolf motor home. It seemed a strange preference over the familiar surroundings of the Marlboro/Texaco trailer, James's base for nearly three seasons. But his thinking had not been distorted by the trauma of the crash; the decision was driven solidly by his personal anguish and thoughts for his own future.

Speculation about drivers' new contracts usually began in the summer as the so-called silly season kicks off with rumours. In July it was suggested Scheckter might leave Wolf to join Ferrari. Official confirmation a month later automatically triggered theories about Scheckter's replacement.

Given McLaren's slide from prominence, coupled with Wolf having won three Grands Prix in their first season, it was the work of a moment to add Hunt's name to the list of possible candidates. The team's ambitious owner, oil baron Walter Wolf, could probably afford the fee required by the calibre of a star driver he felt he needed to have. James Hunt moved to the top of the list.

The deal with Wolf had been agreed by the time of the Monza race, but it had not been made official. But James was in no mood for pretence as he walked quickly through the paddock and sought out Peter Warr, the former Lotus team manager who masterminded the Wolf operation.

Peter Warr *During the summer of 1978, I signed James to come to Wolf for 1979 for a retainer of £150,000. Then we all went to Monza and Ronnie had his accident.*

James was a pretty brave, straight-up sort of guy and when the accident happened right after the start, he jumped out and ran to Ronnie to see if he could help and lift him out. Then there was a long delay while they cleared everything up before they restarted the race. Instead of going back to the McLaren motor home, he came into the Wolf one and started to plead with me to let him out of his contract for the next year. He'd finally had enough after what had happened.

James was too intelligent; he was always thinking, 'There but for the grace of God go I.' He wanted out. I didn't tell him he couldn't. I just said we should wait a week or two for things to settle down and then talk some more. What we didn't know, of course, was that Ronnie would be dead by the next morning [Peterson had agreed to sign for McLaren for 1979. His death might have influenced McLaren in trying to retain Hunt].

Anyway, we did meet and talk some more. James's brother Peter was there too because he was always involved in all his contracts and arrangements and in the end we decided to go ahead.

The announcement, when it came in the first week of October, barely warranted a paragraph in the motor sport press, such was the belief that the deal had long since been signed and was never in doubt.

JAMES WAS TOO INTELLIGENT; HE WAS ALWAYS THINKING, 'THERE BUT FOR THE GRACE OF GOD GO I.' HE WANTED OUT.
PETER WARR

As for James, he was making all the right noises about the excitement of a new challenge and was genuinely pleased that he would be reunited with Harvey Postlethwaite, now the technical chief at Wolf. There was also the unspoken benefit of earning at least a million dollars, the bulk of it – taking into consideration the modest retainer agreed with Warr – coming from sponsorship provided by Olympus, the camera company having been teased away from Lotus. A central theme of Hunt's justification for his move was countering the suggestion that he was neither interested in nor up to the job.

James Hunt
The criticism from some people not only insulted my intelligence but also summed up their lack of it pretty comprehensively. In fact, the safest way to drive is as fast as possible. The harder I try, the better I concentrate and the fewer driving errors I make. Obviously, the nearer the front you are, the greater the chance that a multiple accident will happen behind you.

I decided that, on a professional level, I had grown stale with the McLaren team, our relationship had gone as far as it possibly could, but this new team offers tremendous stimulus. I think they're going to provide me with the challenge that I so desperately want. I've still got it in me to be a winner; I know it's still there even after a year like this. I'm convinced that once I get back into the right car the good results will come. My aim is to be world champion in 1979 so that I can go out of this business on a high. That's the way I want to retire.

The same thought had begun to form in the mind of Walter Wolf. Arriving in Canada in 1957 as a penniless teenager from Slovenia, Wolf had amassed a fortune by setting up and equipping off-shore oil rigs around the world. He was a determined man who had learned English by watching cowboy movies while keeping warm in cinemas and meeting an impoverished Frank Williams struck an immediate chord. He bought Williams a Ford-DFV, assisted his shoe-string effort in 1975 and ended up as a shareholder, having bought Hesketh Racing's redundant plant and equipment for a reputed £450,000. The combination of the two deals gave Wolf full membership of the Formula One Constructors' Association (FOCA) for 1976 as well as the services of Postlethwaite. But the package simply did not work, the Wolf-Williams (née Hesketh 308C) being ineffective.

Williams, unhappy with his secondary role, left to start again under his own name. Wolf did the same. Warr was brought in from Lotus to manage affairs for 1977 and Postlethwaite designed an all-new car for a one-car team built around Scheckter. Wolf greatly admired the single-minded approach of the South African

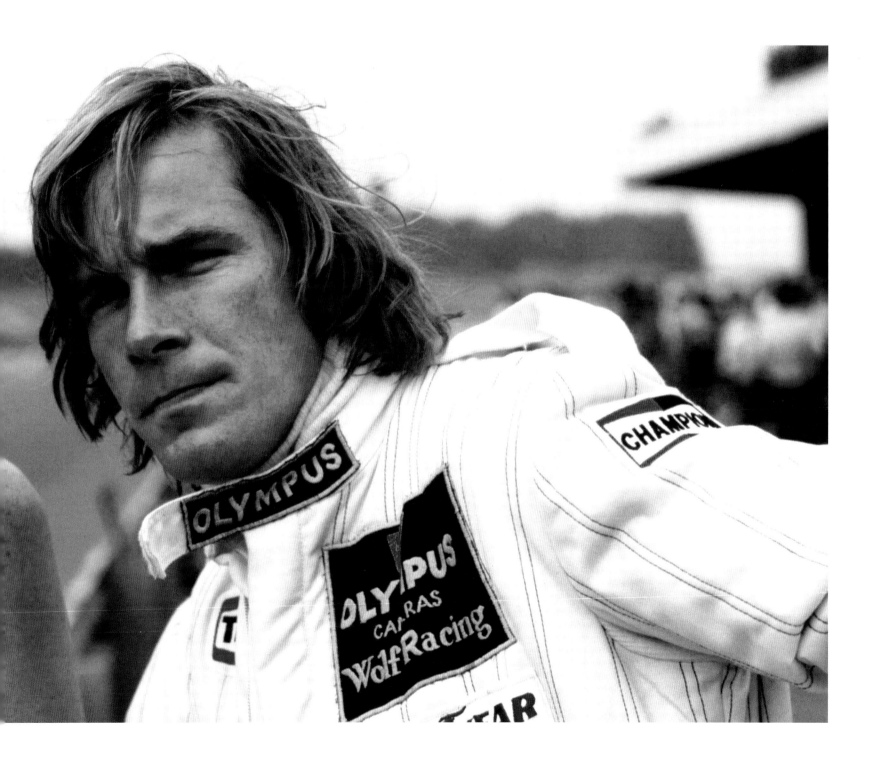

Walter Wolf *Jody was brilliant, a great racer, very fierce. When Jody closed on you, you had two choices: get out of the way or be pushed out of the way. He never made excuses; he was a fighter, a winner. When he left, I started to lose interest because he had been part of the original gang of four – Harvey, Peter, Jody and me.*

So, for 1979 I needed a new driver. James Hunt had worked with Harvey at Hesketh and he was persuaded to come because of that. His salary was entirely paid by Olympus. I wanted to try to get [French-Canadian] Gilles [Villeneuve] out of Ferrari, but I gave in and we signed James.

Postlethwaite designed the WR7, powered as with all previous Wolf F1 cars by the Ford-Cosworth engine. There was major fuss at the first race in Argentina thanks to the clutch impeller vanes drawing air through the oil cooler. This was a sensitive area in the light of the Brabham fan car that had finished one-two in the previous year's Swedish Grand Prix. The Brabham was withdrawn from racing rather than continue to cause controversy through the use of a large fan – this cooled the engine but also provided a massive performance advantage by 'sucking' the car to the ground. Wolf were forced to fit a second oil cooler, distracting the team from the more important goal of sorting out the car's shortcomings, including handling deficiencies.

After the opening rounds in South America, South Africa and California, the writing was on the wall and Jackie Stewart, as retired three-time world champion, was not afraid to read it aloud when discussing prospects for the European season, due to open with the Spanish Grand Prix on 29 April. His views, published in a Goodyear supplement, were prescient.

'I think James has lost a great deal of the spirit he once had,' said Stewart, 'but I believe it goes deeper than that. I think he still desires success, the financial rewards, the life that goes with being a racing driver. But desire is different from spirit and the spirit goes very deep... Basically, I think it's the spirit that's gone.

Hunt and Lauda ponder life on the pit wall in Argentina.

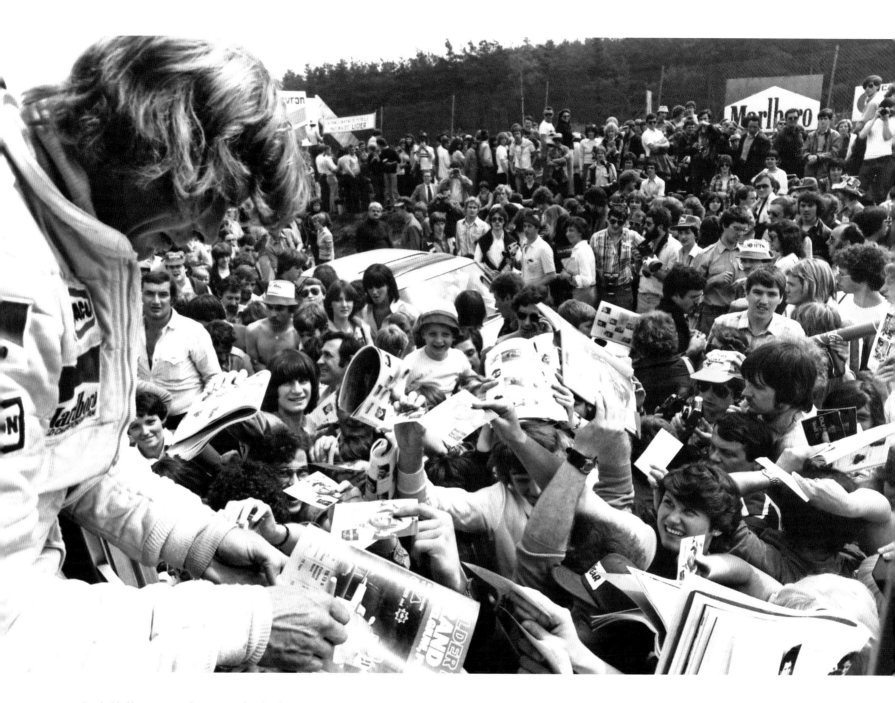

Having decided he wants to retire sooner rather than later, James signs autographs at Zolder on one of the few occasions he will remain a racing driver.

'You would have to liken James's rise to that of some in the pop music industry rather than in sport. It was a very sudden rise to adulation and big money – all the things that being world champion or whatever brings to you. The good life. It's hopelessly intoxicating and very confusing. Your entire world is fantasy and candy floss. There's no substance to it and unless you're very careful, you get carried along on this magic carpet ride.

'But there's a side to this business which most people just do not understand or realise: driving a racing car endlessly, testing chassis, developing tyres, sitting in searing heat for an unacceptable number of hours, presentations, cocktails and dinners with people you don't want to be with. I think that has got to James, along with the pressures on his private life. He wants to do things his way but, unfortunately, you can't do all these things the way you want to. If you're going to stay in, you have to compromise – or you can retire. I don't believe James thinks it's worth the compromise. James has never been shy in saying it's about the money and possibly that's why he decided one more season rather than retiring at the end of last year.

'Another thing is that I think he has become acutely aware of the dangers of motor racing. Add to that the fact that I don't see the Wolf team being at all successful this year and you can see all of these factors having a strong influence on what James will do at the end of the year.'

Apart from finishing eighth, one lap down, in South Africa, Hunt would retire elsewhere, a failure to finish in Belgium being due to a crash after climbing to fourth place. By now, the team were having serious doubts about their driver's motivation.

Walter Wolf *I found that the atmosphere in my team was not as it had been with Jody. When James and Harvey were at Hesketh with Lord Hesketh and Bubbles Horsley, the races were not the important thing. But when James came to Wolf we were more serious and there was a fair bit of friction between him and Harvey. You often get that in a team. The drivers say, 'Give me a better car,' the engineer says, 'Drive the car faster.' The trouble was, the heart had gone out of James. I remembered the state James had been in when he came into our motor home after Ronnie's crash at Monza.*

Peter Warr *He was the most nervous driver I ever worked with. His eye movements would be rapid. He'd be snappy and almost quivering. When his car broke down, he'd jump out, shouting, 'This car's a fucking heap of shit!' You'd just reel under the shock of his onslaught.*

I do remember having the feeling that we were making a mistake [in signing him]. The stuffing had gone out of James and I was concerned that we weren't getting value for money out of him. At Long Beach [round 4] he retired on the first lap with a broken drive shaft. I found out later that he'd said to one of the mechanics, 'I've discovered something. If I run the car along the barrier and give it a squirt in second gear, it breaks a drive shaft'. The following month at Monaco, he stopped on lap 5 – with a broken drive shaft.

This revelation would have been no surprise to Eoin Young. During practice for the Belgian Grand Prix, Young had received a message to visit Hunt. Thinking he might be cross-examined about having written something less than positive, Young braced himself for the sort of straight-talking experienced 18 months before when working on Hunt's biography. Having been on the F1 scene for 15 years (initially as a founding director of McLaren Racing), Young had seen it all. But he was not ready for what happened next.

He found Hunt alone in the back of the Wolf motor home, glancing anxiously around and keen to ask about how to announce his retirement in the coming weeks. Initially, Young explained that James would be better off having an agency handle the announcement since this sort of task was not in his territory. But when Hunt insisted he could trust no one else, Young agreed to meet James and Jane Birbeck in their hotel room that evening.

He got there to find Hunt even more wound up than before. Young had the impression James would have quit there and then had he not been under the moderating influence of Hottie. But whatever happened, Hunt was determined to make the announcement at the following race in Monaco. Young persuaded James that Monte Carlo at Grand Prix time would be the worst possible moment. Hunt reluctantly agreed but, throughout the conversation, Young noted an anxious countdown by James through the racing miles that could

possibly bring personal injury. Although the press release they would put together would not mention the subject, Young was in no doubt that fear of getting hurt was the main factor.

A subsequent crash involving Hunt 24 hours later at Zolder would have exacerbated Hunt's anxiety as he went on to put himself through a test session at Silverstone. He practised, qualified and then made a brief appearance in the Monaco Grand Prix.

James parked the black Wolf by the barrier on the climb to Casino. It was the last time he would sit in a F1 car at a race meeting. Having spent several years desperately trying to get into F1, he could not get out quickly enough.

It was two weeks later and Friday 8 June marked the beginning of a weekend that would feature the Le Mans 24-Hour race but no Grand Prix. Hunt chose this moment to announce his retirement. The surprise news made headlines, with his statement quoted at length.

'I wanted to have a really good final year,' said James. 'It wasn't a matter of thinking about the championship or anything. I wanted a good, competitive car with which to win some races. It's become clear to me that our car will never get there – it's nobody's fault in particular, just one of those things. If you haven't got an absolutely competitive car these days, you can forget it. And quite frankly it's not worth the risk to life and limb to continue under those circumstances.'

The subsequent reviews of Hunt's racing career spoke of his last win being the 1977 US Grand Prix. That may have been true in F1 terms, but it was not technically correct. At the end of 1978, his final season with McLaren, James had flown to Australia and won the Rose City 10,000 at Winton Raceway in a stand-alone race for F5000 cars down under. He had made a guest appearance in an Elfin-Chevrolet: a fun way to end a terrible season. James had travelled with his brother Peter, his friend John Richardson and his faithful McLaren mechanic, Ray Grant.

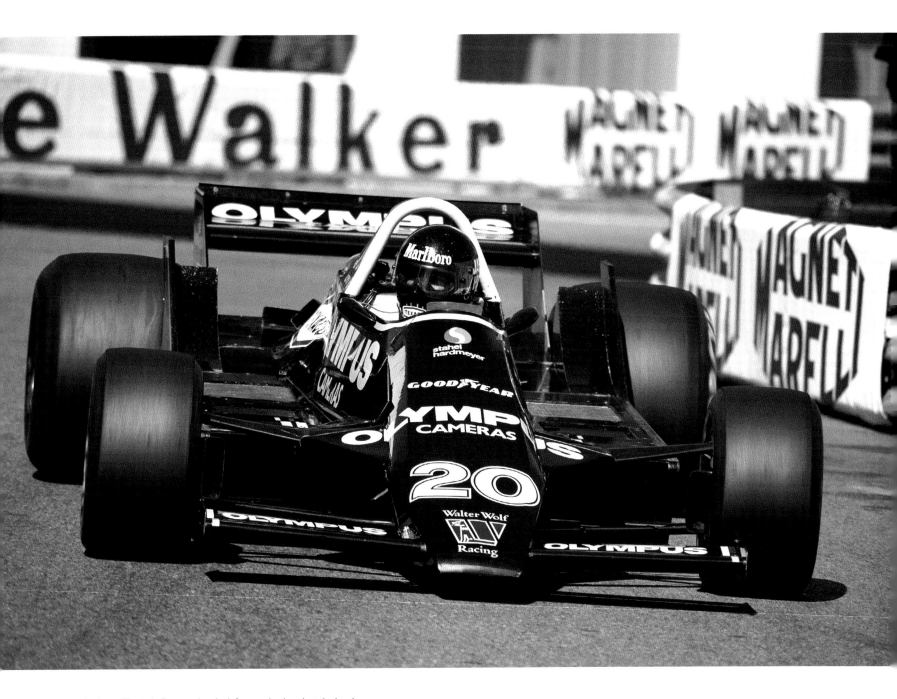

Hunt in the Wolf WR7 before running the left-rear wheel against the barrier
and breaking a driveshaft coupling.

Ray Grant

The trip was really good at the end of such a bad season. James had finished just six of the 18 races and his best result was third. I was his number one by then but I didn't think Teddy would let me go because I might not be back in time to do the initial testing. But it was OK.

Part of the reason I went with James was that we were also supposed to do an invitation race at Surfers' Paradise, but that didn't come off for some reason. At the time, my mum was running a motel in Surfers' Paradise so we arranged for all of us to go and stay there and Mum could meet James. She'd given him his own room and he greeted her the next morning, standing stark-bollock naked on the balcony, enjoying the sun, as she walked outside. She said she was a bit shocked – but didn't expect anything else from what I had told her.

That was the thing about James; he was just one of the lads. My younger brother was there. He took us to a couple of pubs but some of them wouldn't let us in because James was barefoot. In fact, we nearly couldn't get on a flight. They weren't going to take off because he had bare feet and they said that wasn't allowed on an internal flight in Australia. We had to rummage around in a suitcase to try and find something for his feet. Then there was more trouble because he had brought a couple of bottles of champagne on board!

It was a really relaxed trip and a reward for two years of me being his number one. He won the race easily – and against some good guys who knew what they were doing. When the race started, I thought, 'I'll have a fag.' Next minute, the race was over; not as long as a Grand Prix, of course. Then we went into oblivion for the rest of the trip!

From then on, James's career just went downhill. It was a case of a competitive driver not getting the performance out of the car they wanted. By 1978, I think he'd got horribly frustrated. By 1979, he definitely was a different person.

All over, bar the shouting. Hunt walks away from racing at Monaco.

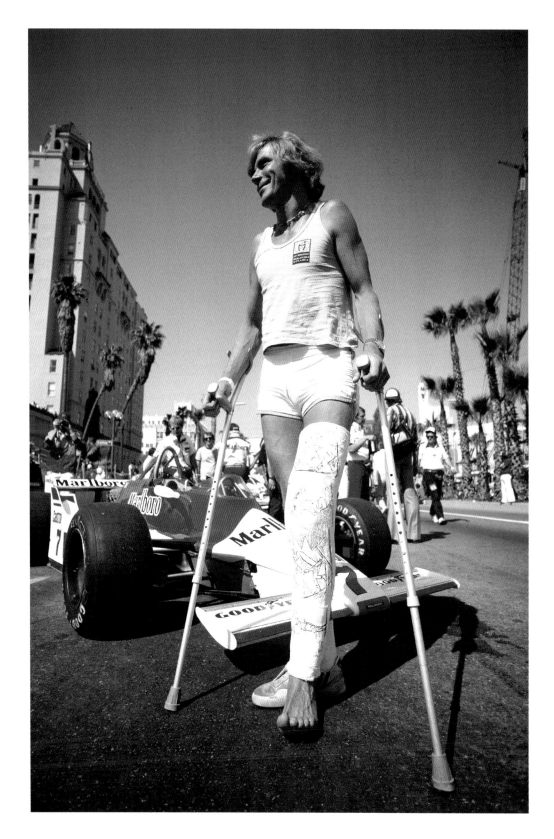

Almost four months to the day after Hunt had walked away from the Wolf in Monaco, Niki Lauda did the same thing in Montreal. Typical of Lauda, there was no formal announcement about the ending of his relationship with Brabham, only the briefest of words to team boss Bernie Ecclestone. Deciding he was fed up with 'going round in circles', Lauda left his helmet on the pit counter after the first practice session, returned to his hotel, packed his bags and flew off to Seattle to talk to Boeing about LaudaAir, Niki's fledgling airline.

The absence of motor sport's two main characters had an adverse effect on a business that had been pushed into the headlines by their spectacular rivalry in 1976. Public interest would only be rekindled in 1980 by a belligerent conflict between Alan Jones and Nelson Piquet.

As the teams gathered in an empty hotel car park in Las Vegas for the final race of the 1981 season, journalists, weary of trying to make something of the title contest between Piquet, Carlos Reutemann and outsider Jacques Laffite, seized on rumours of comebacks for Hunt and Jackie Stewart. In turn, both former champions milked the story – that James allegedly received an offer of £2.6 million from Brabham on behalf of an unnamed sponsor. Stewart's offer went one better – as it would – with a proposal said to be in the region of £3 million. While they were at it, reporters threw in Lauda's name for added value.

'It looks like James may be coming back,' said Stewart. 'The sort of offer I have had is very difficult to turn down. If all three of us came back, it would be the greatest thing on earth for motor racing. The offer to James doesn't surprise me; the sponsors are looking for big names. I'm not saying who made the offer to me, but I will be thinking about it long and hard.'

'It's great news,' said James of Jackie's offer. 'I can't think of anything better than racing against him. But we both have an awful lot of thinking to do. I don't need the money and when I retired it was for reasons of self-preservation and that reason doesn't change.

'Anyway, what do you do with the money? I'm not being big-headed. I lead a very modest life and when I retired I was well-enough off. I agree with Jackie that it would be the best thing in the world for motor racing if we came back and were in top condition. I would certainly have no worries in that direction. It is true that motor racing needs big names. I will make my decision known to Brabham this weekend.'

Nothing came of Stewart's return and Hunt announced that he would have to reluctantly turn down the offer. No one was unduly surprised.

Above: Retired rivals and former champions meet in the pits at Monza in 1981.

Opposite page: James proves being away from racing can be just as hazardous as he sports a cast at Long Beach in 1980 following a skiing accident.

Enjoying life in retirement as a budgie breeder (above) and TV commentator (right).

out sprint. The only time you could use your head was in a wet/dry situation. So I could see why the formula of the 80s really suited someone like Alain Prost. I'm in favour of a formula that requires you to put a bit of brain power into the whole thing.

James moved his permanent residence back to England. He renovated a mews house in London's Baron's Court and also bought a large estate, including a working farm, in Buckinghamshire. He continued to do promotional work for Marlboro, Texaco and Olympus between playing as much golf as he could, with a view to lowering his handicap to scratch.

Hunt had also made a move that would come to define him among younger generations that never saw him race; he took a role as race summariser for BBC television. The corporation's head of sport, Jonathan Martin, noted Hunt's ability to communicate when interviewed as a driver, but the BBC's long-standing commentator, Murray Walker, was not impressed by the new recruit. His initial disapproval was not diminished by the first professional encounter between the pair, when Hunt sported a plaster cast thanks to a skiing accident on holiday at Verbier in Switzerland. He'd been a guest of a Marlboro-sponsored team of acrobatic skiers and enjoyed 'a major lunch' with the team before unwisely attempting to join them on the slopes. The result was detached ligaments in his left knee, an injury that would require a major operation followed by a lengthy and painful recuperation.

James Hunt

I never ever felt I wanted to race again. As I said, I stopped for reasons of self-preservation. I was able to do that because I was financially secure and I wanted to keep on living without taking a risk. If it wasn't dangerous, I probably would never have stopped. I would be very happy about that. But I just don't want to top myself particularly and it is sort of tempting fate to come back.

My only regret – if you could call it that – about when I was racing was that I didn't have a thinking man's formula like the one in the mid-80s – fuel consumption restrictions, tyre changes and so on – because that would have suited me very well. In my day, it was largely an out-and-

I had been commentating alone until that point. When Jonathan Martin called me in and said there would now be two commentators and one would be James Hunt, my immediate reaction was one of outrage. I thought, 'What the hell does he know about commentating? He's a racing driver. And, anyway, I don't like James Hunt.'

I have to be objective and try to work out where and why the friction came from when we were together. I was old enough to be his father. My views on life were diametrically opposed to his. I was a plonking, straightforward, up-and-down bloke and here I was, with this booze swilling, cigarette-smoking, womanising, drug-taking chap who I associated with rudeness and being objectionable. I was pretty wary about it, I have to admit.

The first commentary we did together was on a Formula 5000 race at Silverstone. James had a plaster cast on one leg, from ankle to crotch, because he had torn ligaments while he was stoned somewhere on the continent. So James spent the whole of the commentary lying on the floor looking up at the television screen with me standing alongside.

You try and make the best out of things in life – and this was a pretty dreary, processional race. When it finished, I'd hyped it up as much as I could, and said: 'Well, James, what did you think?'

He took the microphone and he said, 'What a load of rubbish.' He was right – it was a load of rubbish but, really, you didn't say that, did you? I was genuinely shocked.

Monaco 1980 was the first time we did a Grand Prix together; exactly a year

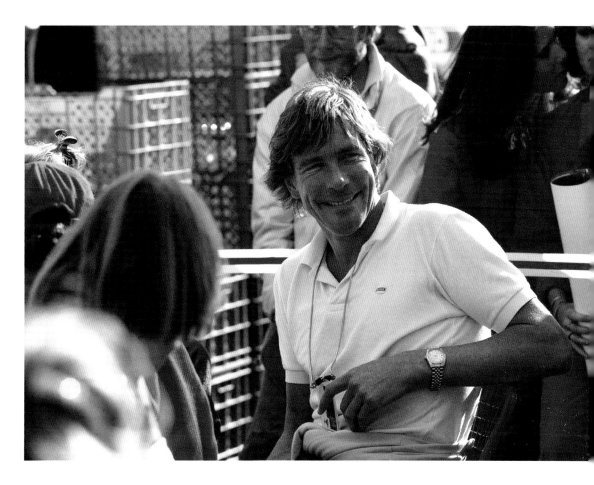

after he had retired. And in those days there weren't any commentary boxes. We sat out in the open, opposite the pit lane exit. We were each given a folding chair with slats and one television set. There was the Armco and the race track. I had Jonathan Martin shouting in my ear and the extremely loud noise from the cars just a few feet away.

James appeared shortly before the start of the race in a pair of tattered cut-off jeans, no shoes, a T-shirt and half a bottle of rosé in his hand; half a bottle because he had drunk the other half already. He sat down in the chair alongside me, put his plaster cast in my lap – and we did the race like that. It went all right, as far as I

remember. James did a perfectly adequate job. But it was pretty clear to me that this was not going to be an easy relationship from a commentating point of view.

Proud Dad with Freddie and wheeling the pram on Wimbledon Common.

Hunt suffered with his skiing injury, becoming frustrated at his lack of mobility and sleeping badly. His relationship with Jane Birbeck deteriorated. The couple had tried hard to make things work, to the point of becoming engaged, but their personal difficulties contributed to a downward spiral as drinking and smoking played an increasing part in both their lives. Hunt's philandering didn't help. By the end of 1981, they had parted as good friends and as amicably as possible under the circumstances.

In the meantime, the farm had been sold, as had his interest in a squash club in Germany. This inactivity and the injury exacerbated the withdrawal symptoms that crept in the moment he had hung up his crash helmet after a decade and more of thinking about nothing but racing.

James had bought a five-bedroom house in Wimbledon. The grand 30s' detached property was slightly frayed round the edges; perfect for James, just as a large garden was ideal for his beloved Alsatian, Oscar.

Sally Jones

James always loved animals. When he was little, he adored our dog, Ricky, a labrador with lots of other breeds mixed in. James cried all the way back from Westerleigh school on the day Mummy told him Ricky, who had become quite old, had to be put down. He was so upset.

The house in Wimbledon was handily located for his busy round of relaxed social engagements but the much-prized bachelor existence would come to a sudden halt in September 1982. While taking a break in Spain, James met Sarah Lomax at a beach party.

Sarah, an English woman working for an interior decorating firm in Washington DC, was instantly smitten. The feeling was mutual. When they weren't dating in the UK, James would commute to Washington. By early 1983, Sarah was living in the house in Wimbledon. By late December of the same year, just over a year after meeting, they were married in the registry office of Sarah's home town in Wiltshire. The blossoming of the relationship really was as swift and as starry-eyed as that.

It was also the signal to resume full-on parties. Extensions and modifications to the house included a large Jacuzzi, which saw activity that became more enthusiastic and revealing in every sense as evenings wore on. This did not always go down well with the neighbours in this select suburb.

On 12 September 1985, Tom Hunt was born, Freddie arriving 22 months later. A month after that, in August 1987, James celebrated his 40th birthday. A large gathering of family, friends and assorted celebrities were invited to Wimbledon and embraced the party theme of 'bird or beast'. James chose the latter category, receiving his guests wearing a kilt. It was no surprise to learn that he was without clothing beneath it or that, in an effort to replicate the famous racehorse Northern Dancer, the tartan was covering, albeit briefly, an enormous salami sausage.

Sarah, choosing the bird category, was dressed as a budgerigar in recognition of James's passion for more than a hundred budgies living in a large fully equipped aviary in the back garden.

Sally Jones

The passion for budgies had started when he was little. Just after the family had moved to Sutton, somebody gave us a budgie. It was called Peter at first until we were told it was a girl and she quickly became Rita. James was very fond of Rita and, off the back of that, he bought a pair and started breeding budgies when he was a teenager. He would take time off from Wellington by telling them – not always completely truthfully – that he was going to a budgie show when, perhaps, he was off to meet a girlfriend.

I ALWAYS LIKED JAMES AND HIS COMPANY: I WAS NOT ALONE IN HAVING A VERY GOOD RELATIONSHIP WITH HIM.
EMERSON FITTIPALDI

As with everything he chose to do, James threw himself into his hobby with energy and enthusiasm, breeding and showing his birds around the country. If this seemed an unusual hobby for a former Grand Prix driver, his choice of transport for the birds was even more bizarre. He chose a 20-year-old Austin A35 van over his 6.9 Mercedes, on the grounds that the Mercedes was expensive to run and less than ideal for carrying cages of chirping cargo.

Between shows, Hunt continued to engage in occasional motor sport events calling for the presence of former world champions.

Emerson Fittipaldi

I had a lot of funny times with James long after he had retired. In 1981, they held exhibition races in Dubai for famous racing drivers and cars. I went there with Jody [Scheckter] and James. We flew from London. I slept really well and woke up just before we landed. Jody and I tried to wake up James – but we couldn't. I don't know what he had been doing – but I could guess! All the VIPs and media were waiting to greet us and I remember Jody and I had to carry James off the plane. We had to tell everyone he had become sick during the flight! I always liked James and his company: I was not alone in having a very good relationship with him.

To all intents and purposes, life appeared grand for the 1976 world champion. Certainly, that is the way this author found it when visiting the Hunt household to discuss life a decade after winning the title. You could have written a colour piece before the host had so much as uttered a word.

The large lounge, a collection of mismatched sofas and easy chairs, had a lived-in look with magazines and sundry paperwork piled here and there. The door had been answered by Winston, an eccentric Jamaican whose introduction to the Hunt household was as a taxi driver, booked for speeding when hurrying at his passenger's urging. James had been late for an appointment and felt so responsible for his driver losing his licence that he offered him a job. Winston covered anything from gardening to cooking and whatever else the man he now called boss might think of.

Blowing his own trumpet and making a different kind of noise.

Right: James and Sarah enjoying one of their frequent parties.

Opposite page: A favourite pastime; with Freddie and Tom feeding the ducks and geese on Wimbledon Common.

Sundry characters wandered in and out of the house, every movement being clocked by Humbert, an African grey parrot with a penchant for foul language and for reproducing the noise of a ring-pull opening a can of lager. This was clearly a sound Humbert had had the opportunity to rehearse on a great many occasions.

On the day of the interview, James emerged from the aviary, waving a plastic spatula. 'Look at this!' he exclaimed. 'I can use this, along with plastic sheets I discovered recently, to clean up the poo in no time at all. Marvellous! Saves so much time and effort. I was able to collect the sheets in my 1967 A35 van. Paid £900 for it. 29,000 genuine miles. Still on the original tyres – doesn't half slide around, even on a dry road when not going particularly fast. Incredible. There's no grip at all; we

take these things for granted nowadays. Unfortunately, it's stuck in first gear and I've got to get that sorted out as soon as I finish this. So, let's get started.'

And with that, the conversation moved to the question of how he had behaved as reigning world champion and the criticism his behaviour had generated.

James Hunt

I didn't really care. At the time, I was terribly busy as world champion. When I was driving, everything was fine. But it was the travelling around after winning the title which really got to me. I think I had about a week off after the last race and then I was up and running. I worked non-stop – all day and, sometimes, most of the night – until about four days before Christmas. At the time I was far too busy just getting everything done to worry about how I went about it. I was basically getting on with my life in my own way and I didn't really care about anything else. Obviously, I wouldn't be the same today. I've changed, become much more in line with the establishment and I'm sure my behaviour would reflect that. I would obviously handle the pressures much better now because I've had a lot of practice at it. Don't forget, I came from nowhere. I had won just one Grand Prix in the year before I became world champion, so I was pitched in pretty heavily at the deep end. It was a big change and all I could do was operate in the only way I knew – which was not to compromise myself but get on with it, if you like, in my own funny style.

James with Nigel Mansell in 1986, before creating controversy with a newspaper article on the Williams driver.

Hunt's view of being more 'in line with the establishment' was heavily disputed in November 1985 when he caused a commotion during a flight to the Australian Grand Prix. Having made good use of the freely available liquid refreshments, James had dozed off, only to be awoken by an urgent call of nature. Finding the lavatories engaged, 'Mr Hunt' – as a British Airways report would later state – 'had problems controlling his bodily functions.' This manifested itself in James relieving himself against the curtain separating club from first class.

News of the former world champion being caught short had been widely circulated by the time he returned home, particularly as first-class passengers Esther Rantzen and her daughter were reported to have been inconvenienced by Hunt's definition of a public convenience. This was a claim the TV personality herself later denied although, along with other passengers, Rantzen had not been in the least impressed by such uncivilised behaviour from someone who should have known better.

In the 1986 interview, Hunt admitted that integrating with society as a former driver and current TV commentator had been difficult.

James Hunt

When I first started commentating I didn't enjoy going to the race meetings at all. I was still treated like I was a driver by the general public. I didn't feel that I deserved all that aggravation that comes with it. I would be in the area of the Grand Prix but would only go to the track about an hour before the race, just enough time to have a word and get myself genned up and then go straight to my commentary position and leave straight afterwards. I might have arrived the day before but I wouldn't go to the track, I would stay in the hotel. Then, when I started to take Sarah to the races, she began to enjoy it – she knew absolutely nothing about racing beforehand. I found that I was able to enjoy it more because my face had become forgotten and I was able to move around like a normal person. The problem at the start was that I couldn't come out from under cover. But now I enjoy being at the Grands Prix much more because I can generally swan around... Ah, here's Tom. He started to crawl yesterday for the first time. He's a well-behaved little man. He's slept all night and every night since he was two weeks old. He was a jolly contented little man – unlike his father, who was a horrendous baby! Where were we?

...Ah, yes, I enjoy commentating very much. It seems to have come quite naturally for me. I just put myself in the position – but without consciously reasoning it in this way – as if I was sitting at home here with half a dozen mates watching a Grand Prix and I colour it in for them because I can see things they can't see. I say exactly what I think, with the good fortune of being able to speak from a position of strength. I don't have to fear any backlash because I know I'm pretty much right.

I think it's fair to say that I have never been confronted or attacked by anybody that I have criticised. There was one instance where I heard someone was wandering about moaning but one is not bad in seven years. I get the odd attacks from lunatic fans who don't understand the business at all but then that's bound to happen. The point is I don't set out to be deliberately controversial. It's strongly delivered when I describe things as I see them. If somebody makes a cock-up then I say it's a cock-up rather than water it down.

Murray is a lot of fun to work with. He does so much for the image of the sport because he's such a tremendous enthusiast. I think we make a very good contrast. Murray is all puff and wind and excitement. I'm fairly laid-back and dry in my delivery. I had to do one race with another commentator last year and, while he was technically very good, his style was similar to mine; quite reasoned with a fairly flat-toned delivery. I didn't think it worked at all well when compared to being with Murray.

IT IS, I SUPPOSE, A CREDIT TO BOTH OF US THAT WE ACTUALLY LASTED TOGETHER FOR 13 YEARS.
MURRAY WALKER

It is, I suppose, a credit to both of us that we actually lasted together for 13 years. I would argue that it called for and got a great deal of tolerance from me. James would, I am sure, say that it called for a great deal of tolerance from him because from my point of view I was always standing on the balls of my feet, adrenalin pouring out, very excited. James sat in a sort of sullen heap alongside me and we shared one microphone. We did this because of Jonathan Martin's wisdom and knowing that if you give two people two microphones they will talk over each other. I had to give the microphone to James which I wasn't particularly anxious to do, partly because I wanted to talk in my own way about what I was seeing and partly because, arrogantly, I thought that James slowed up the action.

In fact, he had a very significant contribution to make very often. If he would actually want the microphone, he would wave his hand. I'm sure from time to time James must've been very irritated in a way that I was hanging on to the microphone.

But I always knew there is no such thing as a dull Formula 1 race. For me, there's always something interesting and exciting if you knew where to look for it. But I'll admit there were some processional ones. If that was the case and it was a bit of a struggle, I knew I only had to say something complimentary about Riccardo Patrese. James would reach for the microphone and pour vitriol on Patrese, whom he blamed for the death of Ronnie Peterson – incorrectly. And he'd say things such as, 'The trouble with [Jean-Pierre] Jarier is, he's a French Wally, always has been and always will be.'

But the public loved it. Over the years, we were either going to accommodate each other or split. And we accommodated each other. James could have outbursts of temper that were really, really frightening. I was in the commentary box at Adelaide one year and one of the technicians did something that irritated James. He turned on this bloke and screamed at him using the most foul language, a great torrent of it. This bloke had only done some terribly trivial thing and I was really shocked at that.

But saying that, when he was in a good mood and in a communicative mood – and, the further he got away from his driving career, the better he became – he was an absolutely delightful bloke to be with. I can't say I always agreed with everything he said, but he had the perfect right to say it. Which he made sure he did. Apart from Patrese and one or two others, he wasn't particularly complimentary about Nigel Mansell, which I certainly didn't agree with.

In 1986, at the time of the interview conducted by the present author, Mansell was building a championship momentum that didn't necessarily meet with James's approval. Mansell may have had his faults, but he was a hard-charging racer making excellent copy for UK motor-sport publications. National newspaper reporters turned out in force for the penultimate round in Mexico City where, subject to a good result, Mansell could become the first British world champion since Hunt himself, ten years before.

With Mansell second-fastest on the first day, the mood was generally positive as the drivers went into qualifying. Then the fax machine in the media centre clicked into life. Out stuttered a page from that day's edition of *The Times* carrying a feature written by Hunt. The text on the heat-sensitive paper may have been blurred but the sense of the story was stark: Mansell did not deserve to be world champion and, furthermore, such an event would not be well received by those working in Formula 1.

There was immediate outrage, particularly among those who had been paid to travel to Mexico to sing Mansell's praises. But there was also acknowledgement that others quietly shared Hunt's views. No one else had dared articulate them. Certainly not in print. It was as if James had exposed a skeleton in F1's cupboard.

Setting aside the former champion's willingness to say exactly what he thought, the analogy concerning an unspoken truth was to have an unfortunate association with Hunt himself as his life changed, not always for the better, in the coming years.

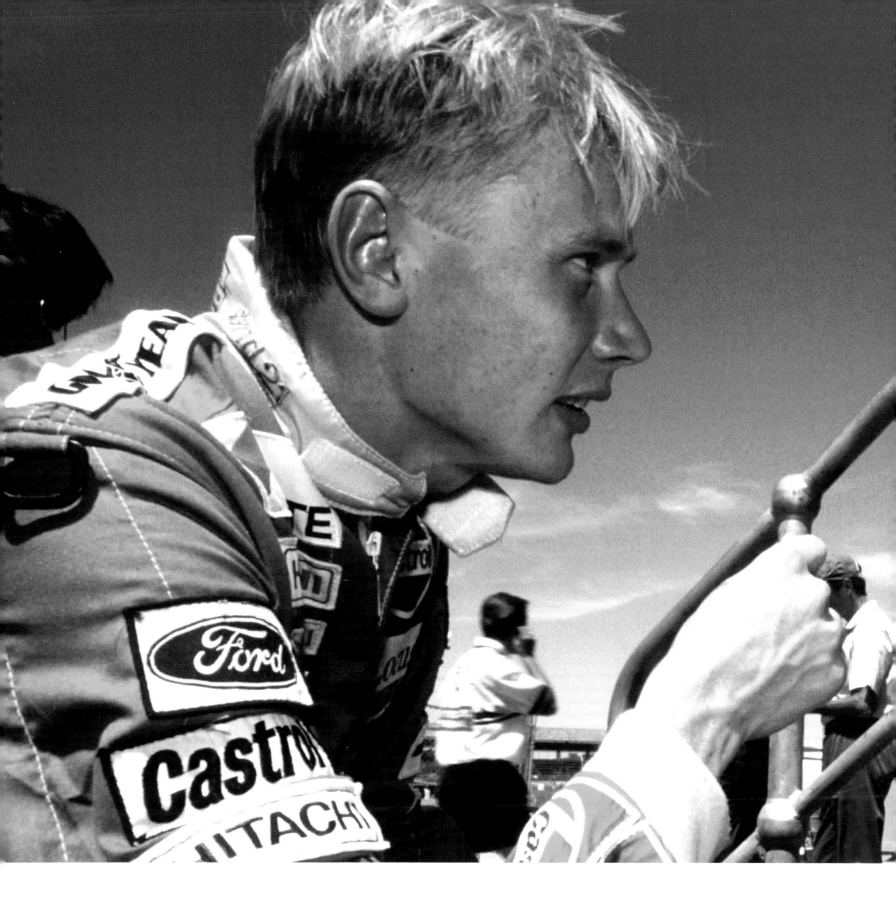

20. 1986-1993: A SUDDEN END

Above: Back in the cockpit in 1989, testing a Williams-Renault.

Previous page: James was employed by John Hogan and Marlboro to mentor young drivers,
including Mika Hakkinen, driving for Lotus in 1992.

James Hunt described himself as 'fantastically busy' in 1986. This was due largely to coaching a young Swedish driver, Tomas Kaiser, a task that took James to Formula 3000 races on free weekends between Grands Prix.

James Hunt

Because of going to F3000 race meetings, which I enjoy because I've been pretty bored hanging around [watching Tomas] testing – actually, I got pretty bored doing testing! – it means I'm trying to cram into four days in the middle of the week what I used to do in seven or ten days between Grands Prix. It's very fraught trying to catch up. Plus the fact that one day a week at least I'm involved with a property company that I have with Bubbles Horsley and another chap. I'm hardly doing any promotional work now – maybe two days a month but that also puts a strain on my four days. Golf has gone out the window; I think I've only managed to play once so far this year. The work with Tomas is an experiment. It's an interesting idea because I'm a good teacher.

John Hogan

When he retired, we wanted to keep him on as an ambassador. By that I mean an ambassador on a short lead, stay with the script, don't get creative.

Being keen to bring on young drivers, we'd noticed that James had an amazing ability to read the game, which is actually quite rare. A lot of people think they can, but they can't. James could spot what was happening, which was why he was a good commentator. He could see with the young drivers who was really good, who was going to get there, who was the real talent.

It was while he was doing this sort of stuff that he became a bit of a coach. And, again, most drivers can't do that. They know what's going on but they can't actually communicate it to the young driver.

James wouldn't sit them down or anything like that. He just sidled up to them or walked into their pit or sat on the side of the car and said, 'You know, you shouldn't be doing that. It would be much better if you did this or you did that.' And they listened and took it on board – or, at least, they would if they were bright. Eddie Irvine was a classic example.

Eddie Irvine

I first met James through his role as consultant to Marlboro. I'd seen James race, of course. I was a great fan. I liked his attitude; James was very much his own man. When I was invited to test for the 1988 Marlboro Formula 3 drive, I really wanted to do Formula Ford 2000 first. But I was offered the drive and James and everyone else said I should accept and move straight into F3 which, for me, was a massive step. But I did it, had a good season and that led to being in line for a Formula 3000 drive the following year. I was told to go to the final F3000 race of the season at Dijon in France, just to see what it was all about. I didn't learn much that weekend thanks to the antics of my mentor, James Hunt.

I met him at London Heathrow. The first thing he did was visit the duty-free shop and buy a bottle of blue vodka. When we landed in Paris, he nipped off to meet two girls at a railway station. As it turned out, the TGV express trains were cancelled due to a strike and we had to catch a slow train loaded with naval conscripts on their way to Marseilles. It took us about five hours

to get to Dijon – by which time there was nothing left of the vodka.

We crawled through the doors of the hotel. Luckily, it was very late by then and the motor-racing people had gone to bed. So we retired to James's room, where he began playing Beethoven at full blast on the portable stereo he carried everywhere with him. James ignored the banging on the walls and the ceiling until someone arrived from reception and told us to stop the party because it was 3 am. And James was supposed to be instructing me on how to be a professional racing driver...

I went down for breakfast the following morning and met Volker Weidler, who was racing for the Marlboro-supported F3000 team that weekend. Volker said, 'Last night was unbelievable. I never got any sleep at all. The people in the room beside me were partying all night. I had to ring reception to get it stopped.'

'Jeez, Volker,' I said. 'That's awful.'

He didn't find out who the culprits were until about four years later. We were racing in Japan and, one night, I told him. His reaction was incredible. He said, 'I knew it! I knew Marlboro wanted me out. They sent you and James Hunt to party and keep me awake all night before the race.' He really believed that and didn't understand it had been the result of a five-hour train journey and a bottle of vodka; nothing more, nothing less.

It was also the wrong reflection of what it was like having James as a mentor. He really understood what was going on between the driver and the car and could talk to you about that and a number of things to do with the racing itself. He was always very good to me and played a part in my involvement with Marlboro when I got to F1.

John Hogan

James and Eddie were two of a kind, no question about it. [Eddie's first Grand Prix] at Suzuka – which James considered to be one of the hardest circuits in the world – finally confirmed James's view that Irvine had real talent. He made sure we knew that. Apart from Irvine's ability, James was a big fan of Eddie because he would talk back; he had his own views – just like James.

At the time of the Dijon trip, neither Irvine nor the rest of the motor-racing world knew about the torment beginning to ferment in Hunt's mind. Struggling with his marriage – through no fault of Sarah – and life in general, Hunt was at the start of a downward spiral that would gradually lead to a form of depression. Hunt's wide circle of acquaintances had no idea that James was becoming introverted, spending more and more time with his budgies between what he referred to as 'dippers'. These black periods of despair would lead him to seek out alcohol and marijuana for temporary respite. He was becoming a mess and his self-medication only served to increase his suffering. In October 1988, James and Sarah separated. Just over a year later, they had divorced. Hunt had hit rock bottom.

He approached a range of healers and psychologists, to no avail. The desperate situation was aggravated by financial difficulties. There was the cost of the divorce, legal fees and a personal investment loss in the region of £200,000. He had been a Lloyd's 'name' at the point where members of the syndicate were suddenly discovering the downside of risk.

With his back well and truly against the wall, Hunt began to fight back as only he could, just as he had in the crisis that hit him just before the final three races of that eventful 1976 season. He bought a bicycle as part of a typically intense campaign to return to fitness. He attempted to give up a cigarette habit that had gone up from a daily intake of 20 when he was racing to more than 30 per day and he cut back on alcohol. The change was remarkable and noticeable.

John Hogan

Initially, I had no idea he was in such trouble. I always thought he was suffering from a hangover when, in fact, he was actually a depressive. Which was quite amazing when you think about how he was or appeared to be. I think it became worse as he got older. In the early days, if he appeared to get the hump or act a bit funny, you left it at that but, as he got older, you could see there was something there. He was under terrible pressure for all sorts of reasons, particularly financial. Then he just turned it all around through nothing more than sheer willpower. It was amazing to see – but not really a surprise if you knew James and what he was capable of. He had enormous strength of character and this is when it really paid off. He cut back on everything; the booze, the drugs, the cigarettes – even the womanising. His focus was phenomenal, which tells you how bad he had been when he couldn't get out of it initially.

'Attack' was always a favourite word in Hunt's vocabulary and now he employed it to the full. He set about becoming established in the media, writing columns for UK national newspapers and, of course, continuing his broadcasting. James became a happy member of the F1 motor-sport press. Journalists who had reviled him as a racing driver grew to enjoy his company as one of their own. Because that's what he was; hard-up, revelling in gossip, appreciating free meals – and in love with the sport.

Hunt chats with Jacques Laffite following the Williams test at Paul Ricard in December 1989. Contrary to rumour, there was no thought of a comeback for James. The test had been arranged to give TV presenters an opportunity to try a current F1 car.

As ever, he didn't hold back in his criticism of drivers or events that, in his view, were not up to the mark. For those willing to listen, he would provide useful and informed feedback. No less a competitor than Ayrton Senna was among their number. His respect for Hunt had grown after James had sought out Senna to admit in person that he'd been wrong when he'd criticised him for some tactic. Hunt later went on to repeat the apology on air. From that grew an appreciation of Hunt's ability to be totally honest, a human trait highly valued by Senna.

Alex Zanardi takes advice from Hunt when the Italian was driving for Lotus in 1993, just a few months before James's demise.

John Hogan

James got very close to Senna, not just coaching but talking things through. Ayrton was all ears. They went for dinner in London one night; it was a chat and a kind of coaching session. At the end of the dinner James said he had to go because he had parked his A35 van in Cadogan Square. Ayrton didn't have a clue what an A35 van was, so James said he'd show him. They ended up doing laps around Cadogan Square, to the point where the A35 with its knackered tyres was beginning to melt!

James might have been making a personal turnaround through his own efforts but he was about to receive a boost from elsewhere. To be precise, from an attractive blonde woman who served him in a Wimbledon restaurant. Helen Dyson worked in Hamburger Heaven at weekends to help fund life as a student in fine arts at Middlesex Polytechnic. Eighteen years Hunt's junior and knowing nothing about him other than the fact that he seemed a charming, likeable man, Helen accepted the offer of a first date. The relationship

quickly blossomed, although it would be more than two years before she moved into the house in which Hunt created a studio for her to practise her skill as an artist. James had never been happier as his life continued to recover its momentum.

On 4 October 1992, Denny Hulme died of a heart attack at the wheel of a BMW M3 touring car during the Bathurst 1000 in Australia. Five months later a memorial service for the 1967 world champion took place, on 24 March 1993 in Chelsea Old Church. James, dressed in a tracksuit, arrived on his bike with a wicker basket on the front. He pulled a crumpled shirt and suit from the basket and proceeded to strip down to his underwear and get changed on the pavement. After the service, he went through the wardrobe exchange in reverse. James pedalling off down Old Church Street with a cheery wave to one and all would become the lasting memory of the man for many of those present.

WE'D NOTICED THAT JAMES HAD AN AMAZING ABILITY TO READ THE GAME.
JOHN HOGAN

The working relationship with Hakkinen had started when the Finn was driving in F3 in 1990.

Murray Walker *It's no secret now that the BBC would cover the races outside Europe from the studio in London. As far as the public were concerned, we were live at the race. You couldn't say you weren't there because, if you weren't there, how could you commentate on the race? But, equally, you couldn't say you were there because that would've been a downright lie. So you used to say things like, 'I can't see the track from my commentary position,' which was perfectly true because we were 6,000 miles away.*

We were doing the South African Grand Prix one year and James was never short of an opinion on almost anything and certainly not on apartheid in South Africa. About halfway through the race, he starts banging on about the evils of apartheid, none of which was relevant to the race and hardly conducive to improving relations between Britain and South Africa. Mark Wilkin, our producer, writes on a piece of paper 'Talk about the race!' and shoves it in front of us. James looks at this piece of paper and says, 'Well, anyway, thank God we're not there.' He completely blew it!

Anyway, we were covering the 1993 Canadian Grand Prix, as usual, from London. James cycled from Wimbledon to Shepherd's Bush. He was riding his bike everywhere. He was seemingly as fit as a fiddle because he had stopped drinking, stopped smoking; he was back into sport again. We did the commentary; it went perfectly well. James then phoned [journalist, author and commentator] Gerald Donaldson, who was ghosting his newspaper column. That done, we went our way, James cycling the five or six miles back to Wimbledon and I went home to Hampshire.

On the Tuesday morning [15 June 1993], my wife, Elizabeth, phoned me. She said, 'Brace yourself. I have got some bad news.' My mother was 96 at the time and I thought it must be her.

'No,' she said. 'James has died.'

I said, 'James who?' When she said 'James Hunt' I simply could not believe it and said something silly like you tend to do on these occasions: 'But I was with him on Sunday and he was perfectly OK.' It was a truly dreadful shock – not just for me, of course, but for millions around the world. He was only 45.

Opposite page: Hunt had a good rapport with McLaren's Ron Dennis and other F1 team principals.

James had died of a massive heart attack in the early hours of the morning. Having had a snooker session in his home with a friend, he had retired complaining of feeling unwell. He never made it to the bed. Earlier in the evening, he had telephoned Helen, who was on a short break with a girlfriend in the Greek islands. James had proposed. Helen had accepted. Now that joy was suddenly turned to devastating sorrow, as it did for his family and many, many friends and associates.

Sally Jones *It was a complete and utter shock. It was particularly difficult for us as a family because my father was in London for a meeting and my mother was in Bristol meeting my sister. This, of course, was before mobile phones and there was some very complicated telephone work trying to reach my sister so that she could tell Mummy. Then we had to ring Victoria station and ask them to page my father, asking him to come to the stationmaster's office or wherever because we didn't want him to learn about it through the headlines on the evening newspaper. Fortunately, we managed to reach him. But it was simply terrible news. All in all, a frantic and awful day.*

Innes Ireland had given an address at Hulme's memorial service a few months earlier. A former racing driver with a tearaway reputation and a president of the British Racing Drivers' Club, Ireland had been occasionally appalled by some of Hunt's antics, and told him so in words of one syllable. Yet he had come to like and respect James enormously. Having retired from the cockpit, Ireland had also proved adept at handling the written word. His tribute summed up the feelings of many who had come to feel affection for James in the same way.

'Often verging on the outrageous,' wrote Ireland, 'his sometimes wild behaviour hid the fact that he was a warm, friendly person of deep understanding and intelligence. More recently, the depth of his caring nature became obvious with the love and consideration he showed for his two sons. Always something of a rebel, he appeared to take some delight in standing – not always gently – on the toes of the establishment. I must say I thought he went over the top on one or two occasions. Somehow, with his acute sense of humour, he always managed to get away with it.'

Ireland himself would die of cancer in October 1993, less than a month after he had read Rudyard Kipling's poem 'If' at a celebration of James Hunt's life. St James's Church in Piccadilly had been chosen for Hunt's memorial service and was attended by his parents Wallis and Sue, family and 600 people from James's life.

It was a grand ceremony and, fittingly, a joyful one, aided by a trumpeter, two soloists and the Wellington College choir. Peter Hunt introduced Wallis and Sue Hunt reading from chapter three of the Book of Ecclesiastes; Stirling Moss, introduced by Sally Jones, read 'Jim' from *Cautionary Tales for Children* by Hilaire Belloc; prefaced by Lord Hesketh, Helen Dyson read from the Psalms and Murray Walker gave an address which was both funny and moving.

'Zadok the Priest' was included towards the end of this lively and varied order of service. Members of the congregation unfamiliar with the piece were caught by surprise as the choir, positioned upstairs and at the rear, suddenly began their urgent rendition after the more solemn and lengthy introduction of organ music. Composed by Handel for the coronation of King George II in 1927, 'Zadok' was another favourite of James. The affirmation of a new reign on this occasion that was predominately happy if only sometimes sad somehow seemed appropriate. As did a party lasting long into the night, partially funded by £5,000 left strictly for that purpose in James's will. A comparatively brief but hugely colourful life was being remembered exactly as it had been lived.

IT WAS A TRULY DREADFUL SHOCK – NOT JUST FOR ME, OF COURSE, BUT FOR MILLIONS AROUND THE WORLD.
MURRAY WALKER

Sally Jones

My last memory of James is being by the pond on Wimbledon Common with him and the boys. James loved feeding the birds and watching the Canada geese in particular. About 18 months after he died, we had a small family ceremony there and planted a tree in his memory. It's a peaceful place, and an appropriate one, to have such good memories of a lovely man.

Opposite page: The friendship with Niki Lauda matured and continued to flourish. The two former rivals get together in Adelaide in November 1992.

EPILOGUE: VIEWS AT VARIANCE

Sitting in the gallery at James's memorial service, I had a good view of every aspect of his life represented throughout the pews below. From his parents and family to friends who had nothing to do with racing and those who had played major parts in such a brief but eventful career, the congregation was as diverse and jam-packed as you would expect of someone who had died so young. And it was reasonable to assume that many of his racing associates were going though emotions similar to my own.

Much as I had admired James as a driver, I had come to detest his persona as reigning world champion. And yet, in the end, I had got to know a very different James Hunt; a man whose company I would actively seek rather than avoid, so much so that the sense of loss in June 1993 had been devastating.

The contradiction had begun as early as that infamous F3 race at Crystal Palace in 1970. Spectating with my mates at the first corner, it was obvious that the fight for second place might end in tears. We couldn't see the contretemps at the final corner but no one was surprised when news came through that James Hunt had felled Dave Morgan. It was not that we had expected Hunt to actually lash out, merely that his action confirmed our suspicion that he was no more than a hooray Henry in racing overalls. That belief would be encouraged by his antics during the next two largely fruitless seasons of F3.

A change of opinion would begin to grow in 1973 when James did remarkable things with the little Hesketh March; a case of the underdog coming good – and having fun. Holding off Niki Lauda to win at Zandvoort in 1975 was very impressive indeed, as were some of his performances in the first part of the following year.

But the absolute clincher for me came when sitting on the grass bank overlooking Turn 1 at Mosport in 1976 and witnessing what I still consider to be the drive of his life. The body language of car and driver through the downhill corner on that day spoke graphically of talent and massive determination when his back was against the wall. It would be repeated a week later at Watkins Glen; this incredible resurgence rounded off by a highly-charged and hilarious night in the Seneca Lodge, as described earlier in the book. When I became a full-time professional writer a couple of months later and my first job was to write for the *James Hunt Magazine,* my joy was unconfined.

It turned out to be purgatory. My illusions were shattered during hours spent waiting outside the Marlboro trailer for interviews – interviews for his own magazine. Once admitted inside, the experience would plumb new depths of embarrassment as he sat in the midst of sycophantic friends and acted like an overgrown schoolboy. I hated every second of the humiliation.

And yet the contradiction so often proved by James would come when we were alone, his answers being intelligent, articulate and reasoned; perfect for the job. And he would be the epitome of politeness throughout. Nonetheless, when he retired halfway through 1979, I was not alone in rejoicing over never having to deal with this driver again.

Our paths did not cross for quite some time. But when they did, circumstances had changed in every direction. James could finally be himself; he was no longer a racing driver under siege by public and media demand. He was one of us in the sense that he was not well off but making a living from a sport that continued to hold him in its thrall. He had the huge advantage of being able to speak with authority; an asset he had no hesitation in using to great effect.

He loved gossip, often fishing for it in the course of long, private calls that, if published or broadcast, would have deeply offended fragile egos within F1. In short, he was huge fun to be with. Our professional relationship had swung through 180 degrees; from seeing an interview as something to be endured, to finding the afternoon spent in his company in Wimbledon 1986 to be an absolute pleasure.

I know there were similar contradictory trains of thought elsewhere during moments of quiet contemplation in St James's Church on 29 September 1993. But the one common thread had to be that an extraordinary character and world-class racing driver had died much too soon.

Opposite page: James with Tom, Pau, France, 1987.

INDEX

ACKNOWLEDGEMENTS

I am greatly indebted to Tom and Freddie Hunt for their help in producing this book and their invaluable assistance with contacts and photographs. As ever, none of this would have been possible without the huge enthusiasm and support of Nigel Moss, Matt Bishop and Steve Cooper of McLaren Racing as we record the story of another of McLaren's outstanding world champions.

Grateful thanks are also due to: Adam Acworth, Mario Andretti, Paul-Henri Cahier, Gordon Coppuck, Stuart Dent, Emerson Fittipaldi, Henry Hope-Frost, Ray Grant, John Hogan, Eddie Irvine, Darrell Ingham, Sally Jones, Linda Keen, Niki Lauda, Maire Marlow, Jochen Mass, Ian Phillips, Dave Ryan, Murray Walker, Peter Windsor and Walter Wolf.

Finally, I must pay tribute to the late Eoin Young, my mentor and the outstanding F1 writer with whom I worked as we put together the *James Hunt Magazine* in 1977. Some of the in-depth interviews with James were never published but have now received belated but timely exposure in this book. I have also taken great pleasure in using sections of Eoin's pithy and penetrating columns in *Autocar* thanks to the generosity and assistance of Peter Foubister and Trevor Dunmore at the Royal Automobile Club's library.

Maurice Hamilton

Bibliography

Hunt v Lauda, David Benson (Beaverbrook Newspapers Ltd, 1976)
James Hunt: the Biography, Gerald Donaldson (Virgin, 2009)
James Hunt, Against all Odds, James Hunt and Eoin Young (Hamlyn, 1978)
The Heavily Censored History of Hesketh Racing, Anna O'Brien (GBM Editorial, 1974)
To Hell and Back, Niki Lauda and Herbert Volker (Stanley Paul, 1986)

Autocar; Autosport; Autocourse; F1 Racing, Grand Prix International; James Hunt Magazine; Motor Sport; the Guardian; the Independent; the Observer

Published by Blink Publishing
3.25, The Plaza, 535 Kings Road,
Chelsea Harbour,
London, SW10 0SZ

www.blinkpublishing.co.uk

www.facebook.com/blinkpublishing
twitter.com/blinkpublishing

HB – 9781910536766
PB – 9781911274681
Ebook – 9781910536773

A CIP catalogue record of this book is available from the British Library.

Design by www.envydesign.co.uk

Printed and bound in Slovenia

1 3 5 7 9 10 8 6 4 2

McLaren © 2016
Text written by Maurice Hamilton, 2016
Text © Blink Publishing, 2016

Pictures selected by Blink Publishing

Papers used by Blink Publishing are natural, recyclable products made from wood grown in sustainable forests. The manufacturing processes conform to the environmental regulations of the country of origin.

Blink Publishing is an imprint of the Bonnier Publishing Group
www.bonnierpublishing.co.uk

Picture credits

Getty Images, pages:

Aarons, Slim: xiv
Blackman, Victor: xvi, 109 (bottom)
Bunge, Roberto: 117
Duffy, Tont: 167
Evening Standard: 95
Galella, Ron: 138
GP Library/UIG: xii
Grand Prix Photo: 73, 287
Harmeyer, Bob: 35, 173
Hogan, Dave: 329
Horstmüller/ullstein bild: 197
Lichfield: 107
Minihan, John: 252-253
Monitor Picture Library/Photoshot: 258
National Motor Museum/Heritage Images: 85
Popperfoto: 261
Rolls Press/Popperfoto: iv-v,
Schlegelmilch, Rainer W.: ii-iii, vi-vii, viii-ix, x-xi, xiii, xviii, 71, 80, 82, 89, 94, 98-99, 104, 108, 109 (top), 110, 111, 114-115, 118, 120, 125, 148, 159, 160-161, 169, 174-175, 181, 182, 185, 192, 200, 202, 211, 217, 271, 272, 281, 282-283, 286, 290, 291, 292, 311, 316, 319, 338, 341
Snowden, Nigel: 67
Universal/Corbis/VCG: 68
Upitis, Alvis: xxi

LAT Photography, pages:

32, 36, 39, 48-49, 52, 55, 57, 60-61, 74, 76, 77, 78-79, 87, 92, 121, 128-129, 130, 133, 134, 137, 141, 142, 144-145, 147, 151, 152, 155, 162, 163, 164, 165, 168, 171, 178, 179, 187, 195, 205, 208, 212, 213, 214, 218-219, 220, 222, 223, 224, 227, 228, 230, 231, 235, 240, 243, 244, 249, 251, 254, 276, 288, 298, 305, 306, 308, 312, 317, 326, 332, 335, 340

Sutton Images, pages:

22-23, 25, 26, 31, 63, 64, 86, 90, 96, 97, 101, 112, 126, 176, 188, 189, 206-207, 232-233, 237, 238, 247, 248, 250, 255, 257, 262-263, 266, 269, 275, 279, 284, 295, 297, 299, 300-301, 302, 313, 314-315, 330-331, 336, 337, 342-343, 345

Paul-Henri Cahier, pages:

102, 113, 122, 124, 127, 156, 190-191, 199

Sally Jones, pages:

38, 43

Freddie Hunt, pages:

265, 318, 320, 321, 322, 324, 325